Norman Mailer was born in 1923 in Long Branch, New Jersey, and grew up in Brooklyn, New York. After graduating from Harvard, he served in the South Pacific during World War II. He published his first book, *The Naked and the Dead*, in 1948. *Portrait of Picasso as a Young Man* is his twenty-ninth book. Mailer won the National Book Award and the Pulitzer Prize in 1968 for *Armies of the Night* and was awarded the Pulitzer Prize again in 1980 for *The Executioner's Song*. He has directed four feature-length films, was a co-founder of *The Village Voice* in 1955, and was president of the American PEN from 1984 to 1986. His latest novel, *The Gospel According to the Son*, was published by Little, Brown in September 1997.

Portrait of Picasso
as a Young Man

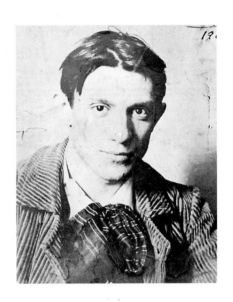

Portrait of

Picasso as a Young Man

An interpretive biography by

Norman Mailer

An *Abacus* Book

First published in the United States of America by The Atlantic Monthly Press 1995
First published in Great Britain by Little, Brown and Company (UK) 1996
This edition published by Abacus 1997

Because of space limitations, all acknowledgements appear on pages 390–400

A CIP catalogue record for this book is available from the British Library.

ISBN 0 349 10832 3

Printed in Italy by LEGO spa
Design by Laura Hammond Hough

Abacus
A Division of
Little, Brown and Company (UK)
Brettenham House
Lancaster Place
London WC2E 7EN

I would like to acknowledge the aid and skillful assistance of Sabra Moore, Veronica Windholz, Lauren Agnelli, John Gall, Laura Hammond Hough, my daughter Maggie Mailer, and Wayne Furman and the staff of the New York Public Library, as well as the staff of the library at the Museum of Modern Art.

I would also pay my respects to the authors I have cited in my bibliography, most particularly to Fernande Olivier, Josep Palau i Fabre, John Richardson, Francis Steegmuller, Roger Shattuck, and Arianna Stassinopoulos Huffington.

A special note of appreciation is due to Nan A. Talese and to Morgan Entrekin.

Painting is freedom. If you jump, you might fall on the wrong side of the rope. But if you're not willing to take the risk of breaking your neck, what good is it? You don't jump at all. You have to wake people up. To revolutionize their way of identifying things. You've got to create images they won't accept. Force them to understand that they're living in a pretty queer world. A world that's not reassuring. A world that's not what they think it is.

— Picasso
as quoted by Kahnweiler in *The Rise of Cubism*

Preface

More than thirty years ago, in the early spring of 1962, a contract was signed with Emile Capouya at Macmillan to do a biography of Picasso, and I then spent eight happy weeks in the library of the Museum of Modern Art looking through Zervos' *Pablo Picasso*, published by Cahiers d'Art. Fifteen thousand reproductions of Picasso's paintings, drawings, prints, etchings, lithographs, watercolors, and sketchbooks were studied page by page through thirty-three large volumes.

The experience may be equal to reading all of Shakespeare in two months—after such immersion, one can hardly sustain one's previous view of existence. The thirty-three volumes of Zervos had as large an effect. My mind was left one hair unhinged. I spent the summer writing a dialogue between an imaginary interviewer and myself dealing with such questions as "What is the distinction between soul and spirit?" and "How do we decide on the nature of form?" One even gave answers. It is all there in the last two hundred pages of a book called *Cannibals and Christians*, but those imaginary dialogues contain hardly a word about Picasso. He had stimulated the dialogues in such a way that one had insights into the extremities of one's own thinking but few biographical perceptions about him.

Following that summer, I seem to recollect giving back the advance to Macmillan, or perhaps I had not yet received it; in any event, the project lapsed. I was not ready to write about Picasso. Nonetheless, the impulse persisted (if usually wistful), until a few years ago, when it was stimulated by a book that I liked by half, and by

half found wanting—precisely what you need and look for in someone else's work in order to get yourself started. In this case, it was Arianna Stassinopoulos Huffington's *Picasso: Creator and Destroyer*, which received a spate of cruel reviews for its faults and did not receive nearly enough good reviews for its virtues. As will be seen, quotes are taken from it more than a few times in the course of what follows.

Other authors would also make their large contribution. One can list Josep Palau i Fabre, Roland Penrose, Patrick O'Brian, Gertrude Stein, Leo Stein, John Richardson, Pierre Cabanne, Jean-Paul Crespelle, Daniel-Henry Kahnweiler, Max Jacob, Roger Shattuck, Roy MacGregor-Hastie, André Malraux, André Salmon, Francis Steegmuller, Isabelle Monod-Fontaine, Hélène Parmelin, and not least but foremost—her two books inspired larger excerpts than any other—Fernande Olivier.

Since this work is characterized as an interpretive biography, it may be worth remarking on the terms of such a description. While one can lay claim to no original scholarship, the desire to make Picasso as real as any good character in life or in art has been the literary virtue sought after here. Which is equal to saying that the interpretation of Picasso's life and work as a young man is my individual understanding of him, and I will rest on such a claim. I will not pretend, however, that I did not learn a great deal from the other men and women who have written at length on the artist. Given the singularity of this effort—no original scholarship, much personal interpretation—there was real purpose to quoting other authors at greater length than is customary, and one is prepared to argue for the value of this as a practice. Style, after all, is revelation. Whether good or bad, style reveals the character of the writer who is perceiving the subject. To paraphrase another author is to deprive the reader, then, of the often unconscious but always instinctive critical judgment the reader is ready to make on the merits of the observer if given the opportunity to live a little while in the style. (An observer can be highly imperfect, but if we have insight into his or her flaws, we can learn a great deal about the subject—it is the adjustment all of us make almost all the time when we listen to one person describing another.) Moreover, most authors write better in some of their pages than in others, and so it is close to criminal to summarize an interesting or well-written passage merely to keep the reins of the book in one's own hands. Coming into a sense of Picasso's character calls for viewing him and his work from many an angle, and to stint on the excerpts is to blur each separate vision.

How intense are these visions, and how special! In the course of writing this book, I came across my old copy of Penrose's *Picasso: His Life and Work*, and in it

was discovered a page of notes I had written back in 1962. It gave me pleasure that the words set down then were sufficiently contemporary to my present purpose to be put with no difficulty in this manuscript. It was nice to know that a part of oneself was still playing the same tune three decades later.

Let me wish you enjoyment as you read this book. I had pleasure in writing it. Life is not so bad for an author when he can spend every hour of his working day lifting his eyes from one Picasso to another.

—*Norman Mailer*

Contents

Part I

I, the King

Picasso, delivered at 11:15 P.M. in the city of Málaga, October 25, 1881, came out stillborn. He did not breathe; neither did he cry. The midwife gave up and turned her attention to the mother. If it had not been for the presence of his uncle, Dr. Salvador Ruiz, the infant might never have come to life. Don Salvador, however, leaned over the stillbirth and exhaled cigar smoke into its nostrils. Picasso stirred. Picasso screamed. A genius came to life. His first breath must have entered on a rush of smoke, searing to the throat, scorching to the lungs, and laced with the stimulants of nicotine. It is not unfair to say that the harsh spirit of tobacco is seldom absent from his work.

Since such family accounts are open to exaggeration, Don Salvador may not actually have shocked the newborn into life. All the same, the story is agreeable. It explains much. Spanish surgeons, for example, do not like to give painkillers to gored *toreros* when cleaning out the wound. Their premise is that the body will heal faster if it has suffered the torment; it must be quintessentially Spanish to assume that reality is the indispensable element in a cure. Don Salvador could have been offering that whiff of smoke as an objective correlative: "Wake up, *niño*" might have been the message. "Life in these parts will seldom smell better than this."

While rapid summary is seldom satisfactory, a quick description can probably be given of the relatives surrounding the infant. Picasso's father, José Ruiz Blasco, was the next-to-youngest son in a large family which was proud to trace its way back to a few aristocratic ancestors. One of them, "Juan de Almoguera, born in

Cordova in 1605, became both an Archbishop and the Viceroy and Captain General of Peru." (He even "became famous for his forceful denunciation of the corruption prevalent at that time in monasteries or convents.")[1] By 1850, however, the family was no better than middle-class. Commerce had beckoned—Picasso's paternal grandfather manufactured gloves. In turn, several of his sons became successful professionals: a doctor; a diplomat of lower rank; a canon in the cathedral. Picasso's father, however, called himself a painter, and did not work too hard at it when young. He was better known, for a time, as a man about town.

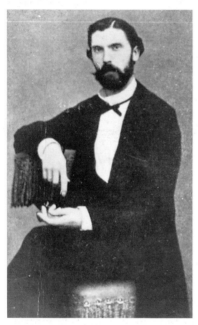

José Ruiz Blasco

Tall, elegant, blue-eyed, "thin and fair, he was sometimes called 'the Englishman'"[2] by his Malagueño friends and was easily the most spoiled member of the family, even managing for a number of years to live rent-free with his older brother Pablo, the canon, while developing his own reputation as a bachelor sport. (He was one of the regulars at an upper-class brothel run by Lola La Chata where the whores would await their clients "in a conventional sitting-room almost as if they were daughters of the bourgeoisie," and the mise-en-scène would include knitting, sewing, reading.)[3]

It was not until the age of thirty-seven that José Ruiz was finally obliged to go to work. He became an art instructor at the Escuela de Bellas Artes in Málaga, and five years later married María Picasso López, who was then twenty-five.

He had married down. His bride was "small and vivacious with black eyes and dark hair,"[4] but she was without a dowry. In Málaga, the family Picasso was hardly in social balance to the family Ruiz. What she could offer to the marriage were large funds of energy and a set of thrifty habits well equipped to make the most of the restricted income that came in from her husband's two low-paying jobs: He was also curator at the local museum.

His wife brought in tow the women of her family—her widowed mother, her two spinster sisters, Eladia and Eliodora, and a maid. So, the child of José Ruiz and María Picasso, first to be sired by any of the Ruiz Blasco brothers, would now spend his next few years surrounded by five women all eager to be of service to

him, all ready to take delight in his every move. They make up his first royal entourage. He was christened Pablo Diego José Francisco de Paulo Juan Nepomuceno María de los Remedios Crispín Crispiano Santísima Trinidad Ruiz y Picasso or, in brief, Pablo Ruiz. As an example of prevailing sentiment, his mother would later say, "He was an angel and a devil in beauty. No one could cease looking at him."[5] Of course, his mother claimed to have told him: "If you become a soldier, you'll be a general. If you become a priest, you'll end up as the Pope!"[6]

In 1900, just before embarking for Paris on his first visit at the age of nineteen, he would do a self-portrait (now lost) that he titled *Yo—el Rey*, and he would sign it three times for emphasis, "I, the King; I, the King;

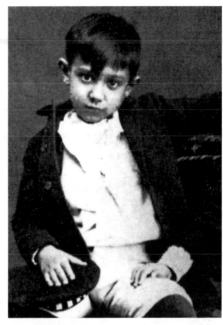

Picasso in 1888.

I, the King." It helps us to take measure of the self-importance that burgeons in a small boy adored by so many women. Of course, he only remains a king within the world of maiden aunts; he is defenseless as soon as he steps outside.

His sister Lola was born three years after Pablo and just three days after an earthquake devastated Málaga. The family fled their apartment on the Plaza de la Merced to stay for a few nights in the studio of don José's most prestigious friend (and employer), Muñoz Degrain, who had an atelier built on a high rock outcrop. Two huge happenings in the life of a three-year-old were now powerfully associated. Just seventy-two hours before the massive disruption to his royal existence caused by a baby sister entering his life, the earth began to move beneath his feet; he was swept up in a blanket and carried to a house that was deemed by his parents to be secure against these terrifying convulsions. Nor was it irrelevant that the place belonged to a man of the first importance to his parents. Muñoz Degrain was not only principal of the Escuela de Bellas Artes, but the most established painter in Málaga. To the child it must have seemed as if the best protection against earthquakes resided in the house of the best painter in town.

Of course, other psychic equations would follow. Since his sister Lola was so soon to follow, the three-year-old boy may have assumed that birth was the after-

effect of a cataclysm. Were women with large bellies omens of earthquake and birth? It is interesting to note the huge misshapen females he would paint in the 1920s. For that matter, his maternal grandmother, still living with them, was a very fat lady with a powerful presence.

Three Bathers, Juan-les-Pins, June 1920. Oil and charcoal on wood, 32 x 39 in.
Unless otherwise noted, works are by Picasso and were completed in Paris. For all artwork, the dimensions are given to the nearest inch.

By the 1950s and 1960s, when Picasso, in his seventies and eighties, had become a gargantuan phenomenon to the media, one theme often appears in his interviews. It is that as he paints, something is happening. He is not alone. A process, separate from himself, is working through him. As in Zen, *it* is doing the job: "One line attracts the other and at the point of maximum attraction, the lines curve in toward the attracting point and form is altered."[7] Again, in 1964, at the

age of eighty-three, he made an unusual remark for a man who was now a Communist, and long a dedicated atheist. Referring to the act of putting pigment on canvas, he said to Hélène Parmelin: "Something sacred, that's it. It's a word that we should be able to use, but people would take it in the wrong way. You ought to be able to say a painting is as it is, with its capacity to move us, because it is as though it were touched by God . . . that is what's nearest to the truth."[8]

Let us entertain the speculation that after the earthquake of 1884, the three-year-old saw birth and cataclysm as closely linked to the same force. Separate from all that was daily and predictable in life, this force was what others referred to as God. If disasters were clear expressions of God's presence, there were positive ones as well—the drawings that emerged from his hand. At the heart of the universe, therefore, was a disruptive power never too far away from this mysterious act of drawing. The family legend, according to Palau, who cites Penrose, is that his first word was *piz*, for *lapiz*, a pencil.[9] Put a pencil in his hand and he could do astonishingly well for a child still looking for his first few words. We can pass over the states of excitement engendered in the court of five women at their beloved's display of early talent, but contemplate the depth of emotion in the father. An academic artist who worked slavishly for his realistic effects, don José had become locally celebrated by now as a painter of pigeons. They were not only his favorite subject but his commercial trademark. If you happened to live in Málaga and were looking for an oil painting full of pigeons to hang in your living room, don José

José Ruiz Blasco, Palomar (The Pigeon Loft), Málaga, 1878. Oil on canvas, 40 x 57 in. *José Ruiz Blasco, Pigeons. Oil on canvas.*

was the painter whose wares you bought. Trapped at his own competent level of mediocrity, don José must have had the same sense of mission (and redemption) that an ex-athlete of no particular renown might feel if his son demonstrated exceptional ability at his father's sport. The father would now have a future. One could be manager for a prodigious talent. To the photographer Brassaï, Picasso said in 1966: "My first drawings could never be exhibited in an exposition of children's drawings. The awkwardness and naïveté of childhood were almost absent from them . . . Their precision, their exactitude, frightens me . . . My father was a professor of drawing, and it was probably he who pushed me prematurely in that direction."[10]

On the other hand, the boy, not yet six, had difficulty in reading and writing and was wholly unable to comprehend arithmetic. He was petrified when he had to go to school. The man who would become his dedicated memoirist, Jaime Sabartés, describes the process: Each morning, on his way to class, the maid dragged an hysterical little boy through the streets and into the classroom.

At his desk, the child could not concentrate. No matter what the teacher was instructing, he would devote himself to drawing. Sometimes, he would get up and tap on the window at people passing below on the street.[11] He might just as well have been a young prince thrown into the bull pen of a county jail. The contrast between his commanding presence at home and these humiliating entrances into a room full of boys his age may have created a fear of the social world that would not leave him for the rest of his life. He showed such panic at these new surroundings that his father had to transfer him to a small private institution, the Colegio de San Rafael, presided over by a friend. The new headmaster, apprised of the boy's unique artistic abilities and exceptional terrors, permitted him to leave class and sit in the kitchen with his wife while she was preparing a meal. There, he was able to draw until his father came to take him home.

There was good reason for the child's inability to learn arithmetic: The numbers did not impinge on him as concepts. Rather, they struck his eye as forms. Later, he would remark that he used to see the number seven as a nose drawn upside-down. Jaime Sabartés has Picasso recalling a few verbal sentiments when going home from school: "I'll show them what I can do! They'll see how I can concentrate. I won't miss a single detail . . . The little eye of the pigeon is round like an 0. Under the 0 is a 6 for the breast, underneath that a 3. The eyes are like 2's, and so are the wings . . ."[12]

We can propose that if the 0 was an eye, then the integer 1 might have signified a person in the distance and 2 was a man or woman kneeling in prayer. If 3 was turned on its side, it became breasts or buttocks—what childish glee! Yes, how he could concentrate on his studies! The number 4 might seem a sailboat in the Mediterranean, 5 a phallus and testicles, 6 a wineskin that men drank from at bullfights, 7 is our friend the nose, and 8 is a head on a body, his fat grandmother perhaps, while 9 might be a flower on a curved stem.

The examples are arbitrary. In whatever manner he saw each number, it is safe to assume they lived in him as forms; he could not, therefore, comprehend them as ciphers. In any case, he was drawing all the time.[13] We have to conceive of what a small miracle in these early years were lines on a piece of paper. To Picasso, a face emerging under his pencil could transport him to the world outside, a process altogether equal to another child's wonder at the fact that being able to speak could bring food or comfort. Since the forms inscribed by his pencil were as real to him as words, it must have been reasonable to believe that pictures produced results as simply and directly as spoken language; both were magical processes: A small cause produced a large effect! So it was not unnatural to assume that as one drew, one steered one's way through a field of forces capable of producing earthquakes or infants. Yet, by dint of his drawing, he could be relatively safe. Fifty years later, he would tell Roland Penrose that among the first things he would draw were spirals. In Spain, one could buy *churros*, spiral-shaped fritters. Draw a spiral and he would receive a *churro* from his mother or his aunts. Early magic![14]

A second sister, Concepción (Concha), was born when he was six; a few years later, the family for economic reasons was obliged to move to Corunna, on the northern coast of Spain. The municipal museum of Málaga, where don José had earned a good part of his income by serving as curator, had now closed down.

In Corunna, however, that once-petrified boy who could not bear to go to school became more manly, at least by his own latter-day account in an interview not published until 1982. He speaks of becoming a prime member of a gang.[15] It is far from impossible. One of the mysteries of boyhood is that one does grow out of fears which but a few years before were seemingly permanent. Whether he actually chased cats with a shotgun, as he claimed, or served as maestro to the other eleven-year-olds when it came to mock bullfights is dubious. What may be more likely is that his ability to draw won some admiration from the gang. If he

Don José, Corunna, January 1, 1895. Pencil with white chalk on sketchbook page, 5 x 8 in.

Doña Maria (left), Corunna, 1894. Conté crayon on sketchbook page, 8 x 5 in.

seems to have thrived in Corunna, that was not true for his parents. Uprooted from Málaga, where they had lived for all of their lives, they soon became depressed in the new city.

Of course, one of these drawings (above) was made but ten days before their youngest daughter would die of diphtheria, on January 10, 1895, at the age of

Head of a Child with Bonnet, Corunna, 1894. Pencil on sketchbook page, 8 x 5 in.

seven. The sketch of Conchita was probably done by Pablo in the previous spring.

At the beginning of his thirteenth year, therefore, he would experience a trauma that would be the very stuff of future obsession. To conceal from his little sister how grave was her condition, the family had celebrated the Christmas season as usual, but they knew: Conchita, confined to bed, was mortally ill. Her thirteen-year-old brother—in what state of desperation and noble resolve we can only surmise—took a vow directed to one no less than God: If Conchita's life could be spared, he would give up all thought of painting again.

We know from John Richardson that some sixty years later Picasso told Jacqueline Roque, his second and last wife, of this vow.[16] A few years earlier he had also recounted to Françoise Gilot his anguish as he watched Conchita deteriorate:

> . . . he was torn between wanting her saved and wanting her dead so that his gift would be saved. When she died, he decided that God was evil and destiny an enemy. At the same time he was convinced that it was his ambivalence that had made it possible for God to kill Conchita. His guilt was enormous, the other side of his belief in his enormous power to affect the world around him. And it was compounded by his primitive, almost magical conviction that his little sister's death had released him to be a painter and follow the call of the power he had been given, whatever the consequences.[17]

Arianna Stassinopoulos Huffington may be too complete in her assessment of the power of this incident; even for a genius, the age of thirteen is a little early to decide that God is evil—but then if Picasso was telling the truth to Gilot and Jacqueline Roque, he had taken a prodigious vow. Only a saint would not have had some afterthoughts about the cost of offering up one's talent for a sacrifice, and only a remarkably virtuous child would not have slipped back to drawing on the sly even as Conchita was failing.

What we do know is that Picasso safeguarded this story for close to six decades. That suggests he gave his word and betrayed it. How could he not feel tainted when she died? God was not only overlord of the field of forces but a judge, doubtless, who kept records of broken vows.

His father suffered noticeably from Conchita's death. Depressed already by the three and a half years he had spent in Corunna, don José would walk each day to the school where he taught, then, after work, come back the few blocks to his house and stare out the window. He would study the rain. In place of that coterie of friends and relatives who shared the warm air of Málaga with him, he now had no company for these cold and northern reaches. He was marooned in a seaport on the winter Atlantic; he did not even have an occasional patron for his pigeons. In Málaga, he had enjoyed taking his son to bullfights, and "once," says Huffington, "the little boy was so taken by a bullfighter's 'suit of lights' that he would not stop crying until he had touched it."[18] According to a later interviewer, the boy sat on the *torero*'s lap, "looking at him, overwhelmed."[19]

Yes, a suit of lights could produce a primal excitement, and don José had been the agent of such joy for his son. Now, in Corunna, don José was surrounded by his dark little wife, dark little son, and dark little daughter. Lost was the one child,

Conchita, who had offered promise of being tall and fair. He grieved. As the Picasso legend developed forty and fifty years later, often with the aid of Sabartés, we are asked to believe that don José gave up painting and bestowed his brushes on his son, whose talent was already demonstrating more than exceptional promise. According to an interview conducted by Pierre Cabanne with Manuel Pallarés, soon to be Picasso's best friend in Barcelona, it was "made up out of whole cloth,"[20] and, for that matter, there are, according to Richardson, paintings by don José dated later than this period.[21] The story, as related by Picasso forty years later to Sabartés, is better appreciated for its subtext. The boy may have decided that there was little to pick up any longer from his father's maxims on how to paint.

This siege of tedium came to an end, however, for don José. A teacher at La Llotja School of Fine Arts in Barcelona was ready to exchange his post for one in Corunna. So the Ruiz family was soon able to transfer to Barcelona. There they not only arrived with the knowledge that the move was major for the family—a

shift from a provincial town to an artistic center—but that they were arriving with a son who was exceptionally accomplished for his age. The oil of Aunt Pepa, painted during a stop for a family visit in Málaga, en route by sea from Corunna to Barcelona, is there to impress us. At the sign of such talent in a fourteen-year-old, we can understand how he had to break his vow.

Portrait of Aunt Pepa, Málaga, c. 1895–96. Oil on canvas, 23 x 20 in.

Barcelona was practically the world capital of anarchism. The medieval society of Catalonia, based on a rigidly hierarchical system, had totally collapsed at the beginning of the 18th century. The various classes that had given that society its shape were replaced by new classes, at least in the upper echelons, but these new classes remained alien to the country itself. They were like the forces of an occupying power . . .[1]

Barcelona was the place to develop. Picasso's self-importance would develop into a rich view of himself as a rogue, an outlaw, a conquistador ready for artistic battles not yet waged. If in Corunna he had underlined *latrocinor*—"I am a pirate: I am a raider"—in his Latin grammar, such roles soon took on more reality. The art students he met at La Llotja, seen through the eyes of an adolescent, were anarchists, madmen, wild men—in short, young middle-class students like himself. Still, they could feel themselves possessed of a genuine mission. Surrounded by a stifling bourgeois world that was virtually summoning them to throw it over, they were full of the intoxication that, yes, they were the ones who would do it. Since the Ruiz family came to Barcelona in September of 1895 and Picasso, but for occasional sojourns in Málaga, Madrid, and Horta de Ebro, would live in this capital of Catalonia for the next five years, it proved to be a powerful, fearful, and stimulating adolescence. Picasso, as we shall see, had a profoundly divided nature, but it was the saving mark of his wit to proceed in opposed directions at once: For the early years in Barcelona, he explores religious subjects and sex.

Of course, the religious themes come first. His family was still immersed in

Conchita's death; besides, the family tradition was pious. Don Salvador (of the cigar smoke) had not only become the richest member of the family but the most devout; he and his wealth would be most approving of the new direction taken by his nephew. Since there were also substantial prizes waiting for the winners of competitions, don José all but directed his son during that first year in Barcelona to complete a major painting called *First Communion*. Indeed, don José sat as the model for the father, his sister Lola was the communicant, and the son of a friend of his father posed for the altar boy. It is worth noting that our fourteen-year-old not only treats these principals as individuals, each with a singular presence, but indeed the candelabra, the floral arrangement, and the altar cloth are just as carefully drafted and painted. The immanence of objects is entering his life. They speak to him as creatures virtually as alive as his models. The sentimental Catholicism of the painting is enhanced, therefore, by his primitive regard for the mysterious value of inanimate objects.

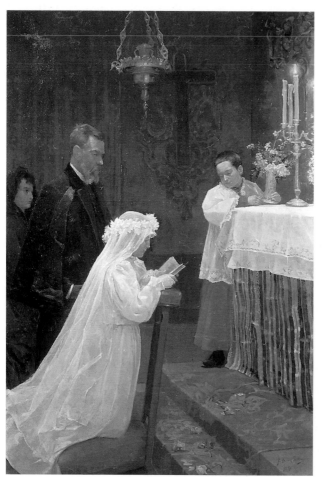

First Communion, Barcelona, 1896. Oil on canvas, 65 x 46 in.

It is obvious. He will be able to make a good living as a painter of religious subjects, or, yes, he would if he were ready to move artistically in one direction. Given the opposites in himself, however, it need not surprise us that he spends a good deal of time in his fourteenth and fifteenth years visiting the brothels in the Barrio Chino of Barcelona.

Picasso's legend would have it that he was an unusually magnetic personality from early adolescence on, and proved irresistible even then to the prostitutes he visited: before he was sixteen, he would know more about sex, went the legend, than most men will ever know. It was certainly not an image of him that he was about to dispel in later years, but it is not easy to believe. For one thing, where did he find the money?

Richardson wonders whether his fellow students occasionally treated him, "or were his boyish charms such that the motherly whores did not charge him?"[2]

Such an hypothesis is conceivable, of course, but one has to question how many women were loving in the Barrio Chino. While he could, with his facility for drawing, have charmed many a whore or paid for his sex with a quick sketch, a visit to a brothel was more likely to have been not only an extraordinary experience for a young art student but harsh as hell. In 1948, more than fifty years after Picasso's introduction to the Barrio Chino, the look of the quarter suggested that it had not changed in a hundred years. The buildings were very old, the streets were wet alleys, and the particular establishment shown to the American visitor by Loyalist friends (who wished to produce a prime example of conditions of social depravity under Franco) happened to be the most famous whorehouse in the quarter. In a large bare room, along a dais some sixty or seventy feet in length, forty or more women in bras and panties were bellowing out the catalogue of their specialties before a near mob of a couple of hundred men, just about all of these putative customers puffing away on cigarettes as if to raise a wall of smoke between themselves and the cacophony of sexual advertisement bombarding them. The density of smoke in that room cannot be exaggerated.

Every half-minute or so, one of the women would succeed in capturing one of the men. Holding her client by the hand, she would step off the dais and lead him promptly to a grilled window, where he could purchase a ticket in triplicate—a stub for the house, a receipt for the client, and a copy for the woman; then, still proceeding hand in hand, they would mount a staircase divided down the middle by a balustrade, the railing installed to separate up-coming traffic from down-going; on the latter side, whores in the process of saying farewell would stroll down the stairs to take up a position again on the dais. All the while, cigarette smoke mounted like storm clouds. It was 1948 and one was full of Loyalist sympathies; all the same, it seemed difficult to believe that every bit of this was uniquely Franco's fault. That brothel in the Barrio Chino possessed its own air. Such nonstop avidity had the power to echo back through a century.

Yet if the legend is correct, we are asked to believe that our once-delicate child, dragged daily by the maid to school, has now metamorphosed, just eight years later, into a phenomenally precocious whorehouse stud. Picasso would certainly become the first master of metamorphosis, but it is asking a lot to picture him there ready for action at the age of fourteen or fifteen. The answer may be that he would go to these places with a physically powerful friend, Manuel Pallarés, whom he had met at class in La Llotja, and that Pallarés, tall and well built, served as an unofficial bodyguard.

Portrait of Manuel Pallarés, Barcelona, 1895. Oil on board, 14 x 10 in.

Pallarés, the stolid son of peasants from a small village who were well off enough to send him to school in Barcelona, was himself twenty, but he was soon captivated by the personality of the fourteen-year-old who worked at the easel next to him. In an interview with Pierre Cabanne in 1972, Pallarés, then ninety-six, recalled their early friendship with what one hopes is some measure of accuracy:

> He had a very strong personality . . . He was appealing and way ahead of the others, who were all five or six years older . . . he grasped everything very quickly; paid no apparent attention to what the professors were saying. Picasso had no artistic culture, but had extraordinary curiosity . . . took things in the blink of an eye, and remembered them months later . . .
>
> In everything, he was different . . .
>
> Sometimes very excited, at other times he could go for hours without saying a word . . . He could get angry quickly but calm down just as fast. He was aware of his superiority over us, but never showed it. He often seemed melancholy as if he had just thought of some sad things. His face would cloud over, his eyes become dark . . .

At fifteen, he neither seemed nor acted like a boy his age. He was very mature.[3]

There is a self-portrait Picasso did at this time that suggests a considerably more inhibited view of himself.

The twenty-year-old and the fourteen-year-old took walks down the Ramblas together, sketched together, went to cafés together; if Picasso visited the Barrio Chino with anything like the frequency he claimed, Pallarés, presumably, was taking care of the tariff. Picasso, in return, would insist that his parents invite Pallarés each Sunday to dinner. After a few such get-togethers, don José and doña María came to the conclusion that the new, mature, and physically powerful friend was a wholesome influence on their temperamental son, the older brother he had never had. When alone, however, neither Picasso nor Pallarés bothered to be conspicuously adult. Picasso recalls leading Pallarés up to a roof in order to lower a coin to the ground, the ducat attached to an invisible black thread. Whenever someone bent over to pick it up, they would snatch back the money. Great glee!

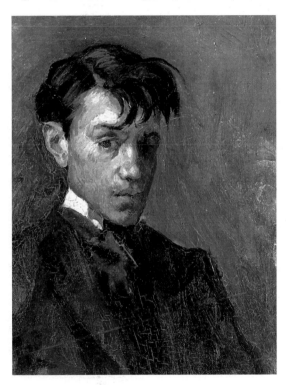

Self-Portrait, Barcelona, 1896. Oil on canvas, 13 x 9 in.

At other times, they might drop pebbles on people passing below. In Barcelona's February Carnival of 1897, they went out together dressed as women. Pallarés made a male conquest—a most persistent seducer—whom he could only get rid of by knocking him down with a punch.[4] Some friendships live on their memories. At the age of ninety, Pallarés would still come to visit Picasso each summer at Mougins.

During these first years in Barcelona, Picasso was busy with work. In 1896, *First Communion* was shown at the Exposición de Bellas Artes, where such locally famous painters as Ramón Casas and Santiago Rusiñol had work hung in the same

year; and in 1897, another painting, *Science and Charity*, received an honorable mention in Madrid at the General Fine Arts Exhibition.

Once again, don José had been the model. "Every time I draw a man," Picasso said in later years, "I think of my father. To me, man is don José, and will be all my life."[5]

In this connection there is an anecdote in *Picasso's Women*, by MacGregor-Hastie, that is without attribution but derives probably from Tristan Tzara, who by his own account was a great intimate of Picasso's from the 1920s on through the next thirty years and served MacGregor-Hastie as "an almost bottomless pit from which I mined Picasso tales long before I thought of writing this book."[6]

MacGregor-Hastie, speaking of this period, informs us that Picasso, before quitting Barcelona for Madrid

> . . . found a way to lose his virginity. Even before the holiday, he had his eye on a young girl who drew wine in the bar above which he had his secret studio. She was a tall thin girl, unlike the voluptuous women most male virgins are attracted to, but she had a ribald sense of humour and made him laugh. She said later that one day, while she was laughing with him, he got her up against a barrel and "made himself a man." Looking at her spare body and red hair, he said to a friend that it had been "like fucking his father."[7]

The story may be worth no more than its paragraph. Tristan Tzara was not only a raconteur but a surrealist, which is about equal to saying that to him, a made-up tale had the virtue of being untarnished. Bourgeois truth, after all, was always sullied. All the same, the story, if in any way valid, might have a touch of connection to Picasso's evolving decision over the next few years to change his signature. Pablo Ruiz was yet to become P. Ruiz Picasso, then P. R. Picasso, and finally, by 1901, certainly at what pain to don José is not agreeable to contemplate, Pablo Picasso. The name fell more happily on the ear—and certainly suggested a more interesting painter—than the more commonplace Pablo Ruiz.

As Picasso was to tell Brassaï in 1943,

> "I'm sure [what attracted me to it] was the double 's' which is very rare in Spain . . . Have you ever noticed that there's a double 's' in Matisse, in Poussin, in Rousseau?"[8]

In any case, such a transformation was hardly routine at the turn of the century in Spain (when the pride of being born a man was still as powerful as blood), especially since he was taking his mother's name in preference to his father's. Intensi-

fying this misidentification (which, paradoxically, offered him a more profound sense of identity) was his physical resemblance to his mother—he would always belong to her short, dark, sturdy Mediterranean stock—"so small that her feet did not touch the ground when she was sitting."[9]

Science and Charity, Barcelona, 1897. Oil on canvas, 77 x 97 in.

That change of name was still a few years away. In 1897, his father must have been proud of *Science and Charity*, which looked to be obtaining a small but positive effect on his son's career. Sabartés mentions that a critic in Madrid mocked the treatment of the invalid's hand—"isn't the doctor taking the pulse of a glove?"—but the prestige of an Honorable Mention excited his uncle don Salvador, who was now married to a Malagueña of impeccably aristocratic family and living "in the Alameda, the most fashionable avenue in Málaga."[10]

Don José and his family went back to visit for their summer vacation in 1897, taking *Science and Charity* with them. It had been up for sale in Madrid at the

extremely high figure of 1500 pesetas (half of don José's annual salary), but had not sold; now, don Salvador, being presented with the painting as a gift, was sufficiently impressed to hang it in the front hall. Science and Charity! It is virtually a logo for the good doctor. Ready to join with don José in planning for the young painter's future, don Salvador agreed that the boy should be sent to the Royal Academy in Madrid; he rounded up all the relatives in Málaga to contribute their share of the expense.

The arrangement, however, did not work out. Don Salvador might have taken a closer look at *Science and Charity*. It may be sentimental, pious, and posed, but there are subtly rebellious elements. The mirror above the sick woman's head is an extraordinary object to be found in an impoverished room; the ecclesiastical and the sexual are brought together in a flamboyant frame that suggests a baroque vagina, which is to say that it is richly over-articulated. If such a visual metaphor would hardly go unremarked today, Picasso, in that era, could count on the certainty that his relatives were not about to separate an object from the word that signified it—a mirror was a mirror; what would it matter what it looked like? Emblematic of his future humor, however, it lives on the wall of that painting vibrantly at odds with the theme.

Picasso would not do much work in Madrid. Alone, resentful of his family's eagerness to direct his career, he was frustrated to discover that instruction at the Royal Academy was even more academically constrained than at La Llotja. Soon enough, he began to disappoint his father's friend and former employer, Muñoz Degrain, who, as one of the principal teachers at the Royal Academy, was planning to keep an eye on don José's son.

> . . . right off they failed to get along. Muñoz Degrain expected to see the little boy who did sketching at the port in Málaga, but instead found a young man confident of himself, his personality, and his talent. No way to establish rapport. The gap between them was the first sign of Pablo's independence. Degrain liked his friend's son, appreciated his talent, and was wise enough to ascribe the gap to Andalusian pride. Later, he would wistfully say, "Had I been able to help him, he would have turned into a good naturalistic painter like me."[11]

In fact, Muñoz Degrain had dispatched letters to don José criticizing in detail the absenteeism, lack of work, and general bohemianism of the prize son. Such word also got back to don Salvador, who promptly cut off the stipend. Picasso, now living on what his parents could scrape together, found himself too poor to rent a studio. He was reduced to painting in the open air, and it is possible that in

the course of living alone in an unheated room without close friends in the city, reduced to being a sketch-pad artist tramping the streets, he may have developed the beginning of a confidence that he could live on next to nothing as a bohemian. If so, it would serve him later in Paris.

He also struggled with illness, and spent more and more time in bed in the spring of 1898, and came down with what could have been scarlet fever. For his convalescence, he returned to Barcelona to discover that the city was in an ugly ferment. The war to subjugate the revolution for independence going on in Cuba had just taken another disastrous turn; the U.S. battleship *Maine* had been sunk in Havana harbor. It was now almost certain that America would soon be in the war against Spain. So, the old laxity in conscription procedures was no longer acceptable to the local authorities. Pallarés, to avoid the draft, had decided to go back to his native village, Horta de Ebro, which was well isolated in the mountain wilds near the border between Aragon and Catalonia. There, he could hide out.

Picasso went along. He would stay with Pallarés for the next half-year. The descriptions by other writers of this period are rich:

> Every evening, when he had finished painting for the day, Picasso would go and meet his friend Pallarés, who usually painted in the oil mill his family had beside the road. Picasso loved watching the mill hands at work. Sometimes, too, he would lend a hand with whatever work was being done at his friend's home, bringing in the hay, or on winter evenings helping to make up the cakes of dried figs. According to what he later told me himself, he also appears to have spent long hours at the village forge, watching the smith working the bellows, shaping the iron and shoeing the horses. From a whole pile of sketches and drawings done at lightning speed, we can see that he took an interest in many other manual activities [and] later in life, when he was to say: "I learnt everything I know in Pallarés' village," it surely meant that he appreciated the direct contact with the life and the people of the village as a real initiation. Not only because it was a help to him in Barcelona or Paris when he had to cook his own food or do up a parcel properly, but because it was reflected later in his plastic language, in the love he revealed in many of his works for certain humble or rudimentary materials previously despised: paper, cardboard, string, nails, cloth, etc.[12]

Picasso's eye served as his intellect—no mean intellect. His eye must have provided a keen sense not only of how one lived in an agricultural community but of the ardors called for to sustain oneself. Even the trip from Barcelona to Horta de Ebro is like a rite of passage.

They took the train to Tortosa, where Pallarés' brother was waiting for them with a mule. They packed their easels, canvases, color-boxes, and baggage on the mule and walked, first up the fertile valley of the Ebro, with its orange-groves still in flower . . . then they struck southward across the mountains . . . rising continually into a new air and a new vegetation—arbutus, rosemary, lentiscus, rock-rose, thyme—the highland country with vast stretches of bare mountain, forests of Aleppo pine, and wastes; only a few primitive villages in the fertile parts and an occasional isolated dwelling . . . The road dwindled as they went, and in fifteen miles or so it was no more than a mule-track. In a deep and sunless gorge, haunted by vultures, it wound about on either side of a rapid stream, crossing it by fords in the less dangerous places.

For one who had never been outside a town and who had never walked five and twenty miles in his life, even with the help of a mule, this was a striking introduction to a new world . . .[13]

A few days later, Pallarés and he packed food, canvas, and oil paints and went further up into the mountains to paint, settling on a natural shelter beneath a huge boulder perched above a fast-running mountain stream that went hurtling down to a gorge below.

With only the occasional poacher to see them, they went native, Picasso recalled. They daubed their cave with paint, threw off their clothes and stayed naked. At night they slept on a huge bed of hay they had cut; they washed under a waterfall.[14]

Arianna Stassinopolous Huffington, on the basis of an unpublished interview with Françoise Gilot, adds a gypsy who is "two years younger than Pablo" to their ménage.

The gypsy taught him the meaning of the random chirping of the birds, and the faraway movement of the stars, and how to forge an alliance with nature, animals, trees, and the invisible. Together they watched the daily miracle of dawn and took long walks on the rough mountain paths. Theirs became a burning friendship and whether they were in the cave or back in the village, they were always together . . . The way Pallarés told the story, just he and Pablo explored Horta; the way Pablo told it, on the one occasion he talked about his passionate friendship, it was always he and the gypsy. "Pallarés was the sturdy piece of bread," he added . . . The gypsy [in contrast] was to the city boy a symbol of freedom as well as the incarnation of a sacred and awe-inspiring world. To solidify their loyalty with an age-old ritual, they took the knife that the gypsy carried

everywhere, cut their wrists [sic] and joined the flow of their blood. But there was a serpent in their paradise: the world outside Horta. The gypsy saw it first and decided to act in the only way he knew how—violently and decisively. He drew his knife and cried out with the same passion that Patroclus felt for Achilles many centuries and cultures before: "I love you too much. I must go away. Otherwise I will have to kill you because you are not a gypsy." . . . He did not love less but his love had become an unbearable weight, and so that same night he vanished forever, wounding Pablo's feelings and leaving him even more bewildered.[15]

While much of Huffington's book is most readable, the passage just quoted is sufficiently overwrought to suggest that her gifts as a writer are not for passionate love and violence.

All the same, there is every possibility that Picasso had a few homosexual episodes in his youth. Richardson, who takes pains to protect Picasso's heterosexual sanctity, uses his well-earned authority to dispose of the gypsy:

> The mule boy . . . has been misrepresented by Stassinopoulos Huffington. On no evidence whatsoever, she accuses Picasso of having "a burning friendship" that burgeoned into a passionate love affair "physically as well as metaphorically true" with this child. Stassinopoulos Huffington claims he was a gypsy "two years younger than Picasso and . . . also a painter." Pallarés, who is a most reliable witness, says he was around ten years old—about what he looks in Picasso's drawings.[16]

Whether the cave proved a site of homosexual idylls or but a stage in male bonding is no longer knowable, but Picasso had his share of primitive experiences during the half-year sojourn that followed in the village of Horta de Ebro: He would soon learn more than he wished to ingest about death in primitive places.

Richardson and Patrick O'Brian both mention a village autopsy that Picasso witnessed. An old woman and her granddaughter were apparently killed by lightning. To verify whether this was so, their bodies were dissected. Shades of Frankenstein, a nocturnal

Goatherd, Horta, 1898. Black chalk on paper, 12 x 9 in.

autopsy was performed in the grave-digger's shed with no more for light than a lantern. On this Gothic set, the night watchman made a cut with his saw from the top of the young girl's scalp down to her neck in order to expose the brain. The night watchman also smoked a cigar (described as blood-stained) through the course of the act. Picasso soon turned ill and had to quit the shed. Patrick O'Brian, in the face of such evidence, came to the conclusion that so crude a dissection,

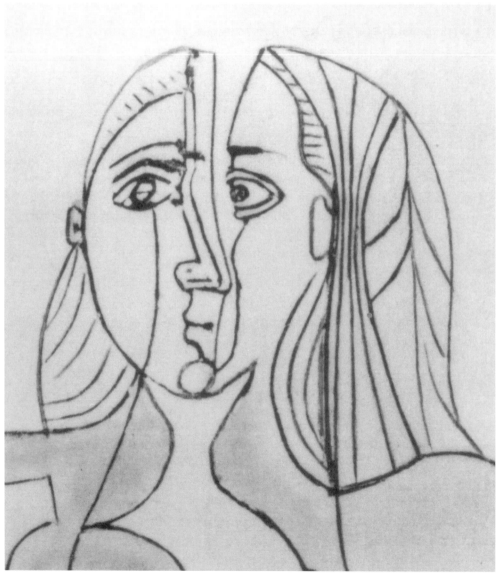

Detail from Standing Woman, 1958. Oil on canvas, 39 x 32 in.

the severing one half of the face from the other, had such a profound effect upon Picasso that he would, over the years, depict endless variations of that theme. Richardson is appalled by such a notion and decides on his own authority that split heads and double profiles have a pictorial, not an autopsical, origin.[17]

Given the intimate ferocity of Picasso's eye, one does not have to agree with Richardson. If nothing declares the state of death more dramatically than the split-

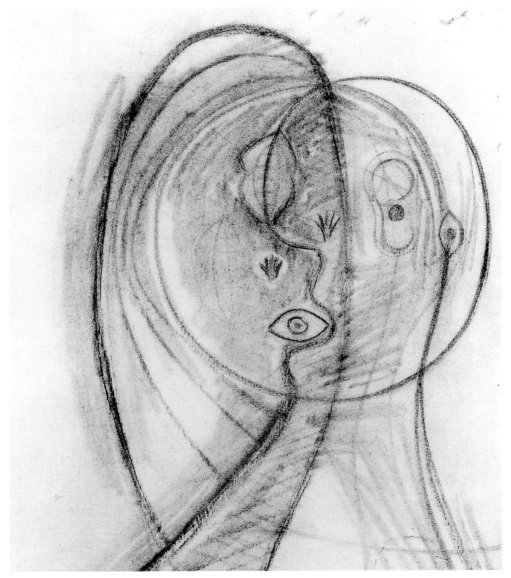

Head of a Woman, 1925. Charcoal on paper, 24 x 18 in.

ting of a face, Picasso might have concluded that character could also be delineated in that manner. It will take thirty years before his portraits present half of a full face meeting a profile, but then he may have been pickling such horror through several decades. What is not debatable is the shock we feel when we encounter his double faces. The portraits impinge on us with all the contradictions of their double

Head of a Woman, August 1938. Oil on canvas, 25 x 19 in.

personality: We are filled with a sense of *their* authority and *our* horror. Holding this autopsy in mind, how much they do suggest anatomical dissections, if only on the dissecting table of his perception. He was, with all else, a coroner, and he delineated every anomaly in the psyche of his subject when the mood to perform a spiritual autopsy came over him.

Bust of a Woman, Royan, June 10, 1940. Oil on paper, 25 x 18 in.

3

By December of 1898, Spain had lost Cuba and the Philippines. The authority of the monarchy was now seriously impaired.

Pierre Cabanne offers a vivid portrait of the Barcelona to which Picasso returned early in 1899:

> . . . a city of contrasts, drunkenly turning toward the northern breezes wafting in fragrances of Nietzsche and Novalis, delighting in César Franck. Alongside its anarchist troublemakers and its aesthetes, its staid bourgeois and pious industrialists, it had a horribly poverty-stricken population, living in sordid filth; thousands of wretches were penned into the notorious *barrio chino* where a dubious fauna of whores, killers, deserters, foot-pads and street urchins permeated the huge mass of workers exploited by their bosses, and now there were super-added the sick and wounded repatriated from forever-lost Cuba, forgotten and made to order for the fomenters of rebellion.[1]

Sympathy for the poor may have stirred in Picasso at this time, but it would have had to war against his sizable ambition to succeed. Since that fierce ambition already detested the sycophantic attitudes necessary for commercial success as a painter, he must have felt spiritually dislocated. At seventeen, he was certainly no patriot, and felt contempt for the crumbling empire of Spain and its complacent bourgeoisie, who had managed the country so badly—as a corollary, he felt estranged from his parents. They might adore him, they might support him, but there was nothing in their philosophy to impress him unless it was his father's limited managerial talents. Already, Picasso had rejected the paternal route laid out

for his career. This itinerary would have him strive to win prizes at state exhibitions so that he could thereby acquire a prestigious teaching post. Once that was in hand, Pablo could plump out his income by a growing reputation as a portrait artist, a successor, conceivably, to Muñoz Degrain. That scenario brought no large spark to the adolescent eye.

Add to this a subtler alienation. He was an Andalusian in Catalan country; that was not unlike being a poor Puerto Rican in New York. Sabartés would write: "Among Barcelonians of my class, the word Andalusian [is] never pronounced without a grimace of repulsion . . . tight trousers, short vests, cordoban hats and cock and bull stories, ugh!"[2] If there was one clan in Spain who would claim machismo for their own, it was Andalusians; scorned by the more cultivated north, they were deemed too Catholic, too reactionary, too authoritarian. Forty years later, they would be Falangists. (Franco's rebellion found its first support in Andalusia.) By contrast, Catalans, speaking a language as separate from Spanish as Portuguese, considered themselves an old race with their own bona-fide aristocracy.

Picasso could barely comprehend the tongue when he first came to Barcelona; if he was accepted by some of his fellow students for his talent, it was in spite of being from Málaga. After speaking and listening to nothing but Catalan during his six months in Horta de Ebro with Pallarés, he was fluent, however, on his return. He had also appropriated a new identity: He was now a self-declared Catalan. That may have been the subtlest alienation of them all: At the core, he could only feel more fraudulent.

Add the paradox of being endowed with an exceptional intelligence that had to keep company with an undeveloped education. Living among nihilistic but cultured middle-class students, he must at that time have hardly been able to contribute to the coffee-house discussions of Art Nouveau and modernism, of *Jugendstil*, *Sezession*, German Expressionism, and the new work of Edvard Munch and Toulouse-Lautrec. Nonetheless, Bakunin's first principle of anarchism—"The urge to destroy is also a creative urge"[3]—was there for a credo. Nor would he have been indifferent to Nietzsche's declaration (which would later prove even more valuable to Hitler): "I myself am fate and have conditioned existence for all eternity."[4]

Most of all, however, he absorbed the tenets of "modernism." In Barcelona in 1899, modernism called for the artist to play all the roles that might be needed to fortify the spirit of change: One must be ready to act as painter, sculptor, poster artist, dramatist, polemicist, actor, juggler, acrobat, and/or café-owner, architect,

interior decorator and, by all means, impresario. One could have added: guerrilla warrior. Any notions of aesthetic hierarchy—the painter to be honored above the poster artist—were to be discarded. In hierarchies rested congealed power—oppressive, constipating, deadening. Freedom resided in the demolition of category.

The local paladin of *modernismo* was the painter Santiago Rusiñol, who offered the following manifesto in two speeches at the Festa Modernista in 1893 and 1894, three years before Pablo's family even moved to Barcelona.[5] The translation from the Catalan is by way of John Richardson:

> [Our aim is] to translate eternal verities into wild paradox: to extract life from the abnormal, the extraordinary, the outrageous, to express the horror of the rational mind as it contemplates the pit."[6]

Its corollary: "We prefer to be symbolists and unstable, even crazy and decadent, rather than fallen and meek."[7]

By 1899, the movement had its own café, Els Quatre Gats, a coffee-house,

Els Quatre Gats, c. 1899

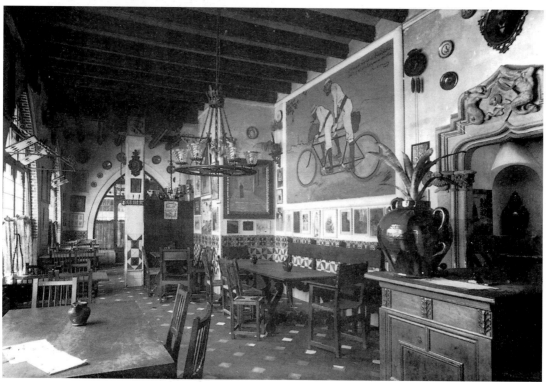

restaurant, and bar that soon became a center for advanced bohemian circles in Barcelona in the late Nineties. Rusiñol and Ramón Casas, Isidro Nonell, Ricard Canals, and Miguel Utrillo (father of Maurice) were the established painters who formed a nucleus, meeting there on many a night.

Since these men were about ten years older than Picasso, he did not drink with them so much as with his own younger group. It is worth noting that in Picasso's *tertulia* was Jaime Sabartés, a new friend who thirty-five years later would become his secretary, his confidant, and the all-but-official curator of the legend.

Sabartés, as is evident from the charcoal-and-watercolor Picasso did of him in 1900, not long after their first meeting, reveals his inner nature by his surface appearance (or is it that we are responding to Picasso's talent for characterization?).

Sabartés writes, "After lunch we met in Els Quatre Gats and from there I accompanied him to the studio. Henceforth, every day was the same. At times I left him at the foot of the stairs; at others, if he insisted, I went up with him. If he asked me to stay, I stayed. [Sometimes] he was more at ease once he began to work than if he were alone, for with me at his side, he did not need to think about me."[8]

Sabartés Seated, Barcelona, 1900. Charcoal and watercolor on paper, 19 x 13 in.

It need come as no surprise that Sabartés considered Picasso's other friends as not good for much more than wasted evenings in the low-life of Barcelona, but

then Sabartés' most attractive virtue for his new friend may have been that he always had pocket money.

Besides, Sabartés was slavish. Even at the age of nineteen, Picasso could enjoy an absolute sycophant. In *Picasso: Portraits et souvenirs*, published almost forty years later, Sabartés takes us for a ride on the good horse Hyperbole:

> . . . It was my first visit to his studio in Escuditters Blancs Street. It was noon. My eyes were still dazzled by what they had seen among his papers and sketchbooks. Picasso . . . intensified my confusion with his fixed stare. As I stepped in front of him to say goodbye, I was ready to bow, stunned by the magic power that emanated from his whole being, the marvelous power of a magus, offering gifts so rich in surprises and hope.[9]

Picasso was more intimate, however, with another friend, Carles Casagemas, whom Sabartés, as one would expect, did not approve of at all. One is tempted to claim (on the merits of the ink-and-watercolor that Picasso did of Casagemas, also in 1900) that there are few caricatures of a young aesthete which tell us as much. Picasso was influenced doubtless by Aubrey Beardsley, who had died in 1899 at the age of twenty-six, but then what an excellent influence it proved to be for this portrait!

The youngest child in a wealthy and established family, Casagemas was overindulged—in fact, he carries

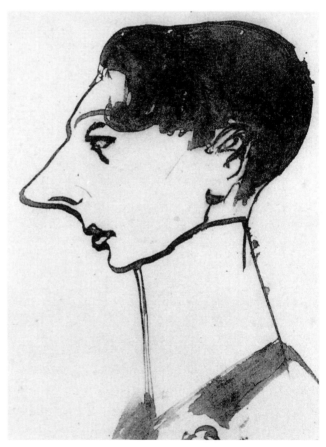

Casagemas as a Dandy, Barcelona, 1900. Ink and watercolor on paper, 7 x 6 in.

the label to new levels of meaning. Casagemas was so taken with the legitimacy of his impulses that he had a love affair with the daughter of one of his sisters. If it was platonic, that may have been the consequence of his addiction to morphine and his serious devotion to booze. He was also involved in *anarquismo*, *decadente*, and *Catalanisme* and had set up headquarters in a wing of his parents' large apartment on Carrer Non de la Rambla. There, he kept a studio in which Picasso and he not only worked together, but on Sunday afternoons, Casagemas would be at home for a salon—

> huge get-togethers where he and his friends acted out ideas selected by chance; the main participants were the Reventós and the de Soto brothers, Vidal Ventosa, Pallarés, and of course Picasso. They also indulged in doing "fried drawings": their art work was dipped in a pan of boiling oil and "fried," often with strange results.[10]

For a year and a half, Casagemas and Picasso were so close that their most significant separations would take place at the door to a brothel. There, Casagemas, whether on drugs, drunk, or sober, would find some excuse to leave; it is generally accepted that he was not only impotent but that it was the monumental burden of his life. Since he also had an intense interest in firearms, he must, as a friend, have been a veritable isle of peace and security. All the same, he could pay the rent. He and Picasso soon shared an unfurnished loft on the top floor of a broken-down building off an alley in the old part of town, high in the Reforma. The streets around were populated with beggars who may have offered Picasso's eye more than a few stimulations for the Blue Period yet to come. At the studio, since Casagemas had provided the lodging, Picasso did the interior decorating and painted the walls "with the things they lacked: a great bed, a table loaded with exquisite food, a safe, and even a manservant and maidservant (this latter with more than usually exuberant breasts) awaiting the orders of the two new tenants."[11]

Years later in Paris, at a banquet in 1908 at the Bateau Lavoir given by Picasso to honor Henri Rousseau, the *Douanier* said to him: "You and I are the greatest painters of our time, you in the Egyptian style, I in the modern,"[12] an interesting remark. Egyptian tombs also had their walls decorated with drawings of food and furniture designed to make the dead noblemen feel comfortable and well fed.

In this period, Picasso, in accordance with *modernista* precepts, was trying to

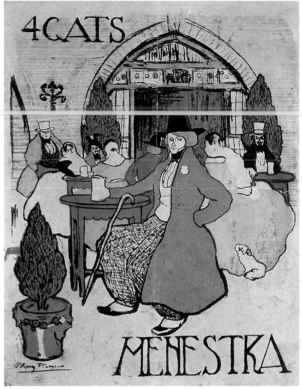

Interior of Els Quatre Gats, Barcelona, 1900.
Oil on canvas, 19 x 11 in.

Menu for Els Quatre Gats, Barcelona,
1899–1900. 8 x 6 in.

make a living with posters; illustrations for magazines; charcoal, pastel, and pencil portraits of his friends; and whatever else was at hand.

By such labors he was not, however, bringing in enough money to survive. The pencil portraits sold for only a few pesetas, and his sketches for posters were never printed. On the other hand, he had the rare excitement of learning that an ambitious oil, *Last Moments*, had been accepted for the Spanish pavilion at the Exposition Universelle in Paris opening in May 1900—no small honor: The Exposition was even more than a supercolossal world's fair—it would also apotheosize the advent of a new century that appeared, by every indication, to offer a magnificent era of progress.

It is a pity that *Last Moments*, a large canvas, was later painted over by Picasso. The artist who came to signify the dislocations and horrendous metamorphoses of the prodigious century to come would not even have a photograph

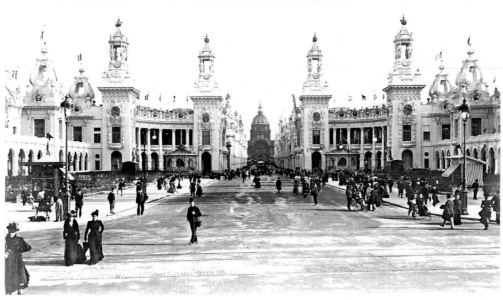

The Universal Exposition, Paris, 1900.

of the painting that hung in the Spanish pavilion of the Exposition Universelle.

Of course, he and Casagemas and Pallarés were now obsessed with going to Paris. There one could find real stimulation for one's talent, and real painters. How could one be properly accepted by the art world of Barcelona if one had not spent time abroad?

A campaign was undertaken, therefore, to convince his parents to put up some money. It is not difficult to conceive of the discussions that ensued. If doña María believed altogether in her son's divine talents, don José preferred him to remain in Barcelona or Madrid. In those two cities resided much of don José's essential estate. He had spent his life making good contacts. Now, they were not being used. That was equal to squandering them. It is the essence of middle-class intuition that art is reckless, art is putatively criminal. So it is prudent to domicile it, to surround talent with security.

Don José lost, however. Finally, he could not resist. He knew better than anyone how talented was his son. Picasso would later tell Sabartés:

"My father paid for the trip. With my mother he came to bid me good-by. When

they returned home all they had were a few pesetas in my father's pocket. They had to wait till the end of the month to get out of the red. My mother told me all this much later."[13]

Nor was it routine to convince Casagemas' parents. They were not without some idea of their son's essential condition, but, of course, there is usually another motif secretly at play in families that live with an unstable son or daughter—they are not necessarily loath, not entirely, to see them depart. If Picasso argued that Paris might be a tonic for the wild one, the parents must have listened—señor Casagemas came up with the wherewithal.

Before leaving Barcelona, Picasso did a self-portrait in which the words *Yo—el Rey* ("I, the King") circle his head three times. He was five-foot-three and a very young man, but then, the same could be said for Napoleon when he was nineteen. Paris was there to receive both of them.

Palau i Fabre describes their preparations for departure:

Picasso and Casagemas had identical suits made in black corduroy . . . When Pallarés learnt this from Picasso's parents, [he] immediately went off to have another such suit made for himself which in later years he described to me as follows:

"The jacket was very loose, with a round collar buttoned up to the neck so as to hide the waistcoat and, in case of extreme necessity, the absence of a shirt. The trousers were in the same material, narrow and open at the bottom with two buttons to fasten them."[14]

On to the capital of the world; on to the empire of sophistication!

Part II

Paris

1

At the turn of the century, Montmartre was not without comparison to the Lower East Side of New York as it is today. The hazards in occupying a studio were similar. Hoods with sexual panache—that is, *apaches*—abounded; so did whores. La Butte de Montmartre was in the process of transformation from the farms and windmills that had charmed van Gogh a little more than a decade earlier to the cobblestone streets of Paris itself.

Although he could not speak French, Picasso was hardly lonely in Montmartre—there were any number of Catalan artists in the quarter. He and Casagemas soon settled in the studio on rue Gabrielle of Isidro Nonell, who had gone back to Barcelona. Once installed, Picasso proceeded to paint at a great rate, in response to the work of Corot, Courbet, Daumier, David, Delacroix, Ingres, Manet, and a host of Impressionists that he could now see hanging in a variety of museums and galleries. He also visited the Exposition Universelle in the company of Casas and Utrillo and had the pleasure, presumably, of their veteran company while looking at his *Last Moments.*

He had just turned nineteen. He was in a fever of creativity, and continued to make the rounds of avant-garde galleries on the rue Lafitte—the names of those dealers now have a ring: Durand-Ruel, Bernheim-Jeune, Ambroise Vollard. Everywhere he encountered art that he wished to appropriate for his own style. If Picasso's intellectual insights were not verbal, the curve of a line proving quite the equal of a turn of phrase, the work of painters he found exciting could stimulate his intellect into funds of new perception.

He was also competitive. As soon as another painter had an impact on him, he would proceed to absorb the work, recreate it, mimic it, and so invest himself in the other painter's style deeply enough to be able to perceive reality by way of the other's vision. Indeed, until Picasso enters the Blue Period we cannot say he possesses a style. He is very talented and just about wholly derivative. Since he would, across the arc of his entire career, discover more new styles than any painter who had come before him, he has to be the foremost example of why one cannot instruct talented artists by established principles. How many teachers would have been tempted to say to him at that point in his career, "You ought to look for your own style."

Not yet. He was going to absorb the world before he would try to recreate it. "It was in Paris I learned," he said, "what a great painter Lautrec had been,"[1] and the evidence is in an ambitious oil, *Le Moulin de la Galette.*

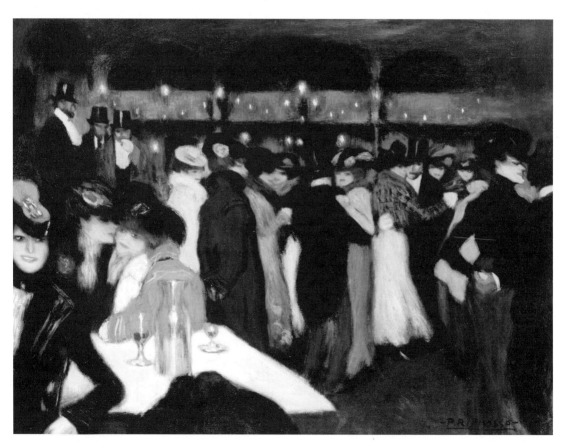

Le Moulin de la Galette, autumn 1900. Oil on canvas, 35 x 46 in.

How these women dominate the men in this canvas! They are lovely, coquettish, confident, intimate with each other, and not at all unsinister in their collectivity. Already we can feel the impact of Paris upon Picasso. It is in the liberation of these sophisticated French women. Their grasp of how to manipulate a man has to be one universe beyond the Spanish whores he has known. So he regards French women with the lust for action and the profound respect of a nineteen-year-old learning to be an animal trainer. Paris, itself, is an aphrodisiac.

Casagemas wrote to a friend:

"The boulevard de Clichy is full of mad places like *Le Néant, Le Ciel, L'Enfer, La Fin du Monde, Les 4 z'Arts, Le Cabaret des Arts, Le Cabaret de Bruant* and a lot more which don't have the least bit of charm but make lots of money. A "Quatre Gats" here would be a mine of gold and muscles . . .

There's nothing as good as that nor anything like it. Here everything is fanfare, full of tinsel and cloth made of cardboard and papier-mâché stuffed with sawdust . . . The Moulin de la Galette has lost all its character and l'idem Rouge costs 3 francs to enter and some days 5. The theatres too. The cheapest places and cheapest theatres cost one franc.[2]

Picasso, by way of Nonell, had been introduced to a thirty-year-old Catalan art dealer now working in Paris. He was named Pere Mañach and he had, in fact, paid one hundred francs for three pastels Picasso had done of bullfights. Quickly, Mañach sold them to another dealer, Berthe Weill, for one hundred and fifty francs. This quick turnover, plus the fact recounted by most biographers that Mañach, "because of his preference for young men," was "instantly mesmerized by"[3] Picasso, resulted in an offer of one hundred and fifty francs each month as a draw upon the paintings he produced.

Manyac introduced Picasso to Berthe Weill, whose audacity and willingness to support young artists made her gallery at 25 rue Victor-Masse an influential center in the art world of Paris. She was referred to as *La Mere Weill*, or "little old lady Weill," but although she was short and stocky, she was in fact young and lively. When she arrived at the rue Gabrielle one day at the hour arranged by Manyac to see Picasso's work, there was no reply no matter how many times she knocked. She left angrily, sought out Manyac who had a key to Picasso's studio, and together they returned to the rue Gabrielle and walked into his room. They found him under the bedcovers with Manolo.[4]

Whether they were in a sexual act or merely playing a prank on Mme. Weill is

not clear. Weill writes in her book *Pan! Dans L'Oeil* that Manolo was a Catalan sculptor then in Paris, but Richardson thinks it was Casagemas. Since Manuel Pallarés had joined them by now (wearing his identical black corduroy suit), he could also have been the Manolo cited.

> Pallarés told me that when he reached Paris he found nobody waiting for him at the station, though he had written to tell his friends the exact day and hour of his arrival. So he got a vehicle to take him to the rue Gabrielle where he found his friends with three models, who all immediately embraced and kissed him. Just at that moment the postman arrived with the letter he had sent. They all went off to lunch at a restaurant at the Moulin Rouge and in the afternoon visited the Louvre. That night they had to improvise a bed for Pallarés . . .[5]

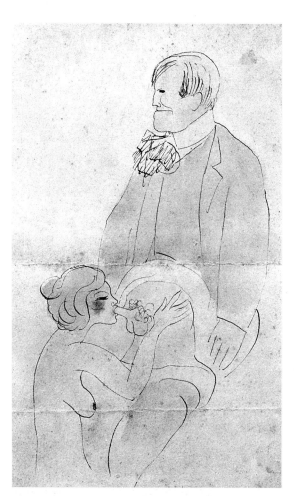

Isidro Nonell and a Female Figure, Barcelona,
c. 1902. Watercolor and ink, 10 x 6 in.

Casagemas, Pallarés, and Picasso were now living together with three women. If their new French friends spoke of themselves as models, it was not wholly untrue; the women had had a go-round with Canals, Nonell, and a number of other Catalan artists in Paris, and probably had posed for them. There were Germaine Gargallo, her sister Antoinette, and a friend named Odette, who became Picasso's girl during this period even though she spoke no Spanish and he had no French. Casagemas fell madly in love with Germaine, and Pallarés was left with Antoinette. Casagemas would joke about it in his letters to Ramón Reventós:

Paris 11 November 1900
Family life is heaven. In the com-

ing week, which begins tomorrow, we're going to fill our lives with peace, tranquillity, work, and other things that fill the soul with well-being and the body with strength. This decision has been reached after a formal meeting with the ladies. We've decided that we've been getting up too late and eating at improper hours and everything was going wrong. On top of this, one of them, Odette, was beginning to get raucous because of alcohol—she had the good habit of getting drunk every night. So we arrived at the conclusion that neither they nor we will go to bed later than midnight and every day we'll finish lunch by one. After lunch we'll dedicate ourselves to our paintings and they'll do women's work, that is, sew, clean up, kiss us, and let themselves be "fondled." Well, this is a kind of Eden or dirty Arcadia . . .

<div align="right">Yours Carles[6]</div>

In fact, the situation proved a disaster for Casagemas. Lovemaking in that studio must often have been a spectacle; the humiliation Casagemas had sought to avoid by never going along with the others to brothels may now have suffered from open display. He was hardly in possession of the kind of readily available virility that could undertake the tests of an orgy, and Germaine was lusty. Doubtless the photograph of her, taken in 1900, does her small justice, but her mouth is worth a second look.

Casagemas, in the midst of such orgiastic franchise, had to have been in a state of titillation, sexual anguish, outsize jealousy, and acute homosexual panic. Sharing a bed

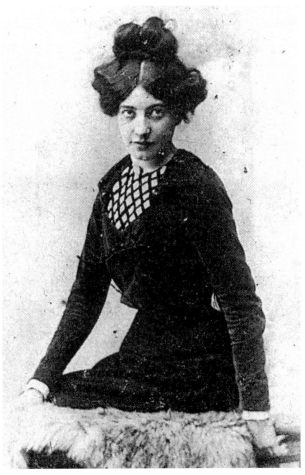

Germaine Gargallo, c. 1900

with a woman for the first time and unable to accomplish more than "fondle" her, he began to come apart so badly that Picasso, growing uneasy about his friend's sanity, decided to go back to Barcelona with him. If it seems off that Picasso would be so ready to cut his trip short when much seemed to be opening for him, it can be noted that he was also afraid of the police. Anarchists abounded among their Catalan acquaintances, and the French authorities were on the alert for subversive activity. Since Picasso had signed an incendiary manifesto, he was able to avoid an inquisitorial session with the Paris police only through the intercession of a client of Mañach's who had bought one of his paintings. This wealthy Parisian, Olivier Sainsère, had influence with the authorities. Shortly thereafter, Picasso decided to cut short his visit. The manifesto he had signed, in concert with his paranoia, now exacerbated by what well might have been sexual excess, plus any guilty residue of his formal Catholicism, plus Casagemas' growing imbalance, must have been a psychic concoction to put him into his own panic. Besides, he had promised his parents to be home for Christmas.

It was not routine to convince Casagemas to return with him. Casagemas was referring to Germaine as his "fiancée"—no matter that there had even been a night when Germaine taunted him for his impotence. No one is more romantic than an impotent man with dreams of sexual glory. He would be all things to this new and passionate fiancée, but he was also ready to terrify her and the others with talk of suicide. He might be impotent, but he was still more courageous than the others. He would die for a premise, a principle, a passion. What an anxious state for all three men! It is to be noted that Pallarés, for all his stolid virtues, had a good deal of fear of the local *apaches* (who had doubtless been looking him over—one big fellow to another) and so he had no wish to live alone at 49 rue Gabrielle after the others left. Besides, the place must have felt spooked by now with the ghosts of bygone orgies. So Pallarés moved to another studio, and the other two reached Barcelona a couple of days before Christmas. Thus ended the first trip to Paris.

Right after Christmas, Picasso and Casagemas moved on from Barcelona down to Málaga. Andalusia's warm sun in winter might be calming to Casagemas' nerves.

It is also likely that Picasso, shamed by the panic he had felt during his near-encounter with the Paris police, was in a mood to shock his bourgeois relatives. In any case, he and Casagemas arrived

wearing the same corduroy suits they had had made in Barcelona, but after three

Bohemian months in Paris they were in a distinctly shabby, almost threadbare state.

[They] tried to get rooms at a hotel or boarding house called the "Tres Naciones" in the Calle de Casas Quemadas. But their clothes and appearance in general must have been really slovenly, because the landlady at first refused to take them in. Finally, Picasso had to apply to his aunt, María de la Paz Ruiz Blasco, who lived in the same building, in order to get himself and his friend accepted as reputable guests.[7]

He now compounded his appearance by wearing

a sort of fob or pendant in which, instead of a romantic curl of hair or a miniature, there was a stuffed beetle. This invention had been made fashionable by some of the Art-Nouveau decorators, like Wolfers, and Picasso had probably brought it from Paris.

When Don Salvador saw his nephew behaving in this eccentric way—and, worse still, not wearing mourning for his aunt, Pepa, who had died a short time before—his first reaction was to give Pablo the address of a tailor and tell him to order a suit of mourning immediately.

By the time the suit arrived, the situation had become quite impossible.[8]

Picasso had taken pains to reply to his uncle by renewing his acquaintance with Lola La Chata, the same whorehouse madam who had once taken care of his father. In the south of Spain, one could look to vice as quickly as to virtue for a sense of tradition.

Casagemas, meanwhile, was wholly obsessed by thoughts of Germaine living alone; Germaine the con-

La Chata, Málaga, 1899. Charcoal, watercolor, and wash on paper, 12 x 3 in.

cupiscent alone in Paris! A drawing made of him one year earlier suggests his love-sick state in Málaga.

Portrait of Carles Casagemas, Barcelona, 1899. Colored pencils.

By now, it seems not unlikely that Picasso was weary of his friend—Casagemas demanded time, all of one's time. He had become so disturbed that Picasso may not have known any longer how to keep control of him. So, he called once more on his uncle Salvador to arrange boat passage home for his unstable companion.

He would never see him again. Back in Barcelona, Casagemas became more obsessed with the need to see Germaine; indeed, he was sending her letters twice a day begging the lady to marry him. Finally, he declared that he was returning to Paris. Germaine reacted to this announcement by going back to the husband she had left to have a fling. He, good ex-mate, accepted her temporary need for sanctuary.

Casagemas had obviously built up a few hopes. He appeared again in Paris on February 16, 1901, wearing a new and well-tailored green velvet suit. Germaine met him at the train station to announce that she would never marry him. Next day, Sunday morning, Casagemas proclaimed that he was going right back to Barcelona and invited Odette, Pallarés, Germaine, and a few other friends to a farewell dinner at a local restaurant. He spent the afternoon composing some suicide notes. At dinner, he seemed free of depression, indeed, signally elated. He even stood up to make a speech in French, and took out a letter for Germaine.

> . . . all the others later said that from that moment on they could not remember exactly what happened. Apparently, however, Casagemas took a pistol from his pocket, while Germaine crawled under the table and placed herself exactly behind Pallarés, using him as a shield. Pallarés suddenly saw a pistol barrel pointing at him, without understanding why, and he barely had time to deflect the direction of the pistol before Casagemas shouted at Germaine: *"Voilà pour toi!"* Pallarés heard a deafening explosion just beside his wrist and felt Germaine's hand, which had been clinging to his chair, gradually loosening and sliding down. In a moment Germaine was lying motionless on the floor.
>
> Casagemas, thinking he had successfully carried out his action of revenge, then

cried: "*Et voilà pour moi!,*" fired a shot straight into his brain and fell where he had been standing, doubled up over a chair.

The people at the other tables fled from the restaurant in panic. After a few moments, they crept back, preceded by the police. Casagemas was taken first, immediately, to the nearest chemist's and from there was at once transferred to the Hôpital Bichat, where he died at half-past eleven the same night.

Germaine picked herself up and, weeping and sobbing, embraced and kissed Pallarés, begging him to forgive her for what she had done. She had played her part in the comedy to perfection.

She and Odette then took Pallarés to the chemist's, for one of his eyes had been irritated by the shots and he could hardly see. Then the two women carried him off to Odette's house, where they settled him in an enormous bed . . .[9]

Picasso would not receive the news until a few days later in Madrid, where he was now living once again. The news "left all the young men of his generation stunned, but none so much as Picasso."[10]

The suicide would yet have an overpowering effect on his palette, but it would be many months before he would turn to dark blue as the dominant color of his vision. The only immediate evidence of his horror at the suicide is in his assessment of how much a certain kind of woman can demand and how little she will give back. Perhaps he is trying to see with the eyes of the dead Casagemas.

Lady in Blue, Madrid, 1901. Oil on canvas, 52 x 39 in.

He will continue this theme in *Dwarf Dancer*, also done in Madrid. The dwarf is as full of female force as any woman he portrays. He is already under-lining the cost of sex. You will never, say these paintings, enjoy a woman for less than she is worth, or at least not such women as the ones painted here, whole in their meanness of spirit and without a hint of weakness, even when they are dwarfs.

If one would ask why Pi-casso was back in Madrid to re-ceive the dreadful news about Casagemas despite the miser-able experience of his first visit, it is because he was now work-ing with a Catalan friend, Fran-cisco de Asís Soler, who had just started a new magazine called *Arte Joven* and wanted Picasso to do the illustrations. Soler, in turn, was in Madrid on business in connection with an invention of his father's . . . called the

Dwarf Dancer, 1901. Oil, 16 x 9 in.

"Electric Belt." According to the prospectus, this belt was a sort of panacea for ailments of certain organs (liver, kidneys and intestines), besides being capable of curing impotence.[11]

The magazine had to be doomed from the start. Their advertising revenue came from the electric belt, and nothing else. His move to Madrid serves, nonetheless, as an example of how many roles Picasso was ready to explore during this period. His

confusions were deep, his ambitions intense, his tastes divided. In Barcelona in the preceding year, two ink drawings give us some clue to the opposites in himself. Even at the age of nineteen, he had a great deal already to offer both sides of his personal divide.

If *Arte Joven* was any part of his desire to conquer Madrid, the magazine did little. Once again, the Madrileños gave him a small welcome. Meanwhile, Pere Mañach was dunning him from Paris. Mañach had been sending 150 francs a month regularly, but where were Picasso's paintings? He needed them. Mañach had arranged a show at Ambroise Vollard's gallery.

Untitled (Christ), Barcelona, 1900. Black lead, 14 x 10 in.

Untitled (Nude women with stockings), 1900. Pen and ink.

Picasso and de Asís Soler put out a few issues of *Arte Joven*, but their mixture of anarchism, literary innovation, and mannerist drawing found no enthusiastic audience in Madrid or Barcelona—in fact, the most extreme reaction may have come in a letter from Uncle Salvador soon after they asked him to help their finances.

> "What on earth are you thinking of? What are you after? What do you take me for? This is not what we expected from you. What ideas! And what friends! . . . go on this way and you'll see where you land . . ."[12]

All the same, Picasso must have been drawn to the idea that he, the child who could hardly write or read, was now associated with a journal that looked to guide the intelligentsia of Spain.

When *Arte Joven* folded, Picasso hurried back to Barcelona. He still had to deliver canvases for the show Mañach was giving him in Paris, and for the next two weeks he did a series of bullfights, cabarets, seascapes, and an oil of his sister Lola. To save money, he was recycling old canvases, and worked therefore in a thick impasto, a new mode for him. Fourteen days of herculean labors and he was ready again for Paris.

Self-Portrait, Madrid, 1901. Charcoal on paper, 18 x 12 in.

2

During his second and fatal two-day visit to Paris, Casagemas had stayed in Pallarés' studio at 130 boulevard de Clichy; it was there that Picasso installed himself on his return to Paris. Pallarés was now back in Horta, so for a roommate Picasso chose Mañach, his dealer. That is roughly equivalent to an actor asking his agent to move in with him, but then, Mañach was willing to pay most of the rent and accept the smaller of the two rooms available. He was, by all accounts, obsessed with Picasso—his talent, his person, his commercial possibilities.

If Picasso was much haunted by Casagemas, it was still a productive period for him. Having left Barcelona with twenty paintings, he now had one month to produce another forty in order to satisfy the opportunity offered by the gallery impresario Ambroise Vollard. Of course, Picasso was creating a large opportunity for Mañach as well. As the middleman between Vollard and Picasso, Mañach had everything to gain, or to fail to gain. Vollard's gallery on the rue Lafitte could lay claim to having promoted Renoir, Degas, Sisley, Pissarro, and Gauguin; Vollard was becoming even more renowned as the man who had championed Cézanne with his first major exhibition in Paris in 1895, and with another in 1899; in fact, his considerable prestige rested on how skillfully he had gathered recognition for Cézanne. To Picasso, the comparisons had to be daunting. Not yet twenty, he had the opportunity to move into the best company; it is characteristic of the fundamental paradox of his nature that his bravery in artistic matters would be equaled by his audacity in emotional relations at this time. Shocked and obsessed by

Casagemas' suicide, he was still ready to move into the studio where the dead youth had stayed with Pallarés for his final hours in Paris, and then almost immediately he commenced an affair with Germaine. The incestuousness of close friends can collect a few more permutations here. Manuel Hugué, the Catalan sculptor called Manolo, who happened to be at the Casagemas table on the night of the shooting, soon thereafter had managed to strike up his own affair with Germaine. Now, Manolo was superseded by Picasso. Manolo proved jealous for at least a week, after which he and Picasso became better friends than ever. It was as if the round of couplings had made them inseparable. Later, Fernande Olivier, Picasso's first serious mistress, would describe Manolo as

Manolo (Manuel Martínez i Hugué), Self-Portrait, Paris, 1901. Conté crayon on paper, 12 x 7 in.

bohemian, easy-going, perpetually on the look out for a bed, a dinner, or "*una peseta*," with a sharp eye for any potentially profitable leg-pull. He was the quintessential Spaniard, small, with the blackest possible eyes set in a black face beneath the blackest of black hair [and] was usually greeted by his friends with a mixture of pleasure and suspicion.[1]

Richardson adds, "He was also a great liar, pickpocket, practical joker, con man,"[2] and recounts how Manolo, on being disciplined once by his father, a Spanish general, burst into tears, asked permission to embrace his

parent, and in the high feeling of this penitential conciliation was able to pick the general's watch out of his pocket. To avoid military service, Manolo subsequently fled to France.

> He was probably the only person Picasso permitted to mock him, criticize him, contradict him. Manolo even got away with the diabolical joke of introducing the youthful-looking "Little Pablo"—condemned to silence by his ignorance of French—as his daughter. Picasso's indignant protests were drowned out by a chorus of laughter and applause. Manolo was not alone in divining a certain girlishness in Picasso: the French Catalan sculptor Maillol, whose studio Picasso visited around this time, gives a description of him: "he was thin, he had a slight build, he was very like a young girl . . ."[3]

It is, yes, the incest of friends. Picasso was now inhabiting Germaine's body, the very same body that his dear friend Manolo had been keeping warm since Casagemas' death. In effect, Picasso was appropriating the psychic remains of Casagemas even as he was violating the dead friend's romance. Yet, by a more occult logic, he was also offering his sanctification to the dead man's lost relationship. Is it not just these complications that inspire such intense reactions to incest? How many can bear such close quarters between violation and sanctification?

Picasso must also have been at large in that sexual no-man's-land between hetero- and homosexuality. Whether he and Casagemas had gone to bed as homosexuals or had played at the edges, or whether, to the contrary, Picasso, true to the severe Andalusian standards of machismo, had drawn a line over which he chose not to pass, may be less pertinent to our understanding than to recognize that he was immersed now in homosexual preoccupations. He had to have carnal knowledge, at no matter what emotional costs, of the nominal *widow* of Casagemas. Even as he would copy other painters—even to mastering their signatures—as one more means of entering into their mentality, so did he absorb the loss of his friend by searching for Casagemas' presence in the body of the woman he had chosen for marriage.

If, in the process, he became the dead man's sexual overlord and (to put it at its worst and most extreme) the thief of Casagemas' romantic hopes beyond the grave, it was also an act of love; it may even have been a species of expiation—to fornicate with Germaine was to invoke Casagemas rather than to dispel him.

He also had a great burst of creative energy. Arriving in Paris with twenty canvases, he managed in a few weeks to add the forty more needed for the on-

Child with Doll (Le Roi Soleil),
1901. Oil on cardboard,
20 x 13 in.

Nude with Stockings (right),
1901. Oil on panel, 26 x 20 in.

coming show. Much was hurried, and no significant vision emerged, but the work was spirited, color-ful, sensual, charming, and highly purchasable. Virtually no trace of Casagemas appears, nor any hint of the Blue Period soon to come.

Lacking his own gallery, Mañach was all the more a manager; he told Picasso to do a portrait of Gustave Coquiot and "offer it to him."[+] Coquiot, who was a critic-for-hire, wrote, in the guise of a preface to the show, a rave review. Since he also had the contacts needed to satisfy his cottage industry in aesthetics, Coquiot placed his panegyric in a newspaper, *Le Journal,* one week before the show opened.

This very young Spanish painter, who has only recently come among us, is a pas-

Woman with a Cape (Jeanne),
1901. Oil on canvas, 28 x 19 in.

Boulevard de Clichy (left), 1901.
Oil on canvas, 24 x 18 in.

sionate lover of modern life
. . . Here we have a new
harmonist of bright tonali-
ties, with dazzling tones of
red, yellow, green and blue. We realize at once that P. R. Picasso wants to see
and express everything . . . Here, to begin with, are his street women, the whole
range of them, with fresh or ravaged faces. We see them at the café, in the the-
atre, in the bed even . . . For the high-class ones he chooses seductive tones with
nuances of pink or mother-of-pearl flesh, while the pickpocket and murderess is
seen lying in wait for her prey or reducing him to exhaustion in some sordid gar-
ret . . .

Here (too) are the happy, mischievous little girls in exquisite pink and grey,
with their wild dances and fluttering skirts . . . the beauty of lively dance-halls,
cafe-concerts and racecourses with their excited crowds. Here for instance is a

dance at the Moulin Rouge, with the boys gyrating in front of the girls who dance a frenzied cancan, legs wide apart, fixed on the canvas like agile butterflies as they swirl around in a flurry of skirts and underwear . . .

Such, at the present time, is the work of Pablo Ruiz Picasso—an artist who paints all round the clock.[5]

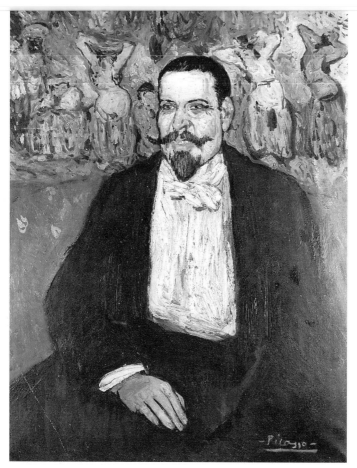

Portrait of Gustave Coquiot, 1901. Oil on canvas, 39 x 31 in.

For payment, Coquiot received the oil portrait of himself in blacks and whites with strong reds and yellows—a close study of venality! Coquiot might applaud his work, but Picasso was mortgaging away no portion of his objectivity.

A critic of greater integrity, Georges Faillet, who used Félicien Fagus as a pseudonym, wrote a highly favorable but admonitory review in the prestigious *La Revue Blanche*.

He paints—and beautifully; his appreciation of "substance" bears sufficient witness to the fact. Like all pure painters he loves colour for itself, and every substance has its own colour. In addition, he is attracted by every subject, and everything can be a subject for Picasso: flowers expand furiously outside the vase, while the air around them has a dancing luminosity; the multicolored specks of a crowd against the green of a race-course, or against the sunlit arena of the bull-ring; the naked bodies of women, all kinds of

women, or their downfall after exposure and punishment, seen through the flexible use of their multicoloured clothing . . .

In the same way that he explores any subject to the full, he is capable of using any idiom, slangy or obscurantist, and even borrowing from a friend. Apart from the great precursors, it is easy to detect numerous likely influences: Delacroix, Manet (clearly indicated with his Spanish connection), Monet, van Gogh, Pissarro, Toulouse-Lautrec, Degas, Forain, and Rops perhaps . . . All are momentary; he abandons them as easily as he adopts them: he is clearly in such a feverish hurry that he has not yet had time to forge his own personal style; his personality is underlined by this fever, by this impetuous, youthful spontaneity (happy not to have reached twenty and to be able to do three canvases a day). For him the very danger lies in this impetuosity, which could easily lead him into facile virtuosity and easy success. It is one thing to produce and quite another to produce something worthwhile, just as violence and energy are two different things. And such a lapse would be particularly lamentable in this case.[6]

The praise may have been bountiful, but a basic wound was touched—would he always lack his own style? In the unaccustomed headiness of having a little money in his pocket (since half of these canvases were sold and the show was considered a success), his preoccupations in the months following the show turned gloomy.

Sabartés had come to Paris and was now living on the other side of the city, in Montparnasse. Since their friendship traveled on the pleasure of conversation, they were capable of walking many miles at night. When one visited the other, he would be escorted home, only to find himself walked back to where they had started. Round trips between Montmartre and Montparnasse were no small hikes, but Picasso must have been riding many an anxiety. His relation to Mañach is never specified by biographers too clearly. Arianna Stassinopoulos Huffington suggests that the dealer was a homosexual, and Palau i Fabre speaks of him as "the black sheep of a respectable family,"[7] while Richardson once again quashes these implications, although not authoritatively. The suggestion persists that Mañach was a homosexual bull and Picasso was afraid of him, longed to be free, yet could not pry himself loose. If these remarks are without high focus, it is because none of the witnesses to this period do more than hint at the difficulties—it is certain, in any event, that Picasso did not like to be alone with Mañach and would often stay out half the night to avoid him.

It is also interesting that about this time he does portraits of Mañach and him-

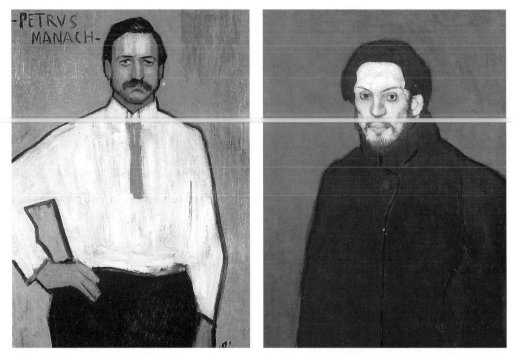

Portrait of Pere Mañach, 1901. Oil on canvas, 39 x 26 in. *Self-Portrait, 1901. Oil on canvas, 32 x 23 in.*

self that most certainly exhibit some sharing of resemblance (even to the distorted length respectively of the right and left shoulders). Since the self-portrait hardly looks like a nineteen-year-old painter, is it wholly unlikely that he was wondering whether sexual cohabitation between two men might not produce a certain congruence of appearance?

In reaction, perhaps, to all those works of overflowing joie de vivre that he did for Vollard, now, not one month after his show, Picasso would paint an incredible oil of the dead Casagemas. It is only eleven by fourteen inches, but it may be fair to speak of it as his first major painting, and he felt sufficiently private about it to show this work to very few friends. (See next page.)

He takes us a distance with the candle flame. It is the first of Picasso's paintings to lead us into deeper perceptions than we might arrive at on our own, or by familiarity with other painters. He is making his own statement at last, and it could be argued that there will be a direct line of development over the next decade from the Blue Period, soon to appear, into the vast aesthetic range of Cubism. Picasso has entered the world of visual equivalents.

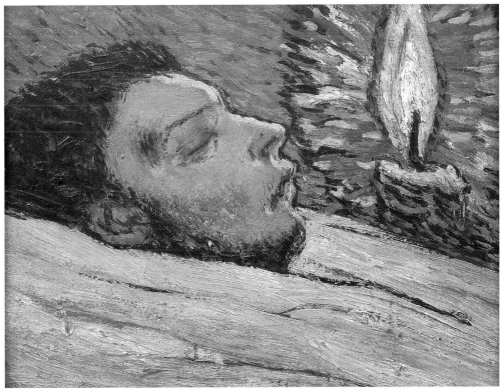

Head of the Dead Casagemas, 1901. Oil on panel, 11 x 14 in.

One can ponder the concept. An artist's line in a drawing can be the equivalent of a spoken word or two. The bend of the fingers can prove equal to a "dejected hand," or the outline of the upper leg muscles speak of an "assertive thigh." Form is also a language, and so it is legitimate to cite visual puns—that is, visual equivalents, and visual exchanges. No matter how one chooses to phrase it, artists, for centuries, have been painting specific objects, only to discover that they also look like something else. A flower's petals in the sardonic view of Picasso at the age of seventy-three (by which time he trusted nothing in man, cosmos, or nature) could as easily be perceived as a cluster of grasping hands.

It can be taken as a joke, a visual pun, but he has discovered that a candle flame not only looks like a vagina, but indeed just such a form should be present, since a vagina, after all, helped to destroy Casagemas. Be it said that Richardson has also seen it as "an incandescent vagina."[8] Of course, that portion of the paint-

ing also remains a candle flame—polar are the nodes of lust and grief—but in this symbol they are speaking for one another: The candle flame also embodies the sorrow of Casagemas' mother sitting in vigil, and Picasso broods with her. After all, she is the same mother he convinced but a year ago to allow her son to go to Paris.

On the other hand, the candle flame and/or vagina not only speaks of a mother in mourning but allows Germaine Gargallo to be present. It opens the supposition that every good painter is a philosopher, ready to speak, if mutely, to other artists rather than to people outside the world of painting. So, Picasso might find no obstacle to suggesting that we are not only delivered into the world by way of the vagina but can also be destroyed by one, only to be mourned in turn by another. If

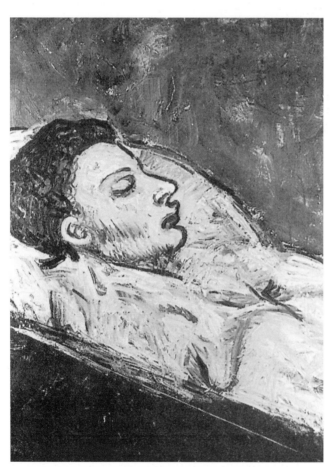

it is only the view of a young Spaniard, he is nonetheless committed to his private perception that nature gives us hints of her profundity and her buried secrets; and the language— call it the key—that nature shares with humankind is form.

A second portrait of Casagemas was to follow. As if Picasso is haunted by how luminous is the boundary between life and death, he now paints an oil on cardboard, *Casagemas in His Coffin*, twenty-eight by twenty-three inches, done in blue, and adds to it another portrait in blue of Sabartés.

As Sabartés was to say of that portrait, neatly tying together his nearsight-

Casagemas in His Coffin, 1901. Oil on cardboard, 28 x 23 in.

edness and the vanity that would not permit him to wear glasses in a public place:

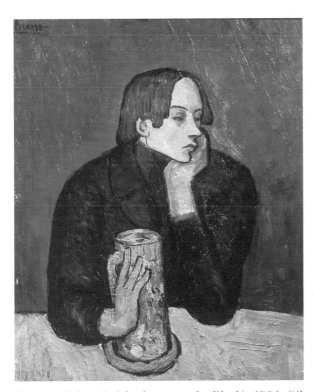

The Poet Sabartés (also known as Le Block), 1901. Oil on canvas, 32 x 26 in.

The canvas was facing the wall when I arrived. When Picasso put it up on the easel, I was astonished to see myself just as he had surprised me in the café, in a fugitive moment of my journey through life. Contemplating myself fixed upon the canvas, I understood what it was that had caught my friend's inspiration: here is the specter of my solitude, seen from without. Because the gaze is lost in the darkness it cannot pierce, thought wanders, and because the vision is myopic and the mind cannot leave the gaze behind, thought and gaze unite and are lost in the void.[9]

Yes, the Blue Period has commenced. This portrait of Sabartés will launch it. For a few years Picasso's paintings will breathe on the edge of the void, inhabiting an empty midnight plain where life itself hovers on the edge of extinction. Picasso is about to enter the darkest and longest depression of his life.

Casagemas' suicide now permeates his vision. Sexuality departs from his work, and dread collects on each canvas. One can only speculate about his unvoiced fear of punishment. He feels full of complicity—not only did he encourage Casagemas to leave Málaga, but he had rushed into bed with the virtual widow of his friend. These first paintings of the Blue Period are hardly to be comprehended if we do not assume that Picasso was in a long slow-dissolving panic at the depth of his responsibility for Casagemas' demise.

To add to his woe, Mañach was opposed to the new turn in his painting. So was Vollard. Picasso had made a name for himself as a young phenomenon who could cheer a living room with his warmth, his vitality, his libido itself. Now canvas after canvas echoed the bottomless misery of the world. Vollard rejected it whole; Mañach hectored him; and Picasso decided to go back to Barcelona. It is significant that he now had no funds. Had he squandered them? Or had he caught a difficult-to-treat syphilis? While this question cannot be answered, it does give a further explanation for his lack of funds and his depression. It would also account for his new-found interest in the women's prison at Saint-Lazare, where prostitutes were treated for the same disease.

Once again he was reduced to writing to his father for the fare. While he waited for the answer, Mañach applied pressure.

Days passed. Sabartés goes into Picasso's state at this time and culminates his descrip-

Women at the Prison Fountain, 1901. Oil on canvas, 32 x 25 in.

tion with an account of how he and Picasso came back to the studio late one night with the keen trepidation that Mañach might be waiting:

> At nightfall we went out together, climbed up the Place Ravignan, [but] left Durio's studio very early for Picasso wanted to get home to see his mail. We went up in single file, like children afraid to face the dangers we imagined ahead. But

when Picasso opened the door, fear vanished, the letter [from don José] was on the floor. On the bed, fully dressed, Mañach was lying on his stomach, talking to himself, as if delirious:

"The letter! The letter!"

Picasso gave him an ugly look, made a scornful grimace and let us into the studio without uttering a word. What for? The three of us were surely thinking the same thing. His eyes surveyed the walls, the floor, the ceiling, and we all went out again into the street. Doubtless he could not work there any longer. He needed a change of environment.[10]

Picasso took the train to Barcelona a couple of days later. A self-portrait done before he left Paris is certainly not close here to Maillol's impression of him as girlish.

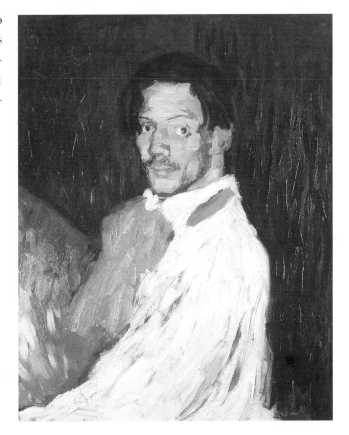

Self-Portrait: Yo Picasso, spring 1901. Oil on canvas, 29 x 24 in.

3

Picasso went back to Spain in January of 1902 and would not return to Paris until the end of the year, and then it was only for a few months before he came back to Barcelona and would work there until the spring of 1904. Short of money, depressed, at odds with his parents, steeped in dread, he was immersed in the Blue Period. If he had been criticized for painting in twenty borrowed styles, now, months after the death of Casagemas, he was exploring a concept that was simple enough: Nothing but a blue palette!—the deep depression of dark blue. Small wonder that painters had staked out so little of that ground and it was available as a territory that belonged altogether to him.

Who can measure the power of artistic investiture? Owning the one powerful style of the Blue Period for a few years may have given him the artistic strength to migrate into a multitude of other styles over the next seven decades. Be it said that each style he took up was sufficiently arresting to stand as a complete oeuvre for another painter, even a major painter. Of course, Picasso had to pay the spiritual impost for the first style: In the early years of the Blue Period he was seriously depressed and may have been closer to suicide than he would ever be again.

Entering the Blue Period, his depression poured out of him like unstanched blood. If he suffered in his own gloom, the irony is that these morose works can also qualify as sentimental art since they are just tender enough to become prodigiously popular in decades to come.

One would not wish to suggest that Picasso was not also inveighing against the inequity of the world, but the Blue Period also speaks from the depth of his sexual

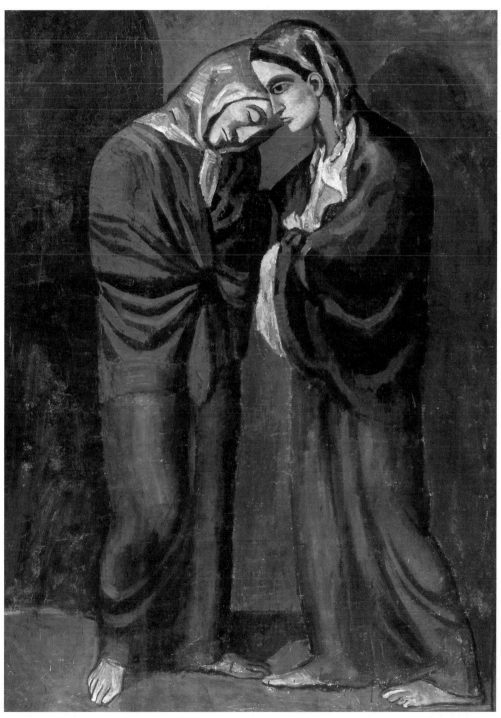

The Two Sisters, Barcelona, 1902. Oil on panel, 59 x 39 in.

fear. In later, more prosperous times, Picasso would always be ready to certify the legend that he had always been a voraciously active sexual animal, happy consort to the brothels of Barcelona and the whores and models of Paris, and there seems small doubt that sex, from an early age, was the preoccupation of his life (indeed, for that matter, has there ever been an artist able to capture the sight *and* the smell of carnality more closely than Picasso?), but it will blur our real comprehension of him to assume that he was a simple stud gifted with indefatigable virility and absolute confidence as a performer. The variations in his self-portraits give more than a glimpse of the distance he saw between strength and weakness in himself. A large portion of his young manhood can even be seen as a search for his sexual identity. But there is little question that in this period, one drawing after another is there to remind us of the impotence of the male and the overbearing carnal presence of the female. Even his flowers burgeon with female power.

Still Life with Flowers (Peonies),
spring–summer 1901. Oil on canvas,
20 x 13 in.

Woman in Stockings, 1901. Oil, 25 x 19 in.

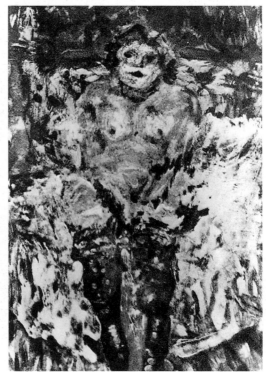

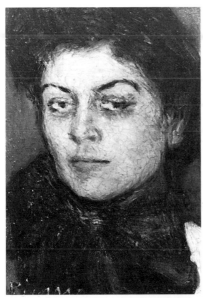

The women in his family also appear as formidable. In the portrait of his sister Lola done in 1901, she cannot be more than seventeen.

It would be hard not to believe that in these years he sees women as harbingers of mortal threat, principles of execution severe enough to have killed Casagemas.

Portrait of Lola (left), 1901. Oil on wood, 14 x 9 in.

Nude Lying Down (also called Female Nude), spring–summer 1901. Oil on canvas, 27 x 35 in.

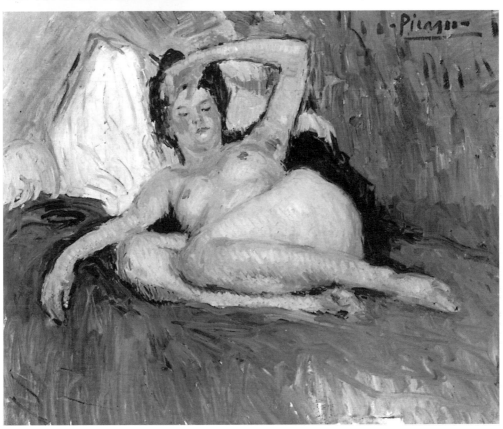

Untitled (Nude with squid), Barcelona, 1903. Pen, sepia, and wax crayon on trade card, 5 x 4 in.

Untitled (Nude in hammock), Barcelona, 1903. Pen, sepia, and wax crayon on trade card, 5 x 4 in.

Reclining Nude and Figures, Barcelona, 1903. Wash and gouache, 10 x 14 in.

There is also a drawing of Germaine Gargallo in a Phrygian headscarf of the kind obligatorily worn by the syphilitic prostitutes then housed in the prison of Saint-Lazare. It returns us to the possibility that Picasso might have contracted a venereal disease. Syphilis in the era before penicillin could produce any man's Blue Period—the treatment was exceptionally painful.

A venereal disease can also generate a perfervid sexual obsession. Picasso at one point in this period wrote a note on a drawing he had done of a female nude: *"Cuando tengas ganas a joder, jode"*— "When you want to fuck, fuck"[1]—which has been generally interpreted by his biographers as a species of logo—heartily

Germaine in a Headscarf, Barcelona, 1902. Oil on canvas, 18 x 16 in.

Self-Caricature and Other Sketches, January 1, 1903. Pen on paper, 5 x 4 in.

tumescent, promiscuous Picasso. It can also be seen, however, as his attempt to find sanction. When a diseased man wishes to fornicate, which indeed can be a passionate impulse—one's phallus, after all, is not only venereally inflamed but stimulated—the question has to present itself: Is one, therefore, twice evil? It is worth repeating that Picasso was far from having sloughed off the last of his Catholicism. One need only take a look at his simian *Self-Caricature* in 1903 to get some notion of his view of himself in heat. It is a low por-

trait, but he is hardly unsatisfied with himself. Only a real man can be this much of a satyr, he is also saying.

The suspicion still remains that he may have been, for considerable periods through those years, obsessed with impotence. It appears in this drawing from his sketchbook.

Can we begin to contemplate what public reaction in 1903 might have been to this cruci-fixion? Here, the head of Christ can also serve for the button of the clit-oris! It is enough to paralyze a young artist from explor-ing further into any philosophy of form. Perhaps it did in-hibit him. Surely it is no accident that the figures of so many of his men at this time are bereft of their genitals. Part of Picasso's profound depres-sion in the Blue Pe-riod has to derive from a sense that his artistic insights were leading him into more and more dangerous discover-ies. What, he had to

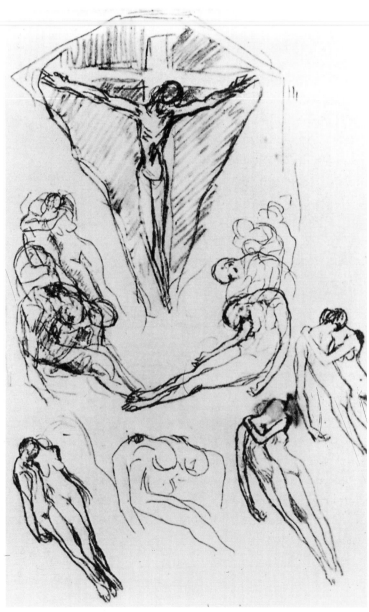

Celestial Vision (Crucifixion), 1903. Pen and ink, 12 x 9 in.

*Parody of Manet's Olympia with Sebastián,
Junyen-Vidal and Picasso, Barcelona, 1901. Ink
and colored pencil, 5 x 4 in.*

*Preparatory drawing for La Vie (right), Barcelona,
1903. Conté crayon on paper, 6 x 4 in.*

have asked himself, if he proved not brave
enough to become the artist he wished to be?
By contrast to the powerful women he depicts,
the men in a great many of his drawings are
singularly neutered now.

 Even his couples go limp in their em-
brace.

Embrace,
Barcelona,
1903. Pastel
on paper,
38 x 22 in.

Lovers Making
Love (top
right), 1901
or 1902.
Watercolor
on sketchbook
paper,
5 x 7 in.

Two Figures
and a Cat
(bottom right),
Barcelona,
c. 1902.
Watercolor
and pencil,
7 x 10 in.

Portrait of the Artist Making Love, 1903. Oil on canvas, 26 x 21 in.

Dead Man, 1902. Crayon on paper, 7 x 12 in.

Casagemas Naked (left), Barcelona, 1903–04. Pen and blue crayon on trade card, 5 x 4 in.

This mood prevailed from 1902 to early 1904, and in that time Sabartés, self-nominated Sancho Panza, becomes his intimate more than ever; no surprise, then, if Sabartés is proprietary about the Blue Period. Picasso, in the midst of this depression, obviously has greater need now of the all-but-flaccid friend. Indeed, by 1902, after Sabartés followed Picasso back from Paris, he was pleased to see that his friend's work continued in the same vein.

> What I could see was sufficient. His pictures continued to bear the blue characteristics which bound my ideas to his, reminding me of the period spent in Paris almost by his side. Had I found him following another road now, I would have thought he was doing so deliberately in order to detach himself from what had only recently united us.[2]

Apart from these personal elements, a portion of Picasso's gloom can certainly be attributed to the world around him. Social conditions in Barcelona were deteriorating. Anarchists and conservatives were both on the march; the slums of Barcelona were renowned throughout Europe for their abysmal living conditions; strikes and general strikes had increased; workers had been shot in the street.

Picasso joined no socialist or anarchist groups, but the slums through which he often wandered offered a squalor to intensify the melancholy he brought to his canvases. We must never lose sight of his prophetic sensitivity to the real intimations offered by events. The injustice of social life in Europe at the turn of the century was probably as palpable to him as leprosy or earthquake—a sizable remark—but then, who has ever given us more intense portraits of concentration camp victims before half of them were even born? *The Blind Beggar* and *The Old Jew*, both painted in 1903, can serve as emblems for 1944 in Auschwitz.

The Blind Man, Barcelona, 1903.
Watercolor on cream wove paper mounted on canvas, 21 x 14 in.

The Old Jew, Barcelona, 1903. Oil on canvas, 49 x 36 in.

His personal life during this period is not nearly so hopeless as the tone of his work, and is replete, as always, with contradictions. Art, even at the most demanding level, can, on occasion, free an artist of an obsession. Obviously, his own mood was not always as stygian as his canvases down in the depths of the Blue. During the same season, he can offer us a pen-and-watercolor that is high-style in its smudges, and fine and hellish in its humor: there is menstrual blood in the bidet, and the whore is contemplating it with the same low-key woe that a musician might bestow upon a guitar that has just snapped a string. But let us not speak prematurely of all the guitars to come. He is still in the foothills of his lifelong preoccupation with the Lord's hiding places and secrets, and his only tool is his instinct that objects which look alike must have unspoken similarities in their nature. It is worth underlining over and over: Form is as much of a presence to him as sound is to others. We are deducing a great deal from one casual drawing, but that is fair. The monumentality of Picasso's art is that it will become more and more difficult to come upon any of his scribbles that does not tell us a great deal indeed.

Female Figure, Barcelona, 1903. Pen and watercolor on paper, 8 x 5 in.

All the same, he is depressed, deeply depressed, through 1902 and 1903.

Since depression often serves as the insulation that surrounds an ambition which has become too livid, he may also have been wounded by reading another critical piece by Félicien Fagus about young Spanish painters, including Picasso:

> They do not yet have their great man, their conqueror . . . who will give shape to a limitless universe . . . Which of them—the time is ripe—will become their Greco?[3]

On October 25, 1902, he would also be twenty-one and eligible for military service. Since he is forever confounding us with his special mix of bravery and cowardice, it can come as no surprise that he has a horror of going into the army. Some of his adult fears were as deep as his early terror of school. What price must his pride have paid to ask Uncle Salvador to come forth with the quit-price—or was it his mother who had to do the begging?

> We know that Picasso, too, bought his way out of military service, and he himself told me that it was his uncle Salvador, the elective head of the family, who provided him with the necessary two thousand . . . pesetas.[+]

Army service now settled, Picasso was on his way to assault the artistic bastions of Paris for a third time. It was just before his twenty-first birthday and three of the worst months of his life awaited him.

4

From the beginning, all went wrong. It had taken most of his funds to buy a ticket from Barcelona to Paris; then, as the first act of his visit, he brought his new work to Durand-Ruel's gallery and was turned down. If he went on to Vollard, there is no record of anything happening there. The Blue Period inspired no enthusiasm. At the end of the week, his money was gone and Picasso had to share an attic room in the Hôtel du Maroc on the rue de Seine with a sculptor named Agero. The garret was so small and the ceiling sloped so abruptly that one man had to lie on the bed if the other was to move around. Moreover, it was filthy and dark.

To keep warm, he would visit the galleries of the Louvre. The poverty he had been painting had now become virtually his own. From the age of three, Picasso was a believer (given the Málaga earthquake) in a catastrophic view of history—things go along as usual until there's a catastrophe! So this sudden inability to sell his work must have given him a nightmarish vision of the perverse power of fashion. Certainly, the fear of being out of fashion would keep him much on edge for the rest of his life—there would never come a time, no matter how renowned and wealthy he became, when he felt financially or artistically secure.

Later, Picasso would characterize his time at the Hôtel du Maroc as abysmal. Sabartés quotes from a letter Picasso wrote to another friend, Max Jacob, "I am thinking, too, about the days of poverty, and I become sad when I think with disgust of those Spaniards at the Rue de Seine," to which Sabartés adds,

> Picasso's disgust with the Spaniards of the Rue de Seine came from an inability to stomach some grotesque incidents . . . Picasso refused to speak about this matter

. . . preferring not to stir the mud with which he was besmirched during a difficult period at the Hôtel du Maroc.[1]

Palau i Fabre adds:

> Picasso retained very unpleasant memories of a group of Catalans in the Rue de Seine . . . This leads me to suppose that one fine day they invited Picasso and Agero to some meal or other, or even invaded the attic room in order to organize some sort of party there that must have degenerated into a most lamentable orgy.[2]

To live in a small room with another man when each has to take turns lying in bed, to be a figure in the corridors of a cheap hotel where other men were looking for an orgy, would not be comfortable, no, especially when he was poor and economic offers may have been coming in for his body rather than his work. One can make too large a case of the nude he did of himself in this period—modest, unadorned, a little seedy, certainly depressed, and taking the vow of allegiance to . . . to what? To his continuing heterosexuality? It is tempting to read too much into this drawing.

In such a pass, he is rescued by one more homosexual, Max Jacob. He had met Jacob in 1901, during his previous trip to Paris, and Jacob was inspired to a romantic passion even greater than Sabartés' idolatry. Certainly there were fewer circumlocutions. Arianna Stassinopoulos Huffington gives a full description of the first meeting.

Nude Self-Portrait, 1902–03. Pencil on paper, 11 x 8 in.

> Max was twenty-five years old when he met Picasso. He had arrived in Paris from Brittany three years earlier, determined to become an "artist"—a poet and a painter. "Stick to poetry" was Picasso's advice, and to a very large extent Max took it. He called Picasso "my little boy," but listened carefully to what the little boy had to say. At first, of course, any listening and talking had to be done in sign language: "Picasso spoke no more French than I did Spanish," he remembered later of his first meet-

ing at the boulevard de Clichy studio, "but we looked at each other and we shook hands with enthusiasm." Despite the absence of a common language, they took to each other right away . . .[3]

Jacob would write: "As for Picasso and me, we spoke in sign language until morning."[4] Soon enough, he would describe Pablo as "perfectly handsome, a face like ivory . . . in which eyes shone, much larger than they are today, while the crow's wing of hair was like a caress on his low forehead."[5]

Let us go on with Huffington's description of Jacob:

> This short, prematurely balding intellectual, who wore a monocle with the sensuality of a woman wearing a garter belt, had already gained considerable influence in the demimonde of poets and painters which he had made his home. He would launch some and help the careers of others already launched, but none would he love as deeply and as unconditionally as he loved Picasso. A tormented homosexual all his life, Max called homosexuality "an atrocious accident, a tear in the robe of humanity."[6]

Portrait of Max Jacob, 1904. Pen, 10 x 8 in.

Max soon took him in. Picasso moved to 137 boulevard Voltaire, where Jacob had a larger room than the attic space offered at the Hôtel du Maroc, and Picasso soon began to acquire something of an education in French literature. Max would often recite Verlaine:

I believe in coloured hours,
Blue and rose, when your delights
Are bared for me through sleepless nights.[7]

Picasso's debt to Jacob is not small. He was to learn a great deal from the poet, including some real capacity to speak French. The true gift, however, may have been his introduction to poetry. It can be proposed that for Picasso, metaphor was more accommodating than logic. Reason, with its formal avenues, its detestation of swamps, backwaters, and crooked alleys, had, for Picasso, always been a foe. Reason, a.k.a. common sense, was a tactic used by others to reduce his strength. Reason extended from don José's maxims on an artistic career to society's control of proper

manners and machine guns, whereas metaphor was elliptic. With it, one could leap through time and space.

So, they lived together. Whether they were lovers we will never know. It does appear that they contemplated suicide together. "Picasso may perhaps remember the day we gazed from the height of our balcony down to the ground . . ." wrote Jacob later.[8]

> . . . they were both leaning over a balcony on their fifth floor and for a moment the same thought of putting an end to it all crossed their minds. But it was only for a moment. "We must not have ideas like that," Picasso said abruptly, as though wanting to shake both of them out of a dark trance.[9]

Jacob's book *Le Roi de Boétie* appeared in 1921 with such disclosures as this, and it may have colored the hostility Picasso later felt for the poet. While willing to create all sorts of myths about himself, Picasso was not in the least inclined to let anyone else put his hand on the lever that moved the legend-machine.

Woman by the Sea (Mother and Child on the Seashore), Barcelona, 1902. Oil on canvas, 32 x 23 in.

All the same, Jacob had a mind capable of the most exceptional intuitions. Addicted to ether and any other intoxicating drug available, he certainly must have taken Picasso down many a road to the occult. He knew a good deal about palmistry, could read the Tarot, and was a devotee of astrology.[10] Since God, catastrophe, and the language of form were all manifests to Picasso of another world beneath the world of appearances, there had to have been many a new insight daily while living with Max Jacob.

All the same, it was the end of the year and he was cold, he was freezing, his parents' home in Barcelona was warm. Hating to ask don José for money still once more, he managed to sell one of his best Blue Period paintings, *Woman by the Sea*, painted in Barcelona and brought to Paris.

He could, however, find no buyers for the rest of his work and had to store it with a Catalan friend, Ramón Pichot, a depressing conclusion to the three most penurious months he would ever spend in Paris.

He would now spend fifteen months in Spain, and the greatest works of the Blue Period would be painted during this period. His first few days back, however, could hardly have been peaceful. More than forty years later, Geneviève Laporte would describe his return.

> I learned one day how Picasso, exhausted by the poverty of his life in Paris, had returned to his parents' house in Spain. He arrived in the evening and, worn out by the long journey, went straight to bed. The following morning, while he was still asleep, his mother brushed his clothes and polished his shoes so that on waking Pablo found that he had been deprived of "his dust of Paris." He told me that this put him in such a terrible rage that he almost reduced his mother to tears.[11]

His fury may be worth our attention. It is reasonable to assume that a field marshal, arising early on the morning of a major battle, might pay great notice to such normally insignificant details as to whether he first places his left leg or his right into his trousers; the forces of destiny could be sitting, after all, on the outcome—the field marshal may be their agent. We can assume that Picasso possessed something of this psychology. It is worth remembering that superstition is our earliest form of psychology, since it is the very stuff of motive. Psychological reality is what we act upon. In this sense, the presence of the evil eye is as psychologically real to some as are our own modern assumptions that we really do act from the promptings of the ego, super-ego, and id, that trinity, incidentally, which has become no more and no less than our most prominent twentieth-century psychological reality—that is, our own working set of superstitions. For Picasso, it would not have been hard to believe that what came in contact with his body, or grew out of it, was of value. By way of Sabartés, we know that in later years he could not even bear to part with his fingernail clippings and, during this time, in 1903, painting the white walls of Sabartés' apartment on the Carrer del Consulado, he wrote the following inscription: "The hairs of my head are gods like myself, although separated from me."[12]

How could the Parisian dust, therefore, not be possessed of special properties? In a few years he would be preoccupied with African masks and their powers of exorcism. Among Bantu tribes, for example, there is great belief in *kuntu*, the particular spirit of each person and each inanimate object. A beautiful woman wearing a beautiful gown is, when overpoweringly lovely, more than the sum of herself and her

dress. It is rather as if the *kuntu* of the gown is able to dwell in lively harmony with the *kuntu* of the woman; the effect has been, therefore, intensified. So, Picasso's dust. The dealers of Paris might have rejected him on his previous visit, but the magical dust of Paris would still cling to his shoes. In just such fashion may he have seen himself. Certainly, he had to believe (given the miracles of delineation that emerged from his fingertips when he picked up a pencil) that he might be an off-spring—if we are to deal with the limitless extent of his vanity—of the godhead it-self.

If he had subscribed to that entirely, he would have been mad. If he had not believed it to some private degree, however, there would be no explanation of the man who would yet dare to tear apart the world of appearances.

Sabartés has an interesting description of Picasso with a brush in his hand:

> I rented a small apartment in a corner house in the narrowest part of Consulado Street—an old house with steep and dark winding stairs . . . I had two rooms and a kitchenette . . . The walls were whitewashed, the floors covered with ill-baked bricks, and beams supported the ceiling . . . I took it because I liked its dilapidated state, because it was picturesque, and because its winding stairs reminded me of a belfry tower.
>
> A few days later Picasso came to decorate the walls . . . We were alone; he be-gan to work as soon as he arrived . . . As usual, in surrendering to his creative ob-session he seemed to isolate himself from everything around him and yet to appropriate the environing space, as if he were drinking in the air, as if his ideas were floating thereabouts and he feared someone might take them away from him. He did not remove his eyes from the wall; he seemed oblivious to outside contact. One might think some occult power guided his hand and caused it to follow, with the tip of his brush, some path of light which only he perceived, for the brush was never lifted from the wall, and the line which it left behind did not seem to proceed from an intention, but to emanate from the wall itself . . .
>
> Facing the window he painted a half-naked Moor hanging from a tree . . . The feet were rigid, just slightly inclined forward: one was bare and from the tip of the other still hung a babouche, forming a right angle with the sole of the foot. This miracle of equilibrium, which gave a slight appearance of life to the lower part of the Moor's body in the throes of agony, attracted the eye and directed it toward the ground, where a young couple, totally naked, delivered themselves, in the pres-ence of the hanged man, to the passionate game of love.
>
> As he lifted the brush, Picasso turned his glance away from the wall and told me, "Someday I'll come back and we'll continue."[13]

He was indeed industrious these days. For over a year, one painting after an-
other would be added to the Blue Period, even if they were almost impossible to
sell. In later decades, the opposite phenomenon occurred, and the prices were
higher

than for any other examples of twentieth-century art. These distillations of suffering
and want either exorcise the guilt of mammon or else make it the more enjoyable.[7]

One ought to add that part of the power of these paintings is due to the artist's
depression, his prodigious woe. If he has deep intimations of how much more he
can see than other artists, then his life must become a mission, even a crusade.
Yet, there is so large a part of him that is materially passionate, ordinary, and
small—which is to say, middle-class—with a greedy desire for recognition, pre-
cisely what the paintings of the Blue Period are not bringing him at all.

There is a rich irony. Perhaps such works did not sell in those years because
the people who viewed them were not yet wealthy enough. The Blue Period
speaks to the profound contradictions of those very rich

*The Blind Man's Meal, Barcelona, 1903. Oil on canvas,
37 x 37 in.*

who are invariably weary in spirit and never free altogether of depression. How can
they not be miserable? Great wealth induces greed and treachery in everyone within
the court of the tycoon; honest relations are consumed by dishonest appetites; the
man of great wealth often lives in gloom amid sensations of profound isolation. The
guilt accompanying great wealth presses upon the rich man's psyche powerfully
enough to suggest the overburdened backs of Picasso's blue-tinted victims and or-
phans; yes, the prodigiously wealthy collector can feel kinship with the poor, and so-

lace as well for his guilt inasmuch as the power of the Blue Period lies in its suggestion that poverty is not a reflection of temporal passing conditions but is as universal as life. That makes wealth a little more palatable! Indeed, by such a logic, wealth and poverty are each other's counterparts—universals! Ergo, the Blue Period would come into commercial fashion about the time collectors of sufficient wealth encountered the works. Nor did it hurt that Picasso was, by then, well established and his later paintings were much more difficult to comprehend. There is an added marrow of satisfaction in purchasing the early work of a great and near-unfathomable genius. Of course, the irremediable bitterness in Picasso's soul, the power of the inner sanction he felt later in life to wound and humiliate others, had to come in part out of

the paradox that the paintings that brought him the greatest sums were precisely the works which had cost him the most miserable days of his life.

What fabulous works he painted, however, in this period! *La Celestina* can serve as one example.

It may be significant that *La Vie*, the most obscure of these paintings and the richest in private themes, also celebrates the return of his dead friend as a model. Picasso was still living at home, but, to avoid discord between don José and himself, was using the studio he had once shared in Barcelona with Casagemas, its walls still bearing the sumptuous handmaidens he had painted some three years before.

Once again, he was en-

La Celestina, Barcelona, March 1904. Oil on canvas, 32 x 23 in.

tering a realm that could prove unruly to an average person's composure. If Picasso had a healthy respect for the ravages of dread, and was obviously aware of its destructive effects upon Casagemas, nonetheless he had a gift for making use of his own dread. It is likely that a cigarette smoker can think more clearly while smoking—many of us have the kind of brain that will react to a threat or a wound to the ego by immediately beginning to cerebrate. Since each inhalation of cigarette smoke is a minute wound inflicted on the lungs, the mind develops a habit of reacting to the infinitesimal injury by a compensatory flow of thought.

La Vie, Barcelona, 1903. Oil on canvas, 77 x 50 in.

In analogous fashion, Picasso may have entered into just such precise negotiations with dread. He could live with dread if it came to him by measured quanta—inhalations, so to speak. Controlled amounts encouraged him to work in order to exorcise the sensation. So, small emanations of dread that he could all but imbibe from the walls of Casagemas' studio may have been the stimulant to virtuoso strokes.

His preoccupation with sexuality, whether potent or less than potent, remains intense. Even in the midst of the Blue Period, his erotic drawings have a cachet that would have made him a good living if pornography had been all he did. We must remind ourselves that he could never work without going in several directions at

once, and the pleasure of contemplating the heated timelessness of foreplay and finger-fucking is immortalized in an eight-by-six-inch ink-and-watercolor he did of his friend Angel de Soto in late 1902 or early 1903, a good year at least before *La Celestina*.

All through 1903 he must have been readying himself to return to Paris. There is a dreadful erotic drawing with pen, sepia, and wax crayon he did that year on a four-by-five-inch card that nonetheless suggests his profound divisions over sex. If the god of the phallus, conventionally drawn, is not only happy but radiant, his full scrotum is occupied by an abject woman. The conclusion is inescapable: Picasso is telling us where to look for the root of femininity in men.

This assignment of roles for the phallus and testicles, appearing respectively as man and woman, will show up again from time to time. One can even come across an aquatint done in 1966, not less than sixty-three years later (see next page). It will not surprise us that it is vastly more sophisticated: We are now asked to deal with two varieties of male genitalia. One offers a languorous albeit tumescent woman at the core, and the other provides a pair of heavy feet as ready to stomp on you as the face in the head of the phallus. (Picasso's late humor is rarely at rest, and so the phalluses, their separate roles now defined, are surrounded by what certainly appear to be body lice.)

That 1966 painting is the resumption of

Angel Fernandez de Soto with a Woman, Barcelona, 1902–03. Ink and watercolor on paper, 8 x 6 in.

Untitled (Erotic drawing on trade card), Barcelona, 1903. Pen, sepia and wax crayon, 5 x 4 in.

Untitled, November 15, 1966. Aquatint etching, 9 x 13 in.

a theme he first explored while trapped in Barcelona, dreaming of Paris with its sexual tolerance. He may not have known that he was on the cusp of quitting Barcelona forever. There would be brief visits back, but whether he was aware or not, he was getting ready to take final leave. He does not know, as we do, that the first major and thoroughgoing affair of his life is waiting for him. Before it is over, these male and female aspects of his nature will be considerably more familiar to him.

Early in the spring of 1904, he heard from Paco Durio, a sculptor and old friend from Barcelona. Durio was giving up his studio in Montmartre, a special studio in a most special place, the Bateau Lavoir, and so for the first time in all these years, Picasso would have a place in Paris he could consider his own.

Part III

Fernande

1

In the summer of 1904, when Picasso met Fernande Olivier, he was twenty-two and she had just turned twenty-three. If their affair began soon after they first spoke to each other, they would not begin to live together until the end of the summer of 1905, a full year later. Every indication provided by Fernande makes it clear that it was Picasso, not she, who was in love for the interval between.

Since Fernande is agreeably candid in her translated book of memoirs, *Picasso and His Friends*, published in 1933, and even more so in her second set of memoirs, *Souvenirs Intimes*, written in 1955 but not published in Paris until 1988 (and as yet untranslated), we can probably accept a good deal of her evaluation of the relationship. Her presentation has authority. Once Pablo and Fernande commence to share his studio at the Bateau Lavoir, Fernande becomes the first woman whom he is ready to accept as a serious mate. He has passed from male bonding—at the least!—with Pallarés, Casagemas, Sabartés, and Max Jacob to the constant company of a woman who is neither a whore nor a playmate but a woman in his domain, his serious mistress. According to Fernande, he was ready to marry her, and was uncontrollably jealous. (That was with some cause, we can assume, since she was tall, red-headed, and beautiful; she stood out vividly in their impoverished bohemian circle.) For that matter, she had become a successful artist's model before they met and was much in demand by other painters.

Indeed, in the week preceding the hot summer Sunday when she finally agreed to move in with him, Fernande had been posing for two well-known academic stalwarts named Corman and Sicard, and they were each in the middle of large can-

vases for which she was the model; Picasso, however, insisted she stop. He would not trust such a situation. How many nude and half-draped models had he seduced himself, after all! Besides, he could amplify his own memoirs with the sexual anecdotes of a hundred other painters. As Fernande writes:

> I no longer work. Corman, the old buzzard, understands when I inform him that I can't pose, and he doesn't insist. Sicard wrote to Picasso, however: "Come with her, then, during these sessions. There is only another two weeks of work."[1]

"I don't give a fuck,"[2] Picasso was to reply. He certainly didn't. If he was going to live with a woman, why then treat her with less possessiveness than he brought to his paintings? Would he allow another artist to put a stroke to one of his works-in-progress?

They would not separate until the spring of 1912, and in those seven years Picasso was to move from the Blue Period through the Rose Period and on to the explorations that would result by 1907 in *Les Demoiselles d'Avignon*. By 1908, he had entered Cubism and his collaboration with Georges Braque, and by 1909, at the age of twenty-eight, he was already an international figure, and prosperous enough to move with Fernande into a bourgeois apartment on the boulevard de Clichy. He had by that time become fast friends with Guillaume Apollinaire and Gertrude Stein and was on the verge of becoming the innovative center of the most passionate artistic controversy of the preceding fifty years in Paris, larger, perhaps, in its impact upon the avant-garde than the visual shocks presented by Manet, Monet, Renoir, Degas, Pissarro, Seurat, Cézanne, van Gogh, Gauguin, Toulouse-Lautrec, or *les Fauves*. With Cubism he had become, for some, a mutilator of aesthetics, for others, the artist-as-hero, which is to say he had already commenced to be *Picasso*. As *Picasso* he would live in the forefront of Western culture for the next sixty years and more; he would die as the wealthiest painter who had ever lived, and possibly the most prolific.

A great deal was obviously shaped in him over those seven years from 1905. Let us enjoy the presence of the number: Fernande was the first of the seven major mistresses and wives who would exercise a measurable influence upon his work. If he has often been depicted as a monster in his relations with women, let him also be characterized as wholly magnetized by such relationships. He would extract a unique inspiration out of the different style in which he lived with each woman. And he would honor each of them in his fashion. Even in depicting his detestation of his first wife, Olga, or in the portraits of Dora Maar and his second wife, Jacque-

line, which could hardly be more savage, we can see that he lived, nonetheless, with these women in a manner that some men never do: He was *in* each relationship—he saw the women as his equal. No matter how hideously he presented these three women, he could never have delineated them so if he had not entered into a depth of revulsion for what their relationship had become, and that, in turn, disclosed how hideous were his own spiritual sores. The physiognomy of his psyche is present in each of these portrayals, respectively, of Olga, Dora, and Jacqueline.

Bust of a Woman with Self-Portrait, February 1929. Oil on canvas, 28 x 24 in.

Woman Seated on a Chair, 1939. Gouache, 18 x 15 in.

Nude, May 2, 1967. Oil on canvas, 45 x 35 in.

Such extremes of cruelty would come later—by which time (in the late 1920s and 1930s, and certainly by the 1960s) he was as wealthy as Midas and profoundly disappointed. He had taken his long decline down an aesthetic retreat from the great discoveries between 1907 and 1912. Those had been the five most creative and astonishing years of his life. But for the working presence of Georges Braque, he had been alone, each Cubist painting a reconnaissance through ambiguities of perception that would have endangered the sanity of a weaker man. In the face of such inner peril, this Spaniard, of weak and intermittent machismo, drenched in his own temerity, full of sentiments of social and intellectual inferiority, short in stature, was possessed of the ambition to mine universes of the mind no one had yet explored. His female companion for these most creative years of his life was a woman who is not without interest in her own right. While their love will suffer the fate of most passionate relationships—at a point they will fail to come closer,

Van Dongen, Portrait of Fernande Olivier, 1906. Pastel on paper, 28 x 24 in.

and so drift just a little apart, thereby to grow some distance apart—she is, nonetheless, the first of those women who will love him for all of his life. Since it is more than likely that she gave him the dignity to believe in himself as a man, so too did he acquire that indispensable buttress to extreme ambition, a measure of self-respect in the social world. Of course, she is worth our close attention!

Fernande Olivier has described herself as indolent, and the description has generally been taken up. Some biographers speak of her as a charming odalisque or as "la belle Fernande," and she has even written:

I remember our childish joy on those days when Picasso managed to make a few extra francs. He used to spend it on eau-de-Cologne because I adored scent.

Then there were the days when we were obliged to fast, and the piles of books bought at the little bookshop in the rue des Martyrs; sustenance which I found essential since Picasso, out of a sort of morbid jealousy, forced me to live like a recluse. But with some tea, books, a couch, not much housework to do, I was very very happy.

It was Picasso who swept the studio and did the shopping. I was, I admit, extremely lazy.[3]

Dreamy may be the more generous word. From an early age she lived with the best of her memories and the sweetest of her fantasies under signally unhappy circumstances. If her literary gifts are modest, still they are not without talent. If she had had a better childhood, where more attention was devoted to her, it is not unlikely that she would have become a good novelist. Her perception is incisive, and in *Souvenirs Intimes*, written when she was seventy-five years old, on the basis, she claims, of a journal she kept through her adolescence, a variety of sharply drawn characters are seen with the same unsentimental clarity that Picasso brought to his portraits in late adolescence; the personages in this second book are evaluated with enough composure to suggest that she has absorbed a few lessons from Flaubert. The list of novelists manqué is always long enough to wind out to the horizon, but Fernande Olivier did live with a great painter through his most profound period of artistic transition and so we are in debt to her for *Souvenirs Intimes*. She will have considerably more to tell us about Picasso than does Gertrude Stein.

The accepted view of Fernande is that she was not only lazy but lusty, a healthy female animal, born to model and share a painter's bed; but then, the common view of Picasso is that he was a priapic demon and screwed everything not nailed down, a glorious over-simplification created in large part by the painter himself. Over her late adolescence, Fernande had to travel through a succession of miserable experiences. Her romantic life began abominably, at the age of seventeen, and for the next five years, she feared, detested, and put up with attacks of copulation—so she virtually saw it—as a necessary concomitant to having any relations with men at all. On the other hand, she had to deal with men constantly. Having left home without a trade, nothing was more logical in her situation than to become an artist's model.

Let it be said that by the time we turn the page and allow her to speak for herself, she has picked up a good bit of the art of living with a man as best she can.

2

I was staying at 13 rue de Ravignan when I first noticed a rather curious person who had just moved into the house . . .

There was nothing especially attractive about him at first sight, though his oddly insistent expression compelled one's attention. It would have been practically impossible to place him socially, but his radiance, an inner fire one sensed, gave him a sort of magnetism . . .[1]

That is from her first memoir, *Picasso and His Friends*. As if it were all one work, we can pick up her account in the second book, *Souvenirs Intimes*.

For some time now, I've been finding him always in my path, and he looks at me with large, heavy eyes which are both acute and pensive at the same time, full of contained fire, and he stares so intensely that I can hardly keep myself from looking back. I cannot guess his age. The pretty line of his lips suggests he is young. The deep wrinkle that runs from his nose to the corner of his lips would make him older. His heavy nose, with thick nostrils, gives his face a certain vulgarity, but it is a most fascinating and moving personality that comes off this person. An acute spirituality emanates from him. Despite his smile, his eyes remain solemn and his pupils are shrouded in a bottomless melancholy. His gestures, simple and clearly sketched, reveal a kind of timidity from which one cannot exclude an intense pride.

However, I've not yet answered him when he tries to engage me in conversation.

In the evening when I return [from work], I've taken the habit of sitting myself

in front of my door with a book. I rest there until night falls. When friends come, we bring our chairs from the studio and we form a little circle. This Spanish painter, in his turn, is in front of the main door surrounded by a group of artists of his nationality who speak noisily. They annoy me a little but, all the same, add a good deal of color to this corner already so colorful.[2]

On a hot evening in August, coming home from work, she is caught in a heavy downpour and finds this "rather curious person" in her way as she is hurrying to her door. "He was holding a tiny kitten in his arms and he held it out to me, laughing and blocking my path. I laughed too, and he took me to see his studio."[3] Inside, she was suitably impressed. He was obviously a painter of remarkable talent.

> [He had done] an etching . . . of a man and a woman sitting at a table in a wine-shop. There is the most intense feeling of poverty and alcoholism . . . the effect was strange, tender, and infinitely sad.[4]

Nonetheless, she would later characterize her seduction in quintessentially French terms: "For several days now, I've been coming around to think that I've gotten into a new stupidity. It's the rain that was the cause of it."[5]

Pablo Picasso, 1904.

The Frugal Repast, 1904. Etching, 18 x 15 in.

She must have been not only intrigued but, to a degree, repelled. The studio had two dogs living in it and a white mouse in a bureau drawer; animal effluvia was in the air and on the floor. There were cobwebs everywhere and dirt in the corners. The floor was pocked with the scars of old cigarette burns and the squalor of dead butts. The bathtub, the mattress on legs, the rusted cast-iron stove, the cane chair, the trunk that served as a substitute for a second chair were all repositories for half-squeezed tubes of paint. Large unfinished canvases had been stacked at every angle, and there were no curtains. It was summer. The studio was a furnace.

Her new lover, however, was smitten with her. Never has there been better evidence of a profound beginning to an affair than the drawing he made of them on that

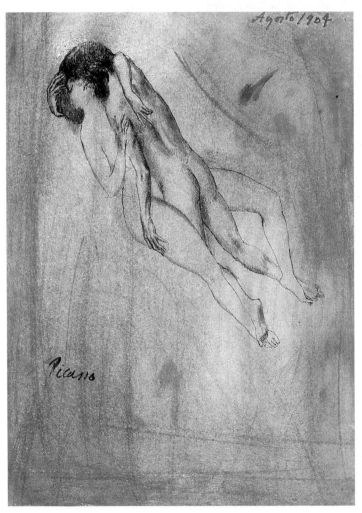

hot August day, as if he had been looking through one of the windows that had no curtains and saw them floating away on a sea of peace.

Her feelings are considerably less intoxicated:

> I go back to the house of the Spanish painter. He has an absolute adoration for me. That touches me. He's sincere, but it's necessary that I be cautious because I don't want Laurent to know where I go.[6]

Laurent is the sculptor with whom she has been living for the last few years. She has been getting ready for some time to leave him, but still!

The Lovers, August 1904. Ink, watercolor, and charcoal on paper, 15 x 10 in.

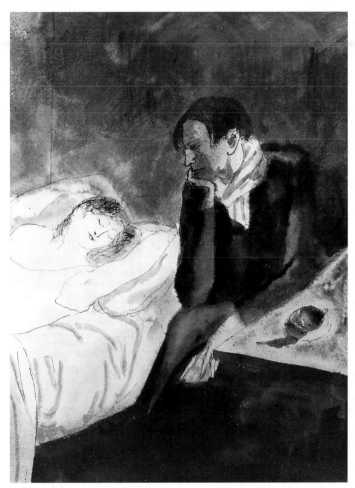

Meditation (Contemplation), 1904. Pen and watercolor, 14 x 10 in.

Can I, perhaps, love this boy at last? Picasso is fine, intelligent, and extraordinarily taken with his art. And yet, would abandon everything for me. His eyes implore me. He watches, religiously, whatever I do . . . when I awake, I find him at the head of the bed, his eyes full of anguish, fixed on me.[7]

He no longer sees his friends, no longer works or rests. Yet he remains in his studio in order to see me more often. He asked me to come live with him. I'm taken by him. It's sweet to be loved so much, and physically, he pleases me also. He's sweet and gentle, but he's not well groomed and that does bother me. I don't give a damn about disorder, but I have a horror of people who don't take care of their person. I don't dare to let him become aware of that; it's too delicate. But I have to get to that point with him.

I've decided to sleep no longer over at Laurent's place . . . I go to Pablo's studio.

It's all still a mess, however. Laurent, who has never been jealous, is that way now. Despite my rebuffs, he is obstinate in trying to convince me to remain with him. However, I leave after dinner, and go running over to Pablo's place; he is

waiting for me behind the open door. For the ten days or so that I've been playing this little game, there's not yet been an ugly row; it is even amusing. However, I don't want any trouble. Laurent, despite his laziness, can be a brute. Besides, a fight with Pablo could turn bad; Pablo speaks immediately of using his revolver. I'm not afraid, but I have a horror of scandal. It's much better to act softly, peacefully, circumspectly. Besides, I can't decide whether to move in with Pablo. He's jealous, he hasn't any money, and he doesn't want me to work. Well, then, it's stupid. And I don't want to live in his miserable studio.

There it is: I don't love him. I've made a mistake again. What an idiot nature I have. I no longer want to go to bed with him, and so this perpetual adoration of his that I took to so strongly at first is now monotonous. I'm bored. I'm bored whenever I am no longer alone. I am never bored when I'm with a book, but a lover bores me, irritates me. When *will* I fall in love?[8]

We may as well orient ourselves to a few of her concerns. Fernande Olivier was born out of wedlock and began life as Amélie Lang, then was raised by her mother's half-sister, who married her off at eighteen to a brute named Percheron. Later, Fernande seems to have taken on Laurent's last name, which was Debienne, and promptly changed it to de la Baume. Madame de la Baume—one of the names she went by. We can suspect that she often felt an inclination to move on to a new role, a not uncommon ambition, but her need to remake herself was genuine; the young girl who lived in any of these names did not always have the finest chances for survival.

Before we look more closely at her life, however, it is worth picturing that unique habitat, the Bateau Lavoir, where Picasso and Fernande have met. We are speaking, after all, of a piece of architecture that will never be repeated. Old and funky, it is by any conventional measure a decrepit slum-tenement, but it is also, in lopsided manner, half grand. The edifice in which Picasso has his studio and Fernande shares living quarters with Laurent Debienne is no more than one story high, on rue Ravignan, but plummets in the back four stories down to the street behind. The Bateau Lavoir was attached to the side of a cliff. Yawing wooden stairways, slanted halls, cockeyed rooms and a variety of skewed angles, moldering windows, and crusted skylights gave a view onto the roofs of other buildings, few of which could have offered as many closet staircases, trapdoors, oubliettes, and warped floors. Christened by Max Jacob after the laundry barges on the Seine, the Bateau Lavoir offered no more for running water than a tub-sink on the cellar floor, and further along, as Fernande tells us . . .

a bad-smelling corridor led to the only WC, a dark closet whose door could not be closed for the lack of a latch. It shook at every current of air, which is to say

Entrance to the Bateau Lavoir.

A staircase in the Bateau Lavoir.

each time that someone opened the large wooden door to the street.

A narrow corridor was lit by a glassed-in ceiling, but such studio lights were darkened by an accumulation of dust that must have been there forever . . . A strange and sordid house, the most diverse noises resounded from morning to night, discussions, songs, exclamations, cries, the racket

of slop pails being emptied and dropped to the floor, the noise of pitchers being set down on the stone of the fountain, doors slammed, and the most questionable groans which passed right through the closed doors of these studios. Laughs, cries, we heard everything; all resounded, without reserve.[9]

To the inhabitants, the Bateau Lavoir must have been not unlike the crazy attics and cellars some had known in childhood; its odors could recall many a painter's infancy. Stinks abounded, and as much mess as was to be found on any playroom floor. If infancy is where a large part of one's creative powers are impounded, then voyages of the psyche back to that state (like drunkenness) can free up many a stimulation. It is true, in any event, that the Bateau Lavoir was filled with painters and had its share of poets, anarchists, and students for its thirty studios and apartments. Van Dongen, Max Jacob, Modigliani, André Salmon, and Pierre MacOrlan would live there at different times. Even Ricard Canals, for all his contemporary renown in Barcelona, was dwelling in the place with his wife, Benedetta.

Since painters were always moving in and out, Picasso soon acquired the rudiments of furniture—a bed of sorts, a broken-down chair and table, and a few other amenities—for the sum of eight francs.

Arriving in May of 1904, Picasso found congenial company. He saw a great deal of Max Jacob and of Ramón Pichot, a Spanish painter now married to the same Germaine Gargallo whom Casagemas had wished to marry. Indeed, in these

days, about all of his friends were Spanish, a reflection perhaps of the difficulties he still experienced in speaking French. There were many besides Fernande who saw him as shy in those days.

Still, much was stirring. The ice-bound reaches of his depression had begun to thaw. A suggestion of warmer hues came into his palette.

Following the beginning of his affair with Fernande, all too soon cut off by her, he found other mistresses among his models, and there was one he would keep seeing during all of that winter of 1904–1905, when he was courting Fernande but failing to convince her to live with him. The model's name was Madeleine

Portrait of Madeleine, 1904. Pastel and gouache on cardboard, 26 x 20 in.

*Mother and Child and Four Studies of
Her Right Hand, 1904. 13 x 11 in.*

*Woman in a Chemise, 1904. Oil on
canvas, 28 x 23 in.*

and she was sylph-like, bird-like—
her nose formed a straight line with
her forehead.

Before too long, Madeleine was
pregnant. With Picasso in full
accord, she had an abortion. All the
more reason, then, to commemo-
rate the loss with another drawing
of Madeleine in the fall. No humor
is, perhaps, as hard-eyed as the
Spanish knowledge of how senti-
mentality is to be derided. Of
course, the drawing is so fine that
he is also telling Madeleine that he
loved her and they suffered a loss,
but then, of what great use is an
artist who cannot bring off several
things at once?

His oil *Woman in a Chemise*
may also be of Madeleine. As Rich-
ardson remarks: "Picasso would
always take pleasure in the fact that
the skinny allure he contrived for his
Blue Period girls predicted a look
that fashionable women would cul-
tivate decades later."[10]

There was also a young woman
named Alice who was living with a
mathematician named Princet. In a
couple of years she would marry
Princet and then quickly divorce

him in order to marry André Derain. In this earlier period, she had a brief affair with Picasso, who aroused her desire one day with *L'Anti-Justine*, a pornographic book by Retif de la Bretonne. If her face reflects an intense but guarded excitement, it is, according to Picasso's biographer Pierre Daix, the moment when Picasso chose to do her portrait. Is he commemorating her mood by putting an exclamation point after her name?

L'Anti-Justine had been loaned to Picasso by a new friend he had met in October. All through that long winter of 1904–1905, as Picasso diverted himself from his failure to impress Fernande by moving from woman to woman, his relation deepened with his new friend Apollinaire, the unique and soon-to-

Alice Derain, 1905. Sepia on paper, 14 x 10 in.

be-legendary Guillaume Apollinaire. In *La Plume* of May 1905, Apollinaire, writing about the Blue Period, would say:

> These children, who have no one to caress them, understand everything. These women, whom no one loves now, are remembering. They shrink back into the shadows as if into some ancient church. They disappear at daybreak, having achieved consolation through silence. Old men stand about, wrapped in icy fog. These old men have the right to beg without humility.[11]

and then would add:

> More than any other poet, sculptor, or painter, this Spaniard sears us like a sudden blast, his meditations are unveiled in silence.[12]

It was as if Picasso had been waiting for years for just such a fine pen to confirm his talent, a poetic voice to certify what he knew already, if with but one part of himself—that he was a great painter. Now, the intervals in which he did not

believe in himself could be shortened. He would have splendid language written about himself to read again in bad moments.

So, a double life began in the winter of 1904–1905 and would proceed through the spring and into the summer. On the one hand, there was his new friend Apollinaire, a huge presence, bringing with him evenings of poetry and intense intellectual stimulation. He will develop into a very large figure in Picasso's life, but we will wait to take our understanding of his influence on the painter. Our emphasis is still at this point on Fernande, and she, by her account, is deliberating in the wings. Her relations with Laurent, although seriously deteriorated, nonetheless continue after her brief fling with Picasso. In the passage to follow, she has just come back from a sojourn in the countryside with the sculptor:

> When I arrived, I went looking for Pablo. He wasn't in his place, and so I climbed the stairs to Canals' place, where he usually ate. When Pablo heard my voice, he suddenly dropped a guitar, and ran around like a wild man. His joy at seeing me gave me pleasure. I was very well received by Canals and his woman— a beauty, a red-head.
>
> I ate with them, and then, Pablo and I went back to his place. He was desolated when I told him I only wanted his friendship, but he prefers that to nothing.[13]

Having decided to leave Laurent permanently, she accepts a more permanent invitation from the Canalses, paying them room and board out of the sums she makes as a model.

> They are so nice to me. I'm really much happier here than at Laurent's place.
>
> Pablo, in turn, is much changed now. He asked me to marry him. If they knew that I'm already married, what a shock! The evenings are gay here; there are always five or six friends playing the guitar and singing Spanish songs after dinner, a meal that usually consists of an enormous plate of spaghetti.
>
> Benedetta is Italian, and this plate is one of her specialties—nourishing, and at the level of our means. The men, all artists, speak among themselves of their work. Benedetta and myself spread ourselves out on the couch, content to be admired. Benedetta is very beautiful.[14]

Fernande then describes a young man who has been following her in the street. When he is finally ready to speak, he explains that he has traced her to Canals' studio and was awfully pleased to discover that that is where she lives. He is, after all, a friend of Ricard Canals. What luck!

> He turned out to be a Catalan painter with a not-wholly-sympathetic quality.

Fernande Olivier and Benedetta Canals, 1904

He looked less like a painter than someone who was a Spanish guitar player, still young, with an energetic face and lots of egotism. Very carefully dressed, but something I can't quite describe irritated me. He was, however, gentle and immediately commenced to give me compliments. Canals told me, "I can't even recognize Sunyer. He seems intimidated. He's so sure, usually, of himself. I believe you've made a great impression on this guy, for generally speaking, he only runs after rich women. He owes them a good deal, for that is why he's well dressed."

Sunyer ate with us. As for Pablo, naturally, he never misses a day, and spends his time looking at me with a sad expression in his eyes that seem always ready to enter you in spite of yourself.[15]

No matter; she maintains her reserve. There are lacks in Picasso she can hardly ignore: "Poor Pablo is very unhappy, but I can do nothing about it. He writes to me in a French that's full of, I can only call it, high fantasy. And it's in rather barbaric grammar and spelling. Desperate letters."[16]

She is certainly French enough to be appalled by this form of incompetence. Even so late as 1911, there is a letter from Picasso to Fernande that reads *"Yer de toute la journé, je ne ai pas eu de letre de toi et ce matin que je t'atendais non plus espérons que cete après-midi je serai plus eureux."*[17] A translation weighted for errors would go about like this: "Yisterdey, all dey long, I did no get a letre from you and this mornin I'm not waiting anymore but hope that thes afternoon I'll be more hapy."

Considering the state of his orthography in 1911, one doesn't want to speculate too long about 1905. "Barbaric grammar and spelling" has to be a deterrent to her, a fact we can confirm as soon as we encounter the middle-class pinch-mindedness of the aunt who raised her.

There is probably no better way to summarize Fernande's life than to present some full-sized excerpts from *Souvenirs Intimes*. If this will take us on a considerable excursion away from our protagonist, Pablo, it will also provide the special flavor of Fernande's presence. She will prove by turns piquant and banal, vain and wounded, critical and generous, wise and full of folly. She is not ordinary, and her story has the added advantage of its considerable readability. Of course, we will be obliged to make the acquaintance of a number of people who have nothing to do with Picasso's life, and so the impatient reader, here to be informed about Picasso, is advised to skip ahead. The rest of us may yet feel superior for resisting such a move, or will, so soon as we recognize that Fernande has something to tell us of the psychology of beautiful young girls who feel unloved. How many of us, comes the next question, can ever know enough about that?

In any event, the proof of how nicely she writes is that the best way to get a sense of her personality is to take a few generous extracts from her work, and live with some of the people she encounters before she meets Picasso.

3

My aunt and uncle . . . had a daughter two years younger than myself, whom they adored and spoiled . . . There were never caresses for me, and that induced me to live very much within myself.[1]

I did like my uncle, but he didn't dare to show openly any of his affection for me. My aunt would reproach him, nonetheless, for preferring me to his own daughter . . . In my turn, I preferred the housemaids. As soon, however, as I attached myself to one, she would be replaced by another . . . My aunt was the cause. She could never keep a maid. She found them full of faults: They ate too much, they were dirty, they stole, they were too "emancipated." That was a word dear to her, and I would hear it whenever I took a liberty. No manifestations of independence had been permitted at the Augustine convent where my aunt, the aristocrat of the family, had been raised.[2]

I passed my early years with a heavy heart, waiting for a sweet or tender gesture, sometimes searching for it without even recognizing what I was up to. I would've liked my uncle to have gone off with me, to have left his wife, his daughter, in order to love only me, as if I had been his true, his only daughter, but there it was. Life does not rearrange itself so easily.[3]

I've taken first in my exams. It's too bad; I would have preferred being left back. I would like to become a great tragic actress; I am gifted for that. Some time ago, my uncle took us to the theatre, and since then I no longer think of anything but that. When I said, somewhat fearfully, that I would like to work at the conservatory, my aunt uttered loud cries, "Go on the boards? Oh, well! We no longer

lack for anything for you to dishonor us completely. A circus performer! It doesn't surprise me a bit."[4]

A few pages later in this account, Fernande, with considerable trepidation, invites a few friends from her lycée to visit after school, but she is most uneasy waiting for them to arrive. She has neither told her aunt of what is about to happen nor given her friends a true picture of what life is like at home. Be it said that the dialogue that follows will be believable only to those who have had the experience of living in a French middle-class home.

When I heard the bell ring, I felt ill. My aunt knew Antoinette but not one of the other three girls. When she learned that they were there on my invitation, I heard her call out for me. Ready to cry, I arrived in time for her to say, "Since when do you give invitations to *my* house? This is not your home; you know it. You are being brought up by charity. You certainly don't lack for cheek. How are you going to end up? I ask myself. I ask you to judge, ladies, for I'm sure that in her place you would all have acted differently. Anyhow, since you are here, let her take you to her room and you can all have a moment together." With that she had wholly demolished the impression I had been trying to give of my life to conceal how abnormal it was.[5]

Today, at the table, they were talking about my appearance. Uncle Charles found my eyes and my hands intelligent, and pretty. But my aunt thought my eyes were small, and my hands were like spiders. As for my hair, I had too much of it, she said; that took away any distinction. I'm indifferent to being treated in this fashion by her, because I'm now old enough to be able to notice several things, and above all, that my uncle is proud to go out with me.[6]

Hélène, the nice maid, has just spoken to me in secret. It seems her brother-in-law has seen me in the street and can no longer think of anything but me. I don't know him, but he's old—twenty-eight years old, and isn't really her brother-in-law, just the brother of her fiancé. I don't believe I want to meet him. If my aunt ever suspected that Hélène was talking to me like this, she wouldn't wait a moment to fire her.[7]

Yesterday Hélène brought me a letter from this brother-in-law in which he begged me to speak to him. He sends me little presents. I'm flattered. These attentions from a grown man please me. But I've never seen him. I don't even know how he looks.[8]

My aunt's latest mania consists of wanting to marry me off to an old accoun-

tant. She even made a scene and slapped me in front of him because I said, in his hearing, that I would never get married to a fat old man. That gave me a notion of the kind of life I would have if married to him. I promised myself I would cut these family ties. Since my aunt won't give up on the idea, we will see which of us is going to have the last word.[9]

Abruptly, without warning, we are given a transition worthy of a good novelist:

For the last three days I've been locked up in a little apartment that I don't dare leave, so great is my fear that my family will find me. Yet I want so much to be far away from here.

It isn't funny, and I no longer know how it happened, because the man who abducted me also disgusts me profoundly.[10]

All right, then, the other day I met the brother-in-law and he went along with me to Saint-Sulpice. His name is Paul Percheron . . . a small guy, with regular features and large dark eyes, a little wall-eyed and yet without expression. He has a dull complexion but beautiful teeth in a thick-lipped mouth above a small chin. His hair is black and curly, which I don't like in a man. Bearded, a little heavy, his arms too long, his hands too short, and on top of that, he's ordinary. When I met him, I didn't dare to tell him my real desire, which was that he should go away at once. But instead of taking the trolley-car, he hailed a carriage and before you knew it, there we were sitting next to one another in the cab. He was looking at me in a way to frighten me. He took my hands and covered them with kisses. Then he wanted to put his arms around me, but I cried out and he drew back. However, he then began to tell me that he loved me, that he was wild about me from the moment he had seen me, that he could no longer think about anything but me, and so I ended up by finding that nice.

At the City Hall (where I had to go to get some of my documents stamped), he waited for me, and when I was done, he suggested that we have a hot chocolate in the Bois de Boulogne. I was tempted, but I told him that I had to be back before 6 o'clock so my aunt would not know anything . . . All right, I found myself in a carriage again under the trees. I was beginning to feel aware for the first time of my importance. In the Bois, in a restaurant already filled with people, I felt a little ashamed because I was hardly well dressed and we were being stared at. Paul, however, seemed proud to have me. We ordered and I ate cakes and bonbons, and as I was mad about sweets, I no longer thought of the time. When we did look at his watch, I was terrified. It was 6:45. I would never be brave enough to go back to

my house. Surely this time, as I had so often been warned, it would be the convent or the House of Corrections. I began to cry. What was there to do?

Paul didn't say anything, but I could feel that he was pleased. At last he said to me, "Don't go back. I'll take care of you, and tomorrow I will see your uncle and ask for your hand in marriage." That, however, did not console me, and I continued to cry. We walked along a path in the woods and he drew me bit by bit further into the trees, and then took me by the waist and glued his mouth on mine, giving me the most disgusting of kisses so that I almost suffocated. "I have to teach you many things," he said to me, and he paused: "Now you are my woman and I must teach you above all how to make love." "You will never teach me like this," I answered. "It's dirty and useless."

He began to laugh and I laughed too despite my fears, because his face was so pitiful and happy at the same time. I had nothing to do now but to follow him. I couldn't go back to my aunt after this escapade. He'd made me well aware of that. We took another carriage and the thought of going to a restaurant consoled me somewhat: to enter such a place, to order what I wished, soup, consommé, chicken casserole, foie gras, salad, ice cream—I drank wine and some cherry brandy. I left the restaurant very gay. We walked along together as he led me to his house.

He lived in a tiny apartment on the sixth floor of a new building in front of Montsouris Park. What happened next? A night of horror. How could the child I had been just a few hours before have been able to bear up under these odious revelations? I know I will atone painfully for this folly, and my life will be marked by it forever. What are they going to do? Surely they will come looking for me. Hélène, whom I saw yesterday, knows nothing other than that my aunt is shaking her head and saying, "It's her funeral," and they're all whispering about me.

Hélène and her fiancé, Henri, have spent the day with us. Paul seems to swim in happiness. He brings me so much in the way of cakes, chocolates, fruit that it seems to me I've never seen so much in my life. This morning he searched the neighborhood in order to bring me some linen. At noon, Hélène began to prepare the meal. Since we can't go out, we play cards, but I feel sick, heartbroken, sad enough to die. The others are all so happy. I can hear Paul confiding in Henri. He went on about my beauty, my innocence, and Hélène, with a bright smile, said to me, "Is it true what Paul's saying? Seven times last night? Oh, I congratulate you." She began to *tutoie* me and I was annoyed by that. Then, at the mention of last night, I fell sobbing on the couch and almost became hysterical. Henri, the brother . . . spoke severely to Hélène, who, on his direction, put me to bed. I needed that; I was sick, weak, feverish in my bones, my flesh. She covered me with warm linen. Then it was decided they would all spend the night here, Paul and Henri on the

divan. Hélène and myself in the bed [but] Paul has now begun to menace his brother with I don't know what threats in order to make him leave. Poor Henri, who only wanted to protect me, can't stay [so] Paul again passed the night in loving me—as he put it. What a horror.

I'm alone all day. I don't go out. When night comes, I'm there, curled up on a sofa with the magazines spread all around me. I've forgotten what time it is, whose life it is. When Paul comes back from work toward 6 o'clock, he finds me uncombed, not dressed, in bed—stupefied. I know he's not happy about that.

Another terrible night. How to get out of this? I would like to look for a job but don't know where to go. I have a fear of the stairway I'd have to go down, of the concierge, of the street, of the police. I go back to reading. I eat bread and drink chocolate. I don't know how to cook; I don't even know how to comb my hair. My curls are tangled.

What an agreeable life I would lead if there wasn't the menace of these nights with Paul. What pleasure can he find in making love? It all seems so dirty. Can't we sleep peaceably, side by side? What does it get him to go in for such activities? I don't understand a thing. Paul becomes crazy at such moments. Besides, he makes me so afraid that I tremble; I let him do whatever he wants to me. He tells me that I'm like a beautiful marble statue that nothing can bring to life. Thanks to God, I hope it's true. I don't want to see myself ever caught in such madness.[11]

Well, there it is: My aunt is going to come. Hélène arrived just now in a total state of fear. How does my family know? It seems that they put the police on a search, interrogated Hélène, who admitted to everything and gave my address . . . When I told Paul, he turned green. But of what is he afraid? I know my aunt. She's going to treat me as someone infested with lice . . .

What have I done? I would prefer to die than to live with Paul for the rest of my life. He asked me if I think there might be a dowry. I look at him with horror. A dowry? I'm an orphan, and my aunt has taken care of me because my father (her brother) asked her to, and left a little money for my upkeep and my studies. Paul had a dissatisfied attitude when I explained all that to him. "Ah," he said, "I love you enough to take you one way or another." With a weird laugh he threw himself on me and I had to submit to his caresses . . .

I wake up and dress early expecting the arrival of my aunt, but she doesn't come. Hélène is here; we've eaten together and we're going to prepare a *pot au feu.* It's easy, but the cleaning of vegetables—that's not agreeable. She told me to put in some butter, and since there was a good deal of water, I put in half a pound. When Hélène, who had gone to look for some bread, came back, I told her what I'd done and she was almost in a rage and told me that I was as stupid at cooking as I was at

love. I'm shocked, because now Hélène treats me as an equal and I sense her vulgarity.

My aunt arrives with a policeman. In a fury, she leaps upon me and slaps me and I begin to cry. She contemplates me with a look of disgust and stupefaction . . . Then, her fury and her hate relieved, she begins to look the place over. "How badly it's kept up," she says. "And you who don't even know to comb your hair—why have you done this?" I don't answer; I'm afraid. "Why didn't you tell me that you didn't want to marry M. Deforce?" In a nicer tone, "I wouldn't have married you off against your will." The policeman comes near me. I believe he wants to take me away, and I feel sick. I must have passed out for a short while, because I found myself stretched out on the couch and my face was soaked in water . . . The policeman said to my aunt, ". . . the little one, she looks innocent. The man has to be a swine." . . .

My aunt said to me, "You must get married as soon as possible to this individual. Give me some information about him."

But I didn't know anything about him, not what he earned or if he loved me. I said to my aunt, "I don't want to get married to Paul . . . Every night, he keeps me from sleeping and I am covered with bruises."

The policeman had a crude laugh.

"It's your fault," answered my aunt. "When one is immoral, one is punished. You must get married; you will get married or I will no longer want to hear anything about you, and you will go to reform school."

"No, put me in a convent."

"Convents don't want fallen girls like you . . . Marriage or reform school."

I was disheveled, my eyes brimming with tears. My mouth was dry. I was shaking.

When Paul came in, my aunt didn't reproach him at all. She looked at him with disdain and asked, "How do you intend to save the situation?"

"We'll get married as soon as possible," he replied.

"You understand," my aunt then said to me, "I hope that you will choose marriage."

I nodded my head. Like a heroine in Racine, I felt myself sentenced to the gallows, and swore to myself to leave after I was married. Nonetheless, I asked, without any great hope, "Don't you want to keep me in your house till the day of the marriage?"

"Never," she replied . . . "You will only come back to my house once you are married. [Then] you'll have a thousand francs to get you started with the housekeeping expenses, and that's all. You can tell that to monsieur," she said, inclining her head toward Paul, who seemed as frightened as myself. At last, she was gone . . .

Hélène and Henri arrived in the evening, and I asked her to sleep over. I was sick following this scene with my aunt, and I began to shiver with fever. Paul was frightened. I spent the night next to Hélène, who got up and covered me with warm clothes. Then she made me drink warm sugared wine, but I vomited it up and began to have convulsions. Fever took me over . . .

The doctor came, and I believe he made some reproaches to Paul, who seemed penitent and has promised to let me alone or leave me with Hélène for a day or two till I'm getting along better. Paul will sleep over at his brother's house; Hélène will stay with me. I am going to bless this illness which frees me from Paul for a little while.

Paul has brought me several books, Anatole France, D'Annunzio, Abel Hermant—I don't know these authors; I've read so little. I am grateful for this attention. He also offers me long red and yellow gladiolus, which are so beautiful in the sunlight that I spend a good deal of time contemplating them. If he were willing to leave me alone at night, perhaps I could get around to having a little affection for him. I begin to feel a little hope again and am almost happy. There's a lot of sun in this poor apartment.[12]

There we go. It's all begun again last night. Almost no rest and he still desires me while I am worn out, used up, and want to go to sleep. Then he throws himself on me again, crying out, "Oh, but you are so fresh and sweet, so pretty, how I want you! The more I take you, the more I want you. I'm wild about you!" and begins to make love to me all over again. I let him do it. I'm half asleep . . .

Each night is like this. He becomes wicked; he's impatient; he asks me what I'm feeling, why I remain inert. He swears to me there will come a day when he will give me pleasure and happiness. When I beg him to let me sleep, he rolls on top of me like a madman. I prefer to say nothing, but then his eyes bore into me and he says between his teeth, "I will bring you to life," and I feel fear. It seems this fear he reads in my face excites new embraces.

Yesterday, I cried out in revolt, "My God, my God, despite my faults, despite my unworthiness, protect me, or let me die!" Then he looked at me and began to cry. He no longer touched me that night.

This morning, he's on his knees by the bed asking me to forgive him. He cries and he holds my hands very sweetly and I begin to feel a little hope, but suddenly his face changes, it goes tense and there, again, he's on me. Can this be love?[13]

We are being treated to the great love of a brute. It might be comic if he were not such a bad piece of work and she were not suffering so. Abstractly speaking, however, it remains a comedy. He is full of violence and the bullying reflex of a

man who was probably beaten often as a child. Now, in his turn, he beats her for the smallest infraction on his vanity or desire. But then, his ugliness purged, he loves her terribly all over again and takes her forcibly, trying to express the intensity of his love, only to recognize, once he has quieted down, that she still can't bear him. So he weeps because he loves her and she doesn't love him. But then the injustice of it so overcomes him that he beats her again. Yes, if the blows didn't hurt, it would be a comedy.

> Well, it's done. Yesterday I was married to Paul. He was all attentive, very proud, he had tears in his eyes.[14]

Fernande's aunt is not present, but she has sent over a trunk with Fernande's clothes, a gray robe, hat, and shoes to be married in, and a minimal dowry—1,000 francs—which Paul uses to move them out to the suburbs.

Now the newlyweds dwell in a *banlieue* called Fontenay-Sous-Bois, and it is Paul's hope that Fernande will now pay attention to the housekeeping. However, it bores her. He comes home, finds her curled up with a book, far-off on exotic seas of her imagination, and he crashes a vase full of marigolds to the floor.

> "You're no better at housekeeping than you are in bed!" he cried out. Then he struck me violently. I was so afraid that I wanted to escape and made for the door. With a leap he was on me and began to beat me. Blow after blow . . . my look must have been wicked indeed because he beat me even harder and said, "Don't look at me like that—I'm capable of killing you."
>
> Finally he threw himself on me, thrust me onto the sofa, and took me brutally, in his fashion. Then he lay on me inert, heavy on my body, without even seeming to breathe, and I didn't dare to move. I felt sorry that he wasn't dead . . .
>
> At last, when he came to, he got up looking haggard, then, recalling what had happened, got down on his knees and again asked me to forgive him. Then he went out to look for some dinner and came back with his arms full of flowers, presents, bonbons.[15]

> I'm pregnant. The doctor that Paul brought over warned him that I shouldn't have too many emotional scenes. Paul says he doesn't want to have a child, that he will take me in a month to see a woman his friends know.
>
> I cry and ask why. "I love you alone," he says. "A child will annoy us and cost too much. I don't earn enough."
>
> I try to do the housekeeping. I attempt to cook. But it bores me. And I don't succeed despite the cookbook. It's always either under- or over-cooked. Paul, who

loves food, gets very angry but no longer beats me . . . I pass days before the window, my hands holding my knees . . . I still feel myself to be a child and a young girl and yet it seems to me I'm fifty years old.[16]

The steps to the garden are icy, and she slips and falls, goes into false labor, and loses her child. She cries, "but Paul is content."[17]

When she recovers, they spend a Sunday in Paris visiting her aunt and uncle for the first time, and her uncle, jealous and offended by her marriage, acts coldly but never stops looking at her.

When I left, my uncle slipped 20 francs into my hand. I'll probably buy some handkerchiefs and a bottle of perfume. I've always wanted that.

Yesterday, on coming back, Paul smelled the perfume on me. He was furious because I hadn't told him about my uncle's gift and then had gone out from the house without permission. "How did you do it, since you don't have a key?"

For the first time, I felt anger build up in me. "I left the door open," I answered him. "When I want to go out, I leave the door open. And if somebody comes in and steals from us, all the better. You bore me, and the furniture, and the house, everything, everything!"

Then he began to beat me again, like the first time, and like the first time I was capable of reacting without making a sound, without tears, and he therefore got worse and worse. At last he took me in his arms and carried me over to the bed while saying things so stupid and obscene that I was ashamed and he took me the way he always does, and the way it always happens. I felt frightened, inert, cold, and there's my life.

Hélène comes. She told me that she'll take me to Paris and Paul won't know anything about it. It's the unemployment season for her and she's going to stay several days with me. She asks if I'm beginning to get along in this new life, if I'm growing at all attached to Paul. Witnessing the anger and disgust that appear in my eyes, she understands that there's nothing at all going on.

She smiles and says, "I believe I know someone who could console you, the friend of a friend that I have . . . Henri doesn't know anything; it's not necessary for him to know."

All this frightens me: Two men at the same time, and she loves Henri? Is it so easy to fool each one? Despite my fear that Paul may find out, I leave with her the following day. She takes me to lunch with her friend at the house of another friend, L., who manages a large café on the boulevard de Saint Denis . . . After the lunch we drink some liqueurs and spread out on some sofas. Suddenly I feel myself embraced by powerful arms which nonetheless hold me gently and I feel myself

disappearing into the huge chest of L. However, when he makes another gesture that announces the beginning of the act I undergo with Paul each night, I utter a cry, and want to leave. Hélène calms me down, leads me to another room, and promises that no one will enter. Through the open door I hear her tell L. how at a certain point the act of love begins to frighten me; then she makes me return with her to L., who assures me that he only wants what I am willing to give him happily, and I am caught up again in the sweetness of his voice and his two large arms, which hold me tenderly, and his lips are warm on my neck and on my eyes. His light, skillfully applied caresses slip me over into a daze that I find adorable, even astonishing in the way it leaves me. I stay that way, curled up against this man for I don't know how long. I don't know. But I only have awakened from this dream when the voice of Hélène warns me that we have to go back. I would be happier to stay. I would be happier if we never had to return to Fontenay, but I promise to come back tomorrow.

"Oh well," says Hélène to me on leaving. "Paul's the one who's going to profit by it."

I look at her with disbelief. "How can my husband profit from what another has shown me?"

"I believe that you're still frigid," says Hélène.

"I'm what?" I don't understand what she's saying. "Aren't I like others? Isn't Henri sweet and gentle? It's impossible that he carries on the way Paul does."

Hélène bursts out laughing. "Do you believe Paul's different from the others? He's passionate, that's all, and you're frigid."

Another thought obsesses me then. Why has she taken this lover? I ask it of her and she replies to me, "I stay with Henri because he's going to marry me, but in bed I like the other better." I found that ugly of her, and told her to confess everything to Henri—how could she live in these lies? That seemed to amuse her and she said. . . . "I have to have several men. That's my temperament. I'm fickle."

To have temperament! Does that mean you have to desire getting into these filthy things?

We got back at 6 o'clock in order that Paul would not learn anything. [The next time] L. took me to his house, and we ate together at a little table. I had caviar and oysters and drank white wine. It was delicious. After lunch, I lay down on the divan and L. began to undo my skirt. I didn't have the will to resist him; I was becoming all soft and strange. An odd sensation grew in me and it made me wish to bury myself in him. Soon enough, I found myself nude and his lips ran all over me, stopping on occasion for a time, then leaping on, but it was I who led him back to me when I felt him withdraw. It was like a game. Then suddenly, his

caresses made me lose my senses completely and I shivered from the effect of a sensation that I would not have believed was possible. Unhappily, I came back most brutally into reality when he took me in the same way my husband did. If he hadn't, disgust might have overwhelmed me less and I would not have been so suddenly sobered up. I felt more than ever that I could never get used to the idea of this act . . . I will not go back on Saturday.

I did return there after all—not for lunch, but to be embraced. I told him that I would get there at 2 o'clock and that I didn't want the conclusion that repulsed me so. He took me in his arms laughing, and embraced me like the other time, and undressed me. Same procedure, same drunkenness, same disgust at the end. I will no longer go back to him, but certain of his caresses I will miss. I'm missing them already. Despite all that, I can't overcome my repugnance.

When Paul starts the same games with me, *everything* he does is revolting.

Hélène comes over and I tell her about my decision not to go anymore to Paris. "Ah," she answers, "for certain things you're full of feeling, but for others you're like marble?"

I'm annoyed by what she says, but I don't have any rebuttal.

What a silly story is mine! Yesterday, after lunch, Hélène lay down next to me on the sofa and then she began to embrace me and I commenced to feel very strange, just as with L. Then she slid down to my feet and began to offer me the same caresses and made me tremble completely, but it was very agreeable. To be able to experience this sensation nearly divine for so little.

Hélène comes sometimes for lunch and her caresses calm me, but I don't love Hélène.

Ugly scenes between my husband and me now take place daily. An egg over-cooked and he wants to beat me. I show him my temper. I tell him I will go away someday. He shrugs his shoulders. "I will catch you, and you will go through a very bad moment," he tells me. All the same, I answer, "I'm going to leave, and soon."

1900: It's spring now. The month of March is marvelous. The Exposition is going to open. All the world is happy. I can't go to Paris. I have no money except for the two and a half francs I have saved.[18]

It is worth interjecting that this is, of course, the same Exposition Universelle that accepted a canvas of Picasso's and thereby drew him to Paris for his first trip.

On another visit to her aunt's house, she confides in her uncle concerning the misery of her marriage, and he speaks to Paul.

My husband reproached me for having complained. "And me?" Paul added. "Don't I have my complaints about your indifference, your inability to keep house? You don't do anything to please me. And I am obliged to find in your disgust, in your rejection of me, in your indifference, the excitement I was hoping to find in your love." I burst into a wicked laugh and repeated, "My love? But where would you put such love, since I cannot begin to understand what you mean by love. I'm repulsed by ugliness and everything in you is ugly, the expression of your eyes, your gestures, your pleasures." Yes, I was able to say that. I'm beginning to understand that mine is the life of nearly all those women who have married without love to human beings without delicacy. Hearing me say this, he took on the expression of a madman and I only succeeded in having him throw himself upon me once more.

I close my eyes—I don't defend myself in order that everything will be more quickly finished. Now he wants to force me to open my eyes, to look at him. He plays with the fear that he reads in my expression, that he augments by his wild words. He will kill me, he says, and only his ferocious and brutal orgasm frees me from the embrace.

I am going to leave. I am going to leave. Whatever, the first job that comes to me, even to be a maid, but to flee from this, to get away, to get away.

And, as always, when I find myself alone, my good spirits come back and I forget. I place myself again in the warmth of my dreams; I see an interior life put together out of all the elements of my imagination and I succeed in tasting a few moments of happiness, but when evening falls, the anguish which has been waiting for me comes to me again and I feel my heart tremble in my trembling body.[19]

Part IV

Pablo and Fernande

In another few weeks she will leave her husband and begin to live in Paris. So, too, will Picasso be leaving Barcelona for the first time, and they will even live within a few kilometers of each other, although they will not meet until 1904. Since we will stay with Fernande until then, it may be worth taking another look at Paris in 1900. The entrance to the Moulin de la Galette had, for example, this appearance in daylight hours:

The entrance to the Moulin de la Galette, c. 1898.

Whereas at night, it offered another scene altogether:

The Dance Hall at the Moulin de la Galette, 1898.

In 1900, Picasso would visit the Place du Tertre, in Montmartre. Here an old photograph can remind us of how much a city square could still look like a painting at the turn of the century.

Picasso is still nineteen in 1900, but he does a self-portrait in which he looks wise, thirty-five years old,

The Place du Tertre, in Montmartre, 1904.

and sufficiently cosmopolitan for any banquet in Paris—indeed, a perfect and elegant bachelor for all the banquets to which he was not invited.

Once again we can see how intrigued he is with visual puns. The lower left-hand

corner of the drawing offers a sketch of bare round buttocks that can also serve as a plump face staring upward, the dimples in the cheeks serving as eyes; in the upper left-hand corner, the pen drawing of Riera looks at first like a pair of sad breasts about to droop, but then Riera has been drawn upside-down.

He is preparing himself, doubt-less, for all those pleasures of sex that lie somewhere between appetite and the study of the human form, precisely those observations of the female body that one can only make in the course of a long affair.

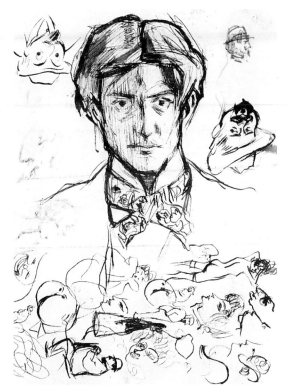

Self-Portrait and Other Sketches, Barcelona, 1899–1900. Pen on paper, 12 x 9 in.

2

Let us go back, then, to Fernande. The Exposition Universelle of 1900 is also having its effects on her. It is a new century, and she, as we know, is about to leave her husband.

> Yesterday evening one of the most brutal scenes took place. I am wounded—I have actually been wounded in the shoulder by a piece of broken glass, which went a full centimeter into my flesh, such was the force of the blow. He struck me with a carafe; I was bleeding, and I was obliged to pull out of the wound a piece of material from my dress that had gone in with the glass. All of which did not prevent Paul from ending this scene by throwing me on the couch before I could even take care of my shoulder. Afterward, coming back to himself, he was overcome with anguish because the flow of blood wouldn't stop. I didn't want his attentions. I believe I was ready to kill him if he came near me.
>
> I refused to lie down near him. He must have cried all night, for in the morning he had a wholly swollen face. He was hideous. I see him as hideous. How have I been able to wait so long?[1]

That morning, as soon as he leaves for work, she collects all her papers—her nest egg as a French citizen!—marriage and birth certificates, school diplomas, even the notebook in which she keeps precisely this journal—so she claims—and, going to the station, she takes the half-hour train ride to Paris, gets off at the Bastille, and goes to an employment office whose address she had clipped from a newspaper. Told to come back at four o'clock, she is afraid to wander for fear she

will run into someone she knows, so she tries to read in a small park, but is restless
and ends up on the rue de Rivoli, where she stops in front of a bakery shop, afraid
to go in since she has only one franc.

I was rooted in front of this exciting store window when I felt an arm slip
under mine and pull me literally across the threshold. In a moment, I was aware of
myself being seated at a little round table with a bearded, smiling young man who
was already ordering something from the waitress, but I still didn't realize what
had happened to me until a hot chocolate and some brioches were put in front of
me, upon which, incapable of holding myself in, I consumed them voraciously. It
was only after having devoured several cakes full of icing and having emptied my
cup that I became aware of things again and so was obliged to look into two large,
gleaming, and much-amused black eyes fixed on mine, and I surprised myself by
bursting out with a laugh so happy that it brought forth an equal laugh from this
man facing me, as if I'd suddenly hugged him to me. I do have the ability to pass
from despair to gaiety. And suddenly, without reason . . . I can only explain it by
saying that I love life and wish to believe in it . . .

I said, "I was so hungry. I hadn't eaten. I have to ask your pardon."

"First," he said, "let me introduce myself. Laurent Debienne, sculptor. Who
would like, if you would permit it, to do a bust of you. I have just the right piece of
lovely marble. Would it be disagreeable for you to pose for me a few times?"

He interested me suddenly. I had dreamed for so long that I was a young girl
who knew artists . . .

He told me that he lived in Neuilly with his family, that economically he was
dependent entirely on his father, but he did have a studio in Montparnasse. He got
there around nine each morning, worked till noon, had a hasty lunch in order not
to lose time, and left at six o'clock. "My father is only giving me two years to earn
my own living. He'll help me until then, but after I must fix things so I can get
along on my work. In a few months, I'll have to serve with my regiment. I've been
postponed several times already in order to keep studying at the Beaux-Arts, but I
must, by the time I'm twenty-five, leave for a period of three years. There it is.
You know everything about me. Tell me about yourself. Is it so embarrassing?"
he asked, seeing me redden . . .

At the recollection of the employment office to which I must soon go, tears
came to my eyes and I had to make a strong effort not to cry. At last I began to tell
him my story. His eyes called forth my confidences. Large black eyes were the only
beauty of his dark face; otherwise, wrinkles marked the corners of his eyelids, and
his nose was too large and jutted out even more given the thinness of his cheeks,

which were covered by a stiff and much too dark beard. His hair was brilliant, but too dark also. His head was too large for his skimpy little body. And he had a long thin neck within which moved a voluminously large Adam's apple, which seemed always in movement. His hands were heavy and hairy, thick and hard, but something that was agreeably calm came forth from this unknown fellow that suddenly gave me some confidence to speak.

He listened without interrupting me. At the end he said, "Do you really want to work in an office? You ought to take account of the difficulties you're going to meet. Even if you get a job, it will not allow you to begin living alone immediately. You'll have to rent a room in a hotel. They'll ask for your papers and if your husband is looking for you, he'll find you immediately. Besides, you have to work for a month before being paid. And," he added laughing, "I will not always be there to offer you cakes and hot chocolate."

I felt stupefied. It was true. I hadn't thought of all that.

His words chilled me. My new friend watched me fall back into my fears, then he proposed, "Come with me. I will set you up in my studio. I don't sleep there, but in a little room under the stairs there's a bed. To pay me back, you will pose. That's it. And I will give you a little money in order for you to live. Very little, I warn you, for I have nothing beyond the pocket money my father gives me . . . However, you'll be well hidden . . . Don't be afraid to come; you will sleep alone— I give you my word of honor on it."

And now I am there. I can breathe. Laurent left me alone yesterday after taking care of the provisions: bread, apples, nuts, ham; there is tea, sugar, chocolate, coffee in the little kitchen . . .

How nice I felt on this first night despite awakening at the smallest noise.[2]

In the morning, true to his promise, Laurent comes by with bed linen, roast beef, face powder, and they chat, do the housework together, have coffee, and he plays the piano for her. Then, politely, he asks her to pull down her blouse while he drapes her, shoulders bare, to pose as his model. They work all day, and she discovers that it is very tiring to pose, but . . .

Already, I've begun to forget my past life, my foul nights with Paul . . . I'd rather die than take it up again.

Saying good-bye yesterday, Laurent approached and embraced me gently. I put my arms around his neck and returned his kiss, thanking him for what he's done for me. "It's nothing," he said. "You will give all that back to me by posing. You're the most beautiful model, and I'm the one who owes you thanks."

After his departure, I went to sleep; I was tired. I had no nightgown but found

that I got along very well rolled up in the fur rug. What an odd situation for a young lady brought up in the strictest bourgeois code—naked in the skin of a beast . . .

Time passes. I've been here for five days already. Laurent takes on the job of selling my little trinkets and I came out of it yesterday with some 50 francs that allows me to buy two shirts, two underpants, two sets of stockings, and a night-shirt. Washing each day, I'll have something clean left in reserve. I'm calm with this new life . . . It all amuses me—to pose for Laurent and he does the cooking.[3]

3

After a few weeks of this, however, the Law of Monotony, that solemn critic of many a new relationship, takes jurisdiction: She begins to feel less content with her new companion. Perhaps, as Picasso would later assume, the sculptor stared and stared at her while she was asleep.

I don't see Laurent's work get on much. He's slow. It probably takes him two hours to do what others manage in ten minutes. He puts in a lot of time washing a dish or peeling a potato, and it's probably the same way with his sculpture. It is certainly that way when he tells a story. He gets ready for it, so to speak, even for the most insignificant subject. He listens to himself speak, rearranges his

Sleeping Nude, 1904. Watercolor and pen.

phrases, goes off in two directions, comes back to the point of departure, and begins again. He does bore me a little, but he's sweet, gentle, agreeable, and does the housework. That's something.

He also becomes tender . . . Yesterday evening, Laurent came back from his father's house at eight and took me to the Café de Versailles, where we had ice cream. When we returned, he came upstairs and lay down next to me. I found it natural. I didn't experience the sentiment of fear that bothered me so much at the idea of love. He embraced me with so much tenderness that he was able to take me without my guarding myself. I had neither pleasure nor disgust, but I would have much preferred that it had all taken place without the final act. I find that useless. Caresses and kisses are all right—but I don't really like the man, I'm beginning to recognize . . . "You're sweet," he told me, "but you're still without passion. That will come, and I'm patient." From now on, he will sleep at the studio and only go to Neuilly in order to eat.[1]

Soon enough, Laurent advises her to pose for other artists so that she can have money for herself. He finds work for her with an old Italian sculptor in Neuilly. A younger painter who had seen her outside Laurent's studio then asks if she'll pose in the nude. Laurent is all for that. "To an artist," he explains, "a nude woman is more decent than a girl in a blouse." [2]

Soon enough she is working mornings and afternoons with the sculptor and the painter, then with Laurent in the evening. She grows thin, but at least she brings back 10 francs a day and puts it in a cash box so she can buy new clothes. She soon discovers, however, that Laurent has used the money to buy clay and shirts.

What an egotist!

Now he asks me to help the cleaning woman do the laundry once every two weeks. I told him no. I'm working too much for that. He's annoyed for the first time; myself as well. We quarrel. We have a fight and he proves stronger, carries me to the couch in the studio afterward, and finishes by acting like my husband except he was gentle where Paul was brutal. Why, then, do men find so much excitement in violence?[3]

Her dissatisfactions increase. She watches with annoyance as he does some carpentry.

Have I already said that he did everything as if he were fulfilling some task of the priesthood? It all had to be foreseen, arranged, decided. He didn't undertake any task until he had prepared it completely in his head, and if he made a mistake, well then, patiently, without revolt, without anger, he would undo what he had done

and begin again. How could he have been able to pick me up and decide to take me to live with him so quickly? Now that I know him well, I imagine that while I was gobbling my brioches and swallowing my chocolate, he was thinking of the profit to be gotten from a live-in model that he could send out to pose for others.[4]

Having seen the work of a good many other artists by now, she also decides that his work is banal. He is too stingy to be a good artist, and his lovemaking is less interesting than his talk about it. He is always extolling the virtues of free love, but she has decided that if he speaks a good deal about the generosity of love, he gives little.

Then she comes back from work one day to discover him sitting next to a thirteen-year-old model he has been using. The model is nude! And rude! When Fernande tells her to dress, leave, and not come back, the girl not only insists on being paid but demands 10 francs instead of 5. She is making twice as much as Fernande!

> What's nicest about this story is that he . . . has adopted an attitude of dignity and reproach toward me.
>
> "You can't understand an artist like me," he said. "The meanness of your thoughts makes me so sick that I don't even care to take the trouble to show you your error. I could have done a masterpiece but you wrecked that in me."
>
> I didn't know if I was stifling everything in him, but I certainly knew that . . . Laurent's statues . . . remain in a half-worked state. He spends his time uncovering them in order to re-cover them with wet cloths so they don't dry out.[5]

Laurent, however, has a friend, Jacques, a café singer, she finds charming, even if he is thirty years older than her.

> He came over one day when Laurent was away with his family. I was down in the mouth, and told him everything, and how I couldn't seem to love Laurent, of my character, my heedlessness, my desire to evade everything.
>
> Jacques consoled me, spoke to me so reasonably, so gently, that I understood then it was all my fault . . . I stay with a man I neither love nor esteem out of a sort of latent laziness. I must have need of steadiness more than anything else. While I am almost tranquil, I am so unsatisfied in this tranquillity that it changes into nervousness. I laugh without explicable reasons. "Come back often," I said to Jacques. "Come back when Laurent is not here."
>
> He answers, "Come back often? That's dangerous. You are very seductive, my child, and I am no longer young."
>
> At first I felt very put off by this but then was in a wonderful mood and I put

my arm around his neck and kissed him sweetly. When he left, I asked myself if it would be all right to give myself to a man much too old for me, but I had a desire to be rocked in his arms and be caressed and protected. He was divorced; he had a family; he had children older than me. I felt troubled. I want to see him again, even this evening. I feel a new emotion being born . . . He's not beautiful; he's too big, sort of fat, although he has the attractiveness of a heavy man, heavy features, deep eyes, good and thoughtful; his mouth is thick but of a fine design. He has beautiful white teeth which show themselves in a large smile. Profound wrinkles cover his forehead and his cheeks, the corners of his mouth and nose. Beautiful hair. I don't know why I love him. Without doubt, because he's spoken to me so affectionately, has confided so. In any event, I love him and want to be near him.

When I saw Jacques again, I reproached him for not having given a sign of life all week. "I'm going to see you this week," I said. "I'm going to see you alone at your house. I love you."

He held me against him, put his lips on mine, and I thought I would faint from happiness.

Since Laurent was going to return any minute, I became reasonable, however, very quickly. After all, I was now sure of seeing Jacques again. Despite a storm that shook the shutters outside and made the house quiver, I passed a delightful day. What a happiness was in me. My life, suddenly enriched, had become precious to me. I went to sleep with Jacques as my imaginary companion. Tomorrow, about four-thirty, I will go to his little place in the Batignolles neighborhood. I can barely contain my impatience. What is this great love going to reveal?

I'm ashamed to say it, but I no longer love Jacques. Wednesday, when I arrived at his home, he had prepared a nice meal with cakes, flowers, and various sweet things he knows I love. Alas, I tasted a joy that I believed was going to be marvelous up to the moment that I cannot get used to, not any part of it.

All of a sudden I saw myself next to an old man whose beard smelled of old cigarette smoke and beer. I felt such disgust that I dressed in a hurry. The poor man held me by the hand and said, "I was certain it would end like this. I've experienced these sudden passions of young ladies. But you leave me with a desire for you that I didn't know yesterday."

As for myself, what could I answer? I didn't understand anything any longer about this madness that swept over me during the last few days.[6]

After Jacques, she has an affair with a student named Roland. Her life may have more logic than she will allow. It is as if each romance is a preparation for the next and larger romance.

. . . he was waiting for me, feverishly. And his kisses left me feeling sweet. I found myself in his bed and undressed without having noticed just how it happened. I was sweetly happy, gently happy, and his tender caresses didn't disillusion me. The act of love has not brought me any joy, but I had gone through it at least without displeasure, simply in order that he be happy. And I was happy in his happiness. We stayed in bed all day long and I slept there that night, close to him, and tranquil. Provided that Laurent doesn't bother me too much, I'm going to spend the night at Roland's house whenever I feel like it. He's asked me to come live with him, but I won't do that. Life together, becoming accustomed to one another, spoils everything. It is necessary that a great love come alive in me.[7]

Still another year passes. It is 1904, and finally she meets Picasso. They have their brief affair, she loses interest, and months go by, then the winter. We are almost in the present, which is to say, we are back in the spring of 1905 in that period when Fernande, living with Canals and his wife Benedetta, was trying to decide which of two Spanish painters, Sunyer or Picasso, she would now choose as a serious lover. Sunyer, the more attractive one, who supports himself on the presents of ladies older than himself, wins out.

I've become Sunyer's mistress. A consenting and even amorous mistress, physically speaking. But only physically. That which hadn't yet happened to me, did happen. Why with him rather than with someone else? It's strange. Sunyer hardly pleases me outside of "that." I don't like to spend the night in his place, so I leave. Love, apparently, has nothing to do with sensuality.

Sunyer is a young man, nicely dressed, with a pleasing body, and he's not stupid, but he doesn't touch my heart. I fell into his arms almost by accident, and he revealed to me sides of life of which I was ignorant! It's splendid, it's exciting! But if my senses have spoken, my heart stays closed. I find, on leaving his arms, that I have nothing but a desire to get back to my own bed, to sleep far from him. However, on waking up, I know that come evening I will go to see him again, and nothing can prevent me from doing so.

Poor Pablo. If I could only love him. Yesterday, Laurent arrived like a wild man and brought me over to his place. I was taken to bed. I had to open for him. He wasn't brutal, but he did take me as if I were his prey. Stocky little Laurent, with heavy, muscular hands, developed by the force of sculpting—he's very strong. But he doesn't excite me at all. I didn't, to my surprise, resist his ardor, and I didn't remain inert, as I used to, but despite all that, he disgusted me. I feared his brutality when I refused him a second time. This evening I will go to Sunyer's place . . .

Sunyer invites me to live with him, but I hesitate. His studio is sad. He has no money, and I don't love Sunyer. I do, however, continue to enjoy his caresses, and ceaselessly. But what makes it happen? Such lovemaking doesn't give me anything on which to live. If I didn't work, I wouldn't eat, and he's out all day long. Yesterday he came back with a package. It was linen for himself. Silk linen, shirts, underwear, socks. Is it true that he has, as I've heard, an old mistress who gives him all that he needs except for money? Ha! I don't give a damn!

I run across Pablo, who doesn't leave me. Happy to see me, his eyes filled with tears, and in his amusing accent, he said, "Come to my house. I love you. I'll do everything for you. You don't *know* what I would do for you!" But I still said no to him. He looked at me greedily, with his large eyes, so brilliant, so restless, so sad. Oh, he loves me, but I don't love him. Can it be that he loves me too much? It isn't only because he is very poor that I don't accept the idea of living with him. Something in me refuses to accept . . . However, his love does warm me up. Perhaps I will get together with him, if he is patient, and if he still wants me, in some future time.[8]

4

In one corner of Picasso's studio, a curtain closed off an alcove. Not long after that summer day in August when he first went to bed with Fernande, Picasso assembled a shrine for her in this space; a wooden crate served for the altar. As Fernande describes it, it had a "pretty pen-and-ink portrait" of her, and "a very fine, white silky blouse lay beside two magnificent cerulean blue Louis Philippe vases containing bunches of artificial flowers like Cézanne must have had."[1]

Fernande interpreted the shrine as not only mystical and nostalgic but full of self-mockery. Given her rational French insight, she may have paid insufficient attention to the first element. Not only was Picasso drawn to magic, but Max Jacob was an adept and their new friend Apollinaire was well read on the subject. How could they not have conspired to create a magical house to exert occult induction upon her? If the alcove had once been given such names as the maid's room and the mortuary, since it had served as the closed-off area in Picasso's loft for matinees and one-night stands, well, all the better. The resonance of old fornications would contribute to the magic.

Waiting, he did an etching of Fernande—where she still looked suspiciously like Madeleine. The spring and summer of 1905 went by miserably, and miserable it had to be if his longing for Fernande was

Head of Woman, January 1905. Etching, 7 x 4 in.

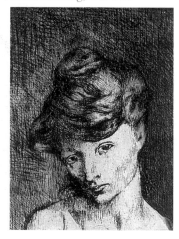

as large as she has described. At the least, his vanity must have been outraged. For this is the period in which her body has finally declared the end of its long war against the fundamental act. She has discovered that she can have pleasure in it. That these new experiences were with Sunyer, a fellow Spaniard, a contemporary—even worse, a fellow painter—must have bothered Picasso all the more. In the summer of 1905, invited to stay in Holland by a Dutch journalist named Tom Schilperoort, a friend of some Dutch artists he knew, Picasso took a poor man's trip to the town of Schoorl, a remote village nestled in the high sand dunes of the north Holland coast. His new pal, Schilperoort-from-Schoorl, had recently come into a little money and was spending it. Picasso's only disbursement would be the fare.

In Holland, he paints the first of his heavy-limbed women, *La Belle Hollandaise*. Many more will follow in separate periods over the next twenty years,

but his comments on coming back to Paris suggest the sizable impact on him of making love to women large enough to remind him of the overweight women of his childhood, the huge grandmother and his aunts.

He will tell a friend, André Salmon, "Fernande is a big girl, but those Dutch women are enormous. Once you get inside them, you could never find your way out again."[2]

It is not inappropriate that Fernande at this time is modeling for a Dutchman.

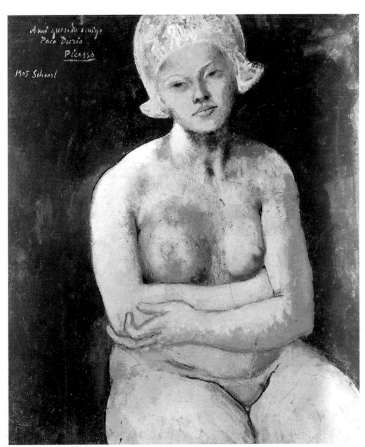

La Belle Hollandaise, Schoorl, 1905. Gouache on cardboard mounted on wood, 30 x 26 in.

It is Kees van Dongen, who had no small reputa-
tion in the Bateau Lavoir. The painting of Fer-
nande done by him in this period may have been
a species of trade-off for *La Belle Hollandaise*.

After his return from the Netherlands,
Picasso's studio is equal to any metaphor of a
furnace in summer. Because of the heat, he
works virtually in the nude with, according to
Fernande, no more than "a scarf tied around the
waist." She remarks that he is obviously proud
of his good if short and stocky build ("the
beauty of his limbs was no secret") and is more
than ready to receive his visitors and friends
half-naked.[3]

*Van Dongen, Portrait of Fernande
Olivier, 1905. Oil on canvas,
39 x 32 in.*

In this primal condition, on an exceptionally
hot day in September of 1905, their affair, often
dormant, but with occasional interludes, now passes into a more serious phase.

One should not deprive the reader of Fernande's account of it:

> Coming back from Corman's studio at noon, I ran into Picasso. He was with
> Guillaume Apollinaire, whom he introduced to me, a large and jovial man, rather
> simpatico. I promised Picasso that I would come to see him when I came back from
> work at five o'clock. Upon entering his place as promised, I was suffocated by a
> new mixture of odors: gasoline, eau de cologne, eau de javel, all done in order to
> make the studio neat for me and proper. Picasso and Apollinaire had spent the
> entire day cleaning it, brushing it with the aid of a broom soaked in gasoline. Then
> the eau de javel, then the cologne. The joy of Picasso! I was almost happy, and
> felt tender to see him so moved. Since Laurent is away, I promise to see Picasso
> this evening. He said to me that during this time he's been smoking opium in the
> home of some friends, but for tonight he will buy a pipe and prepare it for us to
> smoke. I listened to him, absolutely dumbfounded. This is something new and, in
> consequence, interests me.
>
> Picasso had bought the necessary ingredients, that is to say, the little mysteri-
> ous oil lamp, the long bamboo stem with its ivory tip, the pipe with its small octag-
> onal clay bowl in which one smells the sensitive, acid, and penetrating odor of
> opium, which gave off glints of a beautiful golden amber brown.
>
> Propping ourselves up on the dry mat that covered the floor, as if we were on
> a bed of feathers, the smoking materials held in the hand, preparing the pipe while

kneading the teardrop-sized piece of pâté on the end of a needle, applying it to the oil lamp held above the colorless flame of the lamp, taking the end of the ivory pipe between the lips, and breathing slowly into one's open lungs, slowly we took in this odorous smoke, bit by bit, breathing it in carefully to keep from choking . . .

Despite the sickness of stomach and the heavy headache that kept me in bed the next day, I can only think of beginning to find once more that spiritual acuity, that intelligent, refined comprehension, that quickening of mental sensations experienced under the effect of the drug. Everything then seemed beautiful, clear, and good. I owe it to the opium, perhaps, for allowing me to understand the real sense of the word *love*. I discovered that I understood Pablo at last . . . He was the one that I'd always been waiting for.

Love grew in me, sudden, burgeoning. A curious intimacy made it seem as if he was now a part of myself. So much did my imagination wish it to be so that this sentiment did not leave me; that, without doubt, was the cause of my sudden resolution to join my life to his.

I stayed for three days with Pablo. I love to smoke opium. I love Pablo. He is tender; he is nice and amorous. He pleases me. How could I have been blind for so long? Not to understand that right here was happiness waiting for me? I no longer

The Lovers Making Love (also called Erotic Studies), 1905. Oil on canvas.

C. A., Paris 587 *La Place Ravignan d Montmartre*

The Place Ravignan, in Montmartre, postcard, 1903

think, as I used to, of getting up in the night to visit Sunyer because his caresses gave me so much pleasure.

Now I am happy in Pablo's arms, much more happy than with Sunyer. I love Pablo. I am going to love him so much. Pablo insists that I come to live with him. What am I to do? I am going to try to get a week for myself . . . But Benedetta advises me not to wait [and] the sun renews all of this old, shabby Place Ravignan, now gay and full of life. This little plaza, scorched with sunlight, its benches so heated in the summer warmth that the paint is melting off, the cobblestones shine, the leaves are dried off their branches, but the old Bateau Lavoir stands on guard and defends its bohemians from the approach of undesirable people: "Bourgeois, prosperous people, don't approach! . . . Here is hope, love, and thought which comes alive . . . All you guarded people, reasonable people, logical people, leave those who live here alone . . ."

One very hot Sunday I brought over all my things to Picasso's studio. Now, many years later, I've found again a passage that's a bit lyrical in my diary. Here it is:

"Pablo, it's very hot today. It's a Sunday. I've never liked Sunday. It's a heavy day. It's a starchy day, it has an odor. I hadn't even left my studio. The tired heat

did not encourage any movement. I was meditating, somnolent, stretched out on a couch, a book that I was not reading in my hands. Toward five o'clock, suddenly, I took the decision to leave everything in my short and joyless past in order to go join you . . . I called you. You were working, but you left your canvas and brushes and you came running. I borrowed from you the little wooden black suitcase that you had brought from Barcelona. I threw into it, pell-mell, all the finery and clothing that I possess. You stood there, in front of me, not believing. I poked you a little. Then, in a leap, you were outside, pulling the trunk, carrying the trunk as easily as I would carry any one of my small packages."[+]

How intensely do Pablo and Fernande personify at this point all those delicate, lovely, and exploratory romances that flourished like sensuous flowers on slender stems, those marijuana romances of the Fifties and Sixties in America where lovers found ultimates in a one-night stand, and on occasion stayed together. There was always an element of the *other* in such romances—they were a gift from the beyond—and so the lovers who came together on marijuana could never trust their love altogether: The marijuana was the third creature in the act and might disappear someday.

Of all such romances, Pablo and Fernande's seems one of the first. We can wonder if they would ever have begun to live together without the opium. Once the bridge was crossed, however, once she knew she could have extraordinary experiences in bed with him, then many a need and many a mutual social advantage would keep them together for years.

5

There are bound to be questions about the validity of her memory and her manuscript; for now, however, let us enjoy Fernande's aria to love:

At last I'm happy. And Pablo? He no longer sleeps, he tells me. He now does nothing but wait on me since I've consented to live with him. Life goes by sweetly. I, in my turn, feel tranquil, nicely enclosed in this studio. It seems to me that I'm beginning to live my real life.

Pablo loves me. I sleep beautifully. The old habit of resting after long, fatiguing days I still adhere to. I go to bed at nine. Pablo looks at me, draws me, works through the night,

lies down around six in the morning, as he prefers to work through the night in order not to be disturbed, as if it is the night when he lives most. He reproaches me for sleeping all the time. It's true. It is necessary for me to accustom myself to another type of life in order to be able to live a little near Picasso while wide awake.[1]

Questions do arise. We are dealing with a manuscript that was composed when she was in her seventies, on the basis, she claims, of a journal she kept from the age of fifteen. While *Souvenirs Intimes* is written more or less artlessly, the effect is not unprofessional, narrative skills are certainly present, and there is an elevated hint of the romance novel—indeed, it is an elegant example of the form. One has to wonder how much of this book Fernande Olivier wrote herself and how much was added by way of an editorial hand; one can also question some of the facts. After she leaves home, she makes no further mention, for example, of her stepsister, who according to some accounts of the period (the unreliable André Salmon's, among others') lived with a sculptor, Orthon Friesz, who introduced

Untitled (three drawings of Fernande Olivier), all 1905: left, pen, 9 x 6 in.; center, black lead; right, pen, 11 x 16 in.

Fernande to the first artists she modeled for; that is certainly not so intriguing a scenario as her entrance into modeling by way of Laurent Debienne. We must also assume that Fernande's account is at least as self-serving as most memoirs. All the same, we are offered the sexuality of a young woman who begins her amatory experiences with a disaster yet manages over the years to complete her journey from disgust and frigidity into concupiscence. If that is many a woman's story (as well as many a man's), it can be argued that sexual happiness comes only at the end of a number of such rites of passage; so her account, unless wholly fabricated by someone else, has, whatever its misrepresentations, real value.

Paradoxically, given its wholly self-centered vein, it also provides vivid insight into Picasso's palpable presence in a room. We can read in any and all of his biographies about his moodiness, the incomparable power of his eyes, the feminine delicacy of his hands, the small but well-built torso, the forelock of hair over one eye, the animal magnetism he emits in combination with the social insignificance of his presence—*he looked like a bootblack*, comments Nellie Jacot, a friend of Gertrude Stein's,[2] but these are merely descriptions. In Fernande's account, we are offered Pablo rather than Picasso. Pablo is so much a presence that we can smell the garlic on his breath. He is twenty-three, and of human proportions. Fernande has, in addition to her beauty, a French middle-class mind, which is to say some crucial portion of her mental well-being depends on her ability to characterize and to classify. She is not bad at it. When it comes to discussing his painting, she is, of course, like many of her contemporaries: She will not always know what she is talking about. Nonetheless, she will have attitudes and express them well. We will enjoy such examples later. For now, it is enough to remark that of all who have written about Picasso, she is the only one who treats herself with more attention than she offers him, and so we are provided with a portrait that enables us to think about his nature as well as hers. If narcissism can be seen not as self-love or outsize vanity but as a species of self-imprisonment in which one's most profound relations are with oneself, then it should be apparent through the evidence of her narrative that she is a narcissist, and by what we know of Picasso, he too is one.

At the risk of quoting from myself—and indeed, in just this context!—I will offer the following passage from *Genius and Lust*, a book on Henry Miller:

> It is too simple to think of the narcissist as someone in love with himself. One can detest oneself intimately and still be a narcissist. What characterizes narcissism is the fundamental relation—it is with oneself. The same dialectic of love and hate

that mates feel for one another is experienced within the self. But then a special kind of insanity calls to the narcissist, for the inner dialogue never ceases. Each half [is] forever scrutinizing the other. So two narcissists in love are the opposite of two mates. Narcissists do not join each other so much as approach each other like crystals brought into juxtaposition. They have a passionate affair to the degree that each allows the other to resonate more fully than when alone . . . So, it is not love we may encounter so much as fine-tuning . . .

The paradox is that no love can prove so intense, therefore, as the love of two narcissists for each other. So much depends on it. Each is capable of offering deliverance to the other. To the degree that they tune each other superbly well they begin to acquire a skill which enables them to enter the world. (For it is not love of the self but dread of the world outside the self which is the seed of narcissism.) So narcissists can end by having a real need of each other. That is, of course, hardly the characteristic relation. The love of most narcissists tends to become comic, since, seen from the outside, their suffering manages to be equaled only by the rapidity with which they recover from suffering . . .

To the degree, however, that narcissism is an affliction of the talented, the stakes are not small, and the victims are playing their own serious game in the midst of the scenarios. If one can only break out of the penitentiary of self-absorption, there are artistic wonders, conceivably, to achieve . . .[3]

It is obviously not uncommon for writers, actors, or painters to be narcissists—the exception may, in fact, be the rare case, and there is nothing pejorative about the category (except for its intolerable sense of self-imprisonment). One's narcissism can be handmaiden to one's art. Sometimes it takes no less than a long immersion in oneself to deliver the artist within—sometimes. The graves of suicides remind us that there is no royal road to exceptional endeavor.

If this has seemed a diversion, let us recognize that we are soon going to be immersed in a full company of narcissists. Some royal examples are in the wings.

Part V

Apollinaire

1

During the winter of 1904–1905, when Picasso was still wooing Fernande, another domain was opening. His friendship with Max Jacob continued at full throttle, and his fructifying relationship with Guillaume Apollinaire commenced. Then, a few months after Fernande moved into his studio, Leo and Gertrude Stein entered his life. The long friendship between Pablo and Gertrude came alive. We will need our wits if we are to follow it. When it comes to narcissism, Gertrude Stein is equal to Catherine of Russia.

It is easier and chronologically more exact to take account first of Guillaume Apollinaire. Since his personality is, in itself, one bona fide whale of a work of art, we may have to approach him by degrees. Let us call upon Fernande one more time. She will describe Max Jacob for us, and he, in turn, will offer his impression of Apollinaire.

It's now six months that I've been living here with Pablo. When I arrived, it was very hot in the studio. At present, it's fearfully cold. I stay in bed, covered up, to avoid being frozen by the cold. There's no coal, no fire, no money . . .

How was I able to resist Pablo so long? How I love him now. Yesterday, Pablo succeeded in selling several drawings. Quickly we brought the coal merchant over. Quickly the stove turned red. How happy we are now, so much so that we don't even go out to eat at Chez Vernin. We dine with Max, near the fire . . .

Max Jacob and Apollinaire come each day, and Max, so spiritual, so amusing, so full of life and dynamism, is the director of our games. Picasso and Guillaume can laugh through an entire night of suggestions, inventions, songs, games that

Max plays with his face. The studio rings with our laughter. Foolishness takes us over and, like children, we encourage each other, mutually, to see who can become the most absurd. But the award always goes to Max. He can be so droll.[1]

In 1953, Picasso did a drawing of Jacob that suggests those evenings four and a half decades earlier.

We have to remind ourselves that this is the same Max Jacob who has already written to Picasso, "You are what I love most in the world after God and the Saints, who already consider you one of themselves. The world does not know your goodness and your qualities, but I know and God too knows."[2] On another occasion, he was sufficiently inspired to characterize such feeling for Picasso as "an admirable love, an homage to God paid to his successful creations."[3]

Such intensity of love would lead us to expect an abyss of jealousy, but there is no such sign in Max Jacob's description of an evening when Picasso brought him over to meet Apollinaire at Austen's Railway Restaurant near the Gare Saint-Lazare. There, the poet was holding court:

> Apollinaire was smoking a short-stemmed pipe and expatiating on Petronius and Nero to some rather vulgar-looking people whom I took to be jobbers or some kind of traveling salesmen. He was wearing a stained light-colored suit, and a tiny straw hat was perched atop his famous pear-shaped head. He had hazel eyes, terrible and gleaming, a bit of curly blond

Above: Untitled lithograph (Vallauris, September 23, 1953) of Max Jacob, published in Max Jacob's Chronique des temps héroiques, 1956.

Portrait of Guillaume Apollinaire, 1905 or 1906. Pen and ink, 6 x 4 in.

Vlaminck, Portrait of Apollinaire,
1905. Pen on paper.

hair fell over his forehead, his mouth looked like a little pimento, he had strong limbs, a broad chest looped across by a platinum watch-chain, and a ruby on his finger . . . Without interrupting his talk he stretched out a hand that was like a tiger's paw over the marble-topped table . . . Then the three of us went out, and we began that life of three-cornered friendship which lasted almost until the war, never leaving one another whether for work, meals, or fun.[4]

Picasso, always partial to descriptions that offered a wry purchase on the subject, was to say years later to Hélène Parmelin, "Picture to yourself an English bar. Everything was English . . . The bar was very long, made of very nice wood, perhaps mahogany, but English mahogany. The beer was English . . . all the drinks were English."[5]

2

It was hardly out of character for Apollinaire to be drinking in an English bar. He had roots in half a dozen countries. Born in Rome on August 26, 1880, of a Polish mother, his father, legally speaking, was unknown. By way of the rumor that enveloped him, however, he may have been a descendant of Napoleon (which name, it will come as no large surprise, can be spelled with the letters in Apollinaire); equally, the father is reputed to be a high official in the Vatican—just so, Picasso did a caricature of Apollinaire wearing the Pope's tiara plus a wristwatch.

In keeping with the specifications of a royal bastard, he was christened Wilhelm (later to be Guillaume) Wladimir Alexandre Apollinaire de Kostrowitzky. While not one third the length of Pablo Diego José Francisco de Paulo Juan Nepomuceno María de los Remedios Crispín Crispiano Santísima Trinidad Ruiz y Picasso, it is notably more elevated. Of course, Apollinaire belonged to a rare sub-group—the lumpen-aris-

Apollinaire Papé, 1905. Pen sketch.

tocracy—and his mother, Olga, while the
daughter of a titled Polish colonel in the papal
guard, was a lady who had been obliged to learn
how to live off her more affluent men-friends.
Apollinaire was brought up in Monte Carlo,
where Olga, also known as Angelica, was a
"traineuse," which is to say she took her cut out
of the money she steered high-rollers into spend-
ing in restaurants and nightclubs. Considerably
later in her career, now considered sufficiently
unsavory to be banned from the casinos of Spa
and Ostend in Belgium, she would conduct illicit
high-stakes card games at a villa she rented in a
suburb of Paris called Le Vesinet, where she
lived with her longstanding Jewish lover, Jules
Weil, a professional gambler. Indeed, on the
night Apollinaire met Picasso and Max Jacob at
Austen's English bar, one reason for choosing
the place was that it was near the Gare Saint-
Lazare, from whose tracks the poet would take a
late train every night after his working day in a
bank. Twenty-four to Picasso's twenty-three in
November of 1904, Apollinaire was still afraid
of the drunken rages of his mother. Richardson
recounts how André Salmon, who went back one
night with Apollinaire, was greeted in company
with her son at the door with the following
inquiry: "Which of you debauched the other?"[1]

"She treated her 'Wilhelm' as if he were an
incorrigible child and would beat him, as she
would her lover."[2] For that matter, she beat her
other son, Albert, as well. Francis Steegmuller, in
his biography of Apollinaire, adds:

> The men in her life seem to have been
> comparatively few—few, that is, for a

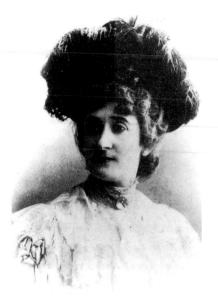

*Photo of Angelica (Olga) de
Kostrowitzky, mother of Guillaume
Apollinaire.*

Drawing of André Salmon, 1907.

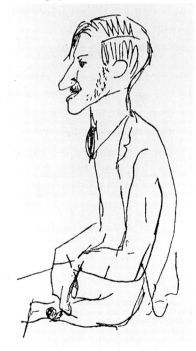

courtesan—and little is known about them. During her years in Monaco she made several trips outside the Principality with admirers whom she presented to her sons as their "uncles"; at least one of them, a rich silk manufacturer with bookish tastes, allowed her to bring the boys to his home in Lyons, where Apollinaire later recalled reveling in a fine private library . . . Angelica was an original. Handsome, strident, living outside society in a strange kind of isolation, she constantly reminded her sons of their descent from northern nobles of the dim past, and scolded them if they kept what she considered unworthy company.[3]

At one point, during his adolescence, Apollinaire's mother and Jules Weil were virtually on the run. He and his brother, Albert, were left

. . . masquerading as "young Russian counts" in a pension at Stavelot in the Ardennes. His charm and courtesy ensured the penniless Guillaume infinite credit. He spent the next three months rambling over the peat bogs of the Fagne, courting a local girl, communing with elves and filling notebooks with ideas . . . At Stavelot he developed an obsession with medieval legend and magic rituals; he took to signing his poems with a cabalistic swastika. His most prized possession was a mildewed book on demonology, from which he read aloud as if already a magus.[4]

In July of 1902, Apollinaire writes to a Monacan school friend about the next episode in his life after Stavelot. It is intriguing how much his style calls to mind how Henry Miller would do it thirty years later in *Tropic of Cancer*.

In Paris, a hard winter. It looked as though we were going to have to eat bricks. I even wrote addresses in an office at four sous an hour, the lowest work imaginable, along with jailbirds, broken-down ex-lawyers, adventurers back from the gold mines. Plenty of them would have been glad to enlist for the Transvaal if they had been eligible; I was one of this starving rabble. At the end of the month I was left with 23 francs I had earned; it was handed to me by the *patronne* of the establishment . . . she paid the poor wretches herself, burning perfume-papers so as not to smell their odor. The lowest I ever sank.

I hang around jobless. Meet up with old Esnard whom I knew in Monaco. He is a Bohemian lawyer who has a novel to write for *Le Matin* and is too busy to do it himself. He asks me to help him . . . I write a few chapters and *Le Matin* publishes the novel serially under the title "Que Faire." Other serial-writers imitate my chapters [but at] home I make a meal of herring. Esnard forgets to pay me for the trash I wrote for him. I see a lot of him anyway, and make his mistress, twenty years old to his 53.[5]

He must be lying. He is still too innocent, and his sex life soon after is peculiarly abstemious. His letter is being written in July of 1902 at the Villa Holterhof, Honnef-on-Rhine, where he is working as a French tutor for Vicontesse de Milhau, who is described as an extraordinarily ugly woman with an unhappy skin disease. Since she wishes her daughter Gabrielle to learn French and English, the Vicontesse has also hired a young English tutor named Annie Playden, who might just as well have been brought up by Queen Victoria. Apollinaire, sensitive to the massive silences of the Rhine, falls in love with her like an eighteenth-century German romantic; he was willing to kill her, and/or commit suicide, and/or remain chaste.

His description of the romance is given in the same letter: "Since then I've seen all of Germany and sleep with the English governess, 21, what curves!"[6]

Yes, when it comes to sex at twenty-two, we can be confident he is a liar, for here is Annie Playden's (now Annie Postings) description of her friendship with Apollinaire, whom she calls Kostro. She will offer it to Francis Steegmuller fifty years later:

"I'm sorry, of course, if I was *too* mean," Mrs. Postings went on, "but what was I to do? Kostro couldn't properly make love to me in words since I knew so little French and his English was almost nonexistent, and neither of us spoke German—the countess hired us because we couldn't; she wanted Gabrielle to learn English and French. And I wasn't one to allow him to do anything else. I'd been warned so before leaving home. My sister and I were the most rigidly brought-up girls in Clapham. My father was so straitlaced that he knew it, and called himself 'the Archbishop of Canterbury.' 'Never speak to anybody, never be alone with anybody,' and all that; my parents kept dinning it into my ears. It was only because the countess's doctor in London was a friend of my father's that I was allowed to take the position and go to the Continent: the doctor said he could vouch that I'd be with a respectable family. I don't suppose that at the time any of us had been told there was going to be a young man in the house. Kostro was so intense! I refused to be alone with him, but sometimes the countess *ordered* the two of us to go out for a walk together. When she did that, she didn't know what she was doing; but then, she thought Kostro was in love with *her*, she thought everybody was. I was amazed by his behavior to me. He terrified me. He'd take me on a dangerous mountain path and tell me if I refused to marry him he was quite capable of hurling me down a precipice. He'd say to me, 'Each man kills the thing he loves!' When we traveled, if he saw me having the most casual, innocent conversation with anybody, he'd stride up in a fury and order whoever it was to leave me alone because, he said, I belonged to him. Then I'd be furious with him and refuse to have anything to do with him, refuse to speak to him."[7]

It is not hard to conceive of this hulking awkward youth, gross and genteel by turns, cultivated, boorish, and rendered near-violent by his inability to converse with her, this Kostro, soon to be Apollinaire, with a gift for conversation that would transport him (on a favorable wind) from a fat young man to a café potentate. Capable a few years later of consuming two full meals in immediate succession, he would be described soon enough by Francis Carco as this "gourmand, huge in size, yet somehow appetising to look at, [who] would crush between his jaws the bones they served him, would suck on them, become smeared with grease, and in the course of relating some story about a painter, would fart into his seat cushions without the least concern for his reputation. What had he to fear? He was like some hilarious god."[8]

Ex-Libris: Guillaume Apollinaire, 1905.

Good. We have a purchase on Apollinaire. He is a man of engorgements, a *pétomaniaque*, but, no, we are caught short. When in his apartment, he exacts the propriety one would expect from an abbess. Fernande gives a good account:

> If one went [into the bedroom] one had to be careful not to disturb anything, as this would have displeased Guillaume exceedingly. It was forbidden ever to touch the bed. The slightest crease or hollow in it was noticed at once and could provoke a good deal of frowning and irritation. His mistress was a friend of mine and she used to say they'd never made love anywhere but the armchair. His bed was sacred! He insisted that it remain intact until the moment he went to bed. No one was allowed to put anything at all on it, though there was never enough room in the hall for all the coats . . .

> Apollinaire always had dozens of visitors. He would be friendly and direct with some; with others he rather overdid his easygoing act. Tea was served, very sparingly; Apollinaire was so childishly, so unconsciously mean, that it made us laugh. Some of his friends were amused by this failing: Cremnitz, among others, used to

open the cupboards and cabinets and take anything edible he found in them. Apollinaire would rush at him in a rage, try to save what he could, and demonstrate his sense of ownership with a good deal of belligerence. His egoism conflicted, though, with his kindheartedness, which could easily be aroused by emotional troubles, never by financial ones. He could often be tender and sympathetic to the point of tears. I don't ever recall that he responded favorably to a request for a loan. I can hardly think of any friends he helped, whereas nobody asked Max for help in vain; he always gave what he had.[9]

If requests for money must have reminded him of his own years of debt and decamping from hotel bills, his mind teemed, however, with other gifts. He had read omnivorously, and was always ready to give away analogies, metaphors, aperçus, and images of a loveliness that could warm the body almost as nicely as the brain. He could give what came to him spontaneously, but he could not bring himself to let others take his food, his money, or poach on the approaches to his name. He was a self-made man when it came to that name—he had written, after all, *"Ton père fut un sphinx et ta mère une nuit."*[10] Yes, his father was a sphinx, his mother was "a night." Conceivably, he was the product of one night of love—which is every bastard's fear—yes, sleep is sacred for those who live above the abyss, and he would protect his bed from any likelihood of aftermaths left in the mattress by those who sat upon it. Like most people who fart a lot, he thought all others were guilty of the vice. Be it said, he was even more ferocious about defending his name. Once he was satirized in a Paris tabloid for coming into a café and ordering a bottle of Apollinaris water with the statement *"C'est mon eau, c'est mon eau."* When he did not obtain a retraction, he challenged the journalist to a duel which, given a certain lassitude in both parties, never did come off. But the name was not to be played with.

> All his life he was to speak mysteriously or grandiloquently of his ancestry . . . "I am descended from Rurik, the chief of the Varangians, the first king and first law-giver of Russia," he announced to a friend in one of his last years.[11]

Of course, he could also look like a Dutch burgher.

Apollinaire, c. 1905. Pencil on paper.

This is but preface to engaging his unique qualities as a poet. He had traveled through Europe considerably more than other young writers of his time, and Roger Shattuck could write with justice that he might be called "the first European poet since Goethe [because] his poems are never content to speak of France alone; their prophecies and conversations and descriptions are all Europe."[12]

Apollinaire inhabited the vowels and consonants of French like no foreigner before him: his verse exhales the perfumed sonorities of the language, and if this excess of the mellifluous resounds suspiciously—perfumed sonorities, indeed!—well, a people who equate good luck with *merde* have obviously kept some primitive connection between the workings of their entrails and chance. At his worst, Apollinaire writes in a cloud of scented bombs; at his best, there seems no delicate emotion of twilight or evening able to escape him. His poet's sense of wonder is full of startling transpositions, imperious and child-like at once. Let us give him the honor of quoting three stanzas from his first great poem, *La Chanson du Mal-Aimé*, written in 1903, while he was still mourning for the affair that never took place with Annie Playden:

Mon beau navire ô ma mémoire	My lovely ship my memory
Avons-nous assez navigué	We have never sailed out to sea
Dans une onde mauvaise à boire	On that dreary wave so vile to drink
Avons-nous assez divagué	Nor have we wandered long enough
De la belle aube au triste soir	From dawn to melancholy dusk
Adieu faux amour confondu	Farewell false love whom I mistook
Avec la femme qui s'éloigne	For a woman far away
Avec celle que j'ai perdue	For the lass that I did lose
L'année dernière en Allemagne	A year ago in Germany
Et que je ne reverrai plus	And will never see again
Mars et Vénus sont revenus	Mars and Venus with their wild mouths
Ils s'embrassent à bouches folles	Have come back to embrace
Devant des sites ingénus	All those innocent places
Où sous les roses qui feuillolent	Beneath the blossoming rose
De beaux dieux roses dansent nus[13]	Where rose gods dance nakedly

3

"*Where rose gods dance nakedly.*" Let the line serve as our introduction to the Rose Period. Of course, *La Chanson du Mal-Aimé* has only been quoted so far by its more beautiful verses. Not ten stanzas further along, we are treated to:

> *Rotting fish of Salonica*
> *Endless chain of repulsive dreams*
> *Of eyes torn out by pointed stakes*
> *Your mother loosed an awful fart*
> *And birthed you in a colic pool*[1]

The capacity to live with opposites in oneself confirms the point: Apollinaire and Picasso were artists to enrich each other. Ready to evoke every transport of romantic loss and longing, Apollinaire lived with an equally powerful vision of coruscation and putrescence; so he could provide the poetic overlay needed then for Picasso's vision. Roger Shattuck, speaking of Apollinaire's revolving roles as clown, scholar, drunkard, gourmet, lover, criminal, devout Catholic, wandering Jew, soldier and, finally, good husband, adds:

> His boldest acts and his boldest works display a desire to touch simultaneously the extremes of tragic despair and of exultant gaiety. Today we have given to the products of this boldness the name "surrealism" or rather we have accepted the name from Apollinaire himself.[2]

The poet soon becomes the guide who will conduct Picasso from the Blue Period into the Rose. Other friends and other factors are present, of course. The successful courtship of Fernande is one; a little later, when Leo and Gertrude Stein enter his life, Picasso will begin to sell his paintings more regularly. That is hardly going to inhibit his palette. There was also his increasing interest in the Médrano Circus at the foot of Montmartre. Picasso's choice of color required more, however, than the alteration of his personal circumstances. An outsize impetus was also needed. After all, there were other forces still locking him into the Blue Period, and they were fully emplaced to wall in larger fears.

It is hopeless to attempt to comprehend Picasso without assuming that he would never let anyone come near to the immensity of dread he contained within himself. One of his most honorable achievements over the ninety-odd years of his life is that he dominated his inner terror sufficiently to use it as a stimulus to work: how he worked! Work was his nostrum for dread. So we do well to view the Blue Period as his palisade built against dread. If we ask, Dread of what?—there can be no answer. Dread is characterized by alienation. We cannot point to the origin or the object of our fear. We know only that we are afraid, we wake up afraid, and this fear lives with us like a delicate nausea of the soul. At its most intense, everything takes on too much meaning—insanity begins to lurk outside that circle of sanity one has cleared for oneself—a circle of sanity often established through an act of will seeking to fortify the last boundaries separating a disturbed person from explosive forces in his psyche.

If this sounds close to insanity itself, we are obliged to recognize that sanity is often maintained by a mental balance which depends upon insane equations. In those years, Picasso must have seen the color blue as a force, an abstract power capable of holding off malign interventions. His limited palette could protect him against invasions which he could hardly name yet that he nonetheless believed were ready to destroy him. We can do worse than to comprehend him in this last of the Blue Period, from 1904 to 1905, as a perfectly sane hardworking young artist with but one insanity, a highly useful and functioning insanity—his belief that he could not shift his palette from dark blue to bright green, let us say, or to brilliant red without being rent apart.

This is shamanism. But then, where is the highly talented painter without some primitive belief that magic is a presence in all artwork? It is not difficult to see painting as an occult act: It transforms a piece of paper, a sheet of cloth, or a cave wall into a life-like presence. If I am an actor and shape my mouth to look like the

man or the emotion I am seeking to emulate, then I come closer to that man and that emotion. Conversely, if I feel myself taking on the emotional states of someone else, then my mouth is bound to form into similar lines. Put in simplest fashion, the actor is one person mimicking another. A painter, however, mimics an object, which is to say that he leaves a record of the object, he transfers it to another existence, he initiates a line that becomes a particular form. Soon enough, the painter is aware that one form can often represent more than one kind of object. The figure 7 can always be seen as a nose upside-down.

Let us go back once more into Picasso's depression as he entered the Blue Period. We can assume that he was close to fears he knew as a child. Everywhere he looked—at a stain on a wall, or a crack in a window—was evidence of an artist more divine than himself, a creator who could show a gargoyle's face in the crumbling of a slab of plaster. Were the lines of a penis at rest revealed in the drooping of a flag? We can hardly conceive of how powerfully did objects impinge on him. Objects spoke of other objects with similar form but highly different function (7, to repeat, equals a nose upside-down). He must have believed that if he allowed himself to follow his visual stimulations, he might lose his mind. So he protected himself with a severe palette, and painted an assemblage of humans imprisoned by poverty, hunger, tragic memories, and dread. No old man was ever as old as the young Spaniard who painted these exorcisms in his Blue Period. If there are cynics who believe that Picasso's work at this time is merely a reflection of the fact that Prussian blue was probably the cheapest pigment available when Picasso was poor, why, they can give this book away right now.

In depression, goes our claim, was his mental safety; in gloom was a force sullen as smoke to keep dank madness outside the circle of his creative fires. Profound gloom was the last and best defense against psychosis, and Picasso, bringing life to paper and canvas with a turn of his wrist, had to feel uncomfortably close to that all-inclusive force which introduced an earthquake to Málaga and took away his young sister in Corunna. Psychosis is the sense that one is in touch with the gods even when one does not deserve to be, or *wish to be*. It is then that monochromatic palettes can be set up as filters to hold cosmic forces at bay. Have we entered the subtext of Picasso's actions through that year, 1904 to 1905, when he was courting Fernande and painting all night, every night, like a watchman on a parapet? André Salmon describes him as "dressed altogether in blue, the blue of workingman's clothes, Picasso painted in blue by the light of a candle."[3]

Now, Apollinaire enters his life, and the poet is ready to conquer the road to

madness by taking excursions upon it. Since there was a side of Picasso that believed one could only find personal significance in the bizarre (as if conventional scenes, still-lifes and landscapes were all part of some gigantic social prison ruled by precisely those powers not particularly congenial to him), it is not surprising that the painter was ready to be influenced profoundly by a friend who had come to manhood out of a childhood and adolescence even more uprooted, grand, debased, cockeyed, and bi-valued than Picasso's. Yet, this variety of unique, even baroque, imbalance had led Apollinaire to build structures of eccentric habit that Picasso had to admire; the poet was not only a prodigious diversion but an advanced piece of human sculpture. To keep up with Guillaume Apollinaire, one had to view him from so many angles that he was already a spiritual model for the Cubism to come.

Together, however, they could share a vision of damnation, apocalypse, and the downfall of the bourgeoisie. In a personal period of prodigious inner anxieties, a collateral imbalance in society can seem reassuring. (You are not as fucked up as the people who are fucking you up!) The last decade of the nineteenth century and the first few years of the twentieth had produced a generation of bohemians, symbolists, and as-yet-untitled crypto-dadaists and surrealists ("pataphysicians," as Alfred Jarry would call them) who were prepared—it was the only solution they could see—to blow up the world, spiritually, socially and, if the dynamite was available, why not physically as well? Richardson shows his powers of synopsis here:

> Reassured by the whiff of brimstone and brilliance they detected in each other, Picasso and Apollinaire became the best of friends . . .
>
> Until he died, fourteen years after they met, Apollinaire would be a constant solace, a constant goad to Picasso. He opened up his imagination to a vast new range of intellectual stimuli: to new concepts of black humor, to the pagan past and the wilder shores of sex. Apollinaire, who was already obsessed with the works of the Marquis de Sade—"the freest spirit that ever existed," he wrote—had no difficulty converting Picasso to the cult of the Divine Marquis [nor to de Sade's] definition of art as "the perpetual immoral subversion of the existing order."[4]

De Sade believed in absolute freedom. As a corollary, he was opposed to property. Inasmuch as property commences with one's body—speak of sexual harassment!—Sade argued that all men and women should have full if temporary rights over the bodies of all other men and women. The question of rape immediately raised by this is quickly carried over to: What does one do about murderers? Sade's answer was: Beware of the dead man's friends. If, as a consequence, everyone is obliged to live in gangs who will serve, if need be, as avengers, the ultimate resolu-

tion of such an implicit pyramid is monarchy: When it comes to retaliation, who can be more powerful than the king?

How could it not prove convivial then to Apollinaire (and Picasso) to come across a philosophy that could ingest anarchism and monarchism into the same system? Magical worlds germinate from the collapse of logic.

If one is to speak, however, of magic, it is worth attempting a small exposition. Let us assume that magic can adhere, for example, to a painting—particularly if it is a fine work, and one owns it—because the artwork can now be contemplated a thousand times rather than on a few occasions in a museum. Each time the owner comes to appreciate more in the composition than he glimpsed before, the painting takes on an added endowment. It becomes a center of meaning, it stimulates new thought, it induces energy in the viewer—that is to say it has assumed magical powers. (Magic offers priceless energy.) If the same can be said of a memory, of athletic victory, of a ritual ceremony, or of political leaders who take on charisma, if it can be said as well of lovers, of children, and of friends, we have a species of equation: Whatever provides us with continually enhanced connotation is magically endowed.

This is, of course, not true of all paintings we own, or of politicians who bore us, friends and lovers who depress us, rituals that weary us, or of relations in which we lose interest. Repetition can also kill the soul, and so a ceremony, a person, or an object is able to enrich us only when its nature, its *artful* nature, rewards further study or calls for more relationship—that is to say, its nature transcends familiarity. And that, indeed, may be why good poetry is more magical than good prose—the message is more elusive, more compressed, and more responsive to sensuous study.

Picasso was in need of new magic to dare to leave the Blue Period; Apollinaire provided it. Here is a last look at the transition:

> . . . taking his place somewhere between the blind beggars and the prostitutes, sharing with them the same café tables, another character makes his appearance. He is a youth disguised for a performance in which, to judge from his fragile looks, he is merely another victim, one of a troupe of players who impersonate the behavior of a society from which they are outcasts . . .[5]

Of course, Germaine Gargallo is also in this portrait, and therefore Casagemas is present by connection. It is necessary to recognize that part of his difficulty in finding an exit from the Blue Period is that Picasso had to take Casagemas through the same door.

. . . there are some pictures belonging to 1904 and 1905 that make one wonder how he reached the apparent detachment of Cubism without hanging himself. One of these is a big oil that shows Picasso and Germaine Pichot at the bar of the Lapin Agile with Frédé in his wooden shoes playing a guitar in the background: Germaine, wearing a tawdry hat and a pink dress, is sulking in front of her empty glass; Picasso, dressed as a harlequin—and the red lozenges clash subtly with her pink—is half turned from her and his greenish face has a look of profound disgust and weariness.[6]

Au Lapin Agile (also called The Harlequin with the Glass), 1904–05. Oil on canvas, 39 x 39 in.

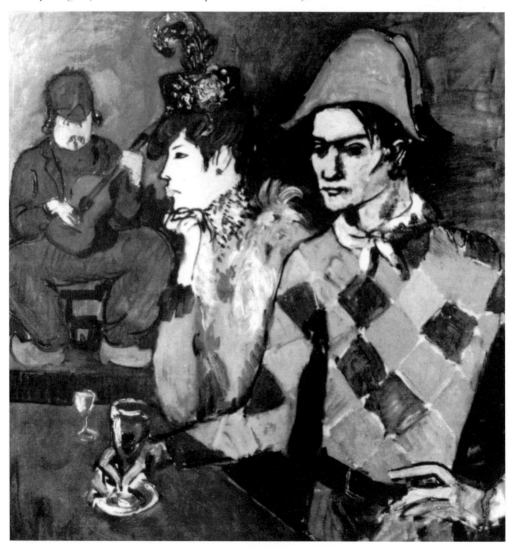

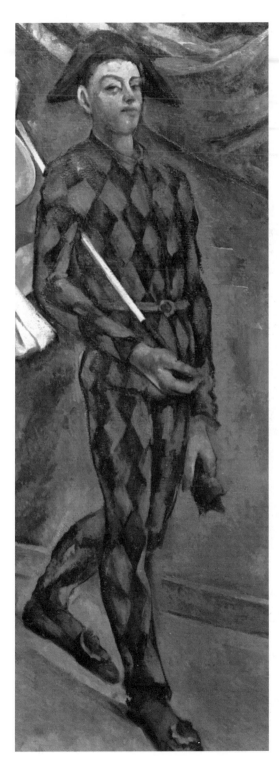

Cézanne, Mardi-Gras. Detail showing Paul Cézanne's son as a harlequin, 1888–90.

We have, however, to keep reminding ourselves that Picasso's inspirations also come from traditional sources, and the first of them may well have been Cézanne. Apart from the several exhibitions in Paris that Cézanne had been given in these years (which Picasso would certainly have seen), Ambroise Vollard kept any number of the older painter's works in the store-room of his gallery. Picasso may have had the opportunity to study these canvases by himself, alone with the brush-stroke of the artist. There was so much about Cézanne that was not only profoundly seminal in its offering—a veritable realm of new concepts on the paradoxes of perception—but there was also his clumsy hand, begging to be improved upon.

Who knows how much good morale was generated for Picasso by the knowledge that he could do a better and more interesting harlequin than Cézanne?

Early in 1905, when Picasso, in the course of pining for Fernande, is still very much engaged with Madeleine, a transitional work appears. It shows a variety of fifteen limbs, some all but hidden, in its four personages (if we count the monkey), yet only the mother and child clasp each other. Since this painting was probably

done not long after Picasso encouraged Madeleine to have an abortion, the ironies are acute. Motherhood, he seems to say (now that he will not be close to it), is the truly tender emotion—the rest is holding on to oneself. But what a harlequin, what a monkey, what a mother and child!

Another transitional work is enriched for us by the story recounted by André Salmon.

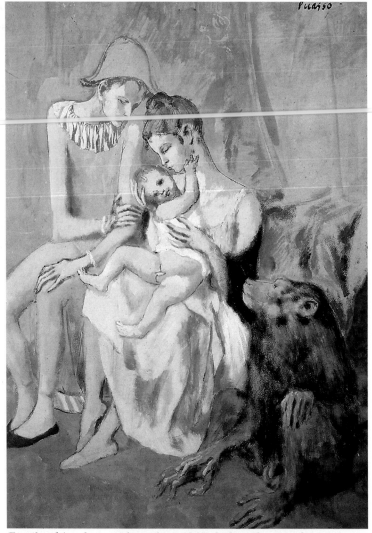

Family of Acrobats with an Ape, 1905. India ink, gouache, watercolor, and pastel on cardboard, 41 x 30 in.

. . . Picasso had painted without a model the extremely pure, simple image of a young Parisian workman, beardless and dressed in blue. Very much as the artist himself looked when he was at work.

One night Picasso deserted the group of friends deep in intellectual discussion: he went back to his studio and, taking up this picture, which he had left untouched for a month, gave the young artisan in it a crown of roses. By a sublime stroke of caprice, he had turned his picture into a masterpiece.[7]

For Picasso, that wreath of red roses could have been the battering ram that

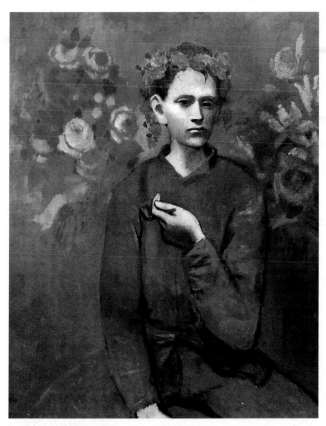

Boy with a Pipe, 1905. Oil on canvas, 39 x 32 in.

breached an old fortified inner structure. Before long, his palette and his themes would move over to the *saltimbanques.*

They are traveling jugglers and acrobats, performers living on the last line between society and the nomadic life; and if one is looking for influences on him, they abound. He had seen traveling circuses in Spain and street entertainers in Paris; he was now, during the fall, winter, spring, and summer of 1904–1905, frequenting the Cirque Médrano at the foot of the Butte de Montmartre. There, as Patrick O'Brian describes it so well, he could see a troupe of

. . . lion-tamers, broad white horses, trapeze artists, jugglers, riding-girls, acrobats, clowns, and at least figuratively its harlequins: when they were in funds Picasso and his friends went there three and even four times a week. He loved the smell of the place, the artistic integrity, and the total professionalism of the people: it was an international world—Dutch clowns, Serbian tumblers, Indian elephants—making little use of any language, French or otherwise, a world apart, remote and often hungry, made up of outsiders whose contact with the public was confined to the performance of very highly skilled and often perilous motions, the fruit of endless practice.

Furthermore, the circus was a link with his past: . . . all over the Spain of his childhood hereditary troops of tumblers were to be seen, sometimes leading apes or bears . . . and it is significant that most of the "saltimbanque" pictures that he painted in those years show not so much the circus proper as dusty vagrants, wan-

dering through bare, indeterminate landscapes in the clothes they wore for their performance.[8]

At the hub of all these influences is Apollinaire, the vital center of the Rose Period. It is interesting to compare Picasso's work in late 1905 with some of Apollinaire's verses in the same season. How compatible they are! The Rose Period with its bouquet of mystery offers a subtle mood of fear and longing, of tender concern, and a full sense of the sinister edge of the silences one feels in the mood of certain evenings when one does not know if one can cross the night.

Saltimbanques	**Acrobats**
Dans la plaine des baladins	Beyond the plain a troop of clowns
S'éloignent au long des jardins	Is strolling through the garden lane
Devant l'huis des auberges grises	And past the doors of worn gray inns
Par les villages sans églises	Lie churchless villages and towns

Circus Family, 1905. Pen and black ink, brush and gouache on brown composition board, 10 x 12 in.

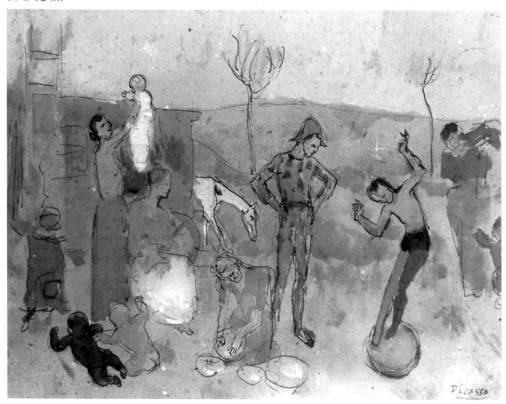

Et les enfants s'en vont devant	Children run quickly to the fore
Les autres suivent en rêvant	And others follow in their dream
Chaque arbre fruitier se résigne	Each tree bearing fruit seems subdued
Quand de très loin ils lui font signe	As from afar they make their sign
Ils ont des poids ronds ou carrés	All weight carried is round or square
Des tambours des cerceaux dorés	The tambourines have gilded hoops
L'ours et signe animaux sages	Old wise beasts are the ape and bear
Quêtent des sous sur leur passage	While begging pennies on the way[9]

Family of Saltimbanques, 1905. Oil on canvas, 84 x 90 in.

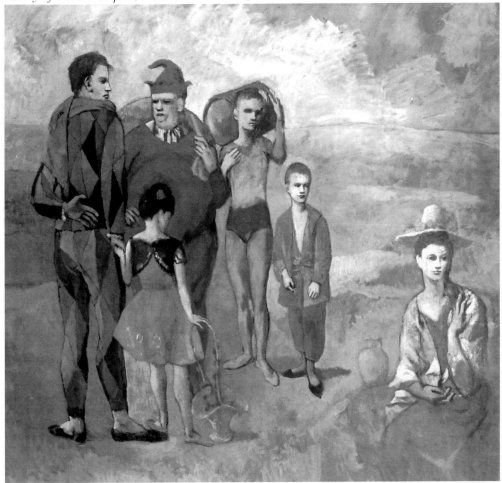

Crépuscule

Sur les tréteaux l'arlequin blême
Salue d'abord les spactateurs
Des sorciers venus et Bohême
Quelques fées et les enchanteurs

Avant décroché une étoile
Il la manie à bras tendu
Tandis que des pieds un pendu
Sonne en mesure les cymbales

L'aveugle berce un bel enfant
La biche passe avec ses faons
Le nain regarde d'un air triste
Grandir l'arlequin trismégiste

Twilight

High on the stage pale harlequin
Prepares to salute the throng
Sorcerers arrive as Bohemians
A few fairies and magicians

Having unhooked a shining star
One holds it by his outstretched arm
And all the while a hanged man rings
A cymbal with his dangling feet

The blind man rocks a lovely child
The roe walks by and all her fawns
The drawf looks on with his sad air
And magic swells in harlequin[10]

La Tzigane

L'amour lourd comme un ours privé
Dansa debout quand nous voulûmes
Et l'oiseau bleu perdit ses plumes
Et les mendicants leurs Ave

The Gypsy

Love like an obese lonely bear
Danced upright when we desired
The bluebird lost his lovely plumes
And all the mendicants their beads[11]

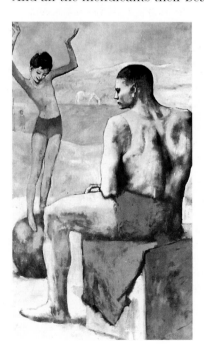

Young Acrobat on a Ball, 1905. Oil on canvas, 57 x 37 in.

He always loved making other people laugh and he could be brilliantly witty and animated when he wanted to be. He was a singer, a singing-teacher, a pianist, a comedian if called upon to be and the life-and-soul of all our parties. He used to improvise little plays in which he was always the main actor. I must have seen him do his imitation of a bare-footed dancer a hundred times, and each time I enjoyed it more. His trousers were rolled up to his knees to reveal two hairy legs. In shirt-sleeves, his collar wide-open to expose a chest forested with curly black hairs, with his bare-bald head and his pince-nez, he would dance with tiny steps and pointed toe, doing his best to be graceful and making us rock with laughter at his superb overacting. It would be impossible to remember all the rich details of that performance. He used to make us laugh so much that we felt physically exhausted. There was the gay songstress, which he did with a lady's hat on his head and a translucent veil swathed about him and singing in a heady soprano which was in tune but somehow totally ridiculous . . .

He used to sing *Langouste atmosphérique* by Offenbach and *Sur les rives de l'Adour.* These and dozens of other songs used to delight us evening after evening. We never grew tired of them.[1]

Fernande is writing, of course, about Max Jacob, and the evening usually takes place in Picasso's studio at the Bateau Lavoir, their friends squeezed in on whatever will serve for a seat between the squashed tubes of paint on the floor and the burnt umber, ochre, and cadmium-yellow turds of the dogs. There will be Apollinaire, of course, and André Salmon, and Manolo the sculptor who stole his father's

watch, and there may be Paco Durio, who has already given Picasso his first lessons in sculpture, and presumably there are Canals and his wife, Benedetta, although one reads no mention of Sunyer anymore. Van Dongen is there from time to time, and Maurice Princet, the actuarial mathematician for insurance companies who would give them his own popular introduction to Einstein's work before long.

We have to remind ourselves that most of the guests were in their twenties and smoked pipes of opium the way later generations would take to pot, if on some nights the mood grew so deep that few could pass from the filigree of their own thought to the conceivably greater depth stirring in the mind of the person next to them, well, they caroused at other times.

Here are two of the songs Jacob would sing:

Ah, superbe Pandore	Ah, superb Pandore
Toi que mon coeur adore	You whom my heart will adore
Si tu résist's encore	If you resist once more
A mon amour pour toi,	My real sweet love for you
Je to de dis, crois-moi,	I tell you, kid, it's true,
Il faudra final'ment	Something has to be
Que tu me mett's dedans	Put inside of you—me!
Sur les rives de l'Adour	On the banks of the Adour
Là-à vivait un pastour	There was living a pastor
Libre, heureux exempt de vices	Free, happy, sinless, pure
Qui pêchait des écrevisses	Enticing crayfish to his lure.[2]

There is no humor so long gone as translations of funny old songs sung by people who died before most of us were born, but some trace of their happy delirium may perhaps remain.

Vlaminck and Derain, occasionally present, were doing a sex book for money on the principle that ink and paper cost less than oil and canvas. It was written by Vlaminck and called *From One Bed to Another*; Derain was doing the illustrations. Vlaminck, when it came to painting, was full of his own maxims: "One doesn't paint to earn money, one paints as if one is making love." His faith: pure color. "Pure color as it comes out of the tube . . . Museums are cemeteries . . . Don't set foot in them."[3]

Sometimes the games had a cutting edge. The spite felt toward Apollinaire was intense. Max Jacob had already walked his long mile in welcome; perhaps he had

decided that the presence of a major poet would strengthen his own ties to Picasso, but his jealousy was not small. Picasso, in turn, was not without envy of Apollinaire's culture, his command of other languages, his talent as a poet, and his familiarity with those who had titles or money; it might be basic to despise the ruling classes, but it was not agreeable to feel oneself outside them.

Besides, Apollinaire was so above his own eccentricities that it must have been close to intolerable not to make fun of the man, at least behind his huge back. He had the habit, for example, of signing off on the smallest note, with the grandest flourish, *"la main amie* [the friendly hand] *de Guillaume Apollinaire,"* and Max Jacob was quick to exploit the opportunity. Salmon returned home one white night in winter to find a snow-filled glove wedged into his door handle. Jacob had written in English, "Snow-glove" and then *"la main sanglante* [the bleeding hand] *de Guillaume Apollinaire."*[4]

They were quick to compete on variations to this theme. Letters now ended with the salutation: "The friendly hand of . . ." and were signed Jacob, or Salmon, or Picasso. Before long, it was refined to "The bloody hand of Max Jacob," etc. Salmon, having told the others about the splendid greeting offered him by Apollinaire's mother, inspired Maurice Princet to write: "Guillaume Apollinaire has such fear of vice that he doesn't dare look at his mother."[5]

And then there was the following verse:

Epouser la mer'd'Apollinaire
La mer'd'Apollinaire
La mer'd'Apollinaire
De quoi qu'on aurait l'air?
De quoi qu'on aurait l'air?[6]

La mer'd'Apollinaire could stand for "the mother of Apollinaire" or "the shit of Apollinaire." A fundamental pun!

To be wed to the mother of Apollinaire
The mother of Apollinaire
The mother of Apollinaire
What will you have for air?
What will you have for air?[7]

Salmon's memoir, *Souvenirs sans fin*, suggests that Apollinaire was not cognizant of these amusements, but Picasso later told Françoise Gilot that Apollinaire

chased Max Jacob around the studio after he heard the song.[8] Some twelve years later, in *La Femme assise*, back from World War I with a head wound, Apollinaire would satirize Picasso by way of a half-Spanish, half-Albanian character "born in Spain, in Málaga," named Pablo Canouris who—in case anyone should fail to discern the model—was also "the painter with hands of a celestial blue."[9] Canouris had an exaggerated Spanish accent and suffered from avalanches of jealousy due to the faithlessness of his mistress, Elvire, a typical Apollinairian creation. Elvire's peregrinations introduced her to a range of anecdotes and royal documents concerning Utah, the California gold rush, Brigham Young, some Mexicans, some blacks from the state of Missouri, a Ute Indian chief named Milopitz, and a few dozen adventurers from Western Europe and the Balkans. Elvire, whose eyes quiver with malice when she is with Pablo, waits for his embraces to end while she thinks of her girlfriend Mavis and "other caresses infinitely more sweet . . . caresses that she knew how to bestow that could only move the heart of a woman . . ."[10]

On one occasion, Pablo runs after her through the streets, catches her outside her door, and embraces her passionately. She gives way long enough for him to fall to his knees in gratitude, whereupon she unlocks her door, whips inside, and closes the portal on him. "For the rest of the night she heard Pablo Canouris banging on the shutters of the ground floor windows, while crying out, '*Elbirre, écoute-moi oubrre-moi, jé te aime, jé te adore et si tu né m'obéis pas, jé té touerrai avec mon rébolber.*' "[11] More knocks on the door, then, "*Oubrré-moi, Elbirre! L'amourr c'est moi . . . oubrre à ton Pablo qui té adorre.*"[12] Which in translation might go something like, "Elbeera, listen to me, openna up, I love ya, I adore ya, and if you no obey me, I'll keel yiz with my rebolber. Openna up, Elbeera, luv, that's me . . . openna up to Pablo who's wild about ya." No one in English or American novels has spoken like this since the turn of the century, but the misuse of *b* for *v* and the rolling of the *r*'s is not without humor in French, and the grammatical errors are basic enough to suggest that Canouris-Picasso would never be able to speak the language decently, an evaluation designed to wound Picasso. Like most expatriates, he was sensitive about his French. (The French make sure of that!)

Invoking the revolver is no small part of Apollinaire's satire. In legend, and probably in fact, it was Alfred Jarry who sent Picasso the gun. Nonetheless, they probably never met face-to-face.

As Richardson points out in a detailed argument, Apollinaire, Jacob, and

Salmon had been friendly with the "pataphysician" and detectably influenced by him. They had met, according to Apollinaire, at one of the soirées of the magazine *La Plume* that were then held at a café in the Place Saint-Michel.[13]

Jarry, however, was ill by the time Picasso encountered Apollinaire, and the closest the painter came, probably, to meeting him was to enjoy Apollinaire's wry description of the man's abode. It was on the second-and-a-half floor! The landlord, in possession of a house with gracious height between its landings and greedy for more income, had succeeded in installing two floors where before there had been only one.

> "Monsieur Alfred Jarry?"
> "Second floor and a half."
> I was somewhat puzzled by that answer from the concierge. I climbed up to where Alfred Jarry lived—second and a half turned out to be correct. The stories of the house had seemed too high-ceilinged to the owner, so he had cut each of them in two. In this way the house, which still exists, has fifteen stories, but since it is actually no higher, it is but the reduction of a skyscraper.
> For that matter, reductions abounded in Alfred Jarry's abode. His second and a half was but the reduction of a story in which Jarry was quite comfortable standing up, but I was taller than he, and had to bend. The bed was but a reduction of a bed—a pallet; low beds were the fashion, Jarry told me. The writing table was but the reduction of a table; Jarry wrote on the floor, stretched out on his stomach. The furnishing was but the reduction of furnishing, consisting solely of the bed. On the wall hung the reduction of a picture. It was a portrait of Jarry, most of which he had burned, leaving only the head, which made him look like a certain lithograph of Balzac that I know. The library was but the reduction of a library, to put it mildly. It consisted of a cheap edition of Rabelais and two or three volumes of the *Bibliothèque rose.* On the mantel stood a large stone phallus, made in Japan, a gift to Jarry from Félicien Rops. This virile member, larger than life, Jarry had kept covered with a purple velvet sheath ever since the day when the exotic monolith had frightened a literary lady. She had arrived breathless from climbing up to this second floor and a half, and bewildered at finding herself in this furnitureless "Grande Chamblerie."
> "Is it a cast?" she inquired.
> "No," answered Jarry, "it's a reduction."[14]

Richardson also makes the point that it was Max Jacob who created the legend that Picasso knew Jarry well, and quotes Hélène Parmelin for support: "[Picasso]

regretted not having known Jarry . . . he went to see him one day with Apollinaire, but Jarry was out, *'et puis c'est fini.'* "[15]

> . . . Jarry had barely survived the winter of 1905–1906 [and] received the last rites around the same time that the *Demoiselles* was receiving its last touches. The breakthrough that this painting constitutes has yet to be seen in the light of the breakthrough that Jarry had made ten years before when he crashed the barrier between fantasy and reality, and established the parodic science of "pataphysics," which would detonate all traditional canons of beauty, good taste and propriety.[16]

Of course, Picasso did receive the gun, and by the laws of Jarry's new logic, that was a profound connection.

> Picasso did Jarry's "pataphysical" weapon proud; he claimed that he constantly used it to scare off bores and morons. There was the evening at the Lapin Agile when he fired a fusillade of shots after three earnest young Germans had exasperated him with questions about his aesthetic theories . . . No less Jarryesque was the time when Picasso and Manolo . . . found themselves sharing a cab with yet another boring German, who insisted on reciting his poems. Such was the tedium that Picasso fired through the cab's roof and left the German to be locked up by the police.[17]

It is reputed that Jimmy Hoffa said, "Run from a knife—move in on a gun." The theory must be based on the idea that a man with a knife is agile enough to use it, and usually slender enough to be defending himself, although not necessarily aggressive enough to chase you. A pistol, on the other hand, cannot be employed without some inner justification, no matter how warped. If one walks toward a handgun, the man holding it has to decide that he has the right to fire. In this case, therefore, we are not speaking of a defensive reflex but of a moral choice. One can, of course, make the gesture of firing into the air—so often Picasso's practice— achieving great effect without victory, defeat, or any serious choice at all. One is mixing gesture with significance.

Richardson bears on this point in the following passage:

> Again and again (sometimes in the same work) the very same symbol is made to stand for principles or ideas that are totally antithetical. . . . "The identity of opposites" is how Jarry explains this phenomenon. "Not only are the signs plus and minus identical but so too, ultimately, are the concepts of day and night, light and darkness, good and evil, Christ and Antichrist." It is a theory by which Picasso

would always live and paint . . . "I remember," Paulo Picasso told his father, "that I used to hear you repeat again and again, 'Truth is a lie.' "[18]

Yes, and anarchism, by way of de Sade, is monarchism. One habitat can serve two opposed symbols. A cellar can be cold, dark, and evil-smelling or warm, womb-like, protective. Picasso, dazzled into new connections by opium, must after a year of the Rose Period have been envisaging a new kind of painting; indeed, under opium, the new palette may have begun to seem cloying to him precisely because of its virtues—that all-too-successful creation of the evocative, the romantic, the dream-like, the tender, all embraced by the tastefully sinister. So, he may have been contemplating more disruptive approaches.

If we are to try to conceive of the subjects that were now being discussed by Picasso and his poets, we have to assume, given the talents of Jacob, Apollinaire, and Picasso, that they pondered many a curious and/or mysterious concept. Since the turn of the century, more than a few exceptional, even incredible, events had occurred. For example, Marconi had sent a wireless message from England to Newfoundland, 2,232 miles away. To the *bande à Picasso*, that must have been replete with aesthetic wonder: If the air could transmit messages, then spirits might be consorting with electricity! These are the thought processes of painters and poets after all!—they had an instinct for the intrinsic oddity of technological transactions. The second half of the nineteenth century, by way of the steamship and the train, had demonstrated that large numbers of people could traverse space much faster than at the rate of a horse, and now, individuals in their own machines—automobiles!—could race along roads at an equally advanced rate of speed. If distance was no longer to be measured by human or animal rates of locomotion, then the artist's space on his canvas might also have to be treated in a new manner.

The Wright brothers lifted themselves up into the air at Kitty Hawk, and our elemental relation to the heights above us was forever altered. A balloon had been essentially a slow-moving point in the sky, but a flying machine was an arrow. Fantastic dreams took on more realism. In New York, the first subway was being completed; the earth, therefore, was no longer a womb for nature or a vault for the departed but a network of new underground routes. One could begin to conceive, as Apollinaire certainly would have had the capacity to do, of a subterranean city, a gastrointestinal sub-structure to the urban surface.

In those years, Freud was already offering interpretations of dreams that could stimulate many a painter into new visual transports. The great bowl of the uncon-

scious had been partially exposed to light. Disruption was everywhere. Queen Victoria was not the only one to have died. President McKinley had been assassinated; so, too, the Grand Duke Sergei Alexandrovich, uncle of Czar Nicholas. There had been a mutiny on the battleship *Potemkin*, and the Czar had established a Duma. The Fauves were demonstrating that color itself, pure color, was also a force powerful enough to dominate form and composition, and these young men were exhibiting in Paris—Matisse, Derain, Vlaminck, Braque, Dufy, and Rouault were Fauves by the autumn of 1905. Max Jacob was studying cabala. Apollinaire, in *La Plume*, in May of 1905, six months after he had met Picasso, was writing:

> It has been said . . . Picasso's work shows a precocious disillusionment. In my opinion the contrary is true. Everything he sees enchants him and it seems to me he uses his incontestable talent in the service of an imagination that mingles delight and horror, abjection and delicacy . . . One feels that his slender acrobats, glowing in their rags, are true sons of the people: versatile, cunning, dexterous, poverty-stricken, and lying.[19]

This was all very well, but Picasso was approaching a recognition that the Rose Period might be no more than a rest camp. Deeper instincts in himself may have been urging him to set out on pursuing a more terrifying vision. He was approaching the crossroads of his aesthetic career. His father, with all the unacknowledged authority of the academic painter—"This is how it looks, after all!"—had imbued his son from childhood with the first imperative of the academic establishment: One must offer one's audience highly skilled works that provide refined pleasure. In the Rose Period, Picasso was still satisfying this paternal injunction.

If he had always seen life and his own existence, his own talent, as subject to unforeseen powers of destruction, he now was coming closer to the belief that he could countermand such forces, could even fight an active rather than a passive battle against the overpowering treachery that was always waiting in the Creation. Or so his experience suggested.

Part VI

Gertrude Stein

Fernande is still fabulously in love with love. As a consequence, she does not always comprehend Picasso's artistic needs. This strange, small, intense, old-young man, forever engaging, wickedly entertaining, sullen, or cruel, is the object of her love, but she has little insight into the aesthetic anxieties of her beloved. Nonetheless, she sees him by the manner she sees him, and so we, with added perspective, receive increments of benefit.

> I've been trying, for some time, to paint. I have gifts. I would like to be taught, to receive Picasso's advice, which he refuses to offer. "Amuse yourself," he says to me. "That will be enough. What you do is more interesting than what you would do under the instruction of another."

> I, however, am bothered by getting into things that arouse my passionate interest without my being able to search more deeply into the subject. That is why I give myself, above all, to reading, which permits me, at least, to study seriously.[1]

So she remains a dilettante, and

Fernande Olivier, Still Life. Oil on canvas, 19 x 22 in.

Fernande Olivier, Self-Portrait (above left).

F. Olivier, Portrait of Picasso (above right).

F. Olivier, Vase of Flowers (right). Oil on canvas, 19 x 15 in.

an intelligent observer of Picasso's highly ambivalent behavior with dealers. The trouble is that he hates to give up a canvas.

One day, however, Picasso found himself with absolutely no money, no paints, and no canvases, and he went to see Sagot, to ask him to visit his studio. The dealer knew perfectly well that only desperation would have prompted such a request.

Sagot goes up with Picasso and settles on three studies . . . offers seven

hundred francs for the lot; Picasso refuses. The dealer leaves and does not return. Several days go by. The painter decides to go and see him again. The dealer is still prepared to buy but this time is only offering five hundred francs for the three studies. Picasso is furious, tells him to go to hell, and comes home in a rage.

The same performance is repeated a few days later. Sagot is only offering three hundred francs now. Driven by sheer necessity, Picasso finally accepts.[2]

There has been so much written about Picasso's poverty in this period that one is tempted to pass over it, except that even when it was a question of economics, his determinedly quirky relation to practical life is on exhibit. He would, for example, unlike other painters, not try to exhibit: The criticisms he had received from earlier reviews had scored his self-esteem; he preferred his work to be characterized by friends like Apollinaire. In consequence, he sent paintings to neither the Salon des Indépendants nor to the Salon d'Automne, where the painters he knew were showing. Instead, he had to listen to increasingly more intense accounts by friends and artistic acquaintances of the excitement aroused by the Fauves. How could he not have had his share of envy concerning Matisse, Derain, Vlaminck, and Braque? He did stay in touch with dealers, but, as we have just seen, suffered humiliation. Once he sold ten drawings for twenty francs to Père Soulié, who dealt mainly in mattresses and bed frames. On another occasion, when his bill at an art-supplies shop reached 900 francs, he was cut off from artists' supplies. He was also rebuffed frequently by Ambroise Vollard, who, no matter his formidable reputation in Montmartre for promoting Cézanne, seemed unable to decide whether he approved or disapproved of this young Spaniard whose style didn't change so much as metamorphose; when Picasso sent a work over to Vollard by way of Max Jacob, the dealer turned down the painting. "Your friend is mad," he said to Max. "Go away." Or, so Jacob reports the dialogue.[3]

One time, their studio cat went prowling over the rooftops and came back with a large piece of stolen sausage. Fernande maintains she washed it well, and "I cooked it for us, who are much obliged, however, to share it with Minou."[4]

One day, when we were absolutely without anything, somebody came by to ask Picasso to do a series of drawings for *L'Assiette au Beurre*, a humorous review then in vogue. The offer was for eight hundred francs. He studied me, looking to know whether I wished he would accept it. He had a most unhappy air. I made him a sign: "No." He insisted, "Don't you want it? I understand, you know, I would do it for you." But—"No," I told him, "—it isn't necessary for you to do

anything that makes you unhappy." And I was thinking. Why, why do it? He will be disgusted, sad. And I, who am happy, wouldn't I then be unhappy? All right, then, let's avoid all that and everything will be fine. Tonight, however, won't we be hungry without our restaurant? And I am often without shoes. But I still had my little flask of perfume, my powder, my books, my tea, and Pablo's tenderness.[5]

It is a fetching tale of young lovers, but she leaves out some of the background. This offer has come by way of Kees van Dongen, who is the in-house artist for *L'Assiette au Beurre* and has passed this 800-franc job on to Picasso. On the one hand, an offer of friendship; on the other, van Dongen did use Fernande as a model in the summer of 1905 while Picasso was having his fling in Holland, and van Dongen, we may recall, owned an even wilder reputation than Picasso in Bateau Lavoir circles when it came to conquests with women. Now, a year later in 1906, he has painted Fernande most attractively, and certainly with more insinuation than Picasso. It is worth looking at the two portraits again. In 1905 van Dongen is obviously attracted, but sees her as one tough slut. By 1906 he seems to have acquired a subtler

Van Dongen, Portrait of Fernande Olivier, 1905. Oil on canvas, 39 x 32 in.

Van Dongen, Portrait of Fernande Olivier, 1906. Pastel on paper, 28 x 24 in.

and more loving carnal knowledge; he is, in effect, saying, "Very attractive indeed!"

One can ask, therefore, how much these two portraits of Fernande are a factor in Picasso's reluctance to accept the assignment.

On the other hand, he would play ceaselessly with van Dongen's child, Gusie:

> She could do with him anything she wished. I didn't know until then that he could please himself so with children. We had often wished to have one for ourselves, but this wish never realized itself, so it was necessary for us to content ourselves with little Miss van Dongen.[6]

While the evidence is not wholly established, the likelihood is that because of her marriage to Percheron and the attendant falls and beatings, Fernande could no longer have a child. Harlequin's wife now appears as a mother.

We are asked to feel the *pathétique* of the man who is ready to love Fernande and their child; on the other hand, Fernande is being punished. She lost her womb before she ever met him; that he will not forgive.

> Picasso, whose morbid, sickly jealousy is the unique cause of our occasional fights, has forbidden me to go to the Lapin Agile alone. One day, the proprietor, Frédé, being attacked, had answered through his window by firing his pistol on a man who was menacing him. The next

Harlequin's Family, 1905. Crayons and wash on paper, 6 x 5 in.

day, I did go alone to see his wife, Berthe, in order to hear the news about it. Picasso, who followed with the same idea, found me there. I received the most unexpected and formidable blow and felt myself being pushed brutally and with-

out concealment out of this place, under the horrified and ironic looks of the curious people who were gathered on the terrace.[7]

His jealousy is so intense that he locks her in when he leaves the Bateau Lavoir; indeed, he will not allow her out by herself. She can stay home and read; he will shop, he will see what is going on in the streets. He knows her well enough to suspect that she is no more trustworthy than himself.

> The other day I opened my door and the neighbors and the concierge were all in front of it, crying out to me that there'd been a fire started in one of the studios under ours. We would all burn up in this building of wood, and me with it. By the time I dressed, the fire was out. An alcohol lamp had burst, no more. However, I was afraid retrospectively. Pablo often closed and double-locked the door in order to keep me from going out. After that, he, feeling a good deal of fear when I told him the story, no longer carried the keys.[8]

The unhappy outbreaks, however, continue:

> Pablo had a stupid, jealous scene coming back yesterday evening toward midnight. We'd been at Lapin, and it seemed that I had unwittingly attracted some looks from one of the diners. I, then, reproached Pablo for some of his familiarities with women who are more or less friends. Hadn't I even found one of them sitting on his lap?
>
> At last, I became angry and, no longer knowing what I was doing, leapt out to the street and swept down rue Lepic, crying with rage. No longer even asking myself where I was going to put up for the night, still running. Pablo, who had followed, took me brusquely by the arm and wanted to go back to the studio. I refused to follow him, and he wouldn't let go. We were almost fighting. But my anger gave way to a sort of despair, and at last I let myself be brought to our house.
>
> The danger is that after such scenes, I begin to think of the meanness of the material life that I lead. I couldn't resist remarking on this to Pablo. He turned pale, didn't say anything. I thought that he would be angry with me, that I had lost something delicate between us, but I made no apologies and went to bed. He began to work, and I slept for a long time before he stretched out near me.
>
> I didn't hear Pablo leave. When I awoke toward noon, he was gone. I had fear. My love came back, reawakened most powerfully. I regretted my behavior. I asked myself if he would come back or if I was never to see him again. I didn't have the courage to get up. I tried to go back to sleep, and I'd almost succeeded when I heard the door open and Pablo came in. He came near the bed and said to me, "You sleep? You still want me?" I looked at him. He held out several bills and a

little package of perfume. Dear Pablo! If you knew how, at that moment, one thing alone made me happy. Your presence. Your love.[9]

It is tempting to receive all this as evidence of a passionate romance, and to a degree, it was: Long after it had ended, the romance, purified by recollection, kept a pristine life in Fernande's mind. If, in actuality, there had been the day-to-day reality of sexual roommates grating on each other's most private needs, she hardly suggests that in her account, even if it is obvious by the end in 1912 how they do not get on anymore. It is tempting, all the same, to think that they were truly happy for a period, and that their love might have gone on much longer if not for the entrance of Gertrude Stein into their lives. Gertrude's presence would change his grasp of the universe.

2

Such a premise is, however, hardly based on any clear evidence. New women, after all, were almost as important to Picasso as new concepts for his work, and since Fernande was ready on occasion to repay his infidelities with her own, their relationship contained its own large potentiality for coming apart. Moreover, Fernande's bourgeois roots had to irritate his own—she was an avid social climber. Given her miserable childhood in that ferociously French middle-class family, her social ambitions are comprehensible, but that, too, had to irritate Picasso. A judge can rarely forgive you for a crime he is capable of committing himself, and Picasso had his own agenda for social advancement. It was just that he was considerably better at hiding it, from himself as well as others.

We cannot blame Gertrude Stein, therefore, if the romance eventually failed, but it is hard to believe she was a force to keep them together. Too virulent a strain of concealed contempt for Fernande lurks in Stein's writings. In *The Autobiography of Alice B. Toklas* (that classic tour de force of boundless vanity where Gertrude Stein had the wit to write about herself through the eyes of Alice while never allowing her mouthpiece one irreligious reaction to her beloved mistress), we learn that Fernande is not to be taken too seriously. If Alice B. Toklas sounds most of the time like Gertrude Stein, lay it to Gertrude's reluctance to sound like Alice any longer than necessary. After all, why be Toklas when one can be Stein?

The geniuses came and talked to Gertrude Stein and the wives sat with me. How they unroll, an endless vista through the years. I began with Fernande and

then there were Madame Matisse and Marcelle Braque and Josette Gris and Eve Picasso and Bridget Gibb and Marjory Gibb and Hadley and Pauline Hemingway and Mrs. Sherwood Anderson and Mrs. Bravig Imbs and Mrs. Ford Madox Ford and endless others, geniuses, near geniuses and might be geniuses, all having wives, and I have sat and talked with them all all the wives and later on, well later on too, I have sat and talked with all. But I began with Fernande.[1]

. . . Fernande was . . . not the least amusing. We talked hats. Fernande had two subjects hats and perfumes. The first day we talked hats. She liked hats, she had the true french feeling about a hat, if a hat did not provoke some witticism from a man on the street the hat was not a success. Later on once in Montmartre she and I were walking together. She had on a large yellow hat and I had on a much smaller blue one. As we were walking along a workman stopped and called out, there go the sun and the moon shining together. Ah, said Fernande to me with a radiant smile, you see our hats are a success.[2]

Picasso and Fernande in Montmartre, c. 1906.

What is missing from this characterization (written a quarter of a century later, in a style that owes as much to early Hemingway as Ernest once owed to early Stein) is that Alice spoke so little French that she had to take lessons from Fernande. It is not easy to amuse someone who does not speak your language! As for Gertrude, however, let there be no mistake. She is more than amusing. On page five of *The Autobiography of Alice B. Toklas*, she gives, by way of Alice, the balanced measure of herself:

. . . I may say that only three times in my life have I met a genius and each time a bell within me rang and I was not mistaken, and I may say in each case it was before there was any general recognition of the quality of genius in them. The three geniuses of whom I wish to speak are Gertrude Stein, Pablo Picasso and Alfred Whitehead. I have met many important people. I have met several great people but I have only known three first class geniuses and in each case on sight within me something rang. In no one of the three cases have I been mistaken. In this way my new full life began.[3]

Gertrude Stein at home in the rue de Fleurus, Paris, 1905.

Patrick O'Brian gives a nice description of Gertrude's first meeting with Picasso:

Leo and Gertrude Stein, wandering along the rue Lafitte, saw two paintings in Sagot's shop that pleased them, the one by a young Spaniard whose name is not recorded, the other by Picasso. Stein bought the first and showed interest in the painter of the second, so Sagot sent him to Père Soulié [who] perceived that they

were Americans and therefore asked as much for his Picasso as Vollard asked for the Cézannes the Steins were then buying. They went back to Sagot who laughed and said that in a few days he would have a big Picasso for them, presumably at a reasonable price. When they returned to the rue Lafitte the dealer showed them the *"Fillette à la corbeille fleurie,"* a slim rebellious blackhaired child, worm-naked but for a little necklace and a hair-ribbon, looking sullenly at the painter as she stands on something tawny and holds an ornamental basket of red flowers, brilliant against the blue-grey background. Gertrude Stein did not like the picture; she found the child's long legs and big feet repulsive. But in the ensuing contest she was defeated; the price of a hundred and fifty francs was paid, and Leo Stein carried the "Fillette" home to the rue de Fleurus to join the Cézannes, the Gauguins and Matisses.

Presently the Steins were taken to Picasso's studio by a French writer who knew him, and they bought eight hundred francs' worth of pictures straight away.[4]

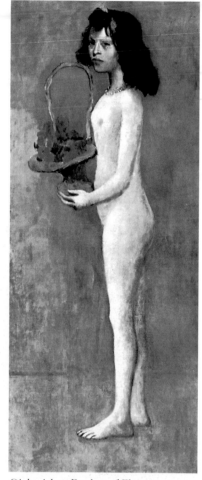

Girl with a Basket of Flowers, 1905. Oil on canvas, 61 x 26 in.

Here is Fernande's description of the same encounter:

One day Picasso and I had the surprise of seeing two Americans come to our studio, a brother and a sister, Leo and Gertrude Stein. He had the air of a professor, bald, with gold-rimmed spectacles, a long curled red beard, a wicked eye. A tall thin stiff body with cultivated gestures. She, fat, short, powerfully built, a beautiful strong head with noble features, highly accented intelligent eyes that see a lot, a clear spirit, masculine in her voice, in all her appearance . . . Both of the Steins were dressed in chestnut-colored corduroys and were wearing sandals. Too sure of themselves to pay attention to what others think, the brother is interested in being a painter and she in writing. She has received compliments from H. G. Wells and is more than a little proud of that.[5]

On this occasion, it was the brother one might notice first. He was tall; he was arrogant. Focused on the stimulations of his own mind, he was barely able to contain his contempt for the minds of others—a rich American eccentric, in short, who happened to come from a German-Jewish family so little Jewish that if Leo shared any attitude with Gertrude it was that they were both comfortably anti-Semitic.

Gertrude Stein who has an explosive temper, came in another evening and there were her brother, Alfy [Maurer] and a stranger. She did not like the stranger's looks. Who is that, said she to Alfy. I didn't bring him, said Alfy. He looks like a Jew, said Gertrude Stein, he is worse than that, says Alfy.[6]

Leo Stein, 1906. Gouache on tan cardboard, 10 x 7 in.

Leo Stein had studied medicine at Johns Hopkins and did not practice; he was a writer not able to write for four decades, a painter who gave up painting, an art connoisseur who spent time with Bernard Berenson only to become an early collector of the avant-garde, yet would be so repelled by Cubism that he ceased collecting. He had a "neurosis," as he would explain it. When not overbearing, however, he must have been a somewhat comic figure.

The best sense one can obtain of Leo Stein is from his book *Appreciation: Painting, Poetry and Prose*, published in 1947. It was intended to be the work that would show his sister up; he wished to demonstrate that he had forgotten more about painting than she ever knew, but Gertrude had the immaculate timing to die shortly before it came out. A full page of excerpt is worth presenting: It is not as if he had nothing to say.

. . . one day it occurred to me to ask the definite question: how does a painter see when he paints? . . . There is no use speculating when one can experiment; so I began to experiment.

I put on a table a plate of the kind common in Italy, an earthenware plate with

a simple pattern in color, and this I looked at every day for minutes or for hours. I had in mind to see it as a picture, and waited for it to become one. In time it did. The change came suddenly when the plate as an inventorial object, one made up of parts that could be separately listed, a certain shape, certain colors applied to it, and so on, went over into a composition to which all these elements were merely contributory. The painted composition on the plate ceased to be *on* it but became a part of a larger composition which was the plate as a whole. I had made a beginning to seeing pictorially.

What had been begun was carried out in all directions. I wanted to be able to see anything *as* a composition, and found that it was possible to do this. I tried it on everything from a scrap of paper torn from the corner of a sheet, to a line of trees extending half a mile into the distance; and I found that with practice seeing pictures was possible everywhere . . .

This habit of mine of seeing pictorial composition in nature, and seeing it anywhere and whenever I am so inclined, in little or on the grandest scale, makes me difficult in the acceptance of pictures. Such a landscape as Claude's and Turner's is for me picturesque only, not really pictorial. It is landscape as anyone sees it, composed, that is, within the limits of a naturalistic vision. In many cases Cézanne does not get beyond that in his composition as a whole. Only in China and Japan was this higher grade of landscape common, and its greatest master in Europe is Poussin.[7]

Stein is an archetype of the ideologue who legislates aesthetics. His definition of art is:

. . . nature seen in the light of its significance. Then, recognizing that this significance was one of form, I added "formal" to "significance." Significant form was then born for me.[8]

He exhibits a mind more powerful than Gertrude's, but even as she is a social creature whose greatest appreciation is for the ripples of social surface, so he is, by his own definition, an "explainer," and people who explain are an obstacle to be avoided in social life. He lives for the supremacy of his own opinion; her judgments are always social, which is to say, paradoxical—she would have been perfectly capable of making the following remark: *Apollinaire has strictures in his talent but his manners are redeeming, while André Salmon has talent in his strictures but no manners.*

One can conceive of Leo Stein grinding his molars at having to listen to such profitless equations when he is primed to declare that surrealism is overrated because it is structureless and no aesthetic can exist without structure.

Untitled (four drawings of Leo Stein), 1905.
Pen and ink.

It is tempting to imagine them together at rue de Fleurus. They were obviously once so close as brother and sister that she followed him to Johns Hopkins in order to study medicine alongside him, at which she was apparently a failure.

In anatomy, she could never succeed in drawing the human brain, or would it be fairer to say she came up with drawings of the brain that were like no others? She was always delighted, or pretended to be, in her absolute lack of depth, her resolute refusal to associate with the occult or the profound. Her self-satisfaction at this characteristic beams out of her prose in the *Autobiography*:

> Gertrude Stein never had subconscious reactions, nor was she a successful subject for automatic writing. One of the students in the psychological seminar of which Gertrude Stein, although an undergraduate was at William James' particular request a member, was carrying on a series of experiments on suggestions to the subconscious. When he read his paper upon the result of his experiments, he began by explaining that one of the subjects gave absolutely no results and as this much lowered the average and made the conclusion of his experiments false he wished to be allowed to cut this record out. Whose record is it, said James. Miss Stein's, said the student. Ah, said James, if Miss Stein gave no response I should say that it was as normal not to give a response as to give one and decidedly the result must not be cut out.[9]

She certainly detested the deep. Her values were to be found in her pleasures, and her pleasures were social. *So-and-so has a well-cut suit*, she might have written at any time, *but here-and-now does not. That is because here-and-now is half-German and half-Armenian and, as everyone knows, Armenians and Germans never mix.* It is more than worthy of the kind of talk one would later hear from people who congregated around Andy Warhol.

Beneath her impenetrable skin, as hard-larded as a walrus, she must have contained wounds, traumas, volcanoes—we don't know: She never lets us know. Once she did reveal that she was happy in her childhood when her father, a cold, domineering man, died, and it could certainly have been no routine matter to be an open practicing lesbian at the turn of the century, but she will never give us any of that. She is instead forever impressive in her own determined way, the way of a hostess; it was probably her first talent. As a writer, it is hard to say whether her reputation would be larger now or non-existent if Hemingway had not been her pupil in the Twenties. But he was—he took the live ember of her perception of a new kind of prose and carried it to places that affected generations of writers; if he had not come along, her work might have perished. Little of it does more than

entertain us today; much of it is pretentious or, worse, lumpy. She can be a very bad writer. Her book *Picasso*, published in 1938, shows a lazy mind, self-indulgent, and slab-sided. She is all too swollen in her sense of the importance of her perceptions and, surprisingly, unable to make a good point and keep it. The truth is that apart from her recognition of Picasso's talent—which is, admittedly, no small matter—she did not understand much else about him, and kept faking it.

Despite the incisive things she can certainly offer on occasion, her vanity proves oppressive. She must characterize everything whether she is near to the subject or not. At her worst she shovels obese generalizations from one pile of words to another. Here, for example, is her reaction in 1938 to Picasso's work following his marriage in 1918 to Olga Kokhlova.

> The Spanish character is a mixture of Europe and the Orient, the Russian character is a mixture of the European and the Oriental but it is neither the same Europe nor the same Orient, but as it is the same mixture the struggle to become once more himself was harder than ever and from 1924 to 1935 this struggle lasted.
>
> During this time his consolation was cubism, the harlequins big and little, and his struggle was in the large pictures where the forms in spite of being fantastic forms were forms like everybody sees them, were, if you wish, pornographic forms, in a word forms like Russians can see them but not forms like a Spaniard can see them.[10]

It was, in retrospect, inevitable that she and Picasso were absolutely taken with one another, she who could approach the deep only by way of these orotund excrescences, and Picasso who would never speak of the deep for fear of being cast instantly into the very abyss he was getting ready to explore.

3

Picasso's relationship with Gertrude Stein was at its most intense and interesting during the first few years.

He had an instinctive and immediate reaction to her. Gertrude stimulated him in ways no other person ever had. While neither of them could recall just when she began to sit for him, both agree that he asked her to model soon after their first meeting, and their acquaintance developed with an easel and canvas between them.

At the Bateau Lavoir she would sit through many an afternoon—she claims ninety such occasions, a large claim, but there may have been scores of such meetings through the fall of 1905 and the spring of 1906. She would take the trip across the Seine from the rue de Fleurus on the Left Bank to the top of Montmartre on the Right, and he would add to the portrait and wipe it away, and explore new passages and paint them over, looking for what he certainly could not name, and Fernande, nearly always present, would read from one or another French classic.

> Fernande spoke a very elegant french, some lapses of course into montmartrois that I found difficult to follow, but she had been educated to be a schoolmistress, her voice was lovely . . .[1]

In such manner would the hours pass, and it is hardly possible not to speculate on their inner state. Richardson suggests that "a powerful charge

> . . . was generated between them: a deep psychic feeling that went way beyond friendship and yet was not in the least amorous, often not even amicable . . .[2]

We are speaking of one of those rare but powerful relationships where people who have not much intimate affection for one another are nonetheless welded for a period in a Draconian relationship—not unlike serving in the Army, which is to say one of the most grueling experiences of one's life and one of the most valuable. Of course, this may exaggerate the difficulties. Those sittings, to the degree they were meditations, could also drift into more agreeable turns of thought, and Gertrude-by-way-of-Alice is quick to emphasize all that was pleasurable and profound in their meetings; but then, she is writing from the vantage point of 1933, twenty-seven years later, and Picasso is now comparable to Einstein in his fame.

> During these long poses and these long walks Gertrude Stein meditated and made sentences. She was then in the middle of her negro story Melanctha Herbert, the second story of Three Lives and the poignant incidents that she wove into the life of Melanctha were often those she noticed walking down the hill from the rue Ravignan . . .
>
> Practically every afternoon Gertrude Stein went to Montmartre and then later wandered down the hill usually walking across Paris to the rue de Fleurus . . . And Saturday evenings the Picassos walked home with her and dined and then there was Saturday evening.[3]

The Saturday night salon had begun. It grew quickly. Picasso was soon able to invite his friends to accompany him, and to their ranks were added any number of visiting Americans and several of the Steins' acquaintances. One of them, a spinster from Baltimore named Etta Cone, later remarked, "I found the Picassos appalling but romantic." (She is presumably speaking of Pablo and Fernande rather than the paintings, although Pierre Cabanne believes she is referring to the paintings.)[4]

Gertrude, by way of Alice, has another description of Picasso's appearance in her salon:

> . . . small, quick-moving but not restless, his eyes having a strange faculty of opening wide and drinking in what he wished to see. He had the isolation and movement of the head of a bull-fighter at the head of their procession.[5]

Others, Fernande and Salmon among them, will use the same image to describe him: A year or two later, entering a room followed by men as large in size as Braque, Derain, and Vlaminck, Picasso is the *torero* at the head of his *cuadrilla*; and when he is an old man, he will look like nothing so much as a venerable

ganadero, proud of his ranch and the bulls he has raised. We do well to remember the little boy on that Sunday afternoon in Málaga, ensconced in a famous bull-fighter's lap and dazzled by the suit of lights.

Now, at Gertrude's, he dazzles odd American ladies with his panache and his utter lack of it. Alice Toklas describes how in the course of the first meal Picasso would have at the rue de Fleurus, he was placed at Gertrude's right hand. When she picked up a piece of bread, he grabbed it back from her and cried out, "It's mine," only to look sheepish immediately thereafter.[6]

Brothers and sisters snatch bread from each other while growing up. Obviously, Pablo and Gertrude were related from the start. How much she must have reminded him of his fat aunts in Málaga and his hefty nude models in Holland.

He must also have been impressed by the Stein collection. By dint of careful choices, it was well commenced. "On all the walls . . ." we read in *Alice*, "were pictures . . . Cézannes, Renoirs, Matisses . . . Gauguins, a Toulouse-Lautrec . . . a little Daumier . . ."[7] Here is a corner of the room in 1907:

Some of the paintings in the Steins' collection at 27 rue de Fleurus, Paris, c. 1907.

By way of Picasso, Apollinaire became a frequent guest at the rue de Fleurus, but he did not necessarily take the Steins too seriously. About them, he would make this small reference in 1907:

> Vallotton . . . is exhibiting six paintings, among which is a portrait of *Mlle. Stein*, that American lady who with her brother and a group of her relatives constitutes the most unexpected patronage of the arts in our time.

> *Leurs pieds nus sont chaussés de sandales delphiques,*
> *Ils lèvent vers le ciel des fronts scientifiques*

> No more than Delphic sandals on their bare feet
> Yet such scientific brows glimpse heaven's suite[8]

Afterward, back in the Bateau Lavoir, the week would commence with more sittings. At this point, Picasso's sentiments are nice to estimate. It is never routine to feel like a snob and a bohemian at the same time, but then, back in Barcelona during the Blue Period, Picasso and his friend de Soto had wanted to look well turned out but had only one pair of gloves between them:

> They used to share it, keeping one bare hand in a pocket and gesturing ostentatiously with the gloved one. I remember Picasso telling me how elegant he felt, dressed in a green suit which he passionately admired, and his single glove.[9]

It is worth remembering that this is the same de Soto who is drawn in the winter of 1902–03 with a whore on his lap—a glove for one hand, a raunchy finger for the other. That can serve as an image for Picasso's social life now that Gertrude Stein has provided the glove.

A year or so later, Matisse would take his daughter Marguerite on a visit to the Bateau Lavoir:

> More than fifty years later she still remembered . . . Fernande's extraordinary beauty, [and] her way of producing sugar for their coffee—she went to a cupboard, scooped up a handful, and emptied it onto a clear space on the filthy table.[10]

The outcome of all those ninety sittings is, of course, engraved in art history by now. Gertrude, in her blithe fashion, gives the account via Alice:

> Spring was coming and the sittings were coming to an end. All of a sudden one day Picasso painted out the whole head. I can't see you any longer when I

look, he said irritably. And so the picture was left like that.

Nobody remembers being particularly disappointed or particularly annoyed at this ending to the long series of posings . . . Gertrude Stein and her brother were going to Italy as was at that time their habit. Pablo and Fernande were going to Spain, she for the first time, and she had to buy a dress and a hat and perfumes and a cooking stove. All french women in those days when they went from one country to another took along a french oil stove to cook on.[11]

By way of Gertrude, it is all part of the flow. Picasso paints out a head, *and* Fernande buys a hat, a dress, some perfume, an oil stove. Nothing in language or in life is more important, suggests Gertrude, than a conjunction. One thing does lead to another and then another. Structure is structureless, a river; how Leo must have hated her ever-flowing mind with never one composition to assert itself.

Hopefully, we are close enough to Picasso to assume that if life is a river, he was encountering a rapids. It was not like him to use a model over and over in the same pose. His virtuosity as a painter, his facility, his speed were all elements of his pride. He could work faster and better than any other young painter around. Now he is marooned for months trying to capture a short and very stocky woman.

We have to make the assumption that he is at a major crossroads in his life. He has been in the Rose Period for a long year and a half, time enough to recognize that it is a sinecure, not a breakthrough. He keeps hearing praise of the Fauves and of Matisse from people he respects—particularly, he is obliged to listen to Leo Stein pointing to Matisse as probably the most important young painter around. Matisse is certainly at the forefront of the avant-garde. The Rose Period is lovely, but it is safe. No one has to tell Picasso. Gauguin and Cézanne are his influences precisely because they have brought something radically new to painting. He is a young, competitive artist with the best-looking mistress in town, but he does not wish to be known for extraordinarily talented depictions of lovely and slightly eerie twilights with *saltimbanques*—not at all; he would rather push on into a visual world never explored, not even necessarily glimpsed. What we can count on is that in the person of Gertrude Stein he saw the embodiment of a set of exceptions to life that he, by his own perception, was also approaching. With his instinct he must have sensed that she was an appropriate Sphinx for him. She offered clues to his artistic future.

We have to assume that he is not only God-driven in his ambitions (which is

to say that he wishes to reach some recognition of how God does it) but that he feels an uncomfortable intimacy with the Deity. God is more dangerous than a full-grown bull in the ring when you are only a naked man; God creates earth-quakes and once again—night after night—lets your youngest sister die; God allows your beloved friend Casagemas to kill himself over a woman; God drives Max Jacob mad from time to time, usually when Max, far out on drugs, comes closest to Him.

God, however, is also a colleague. When Picasso draws, the line that delin-eates a limb seems to spring up out of some graceful collaboration between his hand and the power that conceived the design of that limb—God may be as amorphous as a cloud, but God is also as clear as a well-defined form. God is a dangerous foe because some of His secrets seem to be there to capture. That may indeed be the question: Can one enter the logic by which the forms of a human being are put together? Can one search out God's intentions, experiments, rejec-tions, new explorations?

The key is to be found in form. Form is the language that God has decided to share with a few painters, the very best painters. They are apostles serving the mystery of form. They know more about it than other men and women; they know that a tree can have virtually the same form as a torso. To a verbal mind, tree and torso are separate words and so are wholly separate objects, each with an integrity that is not to be breached. But to Picasso in Paris in 1906, possessed of a power to draw that has to be terrifying even to him, to this young artist with a mistress whose body he explores form by form, to Picasso at the age of twenty-five embarked on opium twice a week into exceptional odysseys of his mind, it is no small matter that a tree can share the same form as a torso, and a man and a woman are not separate entities but meet and coalesce and cross over in gender. Even if we take his explorations with Fernande as no more than sex revealed by opium, his mind had to be influenced by notions about his own gender. He does the shopping and the housekeeping, and she is larger than he is. As O'Brian describes it,

> the beautiful slattern Fernande, lying in bed at the Bateau Lavoir, sleepily watching Picasso sweep the lane that led from the divan "along a narrow valley among the empty sardine-tins and the respectable depth of oyster-shells" to his easel.[12]

Fernande may have been his best-found pleasure, but she was also his equal

and more; he lived in a state of bohemian tyranny where the sordid cohabited with the ideal, and he must often have felt—if in no other place than his dreams—that she was more of a man than he was.

Now, with Gertrude, he could feel himself in the presence of another possibility for love, which is to say he could lock himself into the person of another woman.

Not all love affairs are carnal; some can rest on the weight of the meditation each person inspires in the other. Pablo and Gertrude must have gone through their plenitude of sittings engaged in unspoken psychic transactions; they must have sensed on meeting that each had at last encountered another person with an ambition as large as one's own. Perhaps they struggled silently through those meetings over who could steal the most from the other, a witch and a warlock contesting a lust for power which the other could augment or diminish. Since neither was much removed from the mean-spirited and the diabolical, the real question is whether the sum of their game was for good or for ill.

That calculation is beyond our means, but it is safe to assume that Gertrude Stein was the most monumental crossover in gender that he had ever encountered. He had to be knowing about this. With Fernande, he had entered the essential ambiguity of deep sex, where one's masculinity or femininity is forever turning into its opposite, so that a phallus, once emplaced within a vagina, can become more aware of the vagina than its own phallitude—that is to say, one is, at the moment, a vagina as much as a phallus, or for a woman vice versa, a phallus just so much as a vagina: At such moments, no matter one's physical appearance, one has, in the depths of sex, crossed over into androgyny.

Picasso was obsessed with the subject. For good cause—it spoke to his preoccupation with form. The range of Gertrude Stein's crossover from woman to man could simply not be charted by ordinary means; if she was more like a man than a woman, so she was still by birth a woman, and so a focus for his own preoccupation with androgyny. That confirmed his private sense of himself in acts with Fernande (as well, doubtless, with many another woman). If in the act he felt himself to be part man here, part woman there, whole man here, whole woman there, then sex might be seen as a pool where forms swam over into other forms.

For Picasso, the virtue of androgyny was that it traversed contexts; a nude of a woman to which one added a phallus produced a man; a woman kneeling face-down on the floor could show a back and buttocks that looked like a phallus and

a pair of testicles. We need only peek at a couple of drawings taken from one of his sketchbooks early in 1907.

Untitled (Nude Studies), 1907. Pen on paper, 12 x 10 in.

Seated Nude, Legs Spread, 1907. Lead pencil on sketchbook paper, 10 x 8 in.

After the summer of 1906, he came back from Spain to the Bateau Lavoir and finally painted Gertrude's face in a manner to satisfy him. It had taken months, followed by a summer of being away from the portrait. Trying to obtain a canvas of Stein that would satisfy him, he must have had his fill of alternatives. If it took until 1907 for him to draw a woman with a phallus, he spent much time in 1906 attempting the opposite: He was looking to reduce the differences between Fernande and Gertrude. So he made Fernande heavier, gave Gertrude less bulk, and equated their faces, their expressions.

Two Nudes Holding Hands, 1906. Pen and wash on paper, 19 x 12 in.

Woman Seated and Woman Standing, 1906. Charcoal on paper, 24 x 18 in.

Two Nudes, 1906. Oil on canvas, 60 x 37 in.

He also made Fernande look older in order to bring her physiognomy closer to Gertrude's. We see Fernande as he thinks she might look in ten or fifteen years if, that is, she grows to resemble Gertrude.

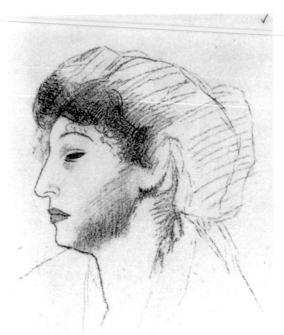

Untitled (drawing of Fernande Olivier), 1906. Lead pencil.

Untitled (drawing of Fernande Olivier), 1906. Pencil.

Mainly, he wrestles with the enigma of Miss Stein. He must work on the premise that if he can solve the riddle she represents, much else will open. She is so exceptionally authoritative. God has come down to visit us in the form of a woman who acts like a man. It must add to his conviction that she is a creature out of the depths, there to provide him with clues.

Failing completely to capture any authoritative sense of her by the spring of 1906, he not only paints out her face but comes up with the formidable body of an earth goddess.

Still engaged in his contemplation of Stein, he paints one of the last of his Rose Period pictures. If it does not contain the hue of rose, it is one of his best all the same, one of his most famous, and forces the suggestion that he is the boy leading a horse more powerful than himself. Would Gertrude have liked or disliked the notion? She did, in any event, purchase the painting. The horse was so graceful,

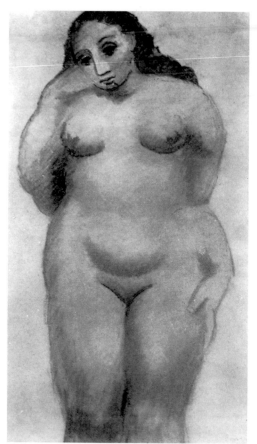

Nude Woman Standing, 1906. Pastel.

Boy Leading a Horse, 1906. Oil on canvas, 87 x 52 in.

quite the image of herself if she chose to come back as a quadruped.

The actual portrait of Stein (see page 215) was, of course, to become famous. The face is an astounding mask; the eyes are unseeing or, rather, in-seeing, and hint at the force buried within her. She is enough of a presence to make it an unforgettable portrait.

She also stands at the crossroads. She is asking in effect where Picasso can go next. Three years down the road, there will no longer be a road. He will live in a network of forms that have become crossovers between a still-life, a human, and a forest, between a forest and a city; in short, Cubism. But first, the Sphinx is fashioned in a formal portrait without more than a hint of the painter's underlying ambition to be ready to examine nothing less than the laws of existence. If a small part of him, still Catholic, had to be terrified of the sacrilege implicit in such pur-

suits, his work would throw up shields to keep him in check as often as he would sally forth to attack conventional vision. It is hopeless to understand Picasso without comprehending that he was not only a painter but a primitive hunter and a medicine man. If *Les Demoiselles d'Avignon*, now less than a year away, can in large part be comprehended as an exorcism, a literal scarecrow—there to repel spirits and demons—Gertrude's portrait precedes it. In relation to what was to come, her painting sits like a great stone god on the path.

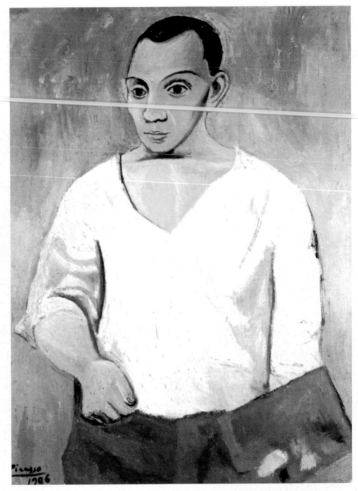

Self-Portrait with Palette, 1906. Oil on canvas, 36 x 29 in.

That he does a portrait of himself in the same period on a canvas almost as large can be no coincidence. There he is, her younger sibling, her fellow mask. He looks haunted. He is hiding both of them.

One evening at the rue de Fleurus, Picasso would remark, "Everybody thinks she is not at all like her portrait but never mind, in the end she will manage to look just like it,"[13] and that is true. By the time she died, no one said any longer that Gertrude's portrait did not look like her, but then, we have all heard that long-married people grow over decades to resemble one another more and more, and so could Gertrude have been married to the image Picasso had finally been able to offer of her.

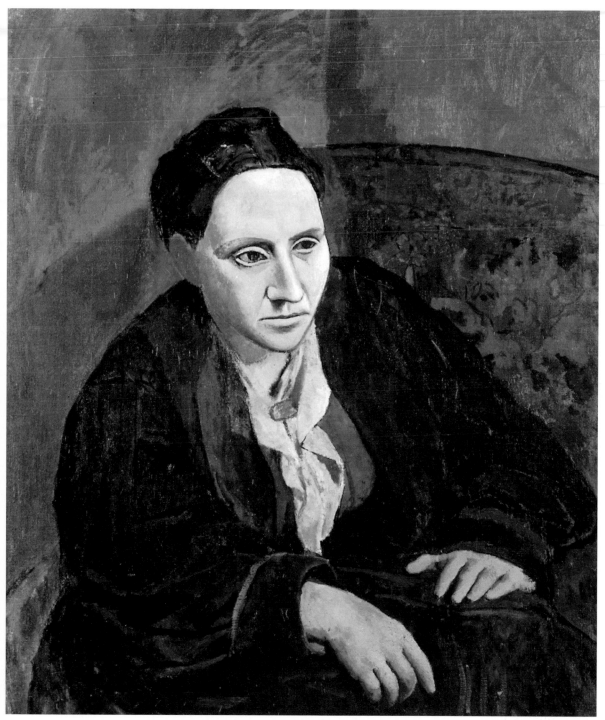

Portrait of Gertrude Stein, 1906. Oil on canvas, 39 x 32 in.

4

During those months, his life did not, of course, consist entirely of sittings between Stein and himself. He was having his nightlife in Montmartre. One of the secrets of Picasso's longevity must have rested on his ability to live not as one individual but two.

In *Picasso and His Friends*, Fernande is ready enough to give a picture of their milieu:

> All the artists used to gather at the Lapin à Gill: on the terrace on summer evenings, in the dark smoke room inside during the winter.
>
> Frédé, the *patron*, used to pay return calls on Picasso. I can still see him arriving at the painter's house, escorted by his donkey, Lolo . . . Frédé used to bring the good, simple creature right into Picasso's studio, which was not difficult as the studio was on the ground floor. While we were drinking the apéritif Frédé had brought with him, Lolo would be tied up in one corner and nibbling at everything within reach. One day he devoured a packet of tobacco and two silk scarves which had been left on the sofa.
>
> Picasso loved animals; they always found favour in his eyes. He would have liked to possess a cock, a goat and a tiger, but he contented himself with dogs and cats, and later a monkey. There was a time, I think, when he had three cats, two dogs, a tortoise and a monkey.[1]

Morale in bohemian life depends on war stories, and Lolo had already become famous. Fernande mentions how "as a result of an art-students' prank thought up by Dorgeles," a paintbrush had been tied to Lolo's tail, and the donkey's swipings

on a canvas (with, presumably, an occasional change of pigment) managed to produce three works that were accepted by the Salon des Indépendants.[2]

Since Picasso had become equally celebrated for firing his revolver, it was appropriate for Frédé to bring Lolo over on this visit. In bohemian life, gestures are life-giving elements in the face of everyone's collective poverty; gestures take on the ambience of old songs, but then, such episodes were not commonplace. Fernande confesses, "There was very little variety to our amusements and distractions . . . evening followed evening with little to distinguish one from another."

Picasso didn't like the theatre; he found it boring. As for orchestral music, he might perhaps have liked it if he'd not been afraid of making foolish judgments, for he knew nothing about it at all . . . and he never went to a concert. Perhaps he's changed since.

What he did like was the guitar, guitarists, Spanish dance and dancers and gypsies, everything which reminded him of Spain. He was always moved by the women dancers, [who] manipulated fan and castinets with such skill and elegance. Every time he listened to the guitarists he marveled afresh. He had never been an exuberant person, but he was capable of intense concentration. Feelings like these would transmute themselves into an expression of tenderness, which could illuminate his whole face . . .

Picasso always seemed drawn to those things which he would never be able to do himself, and people who were totally different from him. He loved risqué cabarets and music-halls . . . anything with strong local colour, and a characteristic smell could fill him with ecstasy . . . How foreign he was in France, this Andalusian with Italian blood . . .

He was always attracted by anything which reflected that quality of harshness which seems to go with being poor and is often accompanied by a special sort of naïveté in Latin countries . . .

On evenings we went to the Médrano circus Picasso would spend all the time at the bar, which was always thick with the hot, slightly sickening smell that seeped up from the stables. He would stay there all evening . . . talking to the clowns . . .

His love for boxing was of a different order. Physical strength . . . compelled his admiration. He was affected by the beauty of a fight as by a work of art. He liked boxers as much as he liked clowns, but differently. They seemed to awe him. He would have been proud to make friends with a boxer.[3]

To refer once again to the legend of Picasso as a formidable stud, there is probably more evidence that he was not macho so much as an acolyte of machismo.

Today, in a world of prevailing feminism, machismo is scorned. Yet, few men are able to sneer at it with absolute confidence. The case for machismo, if we can put its extravagances and violence to the side, is that it is not an easy way to live. When one puts a large investment in personal honor, day-to-day security is mortgaged for life. One's physical bravery is always to be called upon. Few men, therefore, are honestly macho—most depend on their ability to play a role rather than to embody such a life at all costs. If, even in the face of contemporary ridicule, men still strive for machismo, that is because it speaks to a primitive certainty in male gender—even as a similar claim might be presented for elegance in women. Yuppies and wonks may scorn the first, and liberated women repudiate the second, but their ridicule remains subtly uneasy. Not many have a conscience so comfortable or so blind that they can condemn either without a backward look.

If that is true today, what is to be said of the force of machismo upon Picasso's values at the turn of the century? He came from Andalusia, where men prided themselves, often over a lifetime of inflated and frequently absurd postures, on precisely how macho they were. Picasso began as the most timid, sensitive, and cowardly of little boys, a crybaby in school, a household pet with plump aunts to cozen him. It can be taken as fundamental that every one of his male qualities was earned in hard fashion, each bold new habit fashioned from his limited store of physical bravery. So he could be sure of none of his acquired macho characteristics. Full-grown, he still was short; well-muscled, he nonetheless was not significantly endowed with strength when compared to painters like Braque and Vlaminck and Derain.

[They] made an astonishing and certainly imposing trio. People would turn around to look at them in the street. All three of them were very tall, with big shoulders, and they gave an unusual impression of sheer physical power.

Derain was the tallest of the three. He was slim and elegant, with brilliant coloring and smooth black hair. His elegance was English and slightly over-done. He wore elaborate waistcoats and green or red ties. His pipe was always in his mouth; an essential feature of his phlegmatic, mocking, cold and argumentative nature.

Braque was shorter and heavier, with a powerful head which made him look like a white negro. He had the shoulders and the neck of a boxer, very brown skin, curly black hair, and a clipped moustache. There was something a little affected about the brutality of his expression and the coarseness of his voice and gestures . . .[4]

Vlaminck was massive, with red hair; he had a

brutal, stubborn expression, which made one think that he knew what he wanted

. . . He had once been a racing cyclist and he was so strong that he believed he was naturally invincible. When occasionally, owing to lack of money, he had to walk all the way back to Chatou at night, he told us that he was sometimes obliged to defend himself on the way against various forms of aggression, and that he always emerged victorious from such encounters because of his superior physical strength.

He used constantly to deny the efficacy and value of boxing, as opposed to simple brute force, until that day when Derain and Braque, both of whom boxed regularly, beat him, one after the other, and conclusively. We met him as he was leaving Derain's studio, his nose swollen like a potato and in a pretty sad state, although totally convinced.

Picasso was attracted by boxing. He enjoyed going to fights and he used to follow them keenly. He would have liked to box himself, but he hated being hit, though he liked the idea of dispensing blows himself. He had one lesson with Derain, but that was enough to last a lifetime.

The four of them used often to go out together, Picasso looking very small beside them, but being thick-set he gave a quite illusory impression of physical strength. He delighted in the thought that he might be taken for a boxer because of his three companions.

The fact is that Picasso, though he always wanted fame and glory, longed to achieve it in spheres outside his own. Max Jacob once said of him that he would rather have won fame as a Don Juan than as a great artist.[5]

Yes, next to them, Picasso was a spoiled darling. It helps to explain his infernal possessiveness concerning Fernande. Doubtless, he had some cause to be insecure, but his jealousy smacks of a man who is always aware of his own sexual lacks—he seems to believe that any stud could come along and steal her. They are close, however; they are, according to Fernande, very close:

Our amorous life doesn't seem in any way diminished. To the contrary, I believe that more and more the ties deepen between us, the ties of our entire nature. Physically, morally, and sentimentally, we are in accord. There are wounds—our characters, our natures are too large not to cause that occasionally—but what is that? . . . I know to what a degree he regrets that he is not able to offer me all that I could desire, but I don't ask anything, and keep jealously to his tenderness.[6]

Nonetheless, he rarely trusts her. And then, of course, it is never so simple as that. Orgies, if on a local Bateau Lavoir scale, had to be part of the game, and orgies rarely fail to be a study in prowess and, soon enough, a jealous drama.

In this light, we can take an anecdote out of a memoir from a bright young girl visiting Paris from San Francisco. Her name was Annette Rosenshine and she had

a hare-lip disfigurement about which she was excruciatingly sensitive. She would later bring Gertrude and Alice Toklas together, but what is relevant here is the tale she tells.

I accompanied Gertrude to Montmartre one Sunday afternoon when she suddenly decided it would be interesting to drop in at Picasso's studio, at the Bateau Lavoir . . . Perhaps she may have had some curiosity about my reaction to the . . . painter whom she, as one of his co-discoverers, described as an artist of great promise. Well, he was surprisingly interesting, and I suspect Gertrude was as much surprised as I was when we finally found him. Gertrude had knocked at the door of his studio, but there was no response. Believing that he must be somewhere in the building, she prowled about and tried several doors without success. At last, recalling that Pablo had been planning on getting an extra room as soon as he could conveniently do so, she went to one that she knew had recently been vacated. Again, no response to her knock. She turned the doorknob and pushed—there on the bare floor of a completely unfurnished room lay an attractive woman between two men—Picasso on one side; I cannot recall the name of the other man.

They were fully clothed. The woman, I later learned, was Picasso's mistress, Fernande Olivier . . . They were lying there to rest from a Bohemian revelry the night before; life had caught up with them—Picasso's newly acquired atelier had been put to use. That was what Picasso told us without disturbing himself or bothering to get up. None of the three made the slightest movement towards changing their position.

My attention was instantly focused on Picasso. His eyes had a luminous, penetrating quality that was evident despite his having been so rudely awakened after his gay dissipation—so much so that only gradually did I become aware this sturdy well-knit body was actually that of a small man.

Picasso and his companions said nothing to indicate that we were *de trop*, but since they were disinclined to get up or incapable of it and did nothing to detain us, we left. As we stepped into the dimly lighted hall, closing the door behind us, Gertrude gave me a quick quizzical look that told her interest in my response to our Bohemian foray.

She obviously expected me to be shocked. I resolved to display nothing but complete aplomb. This was easy for me to do. What I had just seen had actually delighted me. Startled as I was by the sight of the three lying on the floor, I felt a keen pleasure to see people so completely natural, so free of the inhibitions that make most of us like automatons. Also, for me it savored of something out of du Maurier's *Trilby*.[7]

Richardson ascribes the "luminous penetrating quality" of Picasso's eyes to hashish or opium and mentions a note in Picasso's Gósol sketchbook. "*opio, azafran, alcool, laudano.*"[8] These were still the years when Picasso was pushing his explorations into sex, drugs, and the partouse, but it is well to keep in mind that he was also a man who could not dance and could not box. (Doubtless, his one session with Derain convinced him that his hands and his eyesight might be impaired.) Nor could he swim. In later years on the Côte d'Azur he would clown away at it, standing waist-deep in water, bent over from the hips and moving his arms at a great rate while he remained in place. Neither could he drive a car. Four decades later he would be enraged when his son Paulo, looking to be superior to his father on precisely one of Papa's weak links, would put his motorcycle through a series of stunts while riding in front of Picasso's chauffeur-driven Hispano-Suiza.

In compensation for avoiding all sport with hazard, Picasso would take his exceptional reflexes of hand and eye and give them over to his painting and to his fucking. Naturally, his impulse in those early years was to lock the door and keep Fernande inside. He had, doubtless, a large gift for lovemaking, but it was circumscribed by all the ways he could not protect it from other men. So, Fernande was well loved but under lock and key—except for the occasional orgy where he could not only participate but double as monitor. Paris days!

There will come a period, nonetheless, in the spring of 1906 when Pablo and Fernande, blessed with a windfall, use it to take a trip to Barcelona and the Pyrenees. There they have an idyll and he does a considerable amount of work and will even seem confident in his possession of her.

5

Picasso had been away from Barcelona since the spring of 1904. Two years later, he was still hearing from his mother, who would send a copy of the Barcelona newspaper *El Noticiero* and an all-but-daily letter to accompany it. She was more than curious about Fernande. If Picasso had no great funds of affection left for his father, who shrank into progressive narrow-mindedness, his mother blossomed as she grew older, and her admiration for her son and his genius increased all the time whether she comprehended his work or not.

An unexpected visit later in April made it possible for him to leave for Spain and even take Fernande. Apollinaire arrived at the Bateau Lavoir bringing with him Ambroise Vollard. Picasso was in his

Picasso's mother, María, c. 1906.

studio with Fernande, Max Jacob and André Salmon. To the amazement of everybody present, the dealer who had not long before called Picasso mad proceeded to buy thirty paintings and leave behind two thousand francs, an incredible sum at their then rate of spending, more than enough to cover their household expenses for the next three years. It was a particularly moving moment for Max, who, a few years earlier, when Picasso was sick, had tried to sell Vollard one of his friend's landscapes. "The bell tower is crooked," he was told disdainfully, and with this the dealer, refusing to waste any more time, had turned his back on him. Now he watched triumphant as Vollard loaded the cab that had brought him to Montmartre with thirty canvases until there was no more room left in the back and he had to sit in the front with the driver. "Max and I," wrote Salmon, "gaped at this sight. [He] clasped my hand without saying a word, without looking at me, utterly content, his eyes like seascapes, full of tears."[1]

They had the money at last for Picasso to return home in style. Fernande's voice reminds us that this is the first long trip she has ever taken:

> I passed the night without sleeping. Exhausted and ill at ease in our third-class compartment . . . I was worn out, and sadness filled me.
>
> In Spain, in a first-class compartment, since it was impossible to travel in any of the lower classes without large inconvenience, I found again a little of my first excitement, but toward evening, 7 o'clock, coming into Barcelona in the middle of a noisy and tumultuous Catalan manifestation, I felt despair surrounding me and, beginning to weep, I begged Pablo to take me back to Paris. He loved me and couldn't bear to see me cry. I believe, if there had been a train ready at that hour to leave for France, we would have gotten on it. Happily, there wasn't.
>
> In La Place Catalan, at the Hotel D'Angleterre, after having taken a bath, I allowed myself to rest under the hopeless look of Pablo, and slept, without dinner. I awoke the next day, relaxed and happy, and was ready to stay. Dear Pablo, full of anticipation, had only been thinking of seeing me happy at the expense, even, of his personal pleasure. Except for his work, I think the most important thing in the world to him was the woman that I then represented. I would like to say that he loved me, because I believe that, despite all that followed, I was the great love of his life, as I was also his great torment.[2]

They spend a couple of exciting weeks in Barcelona, impressing his family and friends with Fernande's beauty and sophistication. Her perfume precedes her entrances and extends her farewells.

Fernande, Pablo, and the writer Ramón Reventós at El Guayaba, May 1906.

She is also seeing a side of Picasso not glimpsed before:

> The Picasso I saw in Spain was completely different; he was gay, less wild, more brilliant and lively and able to interest himself in things in a calmer, more balanced fashion; at ease, in fact. He radiated happiness . . .[3]

Out of this splendid mood comes a desire to work again in the Spanish countryside.

> Pablo decided to go to Gósol, a little village in the Pyrenees, near the valley of Andorra . . . It was necessary, in order to get there, to take a trip for several hours

on muleback. Sometimes, one had to go along paths bordered on one side by a mountain wall so near that one rubbed one's knees and one's hands, yet on the other side was an immense drop, forcing me to close my eyes in order to avoid vertigo . . .[4]

Once arrived at Gósol, she finds it "enchanting." Its high altitude offered pure air and the sight of clouds below them. The natives appeared friendly, even hospitable, and the atmosphere was perfect. "Nearly everybody did contraband. We had found happiness, perhaps."[5]

The town offered a population of nine hundred people who had survived for centuries on agriculture, on sheep, goats, on cattle, a place not unlike Horta de Ebro. It had only one inn, the Cal Tampanada, where Picasso and Fernande would stay, but Picasso had the pleasure of being again with people who only spoke Catalan.

> The views all around are superb, with the Cadi range of mountains on one side and the defiant peaks of the Pedraforca on the other.
>
> The village was—and still is—a very healthy place, with "good air, good water, good milk and good meat," as I was informed in the usual abrupt manner adopted by Picasso's friend, Dr. Cinto Reventós, who used to send some of his patients there. . . .
>
> This delightful natural environment had a very direct effect on Picasso, freshening and invigorating him, opening up his imagination, filling his lungs with clean mountain air.
>
> I should here point out, once and for all, that the earth of Gósol, contrary to what other writers may have said, is not ochre but grey. It is only after strolling all around the village and observing it carefully that we can understand the origin of certain colours that Picasso now added to his palette. Gósol is a village that nestles into a mountain slope, and so one's eyes often see, *below or straight in front of one*, the tiled roofs of the neighbouring houses or the ones in the next street. Thus one is constantly surprised by the rich variety of tiles in ochre tones, sometimes vivid yellow and sometimes burnt or rusty. I think these were the colours which, by contrast with the greys of Paris, attracted Picasso and were thus integrated into his work.[6]

Fernande remarks on the improvement in his health after simple food and much hiking on hunting expeditions. Such trips for game also served the villagers as a cover on smuggling expeditions across the border to Andorra, and Picasso made friends with an old and formidable man, an all but ancient smuggler of

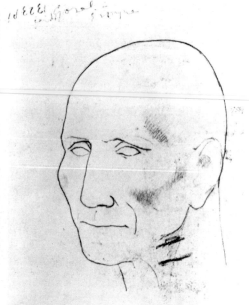

Head of Josep Fontdevila, Gósol, 1906. Oil on canvas, 18 x 16 in.

Head of Josep Fontdevila, Gósol, 1906. Pencil on paper, 17 x 13 in.

ninety, José Fontdevila, who became his closest friend in Gósol. Richardson comments on how smuggling

> is the activity that Picasso remembered most vividly about Gósol. The risk, excitement and profit; the way it pitted noble outlaws . . . against the inimical forces of law and order: all this made the smuggler someone with whom he could identify— a fellow outlaw.[7]

The middle-class artist is not only at war with the stultifying weight of his or her origins but, perversely, is trying to bring illumination to those roots. So the artist serves as a surrogate Robin Hood seeking to bring alms to the spiritually poor—that is, the benighted middle-class family that he or she comes from. Of course Picasso would love an old smuggler.

The air of the mountains now replaced the cigarette smoke of the cafés, and he was alone for the first time in years with his instincts. Much of his well-being had to be a reflection of his confidence in work; we can well suspect that he saw good uninterrupted work as the most profound blessing he would ever experience.

To say that within his labors he finds his strength is almost to miss the point. In his work was where he found the surest sense that there was iron in his soul, and

Two Brothers, Gósol, 1906. Gouache on board, 31 x 23 in.

Two Brothers, Gósol, 1906. Oil on canvas, 55 x 38 in.

nothing would stop him—a necessary self-recognition without which one is no more than a genius to one's friends. The work in this period certainly reflects his calm and his certainty.

Picasso will embark on startling new directions soon after his return to Paris, so it seems reasonable to assume that in Gósol, he is taking artistic farewell of all that he has learned about painting in his first twenty-five years. It is as if he is enjoying a sensuous collaboration with all he has achieved up to this point and is

Woman with Boy and Goat, Gósol, 1906. Oil on canvas, 57 x 44 in.

presenting those images and techniques of which he is supremely confident. He is further away from depression than at any time since he entered the Blue Period.

An event occurs, however, which shatters every security he has enjoyed in Gósol. If his fundamental belief is that one's personal life is but a prelude to catastrophe, this fearful intuition is activated again. And at a stroke! Soon after he completes a portrait of the smuggler Fontdevila's granddaughter, a ten-year-old, she comes down with typhoid![8] If we are correct in assuming Picasso believed that paintings were magical shields against ugly forces, then the converse proposition has also to be entertained: Magic is a gamble—one is changing the given by means of extraordinary procedures; one is tampering with the processes that govern everyday existence. Given the stakes of such a wager, magic must be immaculate. For if an error is committed, then one has set a trap for oneself and for one's friends. A magician whose curse or blessing goes wrong does well to feel terror, and Picasso was wholly panicked by the child's illness. Did he begin to see again the dead girl of the autopsy in Horta, struck by lightning, her head sawed down the middle?

To Fernande's considerable unhappiness, he decided to take leave at once. They set out from Gósol before dawn on mule-back for a town called Bellver. There they could obtain a coach, and go on to Ax, where there would be a train to Paris. On the route, however, their mule-train was thrown into disarray by some wild mares who ran by, and a set of near-catastrophes ensued, with rolled-up canvases and suitcases strewn over the trail by the bolting mules.[9] It was all put together again by the mule-drivers and the mule-train continued, but they never reached Bellver that night, and Picasso, hard put not to see it as one more malign indication, was ill.

Fernande takes up the narrative:

> Returning to Paris at last, we found the studio stifling in the August heat. The mice had come out in force and chewed up everything under their teeth. For want of anything better to eat, they had torn into confetti the yellow cloth of a parasol and a long shirt forgotten on my departure that I'd liked very much for its *chic*. I was very upset, but even more a little later when, lying down, we discovered that the bedbugs had also profited from our absence to take over the bed in our little room. Emigrating then to the divan, they found us there as well, which obliged us to take refuge I no longer remember where, and after getting some sulphur to burn, we were able to clean up our studio.[10]

Most striking is the way Picasso now finds himself in a good mood. If the

mishaps on their route had suggested a curse so pervasive that it might be capable of following him, then how cheap a sacrifice were the bedbugs and the mice. Fernande loses a shirt and a parasol, and he is obliged to fumigate his studio. An acceptable loss!

Soon after their return, he finishes Gertrude's portrait and provides her with a mask for a face. He will use masks in preference to faces many times over the next six and a half decades. If a form can represent more than one object, so can a mask serve for a multitude of men and women, and archetypes in nature as well. A face, once distorted, can also look like a teapot or a torso, or a misshapen rock.

Soon, in Paris, he will draw again the face of the old smuggler Fontdevila—as a mask. *Les Demoiselles d'Avignon* comes nearer. But then, Picasso is so fascinated by the striking form of the old man's bone structure that it will be repeated sixty-six years later, when Picasso, after every delay and evasion, is now close to ninety years old and is facing into his death.

All but obsessively, that canted drawing of Fontdevila will reappear in other sketches through the winter. As Picasso's style grows older and certainly more harsh, intimations of *Les Demoiselles*

Self-Portrait, Mougins, July 1972. Pencil and white chalk on paper, 26 x 20 in.

Bust of a Man (also called Head of Josep Fontdevila), 1907. Charcoal on paper, 25 x 19 in.

Untitled (drawing), 1907.

Nude with Her Right Arm Raised (above right), spring–summer 1907. Watercolor, 9 x 7 in.

Untitled (right), 1907. Watercolor, 9 x 7 in.

d'Avignon begin to appear; Fontdevila's face emerges in the guise of a female torso or a vase, and hints of the old smuggler's cheekbones can be seen in every jagged out-thrust limb or contour.

Fontdevila poses his enigma: Why does he present so obsessive a theme to the painter? Since he is a smuggler—which is to say, an agreeable criminal—and has managed to live to an old age, that obviously sat-

isfies much in Picasso. To be free of society and yet to endure, to be even respected. That is a feat.

In any event, Picasso is fascinated by the form of Fontdevila's face. The distortion of the facial bones intrigues the painter endlessly. It is as if the angles of that carbuncular cheekbone hint of future distortions of form that Picasso will not use to full effect for another twenty-five years, of faces drawn as if we were walking around them, so that where one used to see a profile, a three-quarter view, and a full face in succession, now all three can be perceived at once.

Here are paintings from 1932, 1939, and 1943.

The Dream, 1932.
Oil, 50 x 38 in.

Head of a Woman, 1939. Oil on paper, 17 x 11 in.

Bust of a Woman, 1943. Oil on canvas, 28 x 23 in.

Part VII

The Brothel

The radical shift in style that is approaching will come not only from the best of his impulses but also from the most calculating. Given the seriousness of his talent, his motives have always to be respected as aesthetic—yet all the same, a part of his ambition has to be on edge at this time: He is performing superbly at what he can already do, but is he conquering any new worlds? Can he still believe that he is the most exciting young painter in Paris?

Writing some five decades later, Fernande reflects on this period of 1906–1907 as if it were still outraging her conservative instincts in art:

> Among the drawings he has done of me, there is one which surprised me and made me reflect. The portrait was classic in style, and revealed a mastery in a genre altogether opposed to his new explorations. This study that he never shows to anyone, that he puts away carefully in a cupboard reserved for secret works, this portrait, calm, sensitive, and severe in line . . . Oh, I like it so much. What has become of it? Without doubt, it's still in a cupboard.
>
> At this moment I ask myself whether he isn't really a repressed person who won't accept this form of art, [and sees it as] opposed to his desperate will to become chief of the most adventurous school in order that others would have to follow him.
>
> A great ambition excites him. He has always refused to show in exhibitions, to become part of the artistic movement of his time. He wants to create a new form, be an innovator rather than a follower of great traditions . . . he wishes to subject his art to new laws. So, he struggled against all his human sentiments. If his eye

captured something, he distrusted his eye. His spirit alone, his sense of fantasy, his will must guide him. His facility irritated him. He will oblige his hand to upset a harmonious and musical design. He will wildly deny such music, destroy the harmony in it, rip apart the features, the volumes, the tones . . . in order to arrive at a synthesis that he has willed—perhaps incoherent to ordinary people—but illumined with his inspiration.[1]

There is no record of his feelings toward Apollinaire in this period, but Picasso could have been wondering whether his poet friend, by inspiring the Rose Period, had steered his painting into a cul-de-sac. If Picasso's ambition as he once expressed it in Gósol was to be the tenor who hits the highest note, he now has a formidable rival in Henri Matisse, twelve years older than himself and most impressive in person.

They are brought together by Gertrude Stein, who characterizes their relations with her predictably synoptic and determinedly casual air:

> Matisse and Picasso then being introduced to each other by Gertrude Stein and her brother became friends but they were enemies. Now they are neither friends nor enemies. At that time they were both.[2]

Fernande gives a more useful description of her reactions to the meeting:

> There was something very sympathetic about Matisse. With his regular features and his thick, golden beard, he really looked like a grand old man of art. He seemed to be hiding, though, behind his thick spectacles, and his expression was opaque, gave nothing away, though he always talked for ages as soon as the conversation moved on to painting.
>
> He would argue, assert, and endeavor to persuade. He had an astonishing lucidity of mind, precise, concise, and intelligent . . .
>
> He was . . . very much master of himself, unlike Picasso, who was usually rather sullen and inhibited at occasions like the Steins' Saturdays. Matisse shone and impressed people.[3]

Leo Stein more than corroborates this estimate:

Picasso and Matisse were extreme contrasts, Matisse—bearded, but with propriety; spectacled neatly; intelligent; freely spoken, but a little shy—in an immaculate room, a place for everything and everything in its place, both within his head and without. Picasso—with nothing to say except an occasional sparkle, his work developing with no plan, but with the immediate outpourings of an intuition which

kept on to exhaustion, after which there was nothing until another came. The difference in mental type between Picasso and Matisse came out vividly in a later incident.

At Durand Ruel's there were at one time two exhibitions on, one of Odilon Redon, and one of Manet. Matisse was at this time specially interested in Redon, because of his own work and because of friendship with the older man who was then in difficulties. When I happened in, he . . . spoke at length of Redon and Manet, with emphasis on the superior merits of the lesser man . . . He told me he had seen Picasso earlier and Picasso had agreed with him. This seemed to me improbable. Picasso had no special interest in Redon.

Later on that same day Picasso came to the house and I told him what Matisse had said about Redon and Manet. Picasso burst out almost angrily, "But that is nonsense. Redon is an interesting painter, certainly, but Manet, Manet is a giant." I answered, "Matisse told me you agreed with him." Picasso, more angrily: "Of course I agreed with him. Matisse talks and talks. I can't talk, so I just said *oui, oui, oui*. But it's damned nonsense all the same." Picasso, though often influenced by others, was not so openly receptive as Matisse was.[4]

Behind the outburst rest a few woes. Picasso, whose French labored under the weight of a heavy Spanish accent, was certainly sensitive enough to notice that, unlike himself, people listened carefully to Matisse at Gertrude Stein's evenings, Fernande perhaps most of all, whereas his own conversations were uphill work.

We do well to think of him as having the vanity and the need for group applause of someone like Muhammad Ali—how competitive he had to feel, therefore, toward Matisse, how envious, as Richardson points out, of all the uproar and outrage Matisse and the painters surrounding him then—Vlaminck and Derain to the fore—had caused at the Salon d'Automne in 1905. "*Succès de scandale* put Matisse very much ahead."[5]

The essential difference was aesthetic—which is to say, it was profound. The presence of a painting—its inner architecture—was developed by Matisse through the use of color. Where Matisse was becoming one of those rare painters to whom the use of color was easy and natural and therefore as rare as a lover for whom love is altogether natural, Picasso remained embattled in his attitude. Form was more important. Once he even exclaimed: "Color weakens!"[6]

Perhaps it was around this time that Picasso made the following remark to Matisse, "I've mastered drawing and am looking for color; you've mastered color and are looking for drawing."[7]

We can be certain that Hemingway and Faulkner never had such an exchange. "I will give you short sentences if you will lend me long ones," one would like Hemingway to have said to Faulkner. But then, he never did. Great artists usually give a wide berth to their weaknesses—one can even argue that the lacks themselves can keep them focused on their strength right up to the point of greatness.

"Friends but . . . enemies,"[8] said Gertrude. Picasso and Matisse are, of course, more than that. Artistic rivals at the highest level, they would, through the years, illumine each other and infuriate each other, stimulate the talent of the other, galvanize the ambition of the other.

> If only everything that Matisse and I did at that period could be put side by side. Nobody ever looked at Matisse's work as thoroughly as I did. And he at mine.[9]

They were each determined to become the greatest painter alive, and neither was unrealistic. It could be done. It must have been an exquisite and agonizing emotion to know that there was one man in the world who might, or might not, be a better painter than oneself; such emotion, doubtless, commenced early. Picasso must have been hearing about Henri Matisse from the time he came back to Paris in 1904. By 1906, he had to recognize that Matisse had done as much as any painter to *metamorphose*—nothing less than this verb can serve—the use of color into a presence powerful enough to dominate form. In counterpoint, Picasso, when he reached Cubism, would banish a lively palette from his researches and would demonstrate how luminous a limited palette could become when one concentrated wholly on revelations of form.

How much of Cubism is a reaction against Matisse! As early as 1905, Matisse's paintings had color speaking "for itself with a directness previously unknown in Western painting."[10] The painter was declaring that color was supposed to excite the emotion of the viewer rather than to help depict the object. One could, if necessary, change "the color of the world the better to render that emotion."[11] Color could not only be chosen independently from the object in which it originated (an orange could be blue), but indeed color was no longer obliged to obey shifts of tone in shadows. Dispense, said the Fauves, with all that modulation by which the Impressionists had created an illusion of light; Matisse and the Fauves looked instead to obtain their painterly light by the impact of one bold pigment next to another. To an eye coddled by Impressionism, it had to seem a visual explosion. A crude green was now forced to sit beside a full red with a primary blue sitting above both, a ferocity of contrasts that in Matisse's hands was able to produce a dazzling light. The subject matter was no longer important; an apple needed no

longer to look like an apple—sufficient that it was an ellipse of color able to act upon one's eye. Matisse, during his Fauve period, wanted his paintings to look alive rather than to represent life. To obtain such an effect, he would often leave the spaces between broad passages of color undrawn, undefined, uncolored, as though to unbind the colors from their context and so dramatize their readiness to breathe. In 1905 and 1906, Matisse was working, therefore, in complete opposition to what Picasso was doing in the same two years. A measure of the difference: One can study black-and-white reproductions of Picasso's work during this period and have more than a reasonable appreciation of his intent, whereas reproductions of Matisse's paintings often have little to tell us because they are not in color. Once we see them in color, however, they astound us. For example, *Goldfish and Sculpture*, from 1911, stripped of its palette, gives up nearly all of its rhythm.

Henri Matisse, Goldfish, Issy-les-Moulineaux, October 1911. Oil on canvas, 46 x 39 in.

We can, of course, not be certain that Picasso felt at all inferior to Matisse when they met, yet the relative standing of their careers suggests as much. The Salon des Indépendants had opened on March 20, 1906, and Picasso had, as usual, not submitted any work, whereas Matisse had dominated the occasion with a large canvas, *Le Bonheur de Vivre*, huge in its scope and its ambitious intent.

The painting was remarkable for its unloosed sensuality, its unloosed color, its unloosed physical scale, its unloosed imagination . . . That this single large painting was meant as a kind of manifesto was not lost on the critics. Charles Morice, who had strong reservations about the work, nonetheless referred to it as *"la question du salon"* . . . and Louis Vauxcelles, who had a few reservations, nonetheless

Henri Matisse, Le Bonheur de Vivre, 1905–06. Oil on canvas, 68 x 93 in.

wrote: "There are great qualities here: the masses are rhythmically balanced, the green of the trees, the blue of the sea, the pink of the bodies [are] closely enveloped in a halo of complementary violet, harmonize and blend, and there emanates from this canvas a sensation of refreshing joy . . ."[12]

Salon crowds found the work extreme and strange, even hilarious, and these reactions must have impressed Picasso, as did the intensity of the vituperation.

Signac was so angry that he picked a fight with Matisse at the café where the exhibitors and members of the hanging committee met after the opening. Even Leo Stein was shaken by the painting. But, still open-minded and eager to expand his horizons, Stein went back to study it numerous times, and eventually came to feel that it was "the most important painting done in our time," and eventually bought it.[13]

All of this, most notably Leo Stein's acquisition of *Le Bonheur de Vivre* with his accompanying encomiums, had to push Picasso toward the radical departure of *Les Demoiselles d'Avignon*. If Matisse was arousing prodigies of attention among his fellow artists and critics by what he could accomplish with color, Picasso now had to show what could be done with form—even more, the destruction of form, at least as everyone understood it. If painting, for centuries, had rested upon the well-tempered interplay of color with form and Matisse had now liberated the first, the Spaniard was bound to apotheosize the second; color need be no more than a parenthesis. So, the early Picasso who infused circus people with a mauve and universal tenderness would proceed over the next half-century to tear apart the world of appearances and leave us with a secret fear that the soul behind the face of each person we meet is more hideous than any tale told by his features. He would yet depict the savagery of the form beneath the form, and do it with considerable independence from color.

In those early years, however, friendship and antipathy take their turns in each painter's attitude toward the other. After *Les Demoiselles d'Avignon*, Matisse—according to Alfred Barr—was in fear that "his position . . . at the very heart of the school of Paris was threatened. The rival star—or dynamo—was Pablo Picasso."[14]

Fernande takes it further. She states that Matisse was so stirred out of his normal and usually pervasive calm by the early Cubism of 1908 that he "talked of getting even with Picasso, of making him beg for mercy."[15]

Earlier, in 1907, they had exchanged paintings, a still-life by Picasso for a portrait of Matisse's daughter, Marguerite. One cannot assume, however, that much of a friendship was flourishing behind the scenes. Salmon informs us that the *bande à*

Pitcher, Bowl and Lemon, 1907. Oil on panel, 24 x 19 in.

Henri Matisse, Marguerite, 1907. Oil on canvas, 25 x 21 in.

Picasso would sometimes enjoy their nocturnal games at the Bateau Lavoir by playing with Matisse's name and work. One sport was to throw small gobbets of bread at the portrait of Marguerite. First they would call their shot: "In the eye of Marguerite!" "Direct hit on the cheek!" Et cetera. They had heard that Matisse,

> already classified as a great man, was conducting a discreet inquiry to find out who was writing on the walls and embankments of Montmartre. "Matisse is nuts." "Matisse is more dangerous than booze." "Matisse is worse than war . . ."[16]

As Gertrude was to write in a notebook, "Pablo and Matisse have a maleness that belongs to genius. *Moi aussi*, perhaps."[17]

2

E arly in 1907, Picasso conceived of a large and ambitious canvas. It would be a scene in a bordello, and in fact, he called it *El Bordel.* Since he was recalling a brothel he used to frequent on the Carrer d'Avinyo in the Barrio Chino of Barcelona, the canvas would, years later in 1916, be rechristened *Les Demoiselles d'Avignon* by André Salmon (see colorplate 1, following page 272). That title, despite Picasso's stated distaste for it, became the name by which it would thereafter be known.

If Picasso was determined to produce a masterpiece (and, indeed, one of the marks of a great artist is that he wills to do more than he, or anyone else, has ever done before—James Joyce, for example!), Picasso nonetheless had a few practical problems to solve. The first was that he did not have room in his studio for the large canvas. Not only was he most certainly not living alone, but Fernande had decided they must adopt a child. If they did, Picasso would then face the problem of trying to paint among a strew of toys, added to Fernande's cache of gowns, perfume bottles, jewelry, and her own hardly insignificant presence.

Gertrude, whether from generous motives, wicked motives, or both, came up with the rent for an additional studio in the Bateau Lavoir. Picasso, fortified with a second purchase by Vollard, this time to the sum of 2,500 francs for a number of canvases of the Blue and Rose periods, was ready to begin his major work, this work that he had determined, absolutely in advance, would be equal to thunder. So he purchased an outsize canvas of the best quality and set out on the most daunting journey in his artistic life.

Pierre Cabanne gives a vivid description of Picasso in the act:

> It is the spring of 1907. In the Bateau Lavoir studio, Picasso paints. Around him his monsters, women with unhealthy flesh, Negroid heads with broadly striated cheeks, masks shaped as by scythe strokes with empty sockets, pink and gray nudes strong as tree trunks . . . totems of some barbaric cult of which he is the high priest. Fernande, nonchalantly sprawled on the couch, looks on.
>
> It was a fantastic spectacle: the stocky little man in front of the picture, a huge canvas he had been fighting with for months, in which [were] disjointed women . . . with unbelievable faces and erratic arms, a tohu-bohu of shapes . . . reminiscent of nothing known, unless perhaps the targets in carnival games of skill. The bodies with their broad flesh-pink planes were . . . chiseled with frigid violence, unrestrained fury. Here and there, on each disjointed torso, a terrifying mask with a madwoman's eyes.[1]

Roland Penrose wrestles with the dichotomy in the work:

> The figure on the extreme left . . . is unmistakably Egyptian, whereas the two figures she reveals in the center of the picture, their tender pink flesh contrasting with the blue of the background, have more affinity to the medieval frescoes of Catalonia.
>
> There is no movement in the three figures. Although singular and lacking in conventional grace, they are poised and serene, making a strong contrast with the two figures on the right, which, placed one above the other, complete the group. Their faces show such grotesque distortion that they appear to have intruded from another world . . . It can be seen at a glance that the two right-hand figures are totally different in treatment from the others. Ghoulish and sinister, they make the already forbidding features of their companions appear dignified, almost gentle . . .
>
> Rather than suppress the evidence of conflict between his two stages of thought, he left it unfinished, allowing us to see clearly the evolution of ideas in his own mind. It is in fact our best clue in bridging the gulf that seems to separate the bewitching charm of the Rose period from the severity of the task on which he was about to embark. The barbarous appearance of the heads on the right . . . give the lie to statements such as "Beauty is truth, truth beauty," because no human face, and these must be recognised as human, could ever assume such monstrous proportions . . .[2]

Penrose, who is Picasso's all but officially approved biographer, immediately veers around to say "yet their powerful presence speaks profoundly and truthfully to our sensibility."

Of course, such words as *profoundly* and *truthfully* are best employed when one no longer necessarily knows what one is talking about.

Even today, *Les Demoiselles d'Avignon* is a peculiar painting. Since it was donated in the 1930s to the Museum of Modern Art, several generations of art students in New York have wrestled, doubtless, with their aesthetic conscience before agreeing that it was, yes, indeed, great. One can think of Fidel Castro in the wilds of eastern Cuba in 1956 a few days after the disastrous ambush he ran into on debarking from his boat *Granma*; four fifths of his entire force of eighty men was killed. Down to sixteen *barbudos*, he is reputed to have said that the days of the dictatorship were numbered, and one of the band later confessed that he thought his leader was mad. Indeed, if Castro had been killed the next day in a skirmish, few would have disagreed—one more fever-distorted insurrectionist, now dead.

So it is with *Les Demoiselles d'Avignon*. If Picasso had perished of a brain hemorrhage while trying to finish it, the art world would still have recognized his earlier work; he would rest today in a much-admired and doubtless expensive collectors' niche. He might even arouse our compassion at the thought of his last failure, that crazy abortion he had done of women in a brothel, a dreadful fiasco, an inchoate confusion of means, an apocalypse of the deranged. It would not be too difficult to believe that the canvas had either brought on his terminal stroke or was the direct prediction of it.

At the time, his friends and fellow painters certainly had their negative reactions. Matisse thought it was a hoax, a mockery of the advanced work of other painters, and the picture may have contributed to his dire comment to Leo Stein that he would make Picasso pay for it. Apollinaire, who was never an art critic of real insight, was dreadfully confused at the lack of poetry in this huge manifesto, and could find no better encomium than "revolutionary," which for Apollinaire was equal to saying "good try."[3] Bewildered, he brought Félix Feneon, a contemporary critic with a reputation for uncovering new talent, over to the Bateau Lavoir, and Feneon, also confused, told Picasso to devote himself to caricature. Vollard now had no interest in buying any more of his output, and Derain was full of morose anticipation: "One day we shall find Pablo has hanged himself behind his great canvas."[4] That may well have been a reflection of the gloom Derain could sense emanating from the work. Picasso had left himself wholly alone. Georges Braque, who in two years would be at work every day with Picasso in their mutual exploration into Cubism, thought *Les Demoiselles* was harsh indeed. "It's as if you are making us eat rope and drink turpentine," he said.[5] Legend has it that shop-

keepers in Montmartre looked at Fernande with pity; the word was out that her lover had gone mad.[6] Leo Stein said: "Now I know what you were trying to do—paint the fourth dimension—how funny."[7] In her turn, Gertrude, obviously bewildered, never spoke to Picasso about it at all. That was an event in itself. Gertrude, like Leo, looked for the privilege of the final comment.

The only people who seemed to approve of the canvas were two young German art dealers, Wilhelm Uhde and Daniel-Henry Kahnweiler, but Picasso was bound to doubt the purity of their reaction—they were looking for talented young artists on the cheap, after all.

In interviews fifty-four years later, Kahnweiler offers his impressions of that period:

[Wilhelm Uhde] first told me about a strange picture that the painter Picasso was working on. A picture, he said, that looked Assyrian, something utterly strange. I wanted to see it.

I did not know Picasso, but I had heard his name, and I had seen many of his drawings in the front window of the shop of an art dealer named Clovis Sagot . . .

So one day I set off. I knew the address, 13 rue Ravignan. For the first time I walked up those stairs on the place Ravignan, which I tramped up and down so many times later, and . . . thus I arrived at the door I had been told was Picasso's. It was covered with the scrawls of friends making appointments: "Manolo is at Azon's . . . Totote has come . . . Derain is coming this afternoon . . ."

I knocked. A young man, barelegged, in shirt sleeves, with the shirt unbuttoned, opened the door, took me by the hand, and showed me in . . .

So I walked into that room which Picasso used as a studio. No one can ever imagine the deplorable misery of those studios in rue Ravignan. The wallpaper hung in tatters from the unplastered wall. There was dust on the drawings and rolled-up canvases on the caved-in couch. Beside the stove was a kind of mountain of piled-up lava, which was ashes. It was unspeakable. It was here that he lived with a very beautiful woman, Fernande, and a huge dog named Fricka. There was also that large painting Uhde had told me about, which was later called *Les Demoiselles d'Avignon* and which constitutes the beginning of cubism. I wish I could convey to you the incredible heroism of a man like Picasso, whose spiritual solitude at this time was truly terrifying, for not one of his painter friends had followed him. The picture he had painted seemed to everyone something mad or monstrous.

CRÉMIEUX: Do you remember your first conversation with Picasso in front of that picture?

KAHNWEILER: No, I don't. I only remember that I must have told him immediately that I found his work admirable, for I was overwhelmed.

CRÉMIEUX: Did this first meeting mark the beginning of your unwritten contract with Picasso?

KAHNWEILER: Oh, no, that came much later. Picasso was, and still is, for that matter, much too suspicious a man to make a deal immediately with some young man who appeared out of the blue . . . No, I immediately bought some of Picasso's pictures, for which, if I may say so, there was no competition. There was no need to draw up a contract or anything of the sort, since no one else was buying from him anymore.[8]

In his interview with Pierre Cabanne in 1961, Kahnweiler adds:

"I did not find the painting 'Assyrian,' but I could not put a label on it. It was something mad and monstrous at the same time. I was deeply and violently moved, and immediately thought it was an important work."

"What made you immediately feel it was important?" I asked.

"I don't know. I might say it was because of its absolute novelty, but that's not exactly it. I could not define just where and how the novelty showed itself, yet I could feel it bursting out."

"It was an intuition, not an analyzed aesthetic feeling?"

"Exactly. I think it's something one might call aesthetic conscience. There is an ethical, moral conscience that determines what is good and what bad; I think such a conscience exists for the fine arts as well. It said to me, 'This is fine. This is important.' "[9]

The flavor of Kahnweiler's remarks suggests that his reaction was authentic, but we have to remind ourselves that by the time that the interview was given, he had become Picasso's foremost dealer.

In any event, we can look at *Les Demoiselles d'Avignon* today and honor it without ever having to enjoy it. For we know that Cubism is going to emerge from it, and Cubism will stimulate Picasso over the next sixty years into an unparalleled career of major periods and astonishing works. *Les Demoiselles* stands before us, therefore, in all its immense implications: We are looking at nothing less moving than a prodigiously important historical artifact—for those who are aesthetically devout, it is quite the equal in modern art to the relics of a saint.

Richardson, who ends the first volume of his monumental biography as Picasso

is about to commence *Les Demoiselles*, will offer an elevated verdict: ". . . the most innovative painting since Giotto . . . the first unequivocally twentieth-century masterpiece, a principal detonator of the modern movement, the cornerstone of twentieth-century art."[10]

Richardson, here, is but elegantly rephrasing the canon of modern art concerning *Les Demoiselles d'Avignon*, but our verdict may owe more to our knowledge of the forces that painting would yet liberate than to its private merits. From our historical vantage, we can now comprehend the intensity of Picasso's impulse in delivering the work, yet, taken by itself, regarded in passing by any museumgoer who has not lived in the shifts of twentieth-century art, *Les Demoiselles* is still a gnomic, repellent work, not unlike an obscure poem that will never repay one's attention without a solemn search into the poet's notes, ambitions, and themes. Be it said that the painting was so personal to Picasso that he kept it in his studio for twenty-five years with its face to the wall and showed the canvas to few people.

What, then, was going on with him? The answer is that he set out to do one thing and changed his mind in the middle, and he never did figure out how to unify the two halves of the work. Indeed, while painting it, he lived for months with unresolved questions about that canvas eight feet by eight feet square, and his mental balance must have tilted often. He and Fernande were taking opium regularly. If it was not in large amounts, still, not a great deal is necessary when you have visual insights as exquisite and as overpowering as Picasso's. Young poets know the anguish of too much rich language that will not stop racing through the brain even as it is being lost forever, especially when the rush manifests itself on drugs. Picasso's recurrent complaint about opium is that it gave him extraordinary images while taking away much of his desire to paint—so too could many a young artist or writer file a similar brief against marijuana.

What we can surmise is that Picasso's inner life was hardly in order during this period. If he had felt relatively calm in Gósol the previous summer, there had been, after all, no drugs, no poets, and no studs lurking around to snag Fernande. Now, Apollinaire was present with all his stimulations, and Max Jacob was exploring deeply into cabala and mystical Catholicism, into astrology and Tarot.

To this amalgam of magic, opium vision, and intense dread, add his competitive ambition; add, too, his urge to be more profound than Matisse. Leo Stein was steeping himself in his own wit when he commented that Picasso was looking for the fourth dimension, but as we shall see, Einstein's Special Theory of Relativity was present as an overarching metaphor in Picasso's consciousness; Einstein, already

moving on from the Special Theory toward a General Theory of Relativity, which would seek not only to connect space and time but gravity as well, was thereby attempting to bring a sense of unity to his conception of the universe. Picasso, obsessed with form as the categorical answer to Matisse's mastery of color, may have been looking for a general theory of form that would connect grapes and horses, forests and women, accomplish, in short, a complete reconstruction of the visual world whereby forms need no longer be part of landscapes, or of figures, or of still-lifes but could exist first as forms. Not only color but magnitude itself—once all frames of natural reference were abolished—would give way to form.

We can be aided in this speculation of what was in his mind by a few paintings that influenced *Les Demoiselles d'Avignon.* There can be little question that the composition pretty directly reflects El Greco's *The Vision of St. John* and Cézanne's *Five Bathers* and *Three Bathers.*

El Greco, The Vision of Saint John, 1608–14. Oil on canvas, 87 x 76 in.

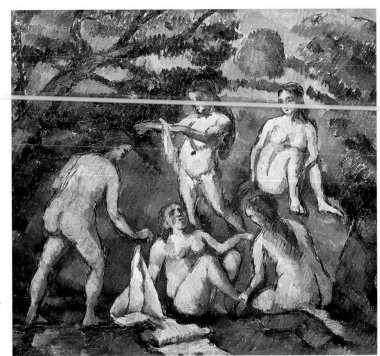

Cézanne, Five Bathers,
c. 1877–78. Oil on
canvas, 18 x 22 in.
Formerly owned by
Picasso.

Cézanne, Three
Bathers, c. 1881–82.
Oil on canvas,
19 x 19 in. Formerly
owned by Matisse.

Picasso's earliest sketches for *Les Demoiselles* reinforce the comparison.

Study for Les Demoiselles d'Avignon (above), 1907.

Study for Les Demoiselles (also called Baigneuses dans la Fôret), 1907. Lead pencil, 8 x 10 in.

In the several *Bathers*, Cézanne's nudes blend with the forest, even as Picasso's figures virtually turn into the shards, fronds, and jagged limbs of some ladies in a cactus patch. The heads may come forth as faces or masks, but the arms and legs present plant forms thrusting every which way. A comparison of a nude and a tree may help to make the point.

Landscape, summer 1907. Gouache on paper, 24 x 18 in.

Nude Woman (left), 1907. Oil on canvas, 36 x 17 in.

Even the distortion of the nose in the next study gives a powerful impression of a branch being bent. The face seems made of wood, not flesh.

And in the next drawing we are virtually looking upon the leaves and stalks of plants: They are close to interchangeable with female nudes.

Of course, Cézanne had already shown him that one could treat hills and sky, mountains and valleys, as parts of a single object—the *field* of the painting. The following passage is relevant:

> One had no sense of scale. It was not possible to tell whether the photograph was of a square mile or of a square five hundred miles. Craters the size of New York were indistinguishable from craters the size of a house . . . Giving oneself to these studies of the moon, there followed that hypnotic sense of falling out of human magnitude into other magnitudes as if in the

Detail of study for Les Demoiselles (top right), spring 1907. Oil on canvas (partially relined), 38 x 13 in.

Three Women (bottom right), summer 1908. Pencil and ink sketch, 13 x 9 in.

hour of death, consciousness might separate into other dimensions, dissipate into other orders of the immense and minuscule, consciousness might at last be off on terminal voyages to microbes, molecules, or the stars.

That offered a glimpse of why Cézanne's work had been obsessive to so many painters. For hundreds of years, they had worked to capture the sheen and texture, the hairs, the dust, the flickering motes of light on the surface of a drape. Miseries and glories of apprenticeship had gone into painting a velvet sleeve, a pearl, a drop of dew on a grape . . . every surface was recognizable in its own right. Did a painter work a canvas properly? Then one could cut out a square inch of canvas, show it to an unfamiliar eye, and the response would be that it was a piece of lace, or a square of velvet, for the canvas had been painted to look exactly like lace or velvet.

Cézanne, however, had looked to destroy the surface. A table cloth in any one of his still-lifes, taken inch by square inch, resembled the snowfields of mountains; his apples could be the paint-stained walls of a red barn; his skies, patch by patch, a sea as easily as a light-blue throw cloth, and the skin of a man's cheek was like the sun-beaten terrain of his hills. The orders of magnitude vanished in his painting, and one could not know, looking at a detail, whether Cézanne was representing the inside of a flower or the inside of a tent. Something in that vision spoke like the voice of the century to come, something in his work turned other painters out of their own directions and into a search for the logic of the abstract. Picasso and Cubism would pour through that hole in the old love of surface until one could not tell which wall was near and whether the floor had begun to recede. It was as if the century to come was already anticipated in the veins of its artists, as if the century to come would go out to explore the dissolution of all orders of magnitude and so begin a search into the secrets and unwindings of birth and death.[11]

The sketch that follows is immersed in *Study for Bathers in a Forest, 1908. Watercolor, 19 x 23 in.*

Landscape, fall 1908. Oil on canvas,
40 x 32 in.

The Dryad (shown upside-down), spring–
summer 1908. Oil on canvas, 73 x 42 in.

precisely such a search for a new logic. The sense of surface and, to a great degree, the sense of magnitude have not so much disappeared as been converted into figures who but for their heads are hardly more human than trees.

A year later, in 1908, Picasso is going further. Now he will try to interchange torsos and trees. To heighten similitude, the painting of the nude is here printed upside-down.

That is still a year away. By then, the innovations first glimpsed in *Les Demoiselles d'Avignon* have been refined. There is a unity now that was absent in the earlier work, where he was not only trapped into dealing with two paintings in one frame but was working out of contradictory impulses. If the lower two thirds of *Les Demoiselles* portrays women's breasts, torsos, and limbs as forms not signally distinguishable from a cactus garden, the masks and faces, by contrast, are not only preternaturally vivid but are at odds—the faces on the right of the canvas

speak of a wholly separate conception of humans and monsters than the figures on the left.

Somewhere in the mid-weeks of painting *Les Demoiselles*, sometime in the spring of 1907, Picasso *discovered* African art, which is to say that although he had seen it before, there came a day when he had a revelation. Wandering through a wing of the Museum of Comparative Sculpture, then located in the Palace of the Trocadéro, he decided on a whim to go across the hall into the old Ethnological Museum. Its musty rooms were filled with African sculpture, and he took them in with shock. Even as the old smuggler Fontdevila had a face that looked to be composed of bone alone, and thereby assumed forms more appropriate to bone than to flesh, so did Africans see faces as expressions of wood. Their masks were not only carved from wood but took the forms appropriate to wood. For Africans, forests, when all is said, were vastly more awesome than animals or humans and so, presumably, were closer to the gods.

Decades later, Picasso would tell André Malraux of the impact of that visit to the Ethnological Museum, and indeed spoke so volubly that Malraux gave the small book he wrote about those conversations no less a title than *Picasso's Mask*.

> When I went to the old Trocadéro, it was disgusting. The Flea Market. The smell. I was all alone. I wanted to get away. But I didn't leave. I stayed. I stayed. I understood that it was very important: something was happening to me, right? The masks weren't just like any other pieces of sculpture. Not at all. They were magic things . . . The Negro pieces were *intercesseurs*, mediators; ever since then I've known the word in French. They were against everything—against unknown, threatening spirits. I always looked at fetishes. I understood; I too am against everything. I too believe that everything is unknown, that everything is an enemy! Everything! Not the details—women, children, babies, tobacco, playing—but the whole of it! I understood what the Negroes used their sculpture for . . . They were weapons. To help people avoid coming under the influence of spirits again, to help them become independent. They're tools. If we give spirits a form, we become independent . . . I understood why I was a painter.[12]

So, masks were installed in *Les Demoiselles d'Avignon*. As Cabanne, along with four or five other experts, estimates, this transmogrification took place in the summer of 1907. Picasso had chosen in mid-passage to perform an exorcism. If we would wonder why it came at that moment, the answer may be particular, not abstract.

While it is not certain that the following episode took place in the spring of

1907, Richardson places it there, and the inner logic of events makes the date likely.

O'Brian tells the story well:

> . . . Fernande Olivier, unable to have a child herself, went to look at the orphanage at the nearby rue Caulaincourt. There she found a girl of about eight or ten: the child hated spinach, but was obliged to eat it. Fernande hated spinach too, and in her indignation she adopted the child out of hand, bringing her back to the Bateau Lavoir. For some time the little girl was fed with sweetmeats, given dolls and toys: Picasso and everyone else in the Bateau Lavoir was kind to her, particularly Max Jacob. Then Fernande suddenly grew tired of it: she decided that she had nothing maternal in her composition and asked Max Jacob to return the little girl to the home. This he did; but in the course of the formalities an official stated that once relinquished the child could never be taken back: at this, she burst into tears, threw her arms around Jacob's neck, and begged him not to leave her. He could not bear it; he led her away, fed her at a restaurant, and took her home.
>
> "I can't keep you," he observed.
>
> "Why not?" said the little girl. "No one will want to take me away. I am only a waif."
>
> "I too am a waif," said Max Jacob, weeping.
>
> In the end, he placed her with a local concierge. Picasso's share in all this, apart from general kindness and the provision of dolls, is not recorded.[13]

If this is the least attractive anecdote we have yet heard about Fernande, it can nonetheless be accounted for: Given the mean hours of her childhood, she must have wished to transcend that stunted past by offering kindness to another waif. Her own childhood bore down on her, however; come the test, the unforgiving laws of deprivation were in effect—she had too much bitterness and too little compassion to raise someone else's child.

For Picasso, however, what a disaster! It must have taken no small march over the rocks in his Spanish soul to accept the idea of raising another man's child with his barren mate, yet he came that far. Then Fernande gave the child away. Speak of curses. He was ready to practice exorcism.

This story of adoption and repudiation is of no relevance to the Negro masks unless both events took place in the spring of 1907, but if so, not only is much accounted for, but it can also explain why, a few months later in that summer of 1907, Picasso decided to separate from Fernande. But there we anticipate.

For now, let us recognize that there may have been other exorcisms present.

In March of 1907, Picasso bought two Iberian heads from a Belgian named Géry Pieret, who was Apollinaire's friend and part-time secretary. Pieret, as a lark, had stolen these small pieces of sculpture from the Louvre. Probably, it had been out of no greater motive than to demonstrate that it could be done. These are the years, let us not forget, when Gide is writing *L'Immoraliste* and crime as a gesture is beginning to present its claims as an advanced art form. Picasso must have been pleased to receive the two pieces, but must also have been suffering some quantum of bourgeois anxiety at the thought of receiving stolen goods. (And from a museum!) We know that he kept these heads hidden from view. He could not, however, keep them out of the painting. The second and third women in *Les Demoiselles d'Avignon* (reading from left to right) reflect those Iberian sculptures. So, their criminal existence is also in the painting.

As Picasso told Zervos in 1935:

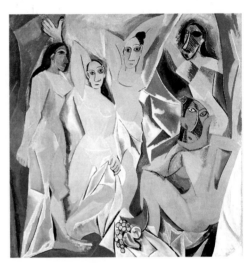

> How can you expect a spectator to live my picture as I lived it? A picture comes to me from far away. Who can say how far away? I have guessed it, seen it, done it, and yet, the next day, I myself cannot see what I've done. How can one . . . grasp what I may have put in in spite of my own will.
>
> I had finished half the picture. I felt: this is not it! I did the other half. I wondered whether I ought to redo the whole thing. Then I thought, "no, they'll understand what I wanted to do."[14]

Les Demoiselles d'Avignon, 1907.

It is worth going back for still one more look at the great dichotomy in the canvas, that gaping hole, that refraction of light and that splitting of planes so much like shattered glass that separates the left half of the picture from the right. On close examination, it shows a new kind of terrain. The shards of Cubism are there. No wonder that Picasso could not bring the two halves of the picture together. An act of vast artistic innovation still had to be developed in that no-man's-land between. Yes, it is certainly worth taking another look. If the picture never became an end in itself, it still lives on as a notable event, a battle, if you will, in the artistic war with himself that drew Picasso on to Cubism.

Part VIII

The Suicide and the Banquet

1

If in the spring and early summer of 1907 Picasso had taken a visionary leap against all the formidable resistance of friends, and had transcended his past by moving from tender and beautiful themes into ugly and discordant material, it was in the same period that Fernande adopted a child and gave her up. That certainly offers a reason for their separation through the summer and fall of 1907. Two mates cannot continue to cohabit free of misery when one has taken an artistic leap and the other has fallen back into the bonds of previous experience.

By late summer of 1907, Fernande wrote a letter to Gertrude Stein, who was then vacationing in Venice:

> Dear Gertrude,
>
> Would you like to hear some interesting news? It's that my Pablo and I are through. We will separate definitely next month. It all waits on the money Vollard owes us [so that Pablo can] give me enough to be able to wait for something else— what these other events will be and what I can still do with my life after he's gone, oh, what disillusion! And above all, don't begin to think that it all could be put together yet.
>
> No, *Pablo's had enough.* These are his words, although, says he, he has nothing to reproach me with. He just isn't made to lead this kind of life. Excuse me if I bore you in telling you all this, but I have a need to. And no one other than you is interested the least bit in me, and I am truly desperate. Imagine my life, now that I have to put up a front that all is the same as before. I am doing everything possible in order not to allow my despair to appear . . . and I have no confidence in the future. Oh, I'm brokenhearted, believe me! Truly brokenhearted . . .[1]

2 Sept. 1907

Dear Gertrude,

I received your letter. Thank you. I am feeling much better in spirit at this moment than when I wrote to you last. Although I'm still very distracted. I spent these last several days looking for an apartment, which I found after much trouble . . .

Perhaps, in a week, I will definitely have moved. [but for the present] Vollard is absent from Paris and so leaves us in a dark misery, and in all the difficulties of our situation. I look forward to seeing you soon. Pablo has been taking the thought of our separation most lightly. The several years we've lived together don't seem to have left any trace in him. No regrets. I believe that a great sigh of satisfaction will salute my departure. I have not, however, bothered his life, nor interfered with his work— he said so himself—although, then, what do you want?

It's a little hard to think one has been a toy, or a caprice . . . I feel mistaken in my path. Perhaps now, I can find something good. I hardly have confidence, how- ever, in my destination. Finally, we will see. There has to be an end to all this, and the idea *that I can finish off with it when I wish*, that reassures me a little. While waiting, however, it is necessary that I buy some furniture. That's almost done.

I have just about renewed relations with one of my aunts. I learned recently and by chance of the tragic death of an uncle whom I loved a good deal when I was young, a death that took place two years ago. I've written to my aunt on this subject, and she answered me, while manifesting a desire to see me again. I do not know yet what will come of this; we hardly were sympathetic to one another before. Perhaps I will be so full of ennui this winter that I'll be happy to go see her from time to time.

I would like to find a complete calm. And you—is the weather beautiful in Italy? Here, there are only storms and bad weather. Say hello to everyone for me.

<div style="text-align:right">

Sincerely,

Fernande . . .[2]

</div>

Gertrude is helpful on her return. She dragoons Alice Toklas into taking French lessons with Fernande, but, dependably, Miss Stein will be less nice about Fernande in recollection.

The conversation around the tea table of Fernande was not lively, nobody had anything to say. It was a pleasure to meet, it was even an honour, but that was about all. Fernande complained a little that her charwoman had not adequately dusted and rinsed the tea things, and also that buying a bed and a piano on the installment plan had elements of unpleasantness. Otherwise we really none of us had much to say.

Finally she and I arranged about french lessons, I was to pay fifty cents an hour

and she was to come to see me two days hence and we were to begin. Just at the end of the visit . . . Fernande asked Miss Stein if she had any of the comic supplements of the american papers left. Gertrude Stein replied that she had just left them with Pablo.

Fernande roused like a lioness defending her cubs. That is a brutality that I will never forgive him, she said. I met him on the street, he had a comic supplement in his hand, I asked him to give it to me to help me distract myself and he brutally refused. It was a piece of cruelty that I will never forgive. I ask you, Gertrude, to give me myself the next copies you have of the comic supplement. Gertrude Stein said, why certainly with pleasure.

As we went out she said to me, it is to be hoped that they will be together again before the next comic supplements of the Katzenjammer kids come out because if I do not give them to Pablo he will be all upset and if I do Fernande will make an awful fuss. Well I suppose I will have to lose them or have my brother give them to Pablo by mistake.

Fernande came quite promptly to the appointment and we proceeded to our lesson. Of course to have a lesson in french one has to converse and Fernande has three subjects, hats, we had not much to say about hats, perfumes, we had something to say about perfumes. Perfumes were Fernande's really great extravagance, she was the scandal of Montmartre because she had once bought a bottle of perfume named Smoke and paid eighty francs for it at that time sixteen dollars and it had no scent but such a wonderful colour, like real bottled liquid smoke. Her third subject was the categories of furs. There were three categories of furs . . .

There we were, she was very beautiful but it was a little heavy and monotonous, so I suggested we should meet out of doors, at a tea place or take walks in Montmartre. That was better. She began to tell me things. I met Max Jacob, Fernande and he were very funny together. They felt themselves to be a courtly couple of the first empire, he being le vieux marquis kissing her hand and paying compliments and she the Empress Josephine receiving them. It was a caricature but a rather wonderful one. Then she told me about a mysterious horrible woman called Marie Laurencin who made noises like an animal and annoyed Picasso. I thought of her as a horrible old woman and was delighted when I met the young chic Marie who looked like a Clouet . . .[3]

In 1955, in the preface to *Souvenirs Intimes*, Fernande will write to Picasso:

I am going to try to tell you about my life; perhaps you will understand me better. You always doubted me—*doubted my love, doubted that I had feelings deep enough to give all of myself to you alone.*

Those years I lived next to you were the only happy time in my life. Now that

age has whitened my hair, that hair you loved so much, and has wrinkled the hands which you also loved, and has pinched off the laughter that you used to enjoy—although not always—I find a desire to tell you about my life before I knew you and after.[4]

Just how they come together again after this first breakup is left unsaid in *Souvenirs Intimes*. Picasso's comments on the separation and reconciliation are unrecorded. We only know that in November of 1907 Pablo and Fernande began to live together once more in his studio, and that he continued to work actively in the wake of *Les Demoiselles d'Avignon*, doing study after related study in canvases and in sketchbooks, as if he had been himself so dazzled by the energies that erupted from his canvas that he now had to do variations on the theme much as if he were an art student absorbing the influence of a formidable master.

Fernande cannot have enjoyed his new preoccupation. Careful beyond measure to avoid inflammatory comment—"I have not . . . interfered with his work—he said so himself,"—we can feel the intensity of her urge to suggest other directions he might take, and, in turn, can feel how his reflex must be one of annoyance as he ingests her silent disapproval of all the garish and misshapen forms he insists on setting loose (see colorplates 2–5, following page 272).

Almost fifty years have gone by since he painted *Les Demoiselles*, but in *Souvenirs Intimes* we can still sense Fernande's horror at the damage that canvas did to their love affair, and indeed, Cubism would help to produce their final separation five years later. "Forever searching, forever dissatisfied, the irreconcilable enemy of all that's already been done," she wrote, "he will pass his life looking into himself for his art, sometimes as if lost in a labyrinth, but," she goes on

> . . . he will never succeed. He struggles desperately against his profound instincts. I repeat it, Picasso is a repressed will. He is a classic artist who will not admit to it. He is an ambitious artist who wants to be an innovator despite the hostilities he arouses. But is he a creator? As paradoxical as this may appear, there is a timidity in all his audacities except the one of being what he really is profoundly: that is, a tender soul who, in art, has wanted to destroy all . . . that his innate talent has been able to do simply . . .
>
> He can no longer live but by searching higher and lower, and more wildly. Thereby, he goes beyond nature. He knows it, but he will not submit himself to it anymore. Will he not come to rest at the bottom of himself in a despair that he will conceal, but which he will mine, until, without doubt, the success and money that he no longer disdains will insulate his anxiety, so that he will succeed in for-

getting himself. But I believe that, despite all, he will never be content, because he is an artist in all the beauty of the word.[5]

It is the view of a woman in her seventies, rejected by a man in her youth, and it is even an adversarial estimate of his achievement. Doubtless, she would have been happier if he had never gone beyond the Blue and the Rose periods. Yet, it is interesting to pose what she has to say against Gertrude Stein's explanation of Picasso's process.

Again, in her book *Picasso*, London 1938, Gertrude offers her insight into the artist's mode of work:

> Picasso was always possessed by the necessity of emptying himself, of emptying himself completely, of always emptying himself, he is so full of it that all his existence is the repetition of a complete emptying, he must empty himself, he can never empty himself of being Spanish, but he can empty himself of what he has created. So every one says that he changes but really it is not that, he empties himself and the moment he has completed emptying himself he must recommence emptying himself, he fills himself up again so quickly.[6]

Picasso, informed by Richardson of this passage, would comment, "She's confusing two functions."[7] Perhaps she wasn't. Gertrude would die eight years later, in 1946, from intestinal cancer.

In any event, it is interesting how much more Fernande has to tell us about Picasso than does Gertrude, serving as a high priestess of the high colonic.

2

Just before the summer of 1908, a catastrophe did ensue. A young German named G. Wiegels, "an unhappy little painter . . . a drug addict," as Fernande describes him, committed suicide in the Bateau Lavoir.

> He was a man of curious habits, and his unnerving appearance—smooth, bald head, a young face with the brutish and emphatic features of a Prussian, and a hard, penetrating expression—did not inspire sympathy. We gradually got used to him, though, as he opened up more and revealed himself to be something of a poet. Once he had acquired a little confidence he turned out to be a person of great gentleness, with a delicate and appealing sensibility. He was rather too highly-strung, though, like so many of the Germans I met at that time.[1]

"Highly strung" suggests that the *bande à Picasso* were inclined to play a few practical jokes on him. In any event, for whatever variety of causes, Wiegels began to suffer from hallucinations and soon started taking large amounts of drugs. Finally, he ingested a huge amount of opium, went out of his head, and found enough rope to hang himself on a beam in his studio. He was not found until morning, when the mailman arrived with a special delivery containing money for him from family or friends. Picasso was called by the postman and so had the dubious privilege of being the first tenant in the Bateau Lavoir to see the body dangling from the beam. The effect on him was not small.

This tragic death caused a stir among the artists of the Bateau Lavoir. They realised that they had gone too far with their mockery, and affected by a feeling of

guilt, they decided to give their victim a magnificent funeral. It was like a burlesque rehearsal for Modigliani's funeral. Knowing that Wiegels had loved colour, the painters and their womenfolk put on their most colourful clothes in his honour to accompany him to the Saint-Ouen cemetery . . .

Behind the multicoloured crowd in this unique procession, a whore in a cab leaned out of the window blowing kisses to the passers-by. Completely drunk, she thought she was the Queen of Spain at the sight of men taking off their hats and men saluting as the hearse went by.

The day after the funeral, nobody in the Bateau-Lavoir gave Wiegels another thought.[2]

This was hardly true for Picasso. His eye had seen the torso on the rope. He and Fernande now had a negative reaction to taking opium. ". . . sick in spirit," she writes, "our own nerves deranged, we decided to no longer touch the drug."[3]

Indeed, they didn't. Picasso never went near the narcotic again, and this was despite his serious appreciation of the pipe. As he would say in later years to Jean Cocteau, "Opium has the most intelligent of all odors,"[4]—a fair example of Picasso's insight: Odors are spirits in their own right, full of balm, tenderness, outrage, shock, stink, discovery, and, yes, intelligence itself. Some of that intelligence is obviously at work in his requiem for Wiegels. Note the form of the lobster claw, avid as death itself, that occupies the left cheekbone of this skull, while the right cheekbone is one more relative to Fontdevila.

Detail of Composition with Death Head (also called Still Life with Skull), 1907. Oil on canvas, 45 x 35 in.

Pablo and Fernande now quit Paris. With their restricted funds, they were able to rent no more than a roof over an open space on a farm in Rue-des-Bois, a hamlet near the edge of the forest of Halatte, seven kilometers from Criel. Their place was wholly without amenities, and they were surrounded by peasants they must have seen as throwbacks to the Middle Ages, since the villagers thought the Queen of France was still on the throne and inquired what her name might be.

> [Pablo] had taken his dog and his cat, who was expecting kittens, with him, and a funny assortment of other luggage. We ate in a room that smelled like a stable, and we slept rocked by the vague murmurings of the forest. We rose late in the mornings, oblivious to the sounds of the farm, where life had been going on since four o'clock.[5]

Fernande describes Picasso as being in a state of such depression that he could neither work nor bear to be alone.

> He made me stay ceaselessly by his side. I was also in a bad enough state, but in the face of his weakness, I tried to dominate mine. It was then, in this magnificent forest, that I understood how little Picasso felt for our French countryside. "It smells of mushrooms," I heard him say. But if he didn't like this sort of nature, he wasn't less happy for the calm and serene life that we led.[6]

In any event, he went back to Paris as soon, Fernande observes, as "he felt himself freed of this obsession that was tormenting him."[7] At the farm, he succeeded nonetheless in doing a number of paintings in a verdant palette that inspired Roland Penrose to suggest that it should be called his "Green Period" (see colorplates 6 and 7, following page 272).[8]

Penrose, who is at his best when writing in technical terms about art, offers a good passage on the art of painting in the countryside, and the pitfalls.

> In contemplating a landscape, the eye has the ability to extend the sense of touch so that it seems possible to caress the surfaces spreading out into the distance. The walls of a house or the slope of a distant mountain can become as tangible to the imagination as a match-box held in the hand. The great landscape painters in the past had neglected this sensation in favour of atmospheric effects. Strong contrasts of tone and colour were situated in the foreground while a blue haze was reserved for the furthest distance . . . The image obtained according to these rules, however, made objects too intangible and indeterminate for Picasso. Just as he had taken liberties with the human form to enable the eye to embrace its shapes more completely, so now he began to treat landscape as sculptural form . . . The time-honoured rules of

perspective were abandoned, together with any attempt to give an effect of immeasurable distance in the background. [Rather] the eye is invited to . . . enjoy the definite though subtle way in which it can be led into the depths of the picture . . .⁹

This is all very good as far as it goes: It may not, however, take into account the depth of Picasso's rebellion against conventional landscape. Natural vistas remind us not only of our insignificance but of timelessness. Even as we sense ourselves to be small in relation to the scene, we commence to feel the endless outreach of the universe. Picasso had no desire to submit himself to such a reduction, nor, by the obverse, to any pantheistic extension of himself; it was better to put it all in a three-dimensional box—precisely of the sort Cézanne had developed for his work. If Picasso was now expanding the artistic means that Cézanne had developed, it was with a different motive. Possessing a box, one could be free to examine the contents; one could explore forms that converted into other forms, supine women, for example, in the roots of trees, and erect women shaped by the trunks of trees (see color-plate 8, following page 272).

During this period at the farm, Fernande was to comment:

> Difficulties alone attract him. He smiles with a sort of condescending spite for the prettiness of the French countryside. Our beautiful forests don't move him. He turns away from this too easy emotion. He detests it like the plague. He refuses any inspirations if they come to him with emotion. He loves the harsh odors of thyme, of rosemary, the wild dusty cactus of his country. He admires grave beauty, austerity, the countryside of the Mediterranean coast which keeps a moorish tone . . .¹⁰

Can Picasso's condescension toward beauty be accounted for by the knowledge that it is not eternal, that it decomposes? In that case, why not search for the uglier form that could serve as an amulet?

In any event, beauty was impermanent. It broke down. The severity of rock and the labyrinth of a cave were forms to offer more promise. The cave could become a labyrinth. Cubism, as we know, was certainly approaching, and Wiegels' death could have accelerated the process. It may not be extravagant to suggest that Cubism enabled Picasso to explore such frontiers as the borderlands of death, a sizable proposition, but then, where is the Cubist painting by Picasso that does not speak of the inside of the body, its cave-like interior? We must never forget the autopsy of the woman that he witnessed by lantern light on that night in Horta some ten years earlier. If death was a journey, deterioration and the coalescence of forms were the traveling companions. In the blurring of all forms might be found

an iridescence, a bizarre and subterranean light.

He could also envisage trees, woods and a mountain as a woman with her legs raised, her mound of Venus dark and large, her breast on the horizon.

A tree, a plant, a nude, a mountain, a breast, a shrub, a reptile wrapped around a tree—the forms draw toward one another even as Picasso lives in all-but-constant fear of his own death.

That fear will plague him through his years and take a hundred hypochondriacal forms. If it never became a manageable anxiety, a resignation before the inevitable, it is worth remembering that he could hardly see himself as a man like others. To the contrary, he was always reminded, and would remind

Landscape, 1908. Gouache and watercolor on paper, 25 x 19 in.

Study for Three Women (Femme Débout), 1908. Oil on canvas, 59 x 39 in.

Study for Three Women, 1908. Lead pencil sketch, 13 x 10 in.

Colorplate 1. Les Demoiselles d'Avignon, June–July 1907. Oil on canvas, 96 x 92 in. For accompanying text, see page 245.

Colorplate 2. Nudes in a Forest (also called Bathers in a Forest), late 1907. Watercolor and graphite on paper, 19 x 23 in. For accompanying text, see page 266.

Colorplate 3. The Dance of the Veils (also called Nude with Drapery), 1907. Oil on canvas, 60 x 40 in. For accompanying text, see page 266.

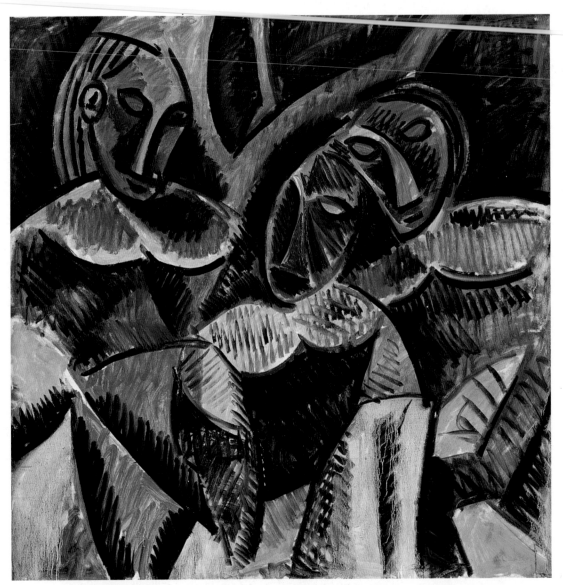

Colorplate 4. Three Figures Under a Tree, autumn 1907. Oil on canvas, 39 x 39 in. For accompanying text, see page 266.

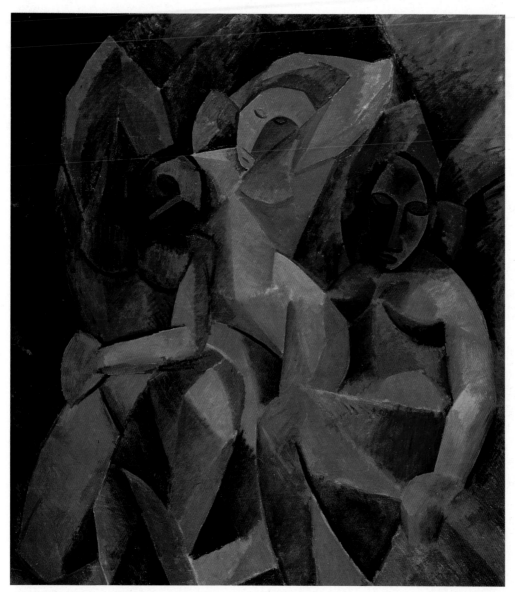

Colorplate 5. Three Women, 1908. Oil on canvas, 78 x 70 in. For accompanying text, see page 266.

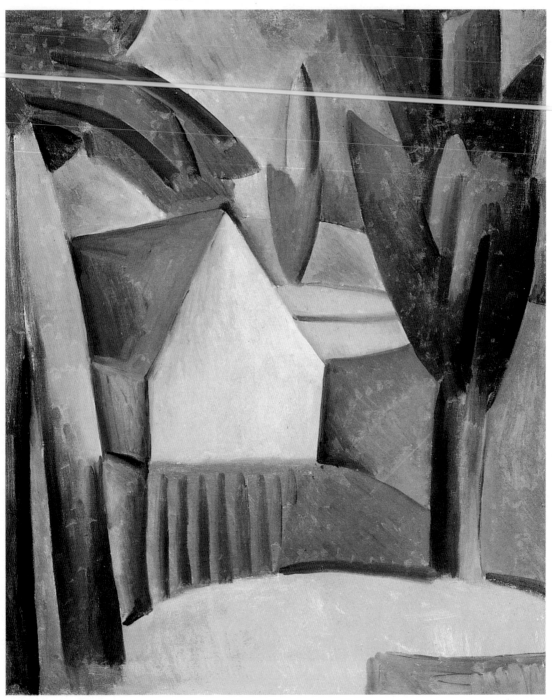

Colorplate 6. House in the Garden, La Rue-des-Bois, August 1908. Oil on canvas, 29 x 26 in. For accompanying text, see page 270.

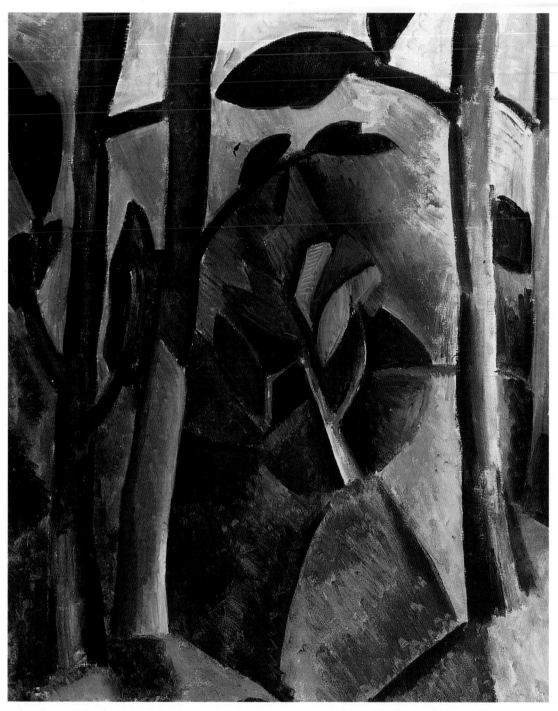

Colorplate 7. Landscape, La Rue-des-Bois, August 1908. Oil on canvas, 29 x 24 in. For accompanying text, see page 270.

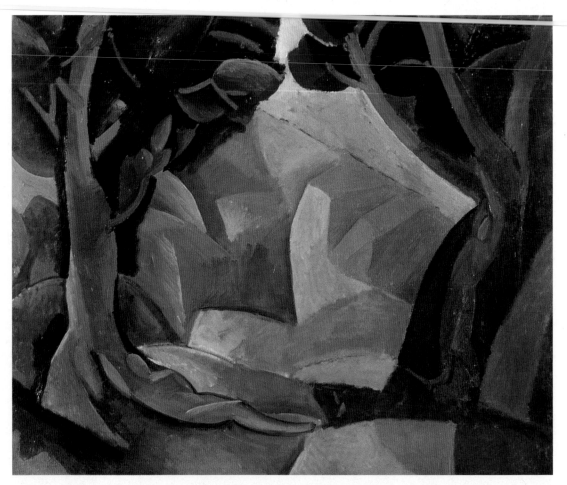

Colorplate 8. *Landscape with Two Figures*, late 1908. Oil on canvas, 23 x 28 in. For accompanying text, see page 271.

others, of his extraordinary powers. Cabanne offers a neat anecdote on this point:

> Among the canvases Gertrude Stein had to relinquish when she and her brother split them up, there was an *Apple* by Cézanne that she deeply regretted losing. As she complained of it one day, Picasso retorted, "Don't let it worry you. I'll do your Cézanne over for you." And on Christmas Day, 1914, he brought her an *Apple* (today the property of Mr. and Mrs. David Rockefeler) that was the exact duplicate of the one she had lost . . .[11]

Obviously, Picasso's eye could recall objects and paintings as if they were still sitting before him. He had the equivalent of a literary memory that will continue to see a text as it appeared on the printed page when first read. Add to such a faculty the vibration of images that came to him on opium or at the edge of dreams, and one begins to appreciate the delights and torture of the shifting imagery with which he could live by closing his eyes. It would have been difficult not to think of himself as possessed of superhuman powers—or, as he might also wonder, of Satanic gifts. There is even some evidence of this attitude in Lydia Gasman's brilliant dissertation, "Mystery, Magic and Love in Picasso, 1925–1938," published in 1981.

> The story of Picasso's rise to renown includes numerous instances of his recurring belief that he was different—a demiurge . . . To Malraux, Gilot and Parrot, Picasso said that "God is really another artist," "like me," he joked. The sculptor Fenosa who was Picasso's "protégé" from the early 1930s on reported that he heard Picasso saying ". . . I am God." To Leiris, Picasso hinted at his urge to wrest from God His lifegiving prerogative . . . to take an inanimate thing and breathe life into it: "one should be able to take a piece of wood and turn it into a bird!" he exclaimed. Quoting Cocteau, he added that "to make a dove you must first wring its neck," implying that a magic sacrifice must be performed in order for him to share in God's attributes . . . one grasps that he felt that his art had an operative magical power . . . [and Picasso once said,] "Drawing is a kind of hypnotism: one looks in such a way at the model, that he comes and takes a seat on the paper." . . . Rubin, to whom Picasso described it, writes, "Picasso's drawing is really a way of possessing things. Not just the woman he draws, but everything in his visual world. It somehow becomes part of him through being drawn."[12]

Cave drawings must have been seen by their artists as presences sent to them by the gods. How else could such power have been given to the primitive hand? Let us take on then the immodest thesis that Picasso, the most secretive of men, saw his mission as one of coming ever closer to the mind of God—to appropriating, that is, neither His spiritual secrets nor His pain but His engineering, His tech-

niques of camouflage. Picasso was not only looking to discover how God might have put it all together, but also how God might have concealed Himself from us in the godly fear that a few of His more interesting creations—most certainly and specifically Picasso—were out to capture His secrets. As a corollary, Picasso, in his turn, certainly did his best to hide his own nature from biographers, lovers, and friends, and enjoyed elaborating legends about himself that would distort the comprehension of others. Of course, given his penchant for moving in opposite directions at once, he would also, in later years, date his sketchbooks in order to help others to a better comprehension of his own processes at work. For in his loneliness he also wished to be understood: his vanity was that his genius could prove a scientific resource for future students of art. And, after all, why not?

We may as well assume that he extrapolated a conception of God from his own contradictory nature. If Picasso could conceal and reveal himself with the most dynamic ambivalence of purpose, why should the Creator not be enmeshed in even larger revelations and deceptions?

Of course, on the day of his own death, Picasso would have to face an enraged chieftain who would not look lightly on this little man's attempts to raid the center of His secrets—as easily would a young Mafia lieutenant visit his Godfather after being discovered with a hand in the till.

Since we will soon follow Picasso into the interstices of Cubism, an austere period to be certain, it is probably worth reminding ourselves that for all his seriousness and dire commitment to an exploration whose end he could not foresee, he had not yet relinquished his friends, his amusements, his evening charades, and his delight in looking for the kind of "pataphysical" gatherings that artists sixty years later would refer to as *happenings*, which is to say events whose aesthetic intensity depends on some adroit mixture of the quotidian, the absurd, the cruel, the magical, and the unforeseen.

So there was a famous *hommage* in 1908 for *le Douanier* Rousseau that took place in Picasso's studio at the Bateau Lavoir. Without question, it became the archetypal party of this sort in this period. Over and over it has been written about, and most often repetitively, the contributions of earlier biographers being redone by later ones. To substitute for such a vice, one will quote at length from the writings of the principals. If this is a form of literary passivity, it is still preferable to routine recapitulation, especially since the initial testimonies are directly enjoyable.

3

A prefatory note. Before moving on to the festivities, we ought to take the pleasure of meeting Apollinaire's mistress, Marie Laurencin.

André Salmon describes how she became part of the *bande à Picasso*.

> One day, Georges Braque who had stopped going to the Academy Humbert because he could see that he was wasting his time, brought over to the Bateau Lavoir an astonishing young lady, escaped just like Braque, and by his advice . . . from the same Academy Humbert where she had enrolled without any greater ambition than to learn a little of this and that in the hope of practicing the pretty little craft of painting on porcelain. With her mother and her cat she lived on Boulevard de la Chapelle. She was beautiful if of an unorthodox kind of beauty, a Savoyard. She made one think, however, of certain beautiful Russian descendants of Pushkin who had Negro blood.[1]

Now that she had been introduced to the Bateau Lavoir by Braque, Picasso presented her to Apollinaire. Despite the fact that she could say, "My happiest days were when I used to be taken as a girl to a little community of nuns: the sisters took me in their arms, showed me picture books and let me play on the harmonium . . ."[2] Picasso told Apollinaire, "I have a fiancée for you."[3]

In later years, Marie Laurencin proved to be wild enough to battle with Apollinaire on equal terms. But that was later. Steegmuller describes the early days:

> . . . before long, Apollinaire moved away from his mother for the first time since returning from Germany. He rented a flat in the present Rue Henner on the lower

Marie Laurencin, Self-Portrait, 1909.

slopes of Montmartre, where Marie Laurencin visited him; and when she and her mother moved to Auteuil he followed them. "She is bright, witty, kind-hearted, and very talented," are his best-known words about his new mistress. "She's like a little sun—a feminine version of myself. She's a true Parisian, with all the adorable ways of a Paris child. Just think—when she came to see me in the Rue Gros she would skip rope all the way across the garden."

"A feminine version of myself . . ." There were dangers in that. [In Marie Laurencin] he had acquired a graceful mistress, as original and unconventional as he was himself: not that the similarity was conducive to continual peace and harmony.[4]

Fernande came to detest her. We know as much by the description of Marie Laurencin given to Alice Toklas: "a mysterious horrible woman who . . . made noises like an animal and annoyed Pablo."[5] Actually, there may have been no small reservoir of wounded ego at work here. Picasso had advised Fernande to learn painting on her own. Now, she had to put up with the contrary example provided by Apollinaire: He promoted Marie Laurencin's work as if she were on a par with Picasso, Braque, Derain, Matisse, Vlaminck, a further proof of Apollinaire's loyalty to friends and his essential incapacity to make critical artistic judgments. Marie Laurencin had a flair; her work was charming if in large part

Marie Laurencin, Group of Artists, 1908. From left to right are Picasso, Marie Laurencin, Apollinaire, and Fernande Olivier. Oil on canvas, 25 x 32 in.

because she settled early, perhaps too early, on a style that can only be described as stylized, but she certainly did not develop as fully as his encomiums on her talents.

In any event, despite the presence of so many remarkable participants, Marie Laurencin would prove to be the dramatic element in the banquet for Henri Rousseau. What a party!

It is not difficult to comprehend why Picasso was ready to honor Rousseau's work. The ability to paint like a primitive must have been seen by Picasso as the happiest route back into the perceptions of children. In the course of attempting such simplicity, Picasso had been obliged to reject all he had learned at La Llotja and the Royal Academy in Madrid. He had been forced, therefore, to pull out one by one the academic ligatures tied into his painterly reflexes in order to strip his style of the myriad of conventional techniques his brushes had already acquired. The process must have left him feeling like a libertine who has decided to make love only in the missionary position. How attractive to Picasso, then, must Rousseau's freedom from schooling have been.

Fernande, predictably, exercises her French sense of measure in describing the old painter:

> Guillaume took us to meet Rousseau, who is a poor and charming man, with a candor and a naïveté that are hardly conceivable. He is not particularly attractive, and his face, under his white hair, has a surprising banality. I didn't see anything in him that could reveal the artist . . .

Henri Rousseau

> We went to a soirée at the house of Rousseau. A little platform at the back of the studio served for a stage. Chairs were placed in straight rows, one behind the other, and benches against the walls. He had there a mixture of people: the spice man, the butcher, the dairy man, the baker—and their wives; other people were a little uneasy, perhaps the concierges from the neighboring buildings; then a whirl of intellectuals and artists—Georges Duhamel and his wife, the comedienne Blanche Albane; the painter Delaunay and his mother; Guillaume and his woman; Braque and us.
>
> The evening was begun by listening to

several people from the quarter. The women sang love songs and the men offered ditties that were more risqué. Then Rousseau played his violin, a long piece; at last he began to sing. "Oh, oh, oh—but I have a toothache!" all the while pantomiming his pain. It was funny but at the same time a little sad, and I was not greatly amused. I was thinking how it's regrettable that Rousseau would give himself to such a spectacle. He seemed to be something of a backward child whose family surrounded him with compliments in order to conceal his craziness. But this crowd had so little to do with his great canvases, so minutely painted, and yet, of a large, strange, and powerful set of works . . . The *Douanier* must live in a perpetual enchantment . . .[6]

Just so. Perpetual enchantment. The word went out about the party. Given the limited resources and the sardonic gleam in the collective eye of the *bande*, "the project was received enthusiastically by the gang who were overjoyed at the prospect of pulling the *Douanier*'s leg."[7] Their plans were to invite thirty people plus anyone who wished to drop in after dinner.

Gertrude's sustained account is worth printing at length. If, by habitual reflex, she gets a good bit of it wrong, we can still enjoy her shamelessness: She never feels any more guilt than would a hot docu-dramatist at warping history:

Fernande was lunching with us one day and she said that there was going to be a banquet given for Rousseau and that she was giving it. She counted up the number of the invited. We were included. Who was Rousseau. I did not know but that really did not matter since it was to be a banquet and everybody was to go, and we were invited . . .

Fernande told me a great deal about the menu. There was to be riz à la Valenciennes, Fernande had learnt how to cook that on her last trip to Spain, and then she had ordered, I forget now what it was that she had ordered, but she had ordered a great deal at Félix Potin, the chain store of groceries where they made prepared dishes. Everybody was excited . . . everybody was to write poetry and songs and it was to be very rigolo, a favourite Montmartre word meaning a jokeful amusement. We were all to meet at the café at the foot of the rue Ravignan and to have an apértif and then go up to Picasso's atelier and have dinner. I put on my new hat and we all went to Montmartre and all met at the café.

As Gertrude Stein and I came into the café there seemed to be a great many people present and in the midst was a tall thin girl who with her long thin arms extended was swaying forward and back. I did not know what she was doing, it was evidently not gymnastics, it was bewildering but she looked very enticing. What is that, I whispered to Gertrude Stein. Oh that is Marie Laurencin, I am

afraid she has been taking too many preliminary apértifs. Is she the old lady that Fernande told me about who makes noises like animals and annoys Pablo. She annoys Pablo alright but she is a very young lady and she has had too much, said Gertrude Stein going in. Just then there was a violent noise at the door of the café and Fernande appeared very large, very excited and very angry. Félix Potin, said she, has not sent the dinner. Everybody seemed overcome at these awful tidings but I, in my american way said to Fernande, come quickly, let us telephone. In those days in Paris one did not telephone and never to a provision store. But Fernande consented and off we went. Everywhere we went there was either no telephone or it was not working, finally we got one that worked but Félix Potin was closed or closing and it was deaf to our appeals. Fernande was completely upset but finally I persuaded her to tell me just what we were to have had from Félix Potin and then in one little shop and another little shop in Montmartre we found substitutes, Fernande finally announcing that she had made so much riz à la Valenciennes that it would take the place of everything and it did . . .

. . . As we toiled up the hill we saw in front of us the whole crowd. In the middle was Marie Laurencin supported on one side by Gertrude Stein and on the other by Gertrude Stein's brother and she was falling first into one pair of arms and then into another, her voice always high and sweet and her arms always thin graceful and long. Guillaume of course was not there, he was to bring Rousseau himself after everyone was seated.

Fernande passed this slow moving procession, I following her and we arrived at the atelier . . . I had just time to deposit my hat and admire the arrangements, Fernande violently abusing Marie Laurencin all the time, when the crowd arrived. Fernande large and imposing, barred the way, she was not going to have her party spoiled by Marie Laurencin. This was a serious party, a serious party for Rousseau and neither she nor Pablo would tolerate such conduct. Of course Pablo, all this time, was well out of sight in the rear. Gertrude Stein remonstrated, she said half in english half in french, that she would be hanged if after the struggle of getting Marie Laurencin up that terrific hill it was going to be for nothing. No indeed and beside she reminded Fernande that Guillaume and Rousseau would be along any minute and it was necessary that everyone should be decorously seated before the event. By this time Pablo had made his way to the front and he joined in and said, yes yes, and Fernande yielded. She was always a little afraid of Guillaume Apollinaire, of his solemnity and of his wit, and they all came in. Everybody sat down.

Everybody sat down and everybody began to eat rice and other things, that is as soon as Guillaume Apollinaire and Rousseau came in which they did very presently and were wildly acclaimed. How well I remember their coming . . .

Everybody was presented and everybody sat down again. Guillaume slipped into a seat beside Marie Laurencin. At the sight of Guillaume, Marie who had become comparatively calm seated next to Gertrude Stein, broke out again in wild movements and outcries. Guillaume got her out of the door and downstairs and after a decent interval they came back Marie a little bruised but sober. By this time everybody had eaten everything and poetry began.[8]

Fernande gives a considerably different account of Marie's activities:

The first thing she did when she came back into the studio was fall onto the jam tarts which had been left on the sofa and, with her hands and dress smothered in jam, start kissing everybody. She got more and more excited, and then found herself quarrelling with Apollinaire . . .

At the end of the room, opposite the big high window, was the seat intended for Rousseau: a sort of throne, made from a chair built up on a packing case and set against a background of flags and lanterns. Behind this was a large banner bearing the words "Honor to Rousseau."

The table was a long board set on trestles. The chairs, plates, and cutlery had been borrowed from our local restaurant, Azon's. Thick glasses, small, heavy plates, and tin knives and forks: but nobody bothered about such things.[9]

We can return here to Gertrude's account:

Oh yes, before this Frédéric of the Lapin Agile and the University of Apaches had wandered in with his usual companion a donkey, was given a drink and wandered out again. Then a little later some italian street singers hearing of the party came in. Fernande rose at the end of the table and flushed and her forefinger straight into the air said it was not that kind of a party, and they were promptly thrown out.

Who was there. We were there and Salmon, André Salmon, then a rising young poet and journalist, Pichot and Germaine Pichot, Braque and perhaps Marcelle Braque but this I do not remember, I know there was talk of her at that time, the Raynals, the Ageros the false Greco and his wife, and several other pairs whom I did not know and do not remember . . .[10]

Fernande again:

There were speeches and songs composed especially for the occasion; then a few words from Rousseau, who was so moved that he spluttered with pleasure. Indeed, so happy was he that he accepted with the greatest stoicism the regular dripping of wax tears on his brow from a huge lantern above him. The wax droppings accumulated to form a small pyramid like a clown's cap on his head, which

stayed there until the lantern eventually caught fire. It didn't take much to persuade Rousseau that this was his apotheosis. Then Rousseau, who had brought his violin, started to play a little tune.[11]

Gertrude once more:

> The ceremonies began. Guillaume Apollinaire got up and made a solemn eulogy, I do not remember at all what he said but it ended up with a poem he had written and which he half chanted and in which everybody joined in the refrain. La peinture de ce Rousseau.[12]

If Apollinaire was mean as a churchmouse with his food and his money, he was as rich as a monarch when it came to praise:

> *Nous sommes réunis pour célébrer le gloire,*
> *Ces vins qu'en ton honneur nous verse Picasso*
> *Buvons-les donc puisque c'est l'heure de les boire*
> *En criant tous en choeur: "Vive! Vive Rousseau!"*

> Here we gather to celebrate your glory,
> These wines Picasso pours are in your honor
> Drink up now since it is the hour to drink.
> And let's sing out as one: Live, long live Rousseau![13]

Other toasts followed, and Gertrude's account may begin to pick up a few liberties:

> . . . all of a sudden André Salmon who was sitting next to my friend and solemnly discoursing of literature and travels, leaped upon the by no means solid table and poured out an extemporaneous eulogy and poem. At the end he seized a big glass and drank what was in it, then promptly went off his head, being completely drunk, and began to fight. The men all got hold of him, the statues tottered, Braque, a great big chap, got hold of a statue in either arm and stood there holding them while Gertrude Stein's brother another big chap, protected little Rousseau and his violin from harm. The others with Picasso leading because Picasso though small is very strong, dragged Salmon into the front atelier and locked him in. Everybody came back and sat down.[14]

Fernande offers her version of the episode:

> Two or three American couples, who had got there by accident, had to make the most excruciating efforts to keep a straight face. The men in their dark suits

and the women in pale evening dresses seemed a bit out of their element amongst us. [and André Salmon] did an imitation of *delirium tremens*, chewing soap and making it froth out of his mouth, which horrified the Americans.[15]

From Gertrude:

Thereafter the evening was peaceful. Marie Laurencin sang in a thin voice some charming old norman songs. The wife of Agero sang some charming old limousin songs. Pichot danced a wonderful religious spanish dance ending in making of himself a crucified Christ upon the floor. Guillaume Apollinaire solemnly approached myself and my friend and asked us to sing some of the native songs of the red indians. We did not either of us feel up to that to the great regret of Guillaume and all the company. Rousseau blissful and gentle played the violin and told us about the plays he had written and his memories of Mexico. It was all very peaceful and about three o'clock in the morning we all went into the atelier where Salmon had been deposited and where we had left our hats and coats to get them to go home. There on the couch lay Salmon peacefully sleeping and surrounding him, half chewed, were a box of matches, a petit bleu and my yellow fantaisie. Imagine my feelings even at three o'clock in the morning. However, Salmon woke up very charming and very polite and we all went out into the street together. All of a sudden with a wild yell Salmon rushed down the hill.

Gertrude Stein and her brother, my friend and I, all in one cab, took Rousseau home.[16]

When *The Autobiography of Alice B. Toklas* came out in 1933, twenty-five years after the event, André Salmon was enraged.

The story of the Rousseau banquet is very badly told . . . The way she recounts this banquet is very flighty, to say the least. I am all the more astounded for I had thought, along with all our other friends, that she had really understood things. It is evident that she had really understood nothing, except in a superficial way.

Her description of my drunkenness on this occasion is entirely false. Madame Fernande Olivier, in her book, *Picasso and His Friends*, tells it much better. "Salmon pretended *delirium tremens* in order to frighten the American ladies present." It was exactly that. Guillaume Apollinaire and I had spent the afternoon together writing the poems that were read. The banquet was not given just for the fun of it either, as Miss Stein seems to have thought, but because we sincerely admired Rousseau. The spectacular features of it were intentional and after the joke of drunkenness I simply went back to my own studio in order to make it seem

more plausible. It is evident Miss Stein understood little of the tendency we all had, Apollinaire, Max Jacob, myself and the others, to frequently play a rather burlesque role . . . Obviously she did not understand very well the rather peculiar French we used to speak.[17]

Since it was the first large party Fernande and Picasso had ever hosted, it is not difficult to speculate on their motives. What with Gertrude's Saturday evenings at the rue de Fleurus, they had not only met a number of American and English artists and writers and collectors but had begun to obtain a kind of celebrity of their own. And now that Picasso's work was selling a little more, there can be small doubt that Fernande was feeling a few social ambitions. Probably, she had been looking for some time to give an important party.

And Picasso? He would have wanted a large, successful evening at the same time that he would have detested the idea. One could lose much bohemian honor by behaving even a shade bourgeois. A party for Rousseau, however, would resolve the problem: One might at the same time be serious and yet mock the event, precisely the sort of irony on which Picasso would rely.

As for Rousseau, he was indeed simple. Patrick O'Brian quotes a conversation between Rousseau and Ambroise Vollard about ghosts:

VOLLARD: No, I don't believe in them.
ROUSSEAU: Well, I do. I've seen some. There was one that persecuted me for quite a while.
VOLLARD: Indeed? What did it look like?
ROUSSEAU: Just an ordinary man . . . He used to come and defy me when I was on duty at the *octroi*. He knew I couldn't leave my post, so he used to put out his tongue or make long noses at me and then let off a great fart.
VOLLARD: But what makes you think he was a ghost?
ROUSSEAU: Monsieur Apollinaire told me so.[18]

Since it was her party, let us give the last word to Fernande:

Rousseau remembered that dinner with emotion for a long time afterwards, and the good man took it in good faith as homage paid to his genius. He even sent a sweet letter to Picasso, thanking him.

It was some time after that that Rousseau, twice a widower, became engaged to be married for the third time. His self-respect was greatly wounded by his future father-in-law, who thought him too old for his daughter. She was, in fact, fifty-nine. Rousseau must have been a little over sixty-six. As for the father-in-law, he

was eighty-three. Rousseau was desolated by the fact his fiancée would not act against her father's wishes. He was quite cast down by this:

"One can still be in love at my age without being ridiculous. It's not the same sort of love as you young people go in for, but must one resign oneself to living alone, just because one's old? It's dreadful going back to lonely lodgings. It's at my age that one most needs one's heart warmed up again and the knowledge that one won't have to die all alone and that perhaps another old heart will help one's passing to the other side. It's not right to laugh at old people who get married again; you need the company of someone you love when you're waiting to die."

He said all this in a soft, tearful voice. He hadn't the time, as it turned out, to put all this into practice: he died alone, in a hospital, a few months later.[19]

Nonetheless, two years after the banquet in his honor, Rousseau did bring off what may be his greatest painting, *The Dream*, and it would be mean-spirited to think that the adulation received on a fall night in 1908 had nothing to do with it.

Henri Rousseau, The Dream, 1910. Oil on canvas, 80 x 117 in.

Part IX

Cubism

Toward the end of 1908, Picasso and Braque were to discover that in the course of working independently, they had begun to explore remarkably similar paths.

It was a curious situation. The two men had known each other for more than a year, but had not been close except for the propinquity of sharing, even before they met, a number of friends, notably Manolo, Derain, Uhde, Matisse, and Apollinaire. On the day that Picasso tried boxing with André Derain, it is likely that Braque was there; he and Derain boxed frequently. Moreover, Apollinaire had brought Braque over to Picasso's studio in 1907 long enough for Braque, taking in *Les Demoiselles d'Avignon*, to make his famous remark about eating rope and drinking turpentine. Braque was outspoken—one of the numerous differences between himself and Picasso. Braque was also tall and extraordinarily strong, more so than any of the other painters in Montmartre, more powerful even than Derain and Vlaminck.

Braque, c. 1904–05.

He was French and came from Le Havre; he sang well and danced well; he could play Beethoven on his accordion. Or such was his boast. Not a mean feat for a man who came from skilled working-class stock. His father was an up-to-date house-painter who sent Braque to Paris in order to acquire "special decorating techniques that would be useful to the family firm and enhance his standing as an artisan: how to paint imitation marble, exotic wood grains, mosaics, cornices, moldings, paneling—in short, how to render all the expensive embellishments of turn-of-the-century interiors as relatively inexpensive two-dimensional illusions."[1]

By 1902, Braque was also going to art school. Living in Paris stimulated his desire to become a serious painter. Being, however, patient, practical, and logical, he was also in accord with the general agreement of his fellow artists that he did not draw very well, not even, indeed, by 1908 (see colorplate 9).

Braque, c. 1908, from The Architectural Record, *May 1910.*

Of *Large Nude*, the critic Charles Morue was to comment at the time: "I think a stone moves him as much as a face." Cubism, from Braque's point of view, had the ideal purpose of putting "painting within the reach of my own gifts."[2]

William Rubin, ready to defend such gifts, speaks of Braque's awareness of light and space, and his fertile appreciation of how to introduce new materials into painting.[3] One might add Braque's ability to conceive new concepts based on such materials and collage. So Braque was correct in his self-assessment. Without Cubism, his special aptitudes would have had nowhere to go.

Given his limitations, it will come as no surprise that he had powerful sentiments. Braque wanted his work to offer tactile sensations. If he painted in a smoker's pipe on a still-life, he wanted that pipe to be life-size so that one's hand would itch to pluck it off the canvas.

Colorplate 9. Georges Braque, Large Nude, Paris, spring 1908. Oil on canvas, 55 x 39 in. For accompanying text, see page 288.

Colorplate 10. Georges Braque, *Road Near L'Estaque*, late summer 1908. Oil on canvas, 24 x 20 in. For accompanying text, see page 289.

Colorplate 11. Cottage and Trees, La Rue-des-Bois, August 1908. Oil on canvas, 36 x 29 in.
For accompanying text, see page 289.

Colorplate 12. Georges Braque, Trees at L'Estaque, August 1908. Oil on canvas, 31 x 24 in. For accompanying text, see page 289.

Colorplate 13. Georges Braque, Houses at L'Estaque, August 1908. Oil on canvas, 29 x 23 in.
For accompanying text, see page 291.

Colorplate 14. Georges Braque, Landscape, Paris, autumn 1908. Oil on canvas, 32 x 25 in. For accompanying text, see page 293.

Colorplate 15. Georges Braque, Castle at La Roche-Guyon, summer 1909. Oil on canvas, 32 x 24 in. For accompanying text, see pages 293–94.

Colorplate 16.
Georges Braque,
Violin and Pitcher,
Paris, early 1910.
Oil on canvas,
46 x 29 in. For
accompanying text,
see pages 293–94.

"If a still life isn't within reach of my hand, it seems to me that it ceases to be a still life, ceases to be affecting." Even Braque's choice of still life objects was influenced by his sense of "manual space." He explained that his now-familiar Cubist iconography was not accidental. "Musical instruments, considered as objects, were special in that a touch would bring them to life."[4]

Neither Braque nor Picasso would ever be forthcoming about the work they did together, but Braque, from an early stage, may have had intimations that future relations with Picasso could prove interesting. Even with Braque's initial reaction to *Les Demoiselles*, the canvas must have obsessed him, for by 1908 he was no longer painting like a Fauve; indeed, his style, though he worked separately, nonetheless grew closer to Picasso's, so much closer that Fernande, commenting twenty-five years later, would write that Picasso "was rather indignant"—Braque was showing a canvas "of Cubist construction . . . painted in secret without informing anyone, even Picasso."[5]

Her recollections suffer, of course, from the slack of memory. The word *Cubist*, never one of Picasso's terms, would certainly not have been used by him in 1908; moreover, Braque had made a point on his return from L'Estaque in the early fall of that year to show Picasso the work he had done over the summer. On the other hand, it would have been uncharacteristic for Picasso not to undergo contradictory reactions to a striking event; doubtless, he was furious that Braque was stealing a march on him, and had told Fernande as much. At the same time, he must have been feeling some mixture of awe, even of vindication, that the lonely direction he had chosen seemed to have induced similar effects in another painter (see colorplates 10–12, following page 288).

Kahnweiler is interesting here:

> While Picasso was . . . at La Rue-des-Bois, Braque, at the other end of France, in L'Estaque (near Marseilles) was painting the series of landscapes we have already mentioned, [yet] Braque arrived at the same point as Picasso. If, in the whole history of art, there was not already sufficient proof that the appearance of the aesthetic product is conditioned in its particularity by the spirit of the time, that even the most powerful artists unconsciously execute its will, then this would be proof. Separated by distance, and working independently, the two artists devoted their most intense efforts to paintings which would share an extraordinary resemblance. This relationship between their paintings continued but [later] ceased to be astonishing because the friendship between the two artists, begun in the winter of that year, brought about a constant exchange of ideas.[6]

Paul Cézanne, Bend in a Road, Paris, 1900–06.

Be it said that Cézanne had offered them a foundation in common before he died on October 22, 1906. *Bend in a Road* cannot be dated more closely than between 1900 and 1906, but we can assume that both painters were familiar with it.

All the same, Picasso's early sentiments about Braque were bound to be contradictory. If he could enjoy the Frenchman's strength and good looks in something like the measure of what he had once felt with Pallarés, he also had to be jealous of the athletic and musical abilities of his new friend. Braque had legitimate machismo. If this could prove sufficiently oppressive for Picasso to speak of Braque behind his back as Mme. Picasso—a reference most likely to Braque's occasional docility face to face with Picasso's greater brilliance and superior technique—well, to Picasso's credit, it had to be seen as an unequal relationship. Picasso was bringing his host of styles, completed periods of work, and painterly virtuosity to their team of two. Braque, as William Rubin points out, could offer little more than art school and two years of all-out commitment as a Fauve. By way of Rubin we also learn that Kahnweiler could sell Picassos for approximately four times more than Braques.[7] Picasso, with his shrewd sense of character, must also have sensed that Braque, given his peasant roots and immediate family background as an artisan, would respect Picasso's considerably greater earning power as a species of virility. Hence Picasso and Mme. Picasso.

Even Kahnweiler, normally cautious, does say in 1916 in *Der Kubismus*, "Admittedly Braque's art is more feminine than Picasso's brilliantly powerful

work," and goes on to suggest that "gracious" Braque is the "gentle moon" against "austere" Picasso's "brilliant sun."[8]

Indeed, there is some truth to this: If one studies their work in these years, one can usually distinguish a Picasso from a Braque. Not always, however. For Picasso would often pick up Braque's themes and produce canvases in Braque's vein; Braque, however, cannot often come off like Picasso. Machismo, obviously, has its mansions and no one was going to be more macho than Picasso when it came to painting. Fair enough. He was not in a hurry to forgive God for making him short after his father was tall.

So, there were obstacles to the early friendship. One of the paintings Braque brought back from L'Estaque in the fall of 1908 was a seminal work that impressed Matisse. He said as much to his intimates, a noteworthy reaction considering that Braque had been one of Matisse's followers and was now moving in Picasso's direction. It may have been Matisse's pride to possess objective judgment in art matters, or for all we really know, it could have been his deliberate intent to annoy Picasso, but Matisse did talk a good deal about *Houses at L'Estaque* (colorplate 13, following page 288), and his always detailed opinions probably made their way over to the Bateau Lavoir.

After the publication of *The Autobiography of Alice B. Toklas* in 1933, in which Gertrude with her usual felicitous inaccuracy spoke of a war between the Matissites and the Picassoites, Matisse, in reply, would sum up his earlier reactions:

> According to my recollections, it was Braque who made the first Cubist painting. He brought back from the south a Mediterranean landscape that represented a seaside village seen from above. In order to give more importance to the roofs, which were few, as they would be in a village, in order to let them stand out in the ensemble of the landscape, and at the same time develop the idea of humanity that they stood for; he had continued the signs that represented the roofs in the drawing on into the sky and had painted them throughout the sky. This is really the first picture constituting the origin of Cubism, and we considered it as something quite new, about which there were many discussions.[9]

Given the critical pummeling Picasso had received for *Les Demoiselles d'Avignon*, he could well have felt no small rage over Braque's investiture of his creative path. It is just as well for the future of Cubism that a magical juxtaposition took place at this time. In *Gil Blas*, on November 14, 1908, a review by Louis Vauxcelles of Braque's show at Kahnweiler's was printed next to a story about

La Conquête de l'air

AU MANS

Wilbur Wright gagne le prix de la hauteur

Le Mans, 13 novembre. — M. Wilbur Wright a commencé à 4 heures pour le prix de hauteur de

Wilbur Wright in his biplane flying over LeMans, August 1908.

Review of Braque's exhibition at the Kahnweiler gallery (left), printed in Gil Blas, November 14, 1908.

Wilbur Wright, who had just set an altitude record at Le Mans with his biplane.[10]

It took a few years before Picasso began to call Braque "mon cher Wilbur," but coincidences had the power of omens for him—nothing less than the whole of his work attests to that! Besides, he was fascinated by airplanes. As Penrose remarks, flight was an effort "to conquer another dimension in space."[11] Or, converted to Picasso's logic: If airplanes can fly, space can be reinvented. Adventuring into the air was one more way of exploring into the secrets. That autumn of 1908, Braque would bring *Houses at L'Estaque* over to Picasso's studio. By 1951, Matisse, contradicting his remarks in 1935, would say in an interview with Tériade: "I saw the picture in the studio of Picasso, who discussed it with his friends."[12]

"Before long," Braque would later remark, "Picasso and I had daily exchanges[13] . . . we discussed and tested each other's ideas as they came to us, and we compared our respective works."[14]

In turn, Picasso would agree: "Almost every evening, either I went to Braque's studio or Braque came to mine. Each of us had to see what the other had done during the day."[15]

Years later Braque, meditating on this period from 1909 to 1914, would declare: "Picasso and I said things to one another that no one will ever say again . . . things that would be incomprehensible to others, but that gave us great joy. It was like being roped together on a mountain . . . All that will end with us."[16]

Hemingway's dictum never to talk about anything good for fear of spoiling it is obviously present in Braque and Picasso. They are as famous as Hemingway for never talking about it, and Picasso took joy in declaring that there was no Cubism. (He detested the word.) Anticipating Marlon Brando, he once skipped out of an interview on Cubism by announcing that he had to feed his monkey.[17]

When it comes, therefore, to definitive understanding of Cubism, it is evident that every explorer will have to do his own bushwhacking. There are, as we shall see, a few accepted theories that come down from Kahnweiler and a good deal of museum catalogue literature is based on the dealer's understanding of Cubism, but if such a combination has garnered considerable authority by now, it is still without great insight. Before we take up the established view, however, it may help to consider some of Braque's and Picasso's artistic motives.

Since they were both in Paris until April of 1909, their early collaboration involved, as Braque stated, several intense months. The partnership had begun. If, by way of Cézanne, they already knew that a tree could serve as a torso, and that a white towel in a still-life might be equal visually to a mountain slope, they were looking for new paths across the space of the canvas. (Not for too little had Braque employed the image that they were roped together like mountaineers.) It can be said that they were opening their eyes to the vertigo of existence itself. Wholly different objects that possessed similar forms could now present dizzying associations. It would take two years and more for Cubism to mature into its full complexity, but for us to stare at length into any one of the major works they painted between 1909 and 1912 is not unequal to peering at the architecture—or is it the inner organs?—of existence itself.

Even by autumn of 1908, Braque had managed to demonstrate in a work titled *Landscape* (colorplate 14, following page 288) that his canvas, held upside-down or rotated through ninety degrees on either side, had as much to show as when studied right-side-up: It was hard not to feel as if one were gazing in turn at a forest, a cave, a village, or a storm at sea. "It's all the same to me," Braque would say in 1959, "whether a form represents a different thing to different people or many things at the same time,"[18] and indeed the print is worth examining from all four sides.

Such artistic freedom brought, however, a host of complex problems. Space was no longer an empyrean void in which selected objects could be displayed—space was now a field of force between objects, and magnitude was stripped of its context: One need only compare Braque's tentative, even milky, portrayal of the *Castle at La Roche-Guyon* (when he was without Picasso's company in the summer

of 1909) to the far superior depiction of a castle done by him in Paris in the early winter of 1910. It is just that now the castle is titled *Violin and Pitcher*. (See color-plates 15 and 16, following page 288.)

The echo of a form was able to invoke a different order of magnitude; a violin and a pitcher could have as much presence as a castle.

Picasso, in turn, was exploring light and time—indeed, he was seeking to integrate them. The *Fruit Dish* of 1908–1909 (colorplate 17, following page 304) has, for example, contradictory sources of illumination—one source overhead and one from underneath. It is early in Cubism, however; the result speaks more of stage-craft (a most agreeable stagecraft) than the exercise of a new theory. The *Fruit Dish* remains a still-life. It may sit luminously on its base, but still it sits.

Just a few months later, however, Picasso takes a huge stride—he embarks on a new kind of figure drawing that he will not relinquish for the next six decades: He conducts the nude through a passage in time as if his eye is in league with a traveling source of light, as if indeed his eye *is* the traveling source! Thereby, he manages to go around the breasts and belly to view the back and buttocks. Since conventional light imprisons reality by offering only one theme per painting—the theme created by the stationary light source—the painting is thereby fixed at an instant in time. Picasso will demonstrate that one form can turn into another as soon as one uses a moving source of light. (See colorplate 22, following page 304.)

It can be said that the foundations of Cubism—a dynamic art!—are now in place. If this is an oxymoron—dynamic foundations—Picasso, for one, was quite at home with intellectual vertigo.

2

Picasso's renown was growing and could be measured by the increase in the price of the paintings being sold by Kahnweiler, Uhde, and Vollard. The burgeoning interest of collectors suggested that he might never be poor again. So, in the summer of 1909, he chose to take Fernande on another trip to Barcelona, and soon after their arrival—was he attempting to recapture the spirit of Gósol?—he took her up to Horta.

Little went well, however, for Fernande. Picasso would be active that summer and come back with six landscapes and fifteen portraits of his mistress, but the trip did not bring them together. Their long separation through the summer and fall of 1907 was bound to have left infuriating memories—each of them had had romances with other people. Then Wiegels' death kept oppressing Picasso; he was the man to understand that madness sits next to every attempt to penetrate the universe. Worse, he was living with a woman who hardly comprehended Cubism and did not like it. And he would be without Braque for the summer.

Picasso may have been working this side of an organic depression; later, when he was back in Paris, he came down with a stomach ailment, a pre-ulcerous condition generated, doubtless, by the stimulations, permutations, and godawful combinations opened by every brush-stroke in each new painting: No relation between the brush and the canvas could be taken for granted any longer—Cubism was easily as complex as three-dimensional chess.

Nonetheless, it was Fernande who became ill. She started to suffer in Barcelona, but by June, when they reached Horta, she was in misery. In July it was worse.

Dear Gertrude,

Excuse me for not having written you, but my bad health is the cause of it. Everything wears me out, and I have not been able to do a thing. I think I have an illness of the kidneys . . . Already in Barcelona the doctors warned me about it, but here I can confirm the sickness myself. I would certainly be better in Paris, where I could have it cared for. But the voyage would aggravate the illness. I am annoyed, moreover, that here there is no way to treat it other than by a regimen. I stay almost all day in bed because I cannot bear to be seated . . .

Life is sad. Pablo is in a bad mood, and I have received nothing from him in the way of moral or physical comfort. When this acute pain takes me, he gets very pale and that's all . . . To you alone, I say that I am very depressed . . . if it lasts another month, I believe it will all be over. I will die of it. And Pablo doesn't help me, he . . . is too egotistical to wish to understand that now it is I who have need of him, that he's responsible for my state, that in great part he brought me to this and he has completely undone me . . . If I become sad, he's furious.[1]

"He's responsible for my state . . . he brought me to this." There is blood in her urine, and sometimes it is all blood. She suffers from acute pain. It is possible that one of his old venereal diseases now inhabits her. Before antibiotics, people lived with the after-effects of syphilis and gonorrhea as if such afflictions were comparable to herpes—an ongoing if intermittent annoyance. Of course, he will shrug. It is her turn in the barrel, that's all. If he seems heartless, he probably is, but in the manner of an investigator, a general, a consecrated athlete. The goal is paramount: one's mate is present, therefore, as an effective and useful aide-de-camp or as an impediment. Guilt is the one overload he will not accept. He cannot afford it. There would be no limit to the corpses who could come back to life in his dreams, and he needs his powers of concentration. He is moving out into the jungles and ice-fields of outer aesthetics.

At this point, how she must suffer with his work. How he must ignore such suffering. The rest of her letter tells us as much:

. . . I am so unhappy, so alone. Despite the fact that he really loves me, I believe it, Pablo would let me die without being aware of my state. Only when I truly suffer does he stop a little to occupy himself with me. He knows nothing . . . You're going to find that I am concerned much too much with myself, but to you alone, I can tell all . . . And don't speak of this to anyone.[2]

O'Brian adds a telling factor:

It may seem trifling to speak of a somewhat vain young woman's reaction to Cubism, but [her] face was her fortune, and she could scarcely watch with philo-

sophic detachment while it was carved into ridges, especially as the ridges and the corresponding hollows . . . belonged to a woman of sixty or more. Braque once said something to this effect: "A portrait is a job in which there is always something wrong with the mouth . . . Show a bourgeois the most advanced art you like and he is delighted: but just you touch his mug and there's all Hell to pay." As far as her physical appearance went, Fernande was a true bourgeoise. Hitherto Picasso had been kind to her face and her person . . . Now all this was changed.[3]

We can compare the way he painted her in 1906 to the manner three years later. In 1906, the girl in blue could even be seen as a surrogate for Picasso, who in this early time was virtually a servant to Fernande. Needless to underline, matters have changed by 1909. (See colorplates 18 and 19, following page 304.)

She must have writhed in mute horror—he obviously loved his work more than he loved her. Picasso's main concern now seems attached to how much the *Reservoir at Horta* can be brought into family resemblance with his portraits of Fernande (see colorplates 20 and 21, following page 304).

From the beginning, his attitude proclaims: She will recover. She does. In a photograph we have of her in Horta de Ebro, it is interesting that she is holding an unhappy child's hand. Yes. One more buried anger between Picasso and herself: the children she will never give birth to, and the recollection of the sad fiasco of the child they adopted for a week.

No question. Something has hardened in the relationship. The form it will take after their return to Paris is a move out of the Bateau Lavoir and into an apartment at 11 boulevard de Clichy, an apartment worthy of

Fernande Olivier, Horta de Ebro, 1909.

a true bourgeois; it is interesting that in years to come, each will blame the other for the move. In all probability, they are both correct.

A profound dichotomy in Picasso's behavior is commencing. He is half-bohemian, half-bourgeois, and will remain so for the rest of his life, inhabiting mansions and castles before he is done, yet always refusing to furnish them in any

manner consistent with his wealth or the style of the architecture. He will collect junk rather than antiques; he will dress on occasion with elegance but work in the same kind of clothes he used to wear at the Bateau Lavoir; he will live for the rest of his life with one thigh thrust into the camp of the wealthy and one toe back in the poverty of the young painter. It is as if, like the majority of artists from middle-class roots who come before and after him, he can escape from the values and ambitions of his parents, but only by half.

Fernande sends a *pneumatique bleu* immediately to Miss Stein:

Sunday

You can, as of now, dear Gertrude, come to visit us at 11 boulevard de Clichy. We've moved in this morning, but unhappily we are still far from being settled. If you wish to come tomorrow, Monday, at least one of us will be there in the after-noon.[4]

Her social ambitions stir. Fernande also has a divided heart. If she is famous for being the best-looking artist's mistress in Paris, she nonetheless remains the

Picasso, in his apartment on the boulevard de Clichy, 1910.

product of her aunt's middle-class strictures. She may adore Picasso for his vigor and his talent, but she is nonetheless ashamed of how crude he still can be. Overseeing one of the first notes Picasso sends off from Gósol to Gertrude Stein back in 1906, Fernande is obviously trying to fill any social pit her Spaniard might be digging with his semi-literate French. In her accompanying letter, we can feel her shame for his orthographical gaffes: "It seems doubtful to me that you will succeed in deciphering Pablo's letter, but I think it is preferable to leave it in the original, such as it is, in this French which is more or less *eccentric.*"[5] "*Fantaisiste*" is the word she actually employs, and that classification is not unkind considering his butchery of French syntax and his

spelling. Picasso is so semi-illiterate in French that he may have been dyslexic. Indeed, how could his eye pass along a run of alphabetic letters wholly in series when his instinct jumps his vision from the breast to the buttocks? Fernande (in one small but final part of herself) is obviously as embarrassed by him as her aunt might be.

What a closet passion, therefore, to live in some kind of middle-class style like other successful people.

> We take our meals in a dining room of old mahogany furniture, served by a maid on a white tablecloth. We sleep in a room that is actually to be used for rest, in a low bed with heavy square copper posts. Behind the bedroom, at the end of the hall, there's a little living room with a sofa, a piano, a pretty Italian piece with carvings of ivory and pearl, which was sent to him by his father, and at the same time several other old, nice pieces. I might remark on the astonishment of the movers at the difference between the two studios, the old and the new. "Surely," said one of them to Raynal, who was helping Picasso, "surely these people have won a lottery."
>
> There are two windows, and when one leans out of them, one can see sunlight and beautiful trees and gardens. Often one returns in the dawn, and when one looks out the window the birds are singing and one hears them for a good moment before sleeping until eleven o'clock or midday.[6]

All the same, her graver sense of reality never departs.

> Despite everything, Pablo is already less happy here than he's been before. The servant very quickly comprehends his character, and forms a good habit of not irritating him. To the contrary, she doesn't clean his studio except when he gives the order. One doesn't sweep; he always has a horror of dust unless it is not moving, but any powder that flies up in the air and collects on new canvases drives him wild. In the morning, naturally, one lets him sleep, and the housekeeping reflects that. The maid grows negligent and gets up late . . .[7]

Probably, she has harangued him for a year or more to move from the Bateau Lavoir, but now she is obviously worried that they have made a large mistake.

> Despite our material prosperity, he's more and more in a dark mood. When one asks him what's going on, if he's annoyed or suffering, he looks back with an astounded air and answers, "No, not at all—I'm thinking about my work." When he's at table he hardly speaks. Often, he stays silent during the length of the repast.
>
> He is, however, suffering, or believes himself to be. When I first knew him,

several years ago, he drank a lot, he ate it didn't matter what. He now cannot take in anything other than what's been prescribed for his diet. For several years now I've seen him drinking nothing but mineral water or milk, eating only vegetables, fish, rice that's been boiled in milk, and grapes. Perhaps it's this regimen that leaves him so sullen.[8]

Soon enough, he is terrified of illness and keeps looking at his handkerchiefs to see if he is spitting blood. Even when a doctor assures him that he is healthy, he disbelieves the verdict. As Fernande adds, "He was nervous of everything, even before it had happened."[9]

No matter. They have moved in order to improve their social standing, and so they work at it despite illness, depression, and the forward march of Cubism.

Picasso continued to make the round of visits to his friends, always protesting to Fernande before they set out that it was a boring waste of time, always remaining taciturn while they were there, but nevertheless unable to live without these contacts which he enjoyed in his own way. The Saturday visit to the Steins at their studio in the rue de Fleurus was a regular event.[10]

They also entertain at home.

Picasso and Fernande not only received all comers on Sundays but they also gave small dinner-parties—small, because the table took up so much space that there was little room for guests, particularly for guests as bulky as Apollinaire and Gertrude Stein. Sometimes Matisse came, and his natural dignity always acted as a restraint; but even when Max Jacob, van Dongen, Pichot, Salmon, or Braque were there it was no longer the same; and for Fernande at least the old comradeship of their poorer days was slowly dissolving. Devouring bread and sardines at a table covered with newspaper, with one napkin for everybody, in a studio smelling of turpentine . . . was one thing; eating a regular number of courses in a proper dining-room, waited upon by a starched and silent maid, was another.[11]

Perhaps, with all else, the gray-and-brown palette of Cubism could be seen as a reflection of long periods of depression walking with one's head down, staring at the wet cobblestones of Paris streets on a rainy autumn day.

3

Nor was work prospering. After their early and brilliant collaboration, Picasso and Braque were now engaging some of the bottomless difficulties implicit in the very concept of Cubism. It is not impossible that the move to boulevard de Clichy contributed to a loss of invention, but whatever the cause, it can be argued that from the fall of 1909 until the summer of 1911, with all notable exceptions granted, Cubism was languishing. While Braque and Picasso maintained their close collaboration for the six months they were both in Paris from November 1909 through April 1910, and again from December 1910 through July 1911, their product lacked the reverberation of its beginnings and would not reach its period of highest realization until the fall of 1912.

There are, of course, few movements in art as inimical to such aesthetic judgments as Picasso's and Braque's Cubism but, the peril acknowledged, one can still feel a blurring of purpose in Picasso's *Woman with a Mandolin* (which looks like a Braque). In truth, there is a mechanical heaping up of planes, empty of real complexity, in Braque's *Woman with a Mandolin* (which looks like a second-rate Picasso; see colorplates 24 and 25, following page 304).

Equally, the *Portrait of Wilhelm Uhde* (colorplate 23, following page 304) may be renowned for too little. If it is one of the first Cubist portraits, it is still relatively barren of invention (barren, at any rate, for Picasso) and seems as much a charming caricature as a Cubist work.

How much better by comparison are two portraits by Cézanne, each of which anticipates Cubism:

Paul Cézanne, Self-Portrait, 1879–82.
Oil on canvas, 16 x 10 in.

Paul Cézanne, Man with Crossed Arms, 1899.

At this point, Picasso seems to be uncertain of his intent. Another portrait titled *Girl with a Mandolin* is of the model Fanny Tellier. Not conspicuously inventive (but for the innovation of its full-fledged breast), it also seems unfinished. Probably it was, or so indicates the Picasso biographer MacGregor-Hastie, who, while rarely to be caught citing a reference, is, with the availability of such liberty, usually ready with good stories.

Picasso, in this instance, was working at the reserve studio he still maintained back at the Bateau Lavoir:

> Another bone of contention was his sudden absences from "home" for a day or two at a time while he was "working on an important picture with a model" . . . and this one, Fanny Tellier, had a reputation for romping with her artists. Fernande never descended to physically spying on them, [but] the girl did not turn up one day for a sitting and he was discouraged from finding out why.[1]

Girl with a Mandolin (Fanny Tellier), late spring 1910. Oil on canvas, 39 x 29 in.

Of course, one can never make a clear case that personal unhappiness is going to have a discernible effect on the quality of Picasso's work. He is the embodiment of a mighty ego: That is equal to stating that he was not vain except in the largest manner—he was wholly dedicated to the importance of his work. Misery or happiness might be one more factor to hinder or contribute to the development of his projects, but finally, his emotional state was rarely allowed to become more than a factor. Only catastrophe could derail him, and that, given his dedicated concentration, his artistic will, might not even show its impact for quite some time. Indeed, a catastrophe was waiting for him in September of 1911, an event powerful enough to shift his character for the rest of his life, but the artistic results would not be visible for most of the following year.

We are still back in 1910, however, and at that point, having committed himself to an exploration into the no-man's-land in the outreaches of existence, he was only having partial success. He was also growing more and more miserable with Fernande.

Examples of work that is less than inspired are not hard to locate in this period. Braque's *Violin*, done by the spring of 1911, matches Picasso's *La Pointe de la Cité* in lack of invention:

La Pointe de la Cité, spring 1911. Oil on canvas, 35 x 28 in.

Georges Braque, Le Violin, Paris, spring 1911. Oil on canvas (oval), 29 x 24 in.

*Colorplate 17. Fruit Dish, winter 1908–09. Oil on canvas, 29 x 24 in. For accompanying text,
see page 294.*

Colorplate 18.
La Toilette,
Gósol, early
summer 1906.
Oil on canvas,
59 x 39 in.
For accom-
panying text,
see page 297.

Colorplate 19. Bust of a Woman (Fernande), Horta de Ebro, summer 1909. Oil on canvas, 37 x 29 in. For accompanying text, see page 297.

Colorplate 20. Nude in an Armchair, Horta de Ebro, summer 1909. For accompanying text, see page 297.

Colorplate 21. Reservoir at Horta, Horta de Ebro, summer 1909. Oil on canvas, 24 x 20 in. For accompanying text, see page 297.

Colorplate 22. Bather, winter 1908–09. Oil on canvas, 42 x 35 in. For accompanying text, see page 294.

Colorplate 23. Portrait of Wilhelm Uhde, 1910. Oil on canvas, 32 x 24 in. For accompanying text, see page 301.

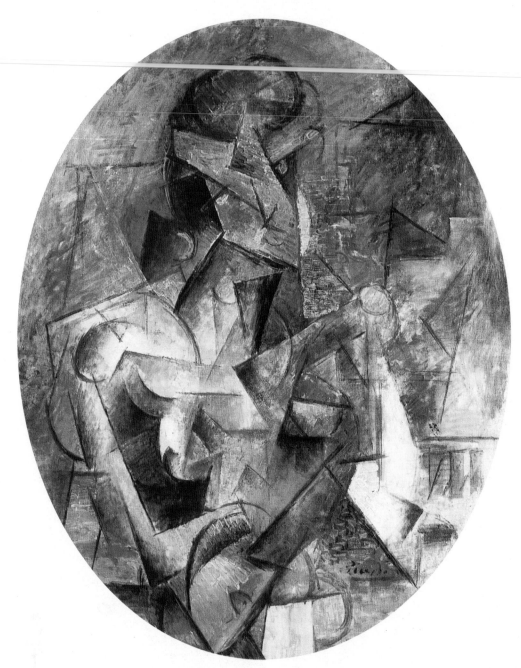

Colorplate 24. Woman with a Mandolin,
spring 1910. For accompanying text, see page 301.

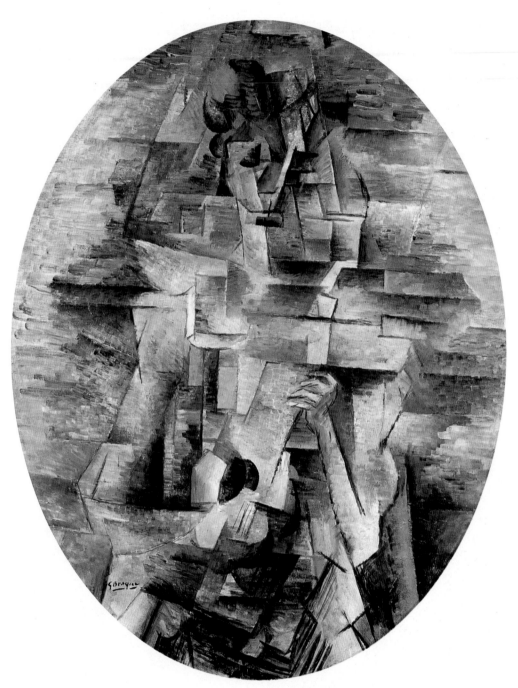

Colorplate 25. Georges Braque, Woman with a Mandolin, Paris, 1910. Oil on canvas (oval), 36 x 29 in. For accompanying text, see page 301.

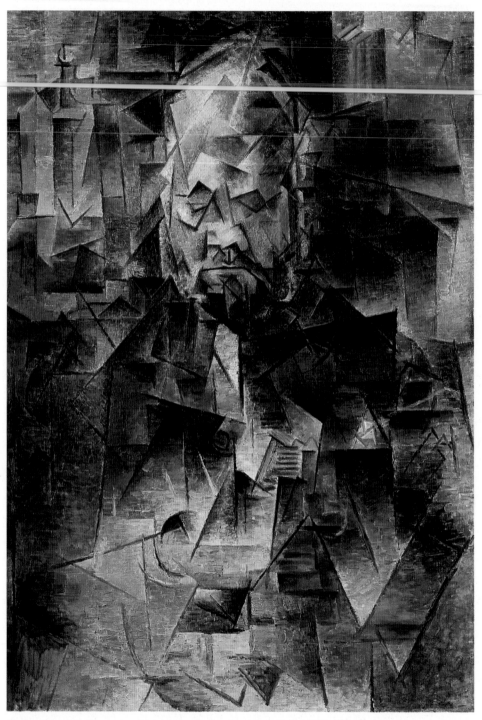

Colorplate 26. Portrait of Ambroise Vollard, spring–fall 1910. Oil on canvas,
36 x 26 in. For accompanying text, see page 305.

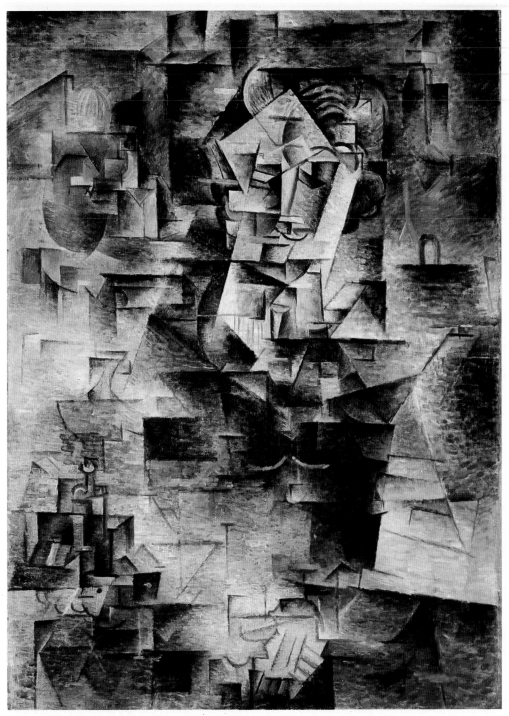

Colorplate 27. Portrait of Daniel-Henry Kahnweiler, autumn–winter 1910. Oil on canvas, 39 x 29 in. For accompanying text, see page 305.

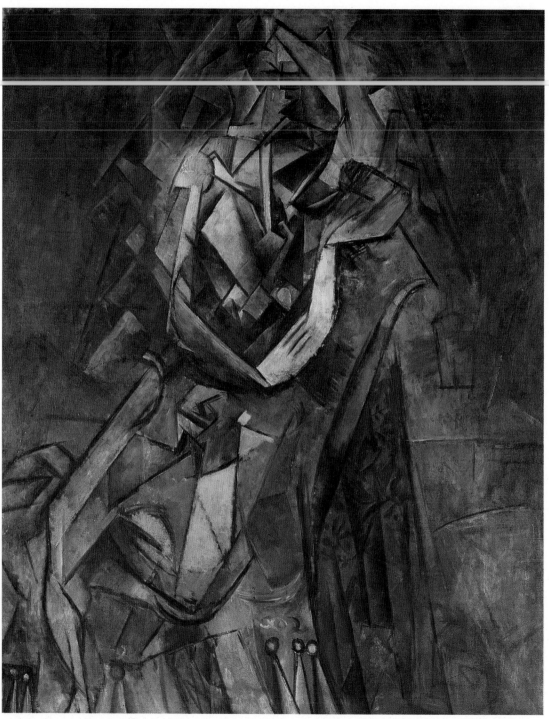

Colorplate 28. Woman in an Armchair, spring 1910. Oil on canvas, 37 x 29 in. For accompanying text, see page 312.

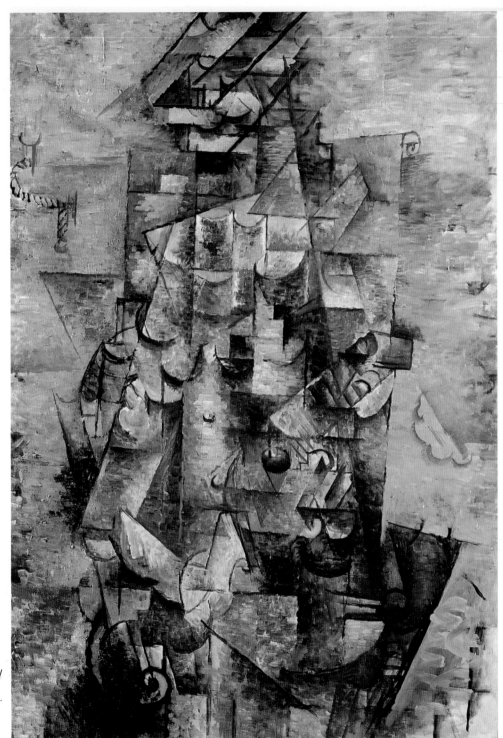

*Colorplate 29.
Georges
Braque, Man
with a Guitar,
begun summer
1911;
completed
early 1912. Oil
on canvas,
46 x 32 in. For
accompanying
text, see page
317.*

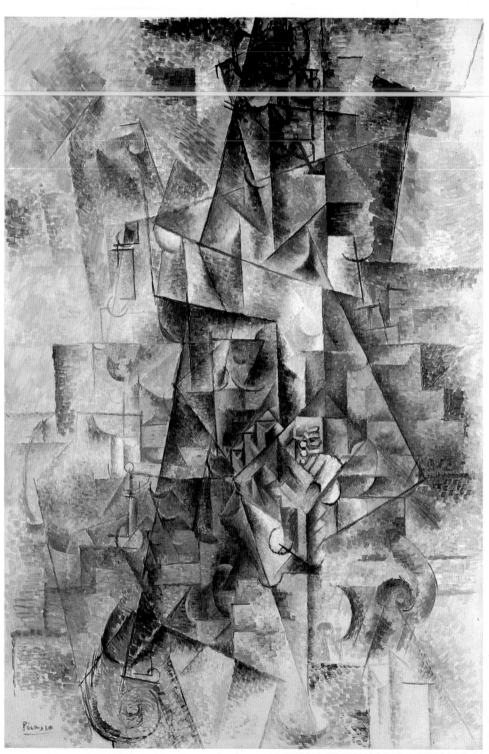

Colorplate 30.
Accordionist,
Céret, summer
1911. Oil on
canvas, 51 x
35 in. For
accompanying
text, see page
317.

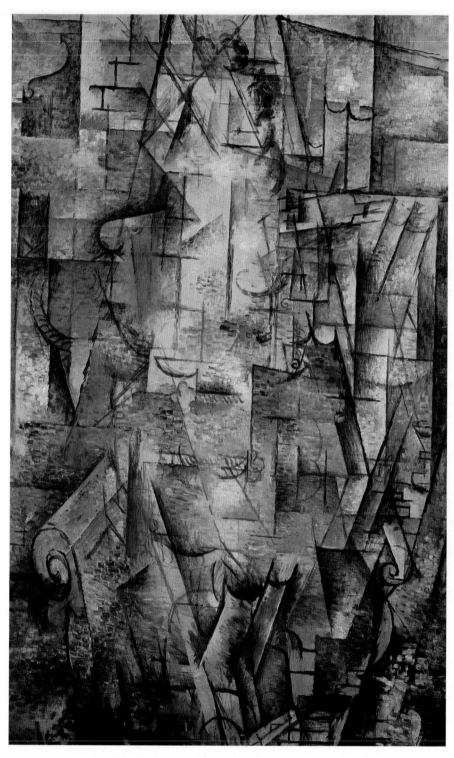

Colorplate 31.
Georges Braque,
Woman Reading,
Céret, autumn
1911. Oil on
canvas, 51 x 32 in.
For accompanying
text, see page 317.

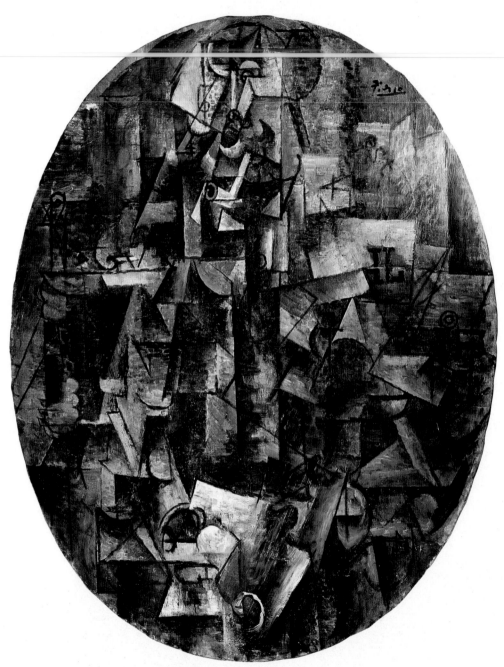

Colorplate 32. Man with a Pipe, summer 1911. Oil on canvas (oval), 36 x 28 in.
For accompanying text, see page 317.

The splendid exceptions of 1910, have, of course, been reprinted in many a book, and they conceal our recognition of what a dull struggle Picasso and Braque were enmeshed in through 1910 and the first part of 1911. The portraits of Ambroise Vollard and Daniel-Henry Kahnweiler (colorplates 26 and 27, following page 304) are, for example, ambitious, vertiginous, and full of little surprises—which are the first demands to make of a Cubist work if one is to call it successful, and these portraits are not only familiar but successful.

Let us offset this description of his pervasive depression and middling work with a couple of excerpts to remind us of the difficulties he was facing.

> For so perilous an enterprise one had to sacrifice the entire illusionist apparatus of painting, that is, everything the public was used to, everything it judged a picture by: perspective, lighting, shading, values, to say nothing of the subject, which remained the stumbling block of taste.
>
> In view of that, the public's panic, anger, and sarcasm against Cubist paintings are understandable. How could such works not be taken for madness or hoaxes?

In the name of the Surrealists, Breton was to write about Picasso in 1928:

> By what miracle did this man . . . happen to have what it took to give shape to what up to then had remained in the domain of wildest fantasy? What revolution had to take place in him for him to hang on to it? . . . to dare an open break . . . one cannot fail to recognize Picasso's immense responsibility. Had the will of this man faltered even once, our present endeavors would at least have been postponed, if not lost.[2]

Picasso knew as much himself. In his last years at the Bateau Lavoir, he had put up a sign pilfered from the cabin of a tourist boat on the Seine: "Talking to the Pilot Is Forbidden."

Indeed, considering this creative pressure, it is worth noting that not all of his hours on the boulevard de Clichy were unreservedly dour:

> He loves animals more and more. The big dog Frika, faithful and sweet, softens him. My little monkey, Monina, takes her meals with us and does him a thousand misdeeds, which he not only accepts but is amused by. He lets her take his cigarettes or the fruit he is eating. She will ensconce herself on his chest or put herself at her own ease. He loves to see this animal who is so confident, and is amused by the cruel little things that she does to Max Jacob, who is afraid of her, as of all animals.[3]

4

There has been no attempt to give any detailed account in this book of Picasso's relations with art dealers or with the contemporary critics who were writing about him, but Cubism was, with all else, a cultural phenomenon, and so some attention ought to be paid to its early reception before we contemplate the explosiveness of an episode in 1911 when Apollinaire was arrested and Picasso interrogated by the Paris police for the theft of the *Mona Lisa* from the Louvre. That encounter with the police would shift both men's lives profoundly; within a year it would alter the ground of Cubism altogether.

Cabanne gives a pithy summary of gallery activity in the immediate years before the scandal at the Louvre:

> In 1910 Fernand Léger . . . was in touch with a group of young avant-gardists, Brancusi, Marcel Duchamp, Metzinger, La Fresnaye, Gleizes, Le Fauconnier, who in their various ways were to subscribe to a sort of tangible cubism closer to Cezanne's heritage than to Picasso's and Braque's researches. All of them exhibited in the two anti-academic salons, the Automne and the Indépendants, along with Picabia, Kupka, Delaunay, Herbin, and the sculptors Duchamp-Villon and Archipenko, while the champions of what was called "orthodox Cubism," Braque and Picasso, showed their work only at Kahnweiler's.

> "We held no more one-man shows after the Braque in 1908," Kahnweiler told me. "[Braque and Picasso] worked quietly and I advanced them money to live on. They brought the works in, collected what was owed them, we hung the

pictures, and those who wanted to, came to see them. Not too many, but we knew we could depend on them. Artists came, too, and people who didn't like this sort of thing but wanted to keep informed, to know about this Cubism the papers were making fun of.

"Try to picture the period, entirely different from today. There were very few galleries, infrequent exhibits, no advertising. The Salons were all the general public saw."

"Was it not an unusual gesture of contempt for critics and public for Braque and Picasso not to enter them?"

"Yes, but mainly it was contempt for the sarcasm and insults. You can't imagine how Cubism was hated in some circles. And even worse, there were people who went to the Indépendants or the Salon d'Automne just to laugh. Or to start trouble . . ."

Kahnweiler . . . does not mention that, sale of paintings aside, his painters, Picasso most of all, owed everything to him. Mistrustful at first, Picasso became quickly and totally sure of his young and ingenious dealer, an unusually faithful friend, a daring art lover, and a wily businessman. He once said to someone, "What would have become of us if Kahnweiler had not had good business sense?" And that was true.[1]

Kahnweiler would also become the most authoritative interpreter of Cubism, and many of his analyses, derived from private conversations with Braque and Picasso, have by now taken on the imprimatur of received wisdom. Picasso, however, rarely talked about his work, and then usually in ways to mislead, for he was invariably gnomic and paradoxical. "There is no Cubism" was the sort of remark he might make. Braque, in his turn, did not necessarily understand all that Picasso was up to and also did not like to discuss his own work, but Kahnweiler was a man with a clear and logical mind, and an unadmitted passion to express himself. The series of wholly confident exegeses he handed down on Cubism ought to be received, therefore, as no more than what Kahnweiler would have declared about his own paintings if God had made him an artist and a Cubist. While he certainly reacted with large emotion to Picasso's and Braque's offerings, he spoke and wrote about them in such a way as to seal in the mystery of just why they affected him and a few others so intensely.

Kahnweiler offers the first and best of a good many curatorial interpretations of Cubism. Today, since many of the expositors are functionaries in the art world—teachers, critics, or dedicated museum staff—the formality and aridity of their crit-

icism hardly fosters any understanding in the general public. It does, however, serve the aims of the art hierarchy. The canons on Cubism restrain the professional interpreter from ever becoming too unconventional, and conceivably *wrong*—just about a fatal hazard to one's career. Besides, the conceptual jargon employed can take years for strangers to acquire, let alone comprehend—the cult of high art is thereby reinforced. With Cubism, such insulating effects have, over the years, sealed in the subject. There may be no movement in art about which so much has been written and so little is comprehended by the average museum-goer, who is left with not much more than an understanding that Cubism is a great, disturbing, and revolutionary phenomenon in art; of course, he or she is thereby deprived of that reassurance an amateur museum-goer needs most—that is, being guided toward an aesthetic appreciation that can actually be *appreciated*. Most viewers of the classic works of Cubism feel little more than a dull anxiety as they stare at what is up before them on the wall.

The official language surrounding Cubism guarantees this lack of response. For example (and the excerpt here is no worse than a hundred others), we can peruse Raymond Cogniat's statement that Picasso and Braque

> needed to arrive at a total conception of the picture which henceforth is an object in itself, independent of the realistic imitation of a motif, an object having its own architecture, space, and perspective, and which is not a series of planes obtained by the methods of traditional perspective, an object which causes the work to form a homogeneous whole, closed up on itself.[2]

The prose tells us more about the need of art critics to generate a private language than it suggests any honest desire to explain the peculiar effect of Cubism on the viewer. We may be confused when we look at a Picasso or a Braque of these years, but all the same we know that something very odd is going on. That *something odd* cannot be explained by any of the vocabularies that the critics have given us. They do not help us to comprehend that a Cubist canvas is a creature as much as it is an object. Instead, most writing about this art is restricted to a discussion of the artist's technical innovations in the treatment of perspective, surface, and planes; the near-impenetrability of the critical jargon is startling to anyone schooled in a literary tradition. It is as if one were to discuss *Remembrance of Things Past* while keeping discussion fixed on no more than Proust's use of syntax.

We may as well go back to Kahnweiler, the prime malefactor behind such hermeneutics. The excerpt now offered has been heavily edited, yet it still requires

a real investment of our concentration; but then, the nature of our complaint is that the interpretations of Cubism have become more difficult to get into than Cubism itself.

Years of research had proved that closed form did not permit an expression sufficient for the two artists' aims. Closed form accepts objects as contained by their own surfaces, viz., the skin; it then endeavours to represent this closed body, and, since no object is visible without light, to paint this "skin" as the contact point between the body and light where both merge into colour. This chiaroscuro can provide only an illusion of the form of objects. In the actual three-dimensional world the object is there to be touched even after light is eliminated. Memory images of tactile perceptions can also be verified on visible bodies. The different accommodations of the retina of the eye enable us, as it were, to "touch" three-dimensional objects from a distance . . . Picasso's new method made it possible to represent the form of objects and their position in space instead of attempting to imitate them through illusionistic means . . . the painter no longer has to limit himself to depicting the object as it would appear from one given viewpoint, but wherever necessary for fuller comprehension, can show it from several sides and from above and below . . .

At this point, Braque's introduction of undistorted real objects into the painting takes on its full significance. When "real details" are thus introduced, the result is stimulus which carries with it memory images. Combining the "real" stimulus and the scheme of forms, these images construct the finished objects in the mind. Thus, the desired physical representation comes into being in the spectator's mind . . .

In the words of Locke, these painters distinguish between primary and secondary qualities. They endeavour to represent the primary, or most important qualities, as exactly as possible. In painting, these are: the object's form, and its position in space; They merely suggest the secondary characteristics such as colour and tactile quality, leaving their incorporation into the object to the mind of the spectator.

This new language has given painting an unprecedented freedom. It is no longer bound to the more or less verisimilar optic image which describes the object from a single viewpoint. It can, in order to give a thorough representation of the object's primary characteristics, depict them as stereometric drawing on the plane, or through several representations of the same objects, can provide an analytic study of that object which the spectator then fuses once again in his mind . . .[3]

In Kahnweiler's conversations with Crémieux he gives away his underlying prejudices—call it his secret desire:

We must not forget something that is absolutely fundamental, in my opinion, to the comprehension of Cubism and of what, for me, is truly modern art: the fact that *painting is a form of writing* [my italics]. Painting is a form of writing that creates signs. A woman in a painting is not a woman; she is a group of signs that I read as "woman." When one writes on a sheet of paper "f-e-m-m-e," someone who knows French and who knows how to read will read not only the word *"femme,"* but he will see, so to speak, a woman. The same is true of painting; there is no difference. Fundamentally, painting has never been a mirror of the external world, nor has it ever been similar to photography; it has been a creation of signs, which were always read correctly by contemporaries, after a certain apprenticeship, of course. Well, the Cubists created signs that were unquestionably new, and this is what made it difficult to read their paintings for such a long time.[4]

As a writer, it is agreeable to assume that painting is an annex to literature, a "plastic" form of communication, a creation of signs. Yet, what signs! Cubism was an attempt to write more than one thing at once. If we are to speak of its likeness to verbal description, let us recognize that the kind of writing to which it bears comparison is to be found in *Finnegans Wake*. Kahnweiler, therefore, keeps us away from the point. Cubism is not exciting because it is able to give a highly trained eye some shiver of pleasure at the artist's manipulation of objects and planes, his ability to provide us with a feeling of three-dimensionality in the dark; no, Cubism is not a form of lovemaking with the lights out: Cubism is compelling because it is eerie, resonant, and full of the uneasy recognition that time itself is being called into question. For as we stare at the objects (call them the depths and creatures and vistas of each complex in the canvas), we have stepped right out of our sense of the present into that other, more mysterious tense of time which is best described as time-other-than-the-present. That puts us into a landscape of the psyche where past and future dwell, all of that inner world of night, dreams, memories, and primitive forebodings. We become aware again that the past and the future have a more profound relation to each other than to the present. The present is palpable, but all we can feel about the past and the future is that they are elusive and curiously related to each other in our dreams. So Cubism took painting out of the present tense, that ubiquitous present tense which was the established time-frame of Western art until the arrival of Cubism, that present tense which was frozen forever into a two-dimensional canvas that gave the illusion of three dimensions. The present tense was the here-and-now of the painted canvas, fixed forever. In the centuries before photography, that was not a mean achievement. A moment in life had

been captured eternally (or for as long as the pigment would last), and that was a bulwark against the dissolutions of mortality and memory, of future and past. But photography forced painting out of the present tense.

There is a famous story told by Fernande of the *bande à Picasso*:

> At a time when we were eager to experience new and different sensations . . . we had gathered at Princet's . . . taking hashish. Princet, Max, Apollinaire and Picasso expanded in ways which revealed a great deal about them. Princet simply wept about his wife, who had just left him; Apollinaire shouted with delight and fantasized that he was in a brothel; Max Jacob, an old hand at these experiences, sat in a corner beatifically happy, while Picasso, in a state of nervous ecstasy, hallucinated that he had invented photography and might as well kill himself as he had nothing left to learn. He appeared to have had a revelation that one day he would be prevented from developing. He would come to the end and find a wall which would impede all progress. No longer would he be able to learn, or discover, or understand, or penetrate little by little into the secrets of an art which he wanted to make new and fresh.[5]

At the time, Picasso was in his Rose Period, and his paintings were already in rebellion against the clarity of the present tense. Part of the indefinable appeal of the Rose Period was the way it could invoke a brooding past and an uneasy future. That night on hashish at Princet's, the problem must have become apparent. One had to find a way to paint works that would embody past, present, and future all in one; such ambition must have seemed as insubstantial as the hashish dream in which he found himself.

To be explicit about the power of Cubism is to recognize how much it is concerned with death and dissolution. We can remind ourselves one more time that Picasso, at an early age, perceived the sign for the number seven as a nose upside-down. One is tempted to argue that Cubism grew out of the inside of the nose for, indeed, its interior is often a cavernous, clotted, intricate web, full of bogs, stalactites, stalagmites, filament-like hairs; in many Cubist canvases, the vision develops into a dream-like view of the inside of a torso or, equally, the maze of a city. But then, can we recognize that our interior anatomy *is* a species of vertical city, a hurly-burly of spatial relationships in a closed box!

We can certainly entertain the idea that much of the Cubism of 1910, 1911, and 1912, consciously or unconsciously, is an exploration of death. Some of the paintings, if we dare to entertain the vision, have the appearance of corpses, their flesh in strips and tatters, organs open. As Apollinaire would write in 1912,

"Picasso studies an object as a surgeon dissects a cadaver."[6] (See colorplate 28, following page 304.)

If this thesis is horrific, it may still not be altogether unwarranted. Cubist paintings are sinister; they do inspire us with uneasiness (and Picasso accomplishes this effect much more often than Braque—indeed, it is one of the ways to tell the painters apart). Picasso's canvases usually look as if he is absolutely confident of what he is seeing, is truly gazing into a great and often ominous depth, whereas Braque, generally, seems merely to be searching, still searching. Of course in later years, Picasso would say to an interviewer, "I do not search; I find!"[7]

What can be agreed upon is that Picasso was looking to paint stasis and motion, growth and decomposition, the perceptions of infancy and the dissolutions of death, and do them all at once and in each painting. So he was as much engaged in capturing the whole as was Einstein devoted to his quest for a General Theory to explain in one formula all of motion, space, time, gravity, and energy.

Picasso, as we have surmised, may not have been free of dyslexia. Higher mathematics, in any case, was beyond him. How was he to deal with mathematical symbols when every bend in a line was, to him, an evocation of form?

Nonetheless, talk of the fourth dimension was not uncommon at the Bateau Lavoir during the years from 1905 to 1910. Maurice Princet, who gave the famous hashish party, was an actuary by profession but also a schooled mathematician. He would speak to the *bande à Picasso* of the theories concerning relativity. Apollinaire, with his prodigious appetite for romantic new connections that might conceivably be cosmic, not only spoke of the fourth dimension as if it were a wonderful new poet but he would write about it. Manolo, in 1930, would tell Josep Pla, "I witnessed the birth of Cubism. If my memory does not fail me, Picasso used to talk a lot then about the fourth dimension, and he carried around the mathematics book of Henri Poincaré."[8] Max Weber, who had a few conversations with Picasso in 1908, would say in an article:

> In plastic work I believe there is a fourth dimension which may be described *as a consciousness of a great and overwhelming sense of space-magnitude in all directions at one time* . . . [italics mine] It exists outside and in the presence of objects, it is the space that envelops a tree, a tower, a mountain, or any solid; or the intervals between objects or volumes . . . It arouses imagination and stirs emotion. It is the immensity of all things.[9]

Apollinaire gives no more evidence than Max Weber of understanding the

fourth dimension, but he must certainly have enjoyed discussions of it in company with Picasso, Braque, Jacob, Princet, and André Salmon. In his book *Les Peintres Cubistes*, published in 1913, he circumnavigates the matter:

> Until now, the three dimensions of Euclid's geometry were sufficient to the restiveness felt by great artists yearning for the infinite . . . Today scholars no longer limit themselves to the three dimensions of Euclid. The painters have been led quite naturally, one might say by intuition, to preoccupy themselves with new possibilities of spatial measurement which, in the language of the modern studios, are designated by the term *fourth dimension*.
>
> As it presents itself to the mind, from the plastic point of view, the fourth dimension appears to be engendered by the three known dimensions: it represents the immensity of space eternalizing itself in all directions at any given moment. It is space itself, the dimension of the infinite; the fourth dimension endows objects with plasticity . . .
>
> Finally, I must point out that the *fourth dimension* . . . has come to stand for the aspirations and premonitions of the many young artists who contemplate Egyptian, negro and oceanic sculptures, meditate on various scientific works, and live in anticipation of a sublime art.[10]

"Sublime art." That was exactly what Apollinaire, as self-appointed impresario of world culture, was looking to present; *fourth dimension* might be the phrase to start the wheel and keep it rolling. Certainly, it could do no harm. The fourth dimension would accompany their efforts—an invisible orchestra of the scientific cultures could offer its reverberation to their isolated artistic voices. So reasoned Apollinaire. On their own, Cubists like Gleize and Metzinger were soon full of theories concerning the fourth dimension and wrote polemics about its relation to their work. Picasso was quick to repudiate them. He detested theory. Cubism was his unvarnished embrace of the universe, and if the result he obtained made one unable to distinguish a landscape from a slum tenement, and if both could invoke a young girl on an autopsy table in Horta de Ebro, well, each painting was there, precisely, to exist as a universe full of teeming multitudes from different eras.

The *Mona Lisa*

Twice a year, Braque had to give a couple of weeks to military service. With the exception of these interruptions, he had stayed in Paris since December of 1910, and he and Picasso had gone back to their practice of close collaboration. They would continue to do so until July of 1911, at which point Picasso, absenting himself from Fernande for the first time since the summer of 1907, decided to go to Céret in the Midi, where his friend Manolo had settled with his wife, Totote. Fernande was planning to remain behind at their apartment in Paris on boulevard de Clichy, but by early August, Picasso was begging her to join him. "Yesterday, all day long, I didn't get a letter from you, and this morning I'm not waiting anymore, but hope this afternoon I'll be more lucky . . . I hope that in a very few days you will be here," a charitable translation of the French—"*Yer de toute la journé,*" et cetera.[1]

She arrived, and so did Braque, and work progressed. In the next two weeks, Picasso and Braque both painted at a great rate, and in stylistic compatibility (see colorplates 29–32, following page 304).

By the end of August, however, Picasso was full of anxiety. The theft of the *Mona Lisa* from the Louvre may have seemed amusing when he first read about it in the Paris newspapers that made their leisurely way down to Céret, but soon enough it began to seem less droll; by September 3, Picasso decided that the episode was dangerous to his security, and he cut short his vacation; by Septem-

ber 4, he and Fernande were back in Paris and were met by Apollinaire, who was in an acute state of concern.

There are several detailed sources for the events that now transpire, and the most central is the thorough account provided by Francis Steegmuller in his book on Apollinaire; then Fernande's recollection of the matter is also indispensable; almost as much can be said for news clips from an enterprising daily, the *Paris-Journal*, whose series of ironic stories about the theft was obviously written by a journalist with literary qualifications and a gift for games.

First sample:

WEDNESDAY, AUGUST 23, 1911:

MONA LISA GONE FROM THE LOUVRE!
The Police, Late on the Scene, Surround the Museum—
Investigation Leads Nowhere—

Robbery, or Practical Joke?

. . . in the eyes of the public, even the uneducated, the *Mona Lisa* occupies a privileged position that is not to be accounted for by its value alone. For many, the *Mona Lisa* is the Louvre . . .

No wonder everyone was dumbfounded yesterday afternoon when the city . . . suddenly heard the incredible news: "The *Mona Lisa* has disappeared! The *Mona Lisa* has been stolen!"

In the Louvre, as is easily imaginable, there was considerable excitement, indeed, near-panic . . . A captain of the guards, suddenly noticing that the wall space in the Salon Carré ordinarily occupied by the *Mona Lisa* was vacant, gave the alarm. What had happened to the picture? . . .[2]

It was further reported that the prefect of police sent sixty inspectors and more than a hundred gendarmes to the Louvre. The doors were locked, the galleries were emptied of visitors, and a squad patrolled the roof to forestall any plans the thief might have been considering to bring off an escape from there.

A day later, Apollinaire, who had been doing occasional pieces for another newspaper, *L'Intransigeant*, now published a column on his opinion of the theft:

The *Mona Lisa* was so beautiful that her perfection has come to be taken for granted.

There are not many works of which this can be said . . .

But what shall we say of "The guard that watches the gates of the Louvre?" . . .

The pictures, even the smallest, are not padlocked to the walls, as they are in most museums abroad. Furthermore, it is a fact that the guards have never been drilled in how to rescue pictures in case of a fire.

The situation is one of carelessness, negligence, indifference . . .[3]

Steegmuller offers a continuing account:

That same day *Paris-Journal* [was] offering readers such assorted bits of information as [that] the Louvre had recently received a postcard addressed to "Mona Lisa, Louvre Museum, Paris," and bearing as a message a "red-hot love declaration, peppered with 'I love you's' and 'I adore you's.' " leading certain officials to wonder whether the theft might not be the work of an *erotomane*. During the days that followed, *Paris-Journal* kept its readers regularly amused in this fashion. But *L'Intransigeant* contained no more articles about the theft of the *Mona Lisa*. Why was [Apollinaire] silent? Why had his first and only article about it been so much duller than those in *Paris-Journal*? Praise of the *Mona Lisa*'s beauty comes oddly from the pen of Apollinaire, who had recently [declared] at one of Paul Fort's Tuesday evening poetry readings at the Closerie des Lilas that "all museums should be destroyed because they paralyze the imagination."

The explanation is to be found in the personality and exploits of a young Belgian named Géry Pieret, who had acted for a time . . . as Apollinaire's "secretary": [Pieret] appealed to Apollinaire's fancy as a refugee from the establishment: he had been a boxer and a stoker, [yet] Pieret's Latin was excellent, and his wit was diverting and original.

For example, one day [in 1907] he had said to Marie Laurencin, "Madame Marie, this afternoon I am going to the Louvre: can I bring you anything you need?" Given the question, everyone assumed he was offering to shop for Marie in the Magasins du Louvre, a department store on the Rue de Rivoli often referred to by Parisians as "the Louvre"; but that evening he turned up at Apollinaire's apartment bearing two Iberian stone sculptured heads, which he gleefully announced had indeed come from the Louvre—the museum.

This *coup* must have aroused much mirth among the artistic revolutionaries in Montmartre, and when Pieret announced that he was, as usual, in need of cash, and offered the statues for sale, they were recommended to Picasso, who bought them and who subsequently, with his usual flair, found a new inspiration

in these antiquities from his native Spain. Indeed, in 1907 Picasso . . . was just beginning *Les Demoiselles d'Avignon* and . . . anyone who looks at the *Demoiselles* can see Pieret's stolen heads—*or at least their ears* [my italics]—in the two central figures.[4]

Detail from Les Demoiselles d'Avignon.

Head of a Man, Iberian sculpture, Cerro de los Santos, 5th–3rd century B.C. Stone, 8 in. high.

Fernande's version of this transaction between Pieret and Picasso makes a point of exonerating the artist from any act of buying stolen artworks, but her piety does not seem convincing. Pieret, as described, was in need of cash.

> Géry [gave Picasso] two quite beautiful little stone heads, without revealing where he had got them from. He only said that they should not be exhibited too conspicuously. Picasso was enchanted, and he treasured these gifts and buried them at the very back of a cupboard . . .[5]

However, Picasso's behavior in September of 1911 is, at the least, a sure indication that he knows his Iberian heads were stolen. It is safe to assume that by the time Picasso read the news story of August 29, he was sharing Apollinaire's heavy foreboding that events in Paris were frightful—Géry Pieret had done it again! Maybe he had even stolen the *Mona Lisa*!

In fact, he hadn't, but Pieret was certainly inserting himself into the brouhaha.

Paris-Journal, AUGUST 29, 1911:

A THIEF BRINGS US A STATUE STOLEN FROM THE LOUVRE

Yesterday morning's mail brought a rather strange letter . . . "On the 7th of May, 1911, I stole a Phoenician statuette from one of the galleries of the Louvre. I am holding it at your disposition, in return for the sum of ___ francs . . ."

Now, *Paris-Journal*, even though it has offered 50,000 francs to anyone who would bring in the *Mona Lisa*, has never undertaken to ransom *all* the works of art stolen from the Louvre.

Still . . . one of our reporters went to the appointed place at the appointed time. There he met a young man . . . between twenty and twenty-five, very well-mannered, with a certain *chic americain*, whose face and look and behavior bespoke at once a kind heart and a lack of scruple. This was "The Thief"—since so he must be called.

The thief [showed] our reporter the object that he claimed to have taken from the Louvre [and then] consented to put into writing, for *Paris-Journal*, the story of his theft, which we herewith reproduce:[6]

It is fair to ask ourselves whether the thief's contribution to the newspaper was written by Géry Pieret. His engaging prose style could also belong to the reporter for the *Paris-Journal*. Soon enough we will be able to pursue a few suspicions as to the identity of the reporter. He may be a personage who has already appeared in this book!

The thief's alleged account:

"It was in March, 1907, that I entered the Louvre for the first time—a young man with time to kill and no money to spend . . . It was about one o'clock . . . and I found myself in a room filled with hieroglyphics and Egyptian statues . . . the place impressed me profoundly because of the deep silence and the absence of any human being. I walked through several adjoining rooms, [before] I suddenly realized how easy it would be to pick up and take away almost any object of moderate size.

"Being absolutely alone, and hearing no sounds whatever, I took the time to examine about fifty heads that were there, and I chose one of a woman . . . put the statue under my arm, pulled up the collar of my overcoat with my left hand, and calmly walked out, asking my way of a guard . . .

"I sold the statue to a Parisian painter friend of mine. He gave me a little money—fifty francs, I think, which I lost the same night in a billiard parlor.

" 'What of it?' I said to myself. 'All Phoenicia is there for the taking.'

"The very next day I took a man's head with enormous ears—a detail that fascinated me. And three days later a plaster fragment covered with hieroglyphs . . .

"Then I emigrated.

"I made a little money in Mexico, and decided to return to France and form an art collection at very little expense. Last May 7 I went to my Phoenician room, and . . . took the head of a woman, and stuffed it into my trousers . . . Now one of my colleagues has spoiled all my plans for a collection by making this hullabaloo in the paintings department. I regret this exceedingly, since there is a strange, almost voluptuous charm about stealing works of art, and I shall probably have to wait several years before resuming my activities . . ."[7]

Steegmuller takes up the narrative:

The reporter from the *Paris-Journal* who had interviewed the thief took the stolen head to the office of the newspaper . . . where it was examined by a Louvre curator and identified as belonging to the museum's collection not of Phoenicia, but of Iberian antiquities. The curator confessed that the museum had not even noticed its absence. "The person who turned the statuette over to us," *Paris-Journal* concluded, "is requested to come to our office, where he will receive the sum of money agreed upon. As for the statuette itself, our readers can see it on exhibition today, in our window."[8]

To bring a quick conclusion to our local mystery within the larger mystery, it should now be stated that André Salmon was the art critic for *Paris-Journal*, and the journalistic style of these pieces is in his vein. It is hard not to suppose that he was the writer for *Paris-Journal*.

Next day the continuing news account took for its headline "FIRST RESTITUTION." Steegmuller pursues the possibility:

Does the word "first" . . . hint that André Salmon . . . had already learned from his friends Apollinaire and Picasso that the two heads stolen from the Louvre in 1907 were still in existence, in Picasso's possession, and that the frightened poet and equally frightened painter had decided to return those heads, too, via *Paris-Journal?*[9]

Given the group friendship, there is reason to assume that Salmon had been given a look more than once between 1907 and 1911 at Picasso's Iberian heads. Besides, Salmon would have seen a good deal of Pieret when he was secretary to Apollinaire. Steegmuller even writes: "It is also possible that Pieret had not approached *Paris-Journal* by letter . . . but through personal contact with Salmon."[10]

This seems likely. It was the kind of hoax Salmon would enjoy. Moreover, in one of several versions of these events that would be offered later by Apollinaire, he does suggest that one way to rid oneself of stolen art objects is to use the press. He even brings in Picasso, although he calls him "X."

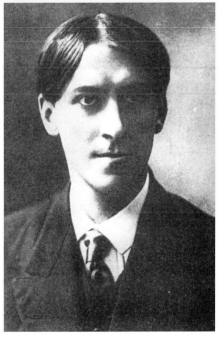

André Salmon, c. 1907–12.

> . . . I tried, long before 1911, still back in 1907 or 1908—to persuade X to give the statues back to the Louvre, but . . . he told me that he had damaged the statues in an attempt to discover certain secrets of the classic yet barbaric art to which they belonged. The method I had found for returning them would have been perfectly safe and honorable for him . . . We would have suggested to the newspaper *Le Matin* that it demonstrate publicly that the treasures in the Louvre were poorly guarded—by stealing first one statue (sensation!) and then another (second sensation!). If this had been done there would have been no trouble.[11]

Clear enough. If Apollinaire could return stolen artworks in this manner, then André Salmon could certainly bring off the same project by acting as Apollinaire's covert agent.

But we can continue with Apollinaire's account:

> In 1911 the fellow who had stolen [the heads in 1907] turned up again. He came to see me, arriving from America, his pockets full of money which he then proceeded to lose at the races. Penniless, he stole another statue. I had to help him—he was down and out—so I took him into my flat and tried to get him to return the statue; he refused, so I had to put him out, along with the statue. A few days later the *Mona Lisa* was stolen. I thought, as the police later thought, that he was the thief . . .
>
> He was not, but he sold his statue to *Paris-Journal*, which returned it to the Louvre. I went to see X, to tell him how unfortunate it was that he had damaged the other two heads, and in what a dangerous position this placed him. I found him terrified. He confessed that he had lied to me, and that the statues were intact.

I told him to turn them in, under pledge of secrecy, to *Paris-Journal*, which he did. *Grande scandale!*[12]

Here, Apollinaire's story of the restitution is wholly at variance with Fernande's account, and it is possible his memory (or even his recollection of which lies he had already told) was playing him false; it is time to go along with Fernande's recollection of how the two Iberian statues stolen by Pieret in 1907 were actually returned.

2

Picasso and Apollinaire met quickly in Paris as soon as Picasso returned with Fernande from Céret. Fernande describes "a frightened and frantic Apollinaire . . . who told Picasso that he was . . . terrified that legal action might be taken [and] added that Picasso was implicated too."

I can see them both now: contrite children, stunned by fear and making plans to flee the country. It was due to me that their despair just stopped short of really drastic measures. They decided to stay in Paris and get rid of the compromising objects immediately. But how could this be done?

Finally, after a hurried dinner and an interminable evening of waiting—for they had made up their minds to go that night and throw the suitcase containing the sculptures into the Seine—they left on foot at about midnight, carrying the suitcase. They returned at two in the morning, absolutely dog-tired. They still had the suitcase, and its contents.

They had wandered up and down, unable to hit on the propitious moment or simply not daring to deliver themselves of their parcel. They thought they were being followed. Their imaginations dreamed up a thousand possible occurrences, each more fantastic than the last. Though I shared their alarm, I had observed them closely earlier that evening. I am sure that without realizing it, they were seeing themselves as characters in a play; so much so that, though neither of them knew the first thing about cards, they had, during the agonizing hours of waiting for the fateful moment when they were to leave for the Seine, pretended to play cards, like gangsters.

In the end Apollinaire spent the night at Picasso's and went the next morning to the offices of the *Paris-Journal*, where he offered them the "undesirable works of art," on condition that their source be kept a secret.[1]

Whether her memory is correct and Apollinaire went in person or whether he and Salmon, separately or together, composed a letter is not clear, but in any event, neither of these courses of action would conflict with the next story in *Paris-Journal*:

September 6, 1911: Yesterday our mail contained a letter [which] emanated from the mysterious art-lover whose identity neither the sagacity of our fellow newspapermen nor the professional skill of the police has as yet been able to discover.

He asked us, of course, to promise discretion, and offered to come in person in the event that we cared to take the responsibility of returning the stolen statues to the Louvre without involving him.

Naturally we accepted, our prime consideration being that our national collections be complete.

A VISIT

At the appointed time, the mysterious visitor was announced. Our editor-in-chief received him.

The statement by the possessor of the sculptures can be summed up in a few words:

An amateur artist, fairly well to do, his greatest pleasure is in collecting works of art.

The sculptures in question were offered to him a few years ago.

Seeing these examples of a rather crude artistic style, he had no idea that they might have come from the Louvre, and attracted by the relatively low price asked for them, he purchased them.

But recently his attention was drawn to the thief's story as published in the *Paris-Journal*, a story that has had wide repercussions . . . The thief's mention of two other objects quickly convinced him that he had them in his collection.

His dismay is easy to imagine. At first he did not know how to proceed, and then it occurred to him that he might have recourse to *Paris-Journal*.[2]

Before Salmon and Apollinaire even had time to celebrate their collective wit and acumen, the police must have descended on the offices of *Paris-Journal*. If Salmon was indeed the reporter who had done the stories, that surely could have been no well-kept secret at the newspaper, and his tale of meeting Pieret probably did not hold up under questioning. Facing the threat of arrest, the editor must have

given Apollinaire's name to the police. Or, perhaps, it was Salmon. If so, this would seem an act of outsize treachery; he was betraying the man who had written inspirational verses for his wedding in 1909:

> *I know that only those will remake the world*
> * who are rooted in poetry*
> *Paris is decked out in flags because my friend*
> * André Salmon is to be married here.*[3]

While it is a dubious procedure to judge a man's character by his politics, it may be worth noting that Salmon would later be allied with the Vichy government during the Second World War, a move to the right which, given his decades as a bohemian's bohemian, suggests that Salmon had a larger than normal share of the need to preserve himself in preference to his friends. If the police succeeded in pressing him to the point where he was obliged to choose between turning Apollinaire in or being accused himself of having stolen the statues, the question is answered by the outcome: Apollinaire was quickly visited by the gendarmerie.

This news story is taken from *Le Matin*:

SEPTEMBER 9, 1911:
Judge Drioux arrests an art critic, M. Guillaume Apollinaire, in connection with the Egyptian statuettes stolen from the Louvre

It was not without emotion and surprise that Paris learned last night of the arrest made by the Sûreté in connection with the recent restitution of Phoenician statuettes stolen from the Louvre in 1907.

The mere name of the person arrested is enough to account for this reaction. He is M. Guillaume Kostrowsky [*sic*], known in literature and art as Guillaume Apollinaire . . . author of a book entitled *L'Heresiarque et Cie*, which was a candidate for the last Prix Goncourt . . .

Such is the man who was arrested the night before last on the order of M. Drioux, on the charge of "harboring a criminal." What exactly are the charges against him? Both the Public Prosecutor and the police are making a considerable mystery of the affair.

"Without endangering progress already made," *Le Matin* was informed, "we can say nothing except that we are on the trail of a gang of international thieves who came to France for the purpose of despoiling our museums. M. Guillaume Apollinaire committed the error of giving shelter to one of these criminals. Was he aware of what he was doing? That is what we are to determine . . ."

BEFORE THE JUDGE

The interrogation of M. Apollinaire lasted well into the night . . . M. Drioux informed him that anonymous denunciations had been received by the Public Prosecutor's office, stating that he had been in contact with the thief of the Phoenician statuettes, and also that he was a receiver of stolen goods, having recently returned, via *Paris-Journal*, two other busts belonging to the same collection.

On hearing these charges, M. Apollinaire protested vigorously, but shortly admitted that he was acquainted with the person who had committed the robbery.

"But," he added, "there is nothing in law that forces me to reveal his name to the authorities."

"In that case," replied M. Drioux, "I charge you with complicity in harboring a criminal."

And the investigating magistrate immediately signed a warrant of arrest.

At that moment, M. Guillaume Apollinaire, aghast at the measure taken against him, exclaimed:

"All I can tell you is that I knew the thief of the statuettes. He is a young Belgian. I employed him as secretary for a few weeks. But when I learned that he was a thief I discharged him, and took it on myself to return, via *Paris-Journal*, the things he had stolen. What have I done wrong?"

And M. Apollinaire finally consented to reveal the name of his robber-secretary.

Nevertheless M. Drioux affirmed the warrant of arrest that he had just signed and M. Apollinaire was forthwith placed in a cell . . .[4]

Steegmuller continues the scenario:

But the police persisted in believing, or in claiming to believe, that the vanished Géry Pieret belonged to an international band of crooks, whose purpose in coming to France had been to strip the country's museums, and who might have taken the *Mona Lisa:* it was because of the possible knowledge of this gang that Apollinaire was held for further questioning. Petitions protesting his arrest, signed by many artists and writers, were delivered to the police and the investigating magistrate.[5]

At this point Fernande's account is once again indispensable.

Hearing nothing from our friend we were worried, but we didn't dare go and see him. [A few days later,] at about seven o'clock, there was a ring at Picasso's door. As the maid had not come down yet, it was I who opened the door to a plain-clothes policeman, who flashed his card, introduced himself, and summoned

Picasso to follow him in order to appear before the examining magistrate at nine o'clock.

Trembling, Picasso dressed with haste, and I had to help him as he was almost out of his mind with fear.

The good-natured policeman was friendly, smiling, cunning, and insinuating, and he did his best to make us talk; but Picasso was consumed by suspicion and would say nothing. He arrived at the Prefecture of Police with the policeman, still not understanding what was wanted of him. The bus between Pigalle and the Halle-aux-Vins, in which he had to ride, was haunted for many a day by those unfortunate memories.[6]

Fernande, with her indefatigable nose for the reason underlying many a small act of behavior, adds: "The detective was not allowed to take a taxi at his client's expense."[7]

The scene that follows is painful to read:

Arriving at the police station after a long wait, Picasso was brought into the chambers of the examining magistrate, where he saw Apollinaire, pale, undone, unshaven, his collar torn, his shirt open, without a tie, skinny, smaller, a lamentable wreck and painful to look at. Arrested for two days, treated for a few days just like a criminal, he had attested to everything they wanted. In his avowals, truth was the least part. What wouldn't he have sworn in order to be allowed to rest?

Very upset by this, Picasso, trembling already, was lost . . . The scene that he told me afterward is impossible to describe. He too would say whatever the investigators wanted him to declare. Besides, Guillaume had sworn to so many real and false things that he had compromised his friend completely. Who wouldn't he have compromised in his panic? It appears that they both wept before the judge, who turned out to be reasonably paternal, but could hardly keep a severe air before their childish misery. Soon enough, some would begin to say that Picasso had denied his friend. That he pretended not to know him.

This is completely false. He didn't desert him. On the contrary! His friendship for Apollinaire was manifest.

Picasso was not charged but was told to keep himself as a witness at the disposition of the investigation.

Apollinaire was sent to the La Santé prison, and only got out of it after several days.[8]

Fernande is a touch evasive concerning the nature of Picasso's loyalty to Apollinaire and she is altogether general about the poet's exit from prison. He certainly

had to undergo one more test of his battered wits.

It is hard to conceive that the following account was written by anyone but Salmon and equally as difficult to trust that the dialogue is accurate:

Paris Journal, SEPTEMBER 13, 1911.

RELEASE OF M. G. APOLLINAIRE

The Public Prosecutor realizes that the charges made against the author of "L'Heresiarque et Cie" are without basis

. . . M. Guillaume Apollinaire's bad dream is ended. Yesterday M. Drioux, the investigating magistrate, finally . . . restored him to his mother and to his innumerable friends.

THE INTERROGATION

It was at three o'clock that Apollinaire, pushing through the crowd of reporters, photographers, and friends from the worlds of journalism, letters, and the arts, come to bring him the comfort of their sympathy, entered the magistrate's office. A policeman accompanied him. Apollinaire—we deplore this inadmissible harshness on the part of the prison authorities—was handcuffed. Nor had the authorities thought of providing a taxi for his trip from the Santé to the Palais de Justice—taxis, apparently, are reserved for bigger game . . . Apollinaire is penniless: he had stolen nothing, and lives solely by his pen.

Maître José Théry was present to defend his client . . . and shook hands with the individual described by the Sûreté as "chief of an international gang come to France to despoil our museums." Even in the Sûreté they write novels—very bad ones!

Apollinaire replied candidly and with good grace to the magistrate's questions . . . "You admit that even though you knew it was stolen, you kept that third statue, stolen in 1911, in your house from June 14 to August 21?"

"Certainly. It was in Pieret's suitcase. I kept everything—the man, the suitcase, and the statue in the suitcase. I assure you that I wasn't very happy about it, but I did not think that I was committing a serious sin." . . .

"Such a degree of indulgence surprises me," said M. Drioux, who had been following M. Apollinaire with interest.

"Here is part of my reason," said M. Apollinaire. "Pieret is a little bit of my creation. He is very queer, very strange, and after studying him I made him the hero of one of the last short stories in my *L'Heresiarque et Cie.* So it would have been a kind of literary ingratitude to let him starve . . ."[9]

At the conclusion of the interrogation, Apollinaire's lawyer petitioned that his client be provisionally released, and M. Drioux consented. Apollinaire then wrote a piece describing his journey from prison to court:

Paris-Journal, SEPTEMBER 14

MES PRISONS
by Guillaume Apollinaire

. . . At the Palais de Justice they locked me in one of the narrow, stinking cells of the "Mousetrap," where I waited from eleven in the morning until three in the afternoon, my face glued to the bars, to see who passed by in the corridor. Four mortal hours: how they dragged! Eventually, the long wait ended, and a guard led me, handcuffed, to the magistrate's office.

What a surprise to find myself suddenly stared at like a strange beast! All at once fifty cameras were aimed at me; the magnesium flashes gave a dramatic aspect to this scene in which I was playing a role. I soon recognized a few friends and acquaintances: I think that I must have laughed and wept at the same time . . .

There remains one obligation for me to fulfill: let me express here my thanks to all the newspapers, all the writers, all the artists who have given me such touching evidence of solidarity and esteem.

I hope that I may be forgiven for not yet having thanked each person separately. But that will be done, by letter or by personal call. However, mere observance of the simple rules of politeness will not make me consider that I have paid my debt of gratitude.[10]

There were more onerous costs as well, and Steegmuller takes note of them:

It was indeed commonly recounted in Apollinaire's circle that . . . he had had to experience the peculiarly bitter despair that comes from the defection of a close friend. Despite Fernande Olivier's loyal denial, the story gradually found its way into print. The painter Albert Gleizes . . . wrote in 1946: "Guillaume had suffered very much in the course of the interrogations that the investigating magistrate had subjected him to. Especially in his affections. Didn't one of his dearest friends deny him when they were brought face to face, losing his head so completely as to declare that he did not know him? Apollinaire spoke to me about this with bitterness, and without hiding his dismay."

In 1952 was printed Apollinaire's version of the whole affair, written to a friend in 1915. "They arrested me, thinking that I knew the whereabouts of the *Mona Lisa* because I had had a 'secretary' who stole statues from the Louvre. I

admitted having had the 'secretary' but refused to betray him; they grilled me and threatened to search the homes of all persons close to me. Finally, in order to avoid causing great trouble to my *amie* and to my mother and brother, I was compelled to tell about X___: I did not describe his actual part in the affair, I merely said that he had been taken advantage of, and that he had never known the antiquities he had bought came from the Louvre. Next afternoon, confrontation with X___, who denied knowing anything whatever about the affair. I thought I was lost, but the investigating magistrate saw that I had done nothing wrong, and was simply being victimized by the police because I refused to betray the fugitive to them, and he authorized me to question the witness; and using the maieutics dear to Socrates I quickly forced X___ to admit that everything I had said was true."[11]

Maieutics enables the interrogator to bring forth what is only *latent* in the subject's mind. Who but Apollinaire would have had the wit to use such a word? How interesting it would be to have a transcript of these maieutics! Forty-eight years after 1911, Picasso spoke at last of his part in the event. (The italics are mine.)

Paris-Presse, JUNE 20, 1959:

PICASSO NOW CONFESSES

Gilbert Prouteau is preparing an art film in which the great contemporary painters will play themselves. Last week he went to solicit the participation of Picasso.

"I know you," the Seigneur of Vauvenargues said to him. "You are the one who taught me that there is such a thing as remorse, when I saw your film on Apollinaire last year. During the hour I spent watching it, I was thirty years old again. And I think I shed a tear or two . . ."

"Memories, Maître?"

"Yes, but not the kind you are thinking. I can admit it now. I did not behave very well with 'Apo' on one occasion. It was after the affair of the theft of the *Mona Lisa*. Guillaume had returned the *picture* in care of a newspaper, but despite that precaution our little group was being watched rather carefully. *We wanted above all to repeat our offense. We were at the age of the gratuitous act. Such childishness amused us, and the idea of owning a series of little statues for a few days delighted me.* It wasn't robbery, *just a good joke.* No sooner said than done. But this time the police were ready. I took fright and wanted to throw the package into the Seine. 'Apo' was against it.

" 'They don't belong to us,' he said.

"And he got himself arrested. Naturally, they confronted us. I can see him

there now, with his handcuffs and his look of a big, placid boy. He smiled at me as I came in, but I made no sign.

"When the judge asked me: 'Do you know this gentleman?' I was suddenly terribly frightened, and without knowing what I was saying, I answered: 'I have never seen this man.'

"I saw Guillaume's expression change. The blood ebbed from his face. *I am still ashamed . . .*"[12]

It is pure Picasso. Half-true and half-false. At work as always to support his legend, he still must tell something of the truth. He wishes to be revered; he also wishes to be understood.

Steegmuller provides a portrait of Apollinaire in the aftermath:

During the months that followed his provisional release, Apollinaire's life was badly out of joint . . . nothing bites more savagely into the personality—especially of a man whose position in society is as equivocal as Apollinaire's: bastard, foreigner, writer of erotica, poet—than first-hand evidence and public proclamation that society does indeed consider one contemptible and expendable. *"Monsieur Apollinaire, vous êtes une canaille!"* one of the police officials is said to have shouted at him; and for someone of Apollinaire's carefully built-up name and personality this is to be made to tremble on the brink of the abyss . . . Someone who met him at this time wrote that he was "depressed, considered himself deserted by all, irretrievably ruined; he had been much affected by his incarceration in the Santé and the unconcealed pleasure that certain malicious fellow-writers had taken in his plight."[13]

Guillaume Apollinaire, c. 1911.

To add to the difficulty, he had only been given a provisional release from

incarceration. Provisional, in this context, was equal to probation. Any unhappy episode in which he now figured could prove sufficient cause to have him, a foreigner, expelled from France.

In his memoirs, André Salmon also speaks of this period:

> A man of his distinction could not help being bitter at the thought that he had been questioned at length by a magistrate: it choked him—he was like a man who had swallowed a fishbone. I called on him: he asked me to admire his monkey, a fine specimen he had recently acquired. This tame macaque was merrily eating an apple, playfully jumping from one piece of furniture to another. His master, praising its gentleness, observed: "You see, he doesn't really have to stay in his cage." Some devil prompted me to reply: "Well, at least he can be *provisionally* released." Whereupon Picasso, who was present, grabbed the animal by its blue behind and thrust it back into its cage. People sometimes react in strange ways.[14]

Part XI

The Decorator

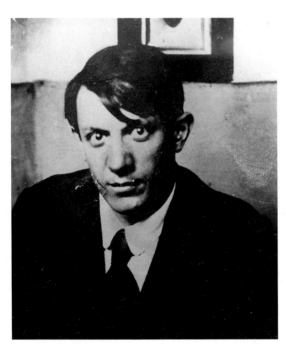

Picasso, 1912

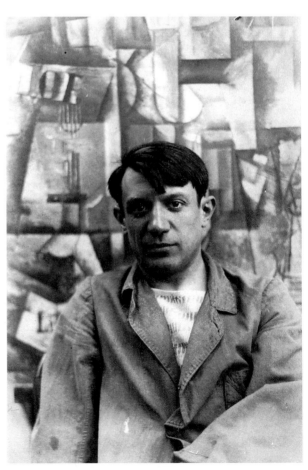

1

Photographs are dangerous as aids to understanding: They may tell us too much. A temperament as subtle as Picasso's can always present a new face before too many hours have passed. All the same, some photographs seem to insist on their integrity. Here, in 1912, the ravages of the encounter with the police still seem visible. Consider the two prints on the facing page: Never has Picasso looked more like (1) an immigrant and (2) a convict who ratted on a friend.

Can we take some measure of the woe? Groveling before the police, trembling under the eyes of his mistress, suffering a whole reversion to the terrified young boy who wept in misery every morning as he was dragged to school can provide us with some idea of the primal panic that still lived in frantic disarray beneath his ego. It is disagreeable to think of how he is now obliged to see himself—a clown searching for machismo who looks to fire his pistol at three in the morning through the roof of a cab. Small wonder if his harlequins were sad. They knew how he would act in a crisis.

Yes, to take a sounding on the depth of his woe, one would have to pass through a failure of nerve as humiliating as his, and initiate a betrayal of friendship as dramatic. It is certain: A large part of Picasso will never feel respect for himself again.

The evidence is present in his work. Over the next sixty years, in all the incomparable immensity of his output, it is astonishing how few drawings, etchings, sculptures, ceramics, and canvases are free of that savage insight into ugliness that virtually becomes his trademark. Even when he sets out to be charming or, worse, cute, his work is often on the edge of the ugly. Small wonder. To him, after 1911,

the world is ugly. Permanently. Never again will he be able to love himself so purely as to write on a canvas, "I, the King."

One can attempt to exculpate him. It may be said in his defense, and one might make an equal brief for Apollinaire, that he was terrified of being deported from France—a real fear considering the circumstances, and a real loss for each of them, equal perhaps to the amputation of a limb. Beneath that heavy woe, however, was even a more profound fear: There was so much they both wished to destroy in society that of course they were petrified by a confrontation with the authorities. If they believed that they were ready to blow up the works, what was going to restrain the gendarmes from punishing them severely so soon as the authorities understood what was in their mind? To make matters worse, they really knew nothing about the functioning of the police and the courts: They could as well have been landing on the moon. So, they broke down. They were weaker than they thought they would be in a confrontation. It was an enormous burden they were supporting, after all. Apollinaire was the impresario for a new world culture, as yet fashioned only at the point of his pen, a culture full of light, love, irony, fantasy, conflagrations, explosions, and the apotheosis of the exceptional. He was the leader of imagination in all the palaces of poetry not yet erected by verse. ". . . *Rooted in poetry we have rights over the words which make and unmake the world*,"[1] he had written in celebration of André Salmon's wedding day in 1909.

And Picasso, in some deep part of himself, had to be near spiritual exhaustion. He had managed to negotiate two major rites of passage—the Blue Period and Cubism. Either one could have destroyed a less resolute artist—the first through depression, the second by one mis-step on the precipices of mental breakdown—all those options, choices, complexities of plane. He was hardly ready to stand nose-to-nose with the police. He had sallied forth so many times to explore the bastions of Creation; now the watchdogs of authority must have weighed upon him like secret agents of that higher, more remote Authority whose secrets he had been looking to expose.

> For a long time Picasso and Apollinaire believed themselves to be followed. Picasso only dared to go out in the evening by taxi. Sometimes he would even change cabs several times to throw any people following him off the track . . . I believe Picasso has never forgiven me for seeing him so worried.[2]

The love of Pablo and Fernande—what was left of it—would not last another eight months. Of course, it can also be said—was Fernande ready to forgive him?

Gertrude, via Alice, gives an account of a Saturday evening at the rue de Fleurus when Fernande started defending the pimps and criminals of Montmartre. Since Gertrude was always superior to chronology, she would have been the last to be able to date the episode, but if it occurred before this period, they would certainly remember it now, and if it occurred after September of 1911, it speaks for itself:

> Fernande contended that the apaches were better than the artists and her forefinger went up in the air. Picasso said, yes apaches of course have their universities, artists do not. Fernande got angry and shook him and said, you think you are very witty but you are only stupid. He ruefully showed that she had shaken off a button and she very angry said, and you, your only claim to distinction is that you are a precocious child. Things were not in those days going any too well between them . . .[3]

No matter the labors of reconstruction that his ego must undertake, he was painting nonetheless every day. It would appear ironic that during these fall months of 1911 Picasso is working better and more profoundly than at any time since he embarked on Cubism, but then, he is not a genius for too little. He is always professional—which is to say that he not only engages his art daily but can excel in it on what is otherwise a very bad day. If his talent had become a justification for each of the flaws in his person, all the more need to exercise it now.

That is easy to say, but not even a professional, lacking the active spirit of genius, could work after such bombardment of the ego, private and public ego both, as was suffered in September of 1911. He had to know how his friends and enemies were gossiping about him now, now that he had betrayed Apollinaire. Perhaps one must look upon Picasso's psyche as a species of tightly compartmented ship; having received a gaping rip in the hold, it is quickly sealed off, the engines remain protected, communications with the bridge are retained—an unwieldy metaphor, to be certain, but let us recall: "Talking to the Pilot Is Forbidden!"

In fact, before the events of September, he had been working very well in Céret all summer of 1911. Problems he had been unable to solve through the fall and winter of 1910–1911 were opening for him: The canvases of early summer were excellent; so was the work, however, that came in the autumn of 1911. Spiritually, he had suffered the equivalent of a stroke, but that had devastated a part of his spirit not engaged with Cubism; he was, as we shall see, like a seriously wounded man fixed on finishing a journey before his body gives out. Cubism was not a matter of separate inspirations for separate days—rather, it was the development of a

new kind of vision. Thereby, the answer to a problem posed yesterday was likely to become a new question that would have to be answered tomorrow; in Cubism, this anticipation of advance was projected into the months ahead. We will do well to conceive of the ongoing aesthetic process as not without analogy to an army engaged in an offensive of long duration. Quartermaster is ordering up supplies today that will probably not be needed for another six or eight weeks; so must Picasso's unconscious have been filled with trains of expectation, concepts for future works partly developed, laid aside, picked up again. The damage to his whole balance, if he had been too stricken to work, would have been vastly greater—all those troops of ideas now idle and standing around in the rain. So, he proceeded with his campaign—to produce great works of Cubism, and on they come in this period from July of 1911 through the winter of 1912 and into the spring, the masterpieces of Cubism (see colorplates 33–36, following page 368). How else could he make amends for his shame? How better?

A new mistress has become, however, very much an element in his work during this winter of 1911–1912. Just when we are beginning to appreciate the dynamics of his nature—or so we think!—he will present us with a new signature: He is, when everything is at its worst, a magician; there is always one more surprise to be drawn forth by those artful hands. So as we look at the masterful complexities of *Ma Jolie* and *The Architect's Table*, the oubliettes, cul-de-sacs, factory floors, alleys, chutes, trapdoors, hallways, partitions, mirrors, stairways, tunnels, fences, quarries, and streets—all that symphonic urban cacophony of a Europe that does not yet comprehend how much it is swelling up for war—we cannot be certain whether these formidable canvases have been generating for months in the mills of his conception and would have appeared no matter how, or whether they were embellished with fresh life given him by the new mistress.

Odds are that these last few paintings would still be ours if Marcelle Humbert had not entered his life. She will yet have her large influence upon him, but as we shall see, her presence succeeds in bringing an end to Cubism as it hitherto existed. It will be replaced by what has never clearly enough been seen as its antithesis—a convulsive departure which Apollinaire, with his flamboyant love of labels, would define as Synthetic Cubism, as opposed to the earlier *Analytic* Cubism. (He would also come up with Rococo and Orphic Cubism.) The new direction would indeed be synthetic—the plastic gewgaws to be seen in the display windows of many a cheap mall store today are the wholly debased great-grandchildren of Synthetic Cubism, but then, Synthetic Cubism is to Analytic Cubism as Formica to walnut. Picasso, as

we shall see, was not only leaving Fernande, but quitting his last ties to the Bateau Lavoir and the life he had known in Paris since 1905.

Gertrude gives us a nice description of how, from her point of view, she saw it all evolve. To follow her account, it is necessary to know that his new mistress was still named Marcelle Humbert, was living with a sculptor named Marcoussis, and had not yet been renamed Eva (not Eve), but then we know by now that Gertrude will lose no sleep trying to set accounts straight!

> Fernande had at this time a new friend of whom she often spoke to me. This was Eve who was living with Marcoussis. And one evening all four of them came to the rue de Fleurus, Pablo, Fernande, Marcoussis and Eve. It was the only time we ever saw Marcoussis until many many years later.
>
> I could perfectly understand Fernande's liking for Eve. As I said Fernande's great heroine was Evelyn Thaw, small and negative. Here was a little french Evelyn Thaw, small and perfect.
>
> Not long after this Picasso came one day and told Gertrude Stein that he had decided to take an atelier in the rue Ravignan. He could work better there. He could not get back his old one but he took one on the lower floor. One day we went to see him there. He was not in and Gertrude Stein as a joke left her visiting card. In a few days we went again and Picasso was at work on a picture on which was written ma jolie and at the lower corner painted in was Gertrude Stein's visiting card. As we went away Gertrude Stein said, Fernande is certainly not ma jolie, I wonder who it is. In a few days we knew. Pablo had gone off with Eve.[4]

That was in May of 1912, but the affair was probably begun as early as November of 1911, two months after the fiasco with the Paris police, and was kept more or less secret over the next half-year until Fernande—we can conceive of how wholly frayed was their relation by then—decided to run off with an Italian painter named Ubaldo Oppi. Picasso sent a quick note to Braque: *"Fernande ditched me for a Futurist. What am I going to do with the dog?"*[5]

The letter is dated May 18, 1912, and the event brought forth his decision. He would live with Eva. His letter went on to say that he was leaving Paris for a time, and would Braque take care of his dog, Frika, for a short while?

Two days later, he is in Céret and writes to Kahnweiler:

> I've put Braque in charge of sending Frika down here. As for the other animals: the monkey and the cats will be taken care of by Madame Pichot. You, however, have to make up a package of the canvas that is now rolled up at the rue

Ravignan and the panels and send them to me here (at Manolo's address) . . .
Don't give my address to anyone for the time being.[6]

Next day, he writes to Kahnweiler to tell him that Eva is with him *"and I am
quite happy. But say nothing to anyone."*[7] On May 24, he has prepared a list for
Kahnweiler:

> You must also send me the paintbrushes that are at rue Ravignan, dirty and
> clean ones both, and the stretchers that are also in the rue Ravignan. I will have
> need of other things but I will write to you later or I will write to my paint supply
> man. The palette from rue Ravignan you must also send me. It's dirty, wrap it in
> paper together with the stretchers and my letters and the numbers and the combs
> for making *faux bois*. Also send the paints from rue Ravignan and from boulevard
> de Clichy—I'm going to tell you where they are and will give you the list. (Actually
> I'm annoyed to have to trouble you with these stupidities.)
>
> In the large armoire are the paints and also on the workshop table. Send me
> the tubes you will find of white, ivory black, burnt sienna, emerald green, Veronese
> green, ultramarine blue, ochre, umber, vermilion, cadmium dark or, better, cad-
> mium yellow and I also have violet cobalt, Peruvian ochre, but I don't know if one
> writes it like that—the oils are on a table in a box.
>
> I prefer to have all my oils here; I may only use the white, but it's necessary to
> have them all with me.[8]

By the next day, there is another letter. Now he needs linens and blankets and
his yellow kimono. "I've more confidence in you than in myself."[9]

On May 30, Wilbur Wright dies in Dayton, Ohio, just twelve days after the
rupture with Fernande. The summer of 1912 becomes a period of transition in
which Picasso commits himself to the large move precisely from Cubism to Syn-
thetic Cubism, so he may even see Wright's death as an omen to confirm the shift.
(No longer will his canvases be obliged to hover in the web of space.) It is not that
he and Braque cease working together—to the contrary, the years from 1912 to
1914 will have Braque producing as many innovations for the team as Picasso—
but their enterprise will move from the Faustian and the apocalyptic to the handy
and the familial. The detritus of small workshops—sawdust and metal filings—the
staples of lumber yards and hardware stores and paint shops—cheap enamels,
sheet metal, wood, cardboard, the stuff of medicine cabinets—razors, combs—are
some of the simple materials they use.[10] Of course, by now they have retreated from
the precipices of Cubism.

The letters continue. Picasso may have sent out more messages in these weeks than at any other time in his working life. His anxiety is enormous. He has gone to Céret because Manolo is there, but then, he had spent the previous summer there as well; he knows it will be one of the first places Fernande will think of. On June 12, he informs Kahnweiler that he has had news from Paris—Fernande is toying with the idea of coming to Céret with Germaine (Gargallo) Pichot. Or, at least, so he has heard from Braque.

I am very annoyed by all this, first of all because I would not wish my great love for Marcelle to suffer in any way from any episodes they might cause me, and neither would I want her to have to run afoul of them in any stupid way; and besides, it's important for me to have peace in order to work. I've had a real need of that for a long time. Marcelle is very nice, and I love her very much and I will write this on my paintings. Apart from all that, I am working hard, and have done more than a few drawings and have begun 8 paintings. I believe that my painting

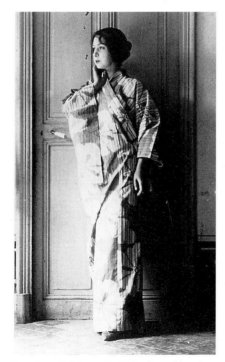

Eva Gouel (Marcelle Humbert), Paris, c. 1911.

Eva Gouel in Avignon, summer 1914.

has been gaining in robustness and clarity but we will see and you will see . . . I need more security . . . Supposing that you meet Fernande, tell her to expect nothing from me. I would be more than happy never to see her again . . .[11]

On June 19, he tells Kahnweiler that it is definite—Fernande is on her way to Céret. Complaining about his need for peace, he decides to leave—he will find a new place.[12]

On June 20, he writes to Kahnweiler that he is leaving for Perpignan. "*. . . don't tell ANYONE, ANYONE AT ALL where I shall be . . .*"[13] By June 23, he has made a move to Avignon, where he has found a small villa with a small garden. Then, on June 25, he writes again to mention that of all the foul luck, he has encountered some people he knew in Montmartre. He moves again. On June 26, he writes from Sorgues, near Avignon; he is now renting a mean and grim little cottage in a charmless village, but at least no one will know him there: "*Tell Braque that I'm writing to him, BUT DO NOT GIVE MY ADDRESS TO ANYONE.*"[14]

The anxiety continues, and he goes into considerable detail about his easel in the rue Ravignan, to which he is naturally "very attached," and his sculpture turntable. Concerned that Fernande will appropriate them, he asks Kahnweiler to request Braque to keep them.[15]

By July 4, he reassures Kahnweiler: "If I weren't so aggravated, I wouldn't work badly here, the light is beautiful and I can paint outside in the garden." But, safe in Sorgues, anxiety consumes him still. He cries out that he needs peace and Kahnweiler must tell Manolo to be careful and tell no one, no one, where he is.[16]

The reason for the sudden move and the attendant anxiety is Fernande. Tired of her affair with Oppi, she has gone back to the apartment on boulevard de Clichy to discover (in all the emptiness of a fling that has fallen to earth) that Picasso is gone! She soon leaves for Céret.

Patrick O'Brian carries it a little further:

. . . the Pichots arrived, and with them Fernande. Ramón Pichot took Fernande's side; there were scenes between the women; life was impossible. Before the end of May [O'Brian is in error—the date was June 21], Picasso and Eva fled . . . to Sorgues-sur-l'Ouveze . . .[17]

The question is very much in order: Why is Pablo so afraid of Fernande? The assumption must be that he is not altogether ready to leave her for Eva, who is, by general accounts, small, sweet, superficially submissive, orderly, thrifty, and

devoted to Picasso. Fernande, with all her social disproportions, is nonetheless a commanding presence by now in social gatherings (Gertrude is always describing Fernande as making a point in discussion by raising one forceful forefinger toward the sky) and, as we know, beautiful. Picasso is interested in social status—it could be his dirty little secret. While obviously his snobbery can never be matched against his preoccupation with work, it is nonetheless there, weighing on him if he is secretly a bit ashamed of his new woman.

There is no overt evidence he is; it is just that he piles up too much evidence to the contrary. He writes "Ma Jolie" into his canvas, taken from the song, "*O Manon, ma jolie, mon coeur te dit bonjour,*" and makes certain once he and Eva are living together that everyone will know who *Ma Jolie* is. Other canvases in Synthetic Cubism will have "Jolie Eva" inserted, or "J'aime Eva," or even "Pablo-Eva"; he makes a large point of telling Kahnweiler (and others soon enough, we will assume) that "*I love her very much and will write her name on my pictures.*"[18] Every one of his protestations is an enhancement of her importance, and all the while he does not wish to see Fernande. He can, of course, not forgive her for Ubaldo Oppi. She can have an apache, a circus roustabout, a crazy pick-up—we do not know what kind of affairs she had—she is discreet in her memoirs—but this we can probably affirm: The one variety of infidelity for which he will not be quick to forgive her is a serious escapade with a fellow painter. Probably, she is still attractive to him. Gertrude offers a characteristic summary of the summer and an aperçu or two on the aftermath:

> This was in the spring. They all had the habit of going to Céret near Perpignan for the summer [and] Fernande was there with the Pichots and Eve was there with Pablo. There were some redoubtable battles and then everybody came back to Paris.
>
> One evening, we too had come back. Picasso came in. He and Gertrude Stein had a long talk alone. It was Pablo, she said when she came in from having bade him goodbye, and he said a marvellous thing about Fernande, he said her beauty always held him but he could not stand any of her little ways. She further added that Pablo and Eve were now settled on the boulevard Raspail and we would go and see them to-morrow.
>
> In the meanwhile Gertrude Stein had received a letter from Fernande, very dignified, written with the reticence of a frenchwoman. She said that she wished to tell Gertrude Stein that she understood perfectly that the friendship had always been with Pablo and that although Gertrude had always shown her every mark of

sympathy and affection now that she and Pablo were separated, it was naturally impossible that in the future there should be any intercourse between them because the friendship having been with Pablo there could of course be no question of a choice. That she would always remember their intercourse with pleasure and that she would permit herself, if ever she were in need, to throw herself upon Gertrude's generosity.

And so Picasso left Montmartre never to return.[19]

The two photographs of Eva back on page 343 do not tell us enough. There she is, nearly invisible, decent, fussy, delicate. She kept house for Picasso, and very well, at 242 boulevard Raspail and later on the rue Schoelcher, and also in Montparnasse. She had an eye for business; she could spot patrons who were going to buy paintings rather than those who were there merely to take a look. She encouraged him every step of his way into Synthetic Cubism and all but hectored him to bring color back to his palette. In the four years before she died, his paintings would command better prices every year, and she worked closely with Kahnweiler and was on the best of terms with Gertrude and Alice.

Until she became ill with an incurable cancer (she would die by the end of 1915), Picasso seems to have lived in domestic peace, and there is no record of relations between Eva and Pablo ever turning as bad as Germaine Gargallo Pichot and Ramón Pichot promised they would in the terrible encounter at Céret in the summer of 1912. Ramón told Picasso

> he was glad in a way that his old friend had found a woman who looked like María [Picasso's mother], small and dark and passionate, as opposed to the tall and red-haired girls he had had until now—"at last he has stopped fucking his father"—but warned that Eva had a notoriously bad temper and was as tough as old boots. Germaine herself was less than kind: Eva was as false as her teeth, and such a liar that she had convinced herself that her dentures were real. She was small, but pure poison all through.[20]

If these qualities had been evident during her years with Marcoussis, well, it was also true that the sculptor used to beat her. Picasso by Eva's account adored her and she adored him. Picasso, she told her friends, liked to wake up about half past ten in the morning. As Eva confided, he would

> sit up in bed in his blue and white striped pyjamas to drink the coffee [she] brought him. They would exchange endearments, and she would tell him what she had in mind to prepare for lunch that day; the room was always neat and tidy, the

bed linen spotless, the silk brocade curtains tied back to show the bright, white net which covered the windows discreetly. Even when the bed became the scene of their theatrical sexual activity, she told her friends that Picasso was always very gentle. To look at him, she used to say, you would think he would be violent, but he is really like a lamb. Unlike Marcoussis, he never struck her.

The rest of their home on the Boulevard Raspail had the same sort of atmosphere. The cushions were always plumped up on the English armchairs and the French furniture in the dining room was dusted and polished every day. The cats and dogs knew their place, too, and looked like part of the decor. Picasso's studio was the exception to all the rules, but even there he had a little table on which tea was served in a flowered tea set. During the spring of 1913 Eva found a new home for them in the Rue Schoelcher (no. 5 *bis*). She liked it because it was even more peaceful and she could look out of the windows at the tombs in Montparnasse cemetery. Here the studio was bigger and had better light, and though the flat was farther away from his favourite bars and cafés, Picasso accepted the move without protest.

Picasso's health certainly improved under this tender loving care, and those of his friends who had had doubts about the dismissal of Fernande were reassured. As a tangible sign of their approval, the new couple was invited to Céret for the summer: Germaine Pichot, who had led the "opposition" the previous year, was asked to stay away.[21]

2

In April of 1912, Picasso had taken a trip to Le Havre with Braque, and on his return he painted a canvas, *Souvenir du Havre*, which—full surprise!—had color, and Braque, studying the canvas, made a famous remark: " 'The weapons,' said Braque, 'have changed.' "[1] (See colorplates 37 and 38, following page 368.)

Indeed, they had. Cubism used dull green and ochre shadings of gray; to some it seemed as impersonal as the old layout of *The New York Times.* If the results were luminous, evocative, ambiguous, and all but anonymous, Picasso and Braque were not being painterly but spatial, priests of high space.

Color, however, was immediate, personal, emotional, individual. One could not explore new laws of form and space and use lively pigment at will. Dark blue speaks of hollows in a landscape, and red, like fire, draws the eye; yellow is dazzling; bright green pulls one's vision into panorama. It was all but impossible to approach some universal language of form as it coalesced into other forms if color was there to intervene. Conceive of a high-tech surgical operation in a wholly sterile room that now is flooded with odors of cooking fat, garlic, and onions—such was the effect of color on Analytic Cubism.

The answer was to take up color at the cost of relinquishing the apocalyptic search implicit in Analytic Cubism. Away with the monastery! Picasso would soon flatten his compositions, give up on dizzying penetrations into depth and please the onlooker with a lovely sensuous palette.

Of course, there had been earlier attempts to introduce color. Life was a taste-

less gruel without it, and up in the high altitudes of Analytic Cubism, a sense of dread was there with every breath. As a manifest of such states, there had even been a period when their canvases were signed only on the back or were not signed at all. If Picasso and Braque were ready to change the history of art, they were also tempted to keep their presence faceless. Since they were ready to dare everything, it was crucial, to the degree that they were high priests, that they display no petty vanity, no thoughts of self-aggrandizement.

> It was a quest that transcended ego and personal ambition, and to underline that what they sought was "pure truth without pretension, tricks or malice," they signed their canvases only on the back to preserve an anonymity uncontaminated by the tinge of personal glory. "Picasso and I," Braque said, "were engaged in what we felt was a search for the anonymous personality. We were inclined to efface our own personalities in order to find originality. Thus it often happened that amateurs mistook Picasso's painting for mine and mine for Picasso's. This was a matter of indifference to us, because we were primarily interested in our work and in the new problem it presented.[2]

William Rubin points up the moment of transition:

> In time, however, Braque came to feel that "without 'tics,' with recognizable traces of the individual personality, no revelation was possible."[3]

They had been dealing with death and decomposition, with motion through time, with modern city uproar—transcendentalism and near-chaos had no need of a signature until it did. But then it did. Anonymity was growing cold. Life was becoming too cold.

If Picasso had had a bellyful of Fernande's final lack of respect for him as a man and as an innovator, so had he also had enough of living on the gray rations of an art so elevated it was for practical living purposes a dire theology. Nonetheless, it died hard. Two of the greatest works of Cubism (with just a hint of color) come forth as terminal expressions even as he has already started in the new direction (see colorplates 39 and 40, following page 368).

Back in Paris, living with Eva on boulevard Raspail in Montparnasse, he went over completely to Synthetic Cubism. People would no longer have to grapple with the enigma: Is Picasso a genius or a hoax? Now, he is a painter again, decorative, agreeable, charming, literally avoiding the obscure. If Cubism produced some of the most complex contents ever to be placed on a canvas, Synthetic Cubism

livened up the walls in a fashion that still puts interior decorators to shame. Where the tension for Picasso in the first years of Cubism had been to create organisms free of magnitude and of character (that is, not clearly figures, still-lifes, skyscrapers, or landscapes) yet wholly there—creatures of great magnitude and complexity—Synthetic Cubism reined in such ambitions and reduced Cubism to decor. It was splendid stuff and would literally affect the tones and style of contemporary decorators more pervasively than any other movement in art, but it was no longer profound. Discipline, austerity, and depression gave way to fun, games, tricks, stunts, paradoxes. From 1912 on, his hand enjoys itself, cashes in (see colorplates 41–44, following page 368).

One can wonder if Cubism has disappeared altogether. Did the pilot to whom we were forbidden to speak decide to jettison his cargo? Of course not. Not entirely. Picasso never relinquished a skill, facility, technique, idea, or research. If he had been roped to Braque on high rock walls until the attrition of the effort brought them down, echoes of Cubism still appear in the work, and it is difficult not to enjoy those hints of return (see colorplates 45–46, following page 368).

Even in this period, when he is determined to repudiate the past—which is to say, be able now to enjoy himself—there is one work which stands as a monumental bridge between Cubism and the prodigiously ugly and frighteningly insightful portraits he will draw of the women with whom he will live for the next sixty years. Fernande could hardly forgive him for the unsparing vision he developed as to how she would probably look to him in old age; Fernande had, however, little to complain about compared to the way Picasso painted Eva in the autumn of 1913, at a time when he may have already known that she was not in good health (colorplate 47, following page 368).

It is possible, of course, that Eva, renowned for her shrewdness, was wise enough to keep the information from her beloved, but then Picasso, with his far-reaching instinct and periodic revulsion against all things pretty and acceptable or too universally admired, may have begun to feel, now that all his friends were coming around to accept her, that Eva was becoming too universally admired. Moreover, his father had died in May. He probably divined all that was diseased in her body and spirit.

Even Roland Penrose, who, next to Paul Éluard, is Picasso's most unabashed epigone, shows himself troubled by the canvas:

> During the winter of 1913–14 Picasso produced one of those works which in later years stand out among other paintings of the period as being prophetic of

trends of development . . . The picture has had several titles but is usually known as the *Woman in a Chemise*. I once had the good fortune to have it lent to me for some months after it had been acclaimed by the surrealists and shown in their exhibition in London in 1936 as a splendid and powerful example of fantastic art. It was in fact so powerful that a friend to whom I had lent my house for a month during its visit complained that it gave her nightmares and endangered the future of her expected child. I also was deeply moved by it. The references to reality are direct and highly sensual. In describing this picture after he had known it twenty years, Paul Éluard wrote: "The enormous sculptured mass of the woman in her chair, the head big like that of the Sphinx, the breasts nailed to her chest, contrast wonderfully . . . with the fine measure in the features of the face, the waving hair, the delicious armpit, the lean ribs, the vaporous petticoat, the soft and comfortable chair, the daily paper." New and disquieting relationships between abstraction and sensuality, between the sublime and the banal, between stark geometric shapes and allusions to organic reactions are brought into being. I have not only been moved by the familiar flesh pinks, greys and purples of this great female nude, by the enveloping arms of the chair which embrace and protect the seated figure, not only loved the cavernous depths that surround the strong central pillar round which is built the enveloping egg-like, womb-like aura of her body and its culmination in the cascade of dark hair which seems at times to transform the upper part of the picture into a landscape by the sea, but also I have been haunted by those pegged-on breasts hanging like the teeth of a sperm whale strung on the necklace of a Fijian king, germinating sensations of tenderness, admiration and cruelty.

With masterly authority of line and composition, the erotic content of this picture, which is almost unbearable in the completeness of its implications, becomes laden with poetic metaphor. The act of creation is situated in one symbolic seated figure surrounded by the newspaper, the armchair and the linen of our everyday existence. The dream and reality meet in the same monumental statement.[+]

Enough! The beast hidden within Cubism has at last emerged. It is one of his first masterpieces of ugliness. And it anticipates the horrible months he would experience in 1915 when Eva was dying in a hospital and he had to make the trip back and forth every day in the Métro to visit her at a time when much of his love had lessened. How he saw her oncoming illness in this cruel portrait!

Arianna Stassinopoulos Huffington offers a good description of Picasso's actions as Eva was dying in 1915.

When it became impossible even for the determined Eva to hide from him the

nature of her sickness. Picasso, terrified of catching it, often fled their apartment and spent hours working in his storeroom at the Bateau Lavoir.

By fall, Eva had to be hospitalized in a clinic in Auteuil, a suburb on the other side of town. Picasso was living alone for the first time in years. He went to the clinic every day, but he needed someone to console him during the long, lonely nights. He found that someone in Gaby Lespinasse, a beautiful twenty-seven-year-old Parisian who was his neighbor at the boulevard Raspail . . . Between seeing Gaby and the long Métro journeys back and forth to visit Eva at the clinic, there was less and less time for work.[5]

His letters and notes to her are reminiscent of epistles in other seasons with other recipients:

". . . Gaby my love my angel I love you my darling and I think only of you I don't want you to be sad To take your mind off things look at the little dining room I will be so happy with you . . . you know how much I love you . . . Till tomorrow my love it is very late at night with all my heart Picasso."[6]

Gertrude, who never knew about Gaby Lespinasse, nonetheless has her bit to add:

During our absence Eve had died and Picasso was now living in a little home in Montrouge. We went out to see him. He had a marvellous rose pink silk counterpane on his bed. Where did that come from Pablo, asked Gertrude Stein. Ah ça, said Picasso with much satisfaction, that is a lady. It was a well known chilean society woman who had given it to him. It was a marvel. He was very cheerful. He was constantly coming to the house, bringing Paquerette a girl who was very nice or Irene a very lovely woman who came from the mountains and wanted to be free.[7]

If he was a monster, we have no alternative but to accept him. We ought to know that violence and creativity all too often connect themselves inextricably. Indeed, how can they not when some of the most creative moments in early childhood are interrupted by adults—concern for one's safety, or one's deportment, are always grounds for interruption—and so in maturity, love is frequently followed by hate, and creation by destruction. So were Picasso's illimitable powers of insight locked into a powerfully negative view of the permanence of all tender sentiments; if this grew worse as he grew older, well, he was not only the genius of us all, but a prisoner in the structure of his character. If no painter ever remained as free in his imagination for as many decades, so may no other artist have been as doomed to relive his obsessions through all of ninety-one years of life. The hand and the eye never cease collaborating; the eye stares into all the dungeons of the human spirit

while the hand is forever ready to capture what is worst in the spirit of each beloved.

It may be worth taking a quick look at a few of the most beautiful and the most hideous visions he would produce of his first wife, Olga, and his mistress Dora Maar.

Olga Picasso, 1917. Pencil.

Nude in an Armchair (Olga), May 5, 1929. Oil on canvas, 77 x 51 in.

Portrait of Dora Maar, January 27, 1937. Pencil sketch on paper, 12 x 16 in.

Study for Guernica (Dora Maar), June 13, 1937. Black pencil and colored pencil on paper, 11 x 14 in.

His second and last wife, Jacqueline, is treated worst of all.

Detail of Jacqueline aux Fleurs, 1954. Oil on canvas, 39 x 32 in.

La Pisseuse, April 16, 1965. Oil on canvas, 76 x 38 in.

Even his mistress Marie-Thérèse Walter, with whom he would not only have a daughter, Maya, but a relation that lasted from 1928 for twenty years and more—Marie-Thérèse, the most concupiscent and voluptuous of his women—is portrayed with a fair and a dark psyche (each with two sides, for that matter) in his classic *Girl Before a Mirror*.

Girl Before a Mirror, Boisgeloup, March 1932. Oil on canvas, 64 x 51 in.

Women obsessed him as the last available manifestation of that Creator whose secrets he had hoped to capture quickly in the Cubist years. At the end, at the age of ninety, in a half-humorous, half-desperate attempt to get one last glimpse of what the

Creation is all about, he attacks it in drawing after drawing; hairier the hole and prettier the face, the more he is entertained by his own explorations. No man ever loved and hated women more.

Nude, 1971, colored ink on cardboard or pencil on cardboard. Top left: 9 x 11 in.; top right: 12 x 9 in.; bottom left: 12 x 9 in.; bottom right: 11 x 8 in.

With it all, he never deluded himself. He had gambled on his ability to reach into mysteries of existence that no one else had even perceived, and he had succeeded often enough to supply his work with energy for seventy-five hardworking years as a painter (if we take no more than the measure from sixteen to ninety-one). Yet, he had done it with a whole disregard for the niceties of human responsibility.

In the last summer of Eva's life, when he was beginning his fling with Gaby Lespinasse, he would paint a boulevardier flanked by small black zones of death, yet in a mighty gay mood (see colorplate 48, following page 368).

Fifty-seven years later, in the last summer of his own life, all the prices soon to be paid, he stares into the terror of his oncoming death and sees the ghost of Font-devila protruding from his own cheekbone. It is as if he is saying that he, Picasso, will die as a man in the only way he knows how—by drawing himself right into the center of the confrontation he will soon face.

Head (all four), 1972. Top left: gouache, 26 x 20; top right: colored pencils, pencil, 26 x 20 in.; bottom left: pencil, 26 x 20 in.; bottom right: pencil, 26 x 20 in.

3

We could end here, but then what of Apollinaire? Or Max Jacob? Or Georges Braque? Or Fernande? Can we take leave of such people with no knowledge of what happened to them? Curiosity also has a few rights.

Let us start then with Max Jacob. If, in the page behind us, we have been contemplating death, Max can appear comfortably. Faithful to his love for Picasso, there was only One he loved more. And drugs brought Him near. Not even the death of Wiegels was going to wean Max from opium or ether. Go rather in the other direction: Shortly after Picasso and Fernande moved to boulevard de Clichy in 1909, Max had a dramatic conversion during the night of October 7. It occurred not long after he had come home from a scholarly day in the Bibliothèque Nationale.

> "I was hunting for my slippers," he said, "and when I lifted my head, there was someone on the wall. There was someone! There was someone on the crimson wallpaper. My chair fell to the ground, a flash of lightning had left me naked. Oh, immortal moment! Oh, truth! Truth, tears of truth! Joy of truth! Unforgettable truth! The heavenly body was there on the wall of my poor room. Why, oh Lord? Oh, forgive me! He was there in a landscape I had painted myself, but it was He! What beauty, elegance, and gentleness! His shoulders, his movements! He wore a robe of yellow silk, with blue embroidery."[1]

It is, of course, not enough to be present at a vision. One must convince the authorities that one has the character to deserve such a blessing.

Partly because of the melodrama inherent in his religious expression and partly because of his dissolute lifestyle, the priests he appealed to, even those specializing in the conversion of Jews, were reluctant to receive him. So Max read all the sacred books, prayed in most of the churches of Paris and waited. The priests hesitated to accept the truth of his conversion, and his friends were inclined to ascribe it to the consumption of ether and his propensity for drama and exhibitionism.[2]

His friends were not necessarily all that unfeeling. Fernande gives a thorough description of living close to Max in the years from 1909 to 1911.

Pablo came back from Max's place very worried. He found Max, standing but so sick that he convinced him to lie down. Since he couldn't stay with him, he asked the concierge to watch over him in order that he doesn't lack for care, and to let us know if he gets worse . . .

Should we call a doctor? He would shrug his shoulders and prescribe detoxification. Max is half poisoned. How can he resist the noxiousness of all the drugs he takes in order to sharpen, or so he pretends to himself, his oracular faculties? He has found, in divination, not only a means of earning some money, but it also satisfies his occult needs, which to him are necessary in order to engage in life and interest in others . . . His artificial paradises take place in his dark room, without air, impregnated with pestilential odors that rise from the court. When he opens his only window, these emanations choke one's throat as soon as they enter into this hole where madness dwells with the desires, the dreams, the extravagance and the material poverty of Max Jacob.

Odors of gasoline, vapors of ether, cooking, stale cigarette smoke, mustiness, the odors of chamber pots, all overlapping and remaining in the narrow court under his window.

But must one be sorry for Max? He immerses himself in this idea he has of himself as a *poet maudit*, he accepts his sordid life [and] we are well aware of the uselessness of efforts to bring him back to a more objective reality, which would, without doubt, heal him, but would also leave him tragically disenchanted with life.

Besides, Picasso as the first of his friends . . . laughs indulgently before his worst extravagances. That encourages Max further. As for myself, when he is without money, don't I injure him by handing him a few francs that I've hidden away? He suffers so much from the absence of ether. He suffers like others suffer from an abscess, from a fierce toothache, from misery of love—oh, he suffers simply. He's unhappy. One can only have pity.

The day after, when he's stretched out in the gutter of the rue Ravignan, drunk on ether, without self-awareness, I swear to myself that I will never let him catch me like that again, but later, his air of pain . . . How can one bear that?

Picasso has brought Max here. It is necessary to take care of him because he's really incapable of resting alone, and with us, at least, he will be in bed and will find his needs taken care of. But what a difficult sickness to take care of, despite his weakness! He is in a nervous state that he cannot get out of. I get angry with him often enough, and I chase him and throw anything at him that's handy. The next day, I . . . surround him with love. However, because of my outbreaks, I appear very uncouth. Anger takes over my timidity. I detest treachery. I comprehend the brutality of deeds better than the wickedness of spirit.[3]

After Picasso and Fernande separate, Max remains loyal to her for some time, and solicits Apollinaire in his capacity as one-time employee in a bank to advise Fernande on what to do with the small amount of money she is able to raise by selling the few drawings that Picasso has given her.

Max's first loyalty, however, is to love; he cannot be without Picasso. So he now admires Eva as once he admired Fernande. A year after the separation in May of 1912, Max is living with Pablo and Eva in Céret and sends a letter to Kahnweiler:

Max Jacob, c. 1908, outside the Bateau Lavoir, wearing the top hat he shared with Picasso.

> I will not try to depict the sites that you know, nor our life together which you will divine for yourself.
>
> I get up at six A.M. And produce a prose-poem to get me going. At eight, Mr. Picasso in a dark blue robe or in a simple cloth robe brings me a phospho-chocolate in company with a heavy and tender croissant. He casts an indulgent eye on my work and goes away swiftly . . . One can only know one's friends after having lived with them. Every day I learn to admire the true grandeur of character of Mr. Picasso, the profound originality of his tastes, the delicacy of his senses, the picturesque details of his spirit, and his truly Christian modesty.[4]

But even in his piety, Max will play games. Here is he, still nominally a Jew, twitting Kahnweiler, who also happens to be Jewish, about nothing less than Christian modesty in the person of Picasso!

He revels in a piety of self-abasement as he goes on with the letter:

> Eva is admirably devoted to the humble works of housekeeping. She loves to write and laughs easily. She is calm in manner and generous in her attention to making happy a guest who is dirty by nature, and all too phlegmatic when he is not acting absurdly.[5]

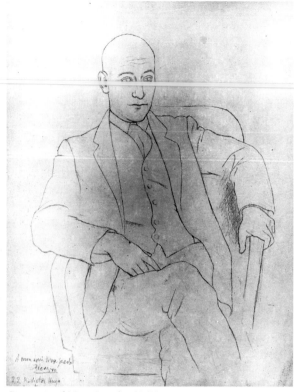

Portrait of Max Jacob, 1917.

Early in 1914, Max succeeds in obtaining his formal conversion to Catholicism:

He had been receiving instruction in preparation for his conversion, but even his visions were unorthodox and took place at theologically unconventional locales. His latest vision had occurred at a movie house during a Paul Feval film titled *The Black-Suit Gang*. Fortunately, the Fathers of Notre-Dame-de-Sion monastery were so eager to further the conversion of Jews to Christianity that they proceeded with Max's baptism.

He chose Picasso as a godfather, undeterred by the fact that if Picasso had any belief at all it was that there was a dark force reigning over the universe. "A good Catholic," he told Max, "is a man with a big apartment, a family, servants, and a motorcar." As a Christian name Picasso wanted to give him Fiacre after the patron saint of French cabdrivers, which made Max suspect that his godfather was not treating the occasion with proper solemnity. Finally they agreed to call him Cyprien—one of Picasso's own Christian names. The baptism took place on February 18 at the Notre-Dame-de-Sion monastery, and Picasso gave his godson a

copy of *The Imitation of Christ*, inscribed "To my brother Cyprien Max Jacob. Souvenir of his baptism, Thursday, February 18, 1915."[6]

As for Apollinaire, there is a photograph of him taken in 1910, at the height of his affair with Marie Laurencin, that tells us a good deal. We are looking at a plump, sensual, well-established, and nicely fed prince of a poet in that first prime between youth and middle age.

To the degree one is accurate in such an assessment, we can appreciate his misery all the more after the episode with the police in 1911. There are details, however, one can hardly anticipate: If Max had converted to Catholicism, a good part of the Paris world was forcibly converting Apollinaire to Judaism.

Photograph of Guillaume Apollinaire, by Picasso, 1910.

The Parisian press did so thorough a job of attaching his name to the robbery that Louise Faure-Favier, writing in 1945, could still say: "Guillaume Apollinaire abruptly became famous throughout the entire world. He was thought of as the man who had stolen the *Mona Lisa*. Even today there are Parisians who believe it, and who are a little disappointed to learn that Apollinaire had nothing to do with the theft."

He was also attacked in print by xenophobes and anti-Semites. Many people supposed him to be a Jew . . . Throughout Apollinaire's life, he was constantly spoken of as being Jewish. The mistake probably had its principal source in his mother's continued liaison with Jules Weil, but it was given currency by anti-Semites who, as Apollinaire put it, "couldn't imagine a Pole not being a Jew," and also by someone who knew the truth: Max Jacob . . . took an odd delight in spreading the rumor of his Catholic friend's Jewishness.[7]

It was not that Apollinaire was anti-Semitic, but he was an illegitimate Polish aristocrat. What more need be said? He turned a hint acerbic, and began to brood over slights, was alert to the most minor manifestations of backstabbing, especially

with friends and professional associates—if they turn on you, can the end be near? Witness his reviews of André Salmon's book *Young French Painting*, published just three months after the Louvre brouhaha in court:

> André Salmon has just published a charming book entitled *La Jeune Peinture française*, in the "Collection des Trente" series. This witty, well-written book contains a great deal of useful information for those who would like to know about the evolution of the young artists in France. Since a certain number of the ideas expressed here are my own, I can say that I fully appreciate this book. Salmon's ideas on contemporary women painters, for example, are expressed in terms almost exactly identical to mine. A number of amusing anecdotes enhance the interest of this volume, whose typography is as attractive as its style.[8]

Some weeks later, he would write a letter to Salmon:

> I do not hold it against you that no mention is made of me in your book, but then we are old friends, I believe.[9]

The tone is subtle—"we are old friends, I believe"—but Apollinaire, when all is said, is a man who once invited another man to a duel for mocking Guillaume's relation to Apollinaris water. If the outcome was comic, that was not necessarily Apollinaire's fault. He is considerably less subtle in a letter to Kahnweiler six months later:

> My dear friend,
> Thank you for buying my book—as for the rest, I now learn that what I have to say about painting is, in your opinion, not interesting—which, to me, is curious since I have been the only writer to defend these painters that you chose to represent only after I had done the writing.
> So, do you think that it's a good idea to look to wipe out the person who has been in effect the only one to create a base of artistic comprehension for such new work? Concerning questions of this sort, one might say that he who looks to demolish another will be, in turn, demolished by a movement that has still not been stopped and cannot be stopped. All that one does against me, therefore, falls also on the movement. See that as the simple warning of a poet who knows his value and the value of others when it comes to art.
>
> <div align="right">My friendly hand
Guillaume Apollinaire[10]</div>

"He who seeks to demolish another will be in turn demolished . . ." He is regaining his footing as a warrior. Perhaps it came to him with mother's milk. He

has, in any event, created his own literary heritage. His heroes are treated as equal to gods, his fantasies are apocalyptic. In 1909, in *Oneirocriticism*, he had written:

> I saw myself a hundred strong. The band which was I sat down beside the sea. Great ships of gold crossed the horizon. And when night had fallen, a hundred flames came to meet me. I procreated a hundred male children whose nurses were the moon and the hillside . . . When I had come to the bank of a river, I took it in both hands and brandished it about. This sword refreshed me. The languid spring warned me that if I stopped the sun, I should see it as actually square. A hundred strong, I swam toward an archipelago. A hundred sailors received me and, having taken me to a palace, they killed me ninety-nine times. I burst out laughing at that moment and danced, whereas they were weeping. I danced on all fours. The sailors no longer dared to move, for I had the frightening appearance of a lion.[11]

As if sniffing the miasma of spiritual smog that would yet become television, Apollinaire has Cromianthal (his protagonist in *Le Poète Assassiné*) say to the masses, "Your hero is boredom, bringing misery."[12]

His own hero would never be boredom. By his logic that condition only came upon men who had lost their honor permanently. When the First World War began in August of 1914, Apollinaire was quick to enlist.

It would end his precarious situation as a foreigner in France; it would give him French citizenship. He had been writing assiduously since 1911, but poems, prose fantasies, and art criticism would not restore his honor. In such vein he still belonged to the nineteenth century and the fierce if modest courts of the Polish aristocracy, where death could always be entertained as vastly superior to dishonor.

So, Apollinaire met his death halfway. He did not have to serve; as a foreigner he would have been exempt. He saw the war, however, as his personal solution; by the end of September 1914, he was in training at the Foreign Legion post in Orléans. By December, even André Salmon would enlist. By 1916, Apolli-

Portrait of Guillaume Apollinaire, 1916. Pencil, 19 x 12 in.

naire was invalided out of service because of head wounds he received, and by 1918, never having recuperated altogether, he was dead.

Georges Braque also went to war. He had been immediately called up by his outfit in the first mobilization. In August of 1914, Picasso would say good-bye to Braque and to André Derain. The cataclysm in art that began with *Les Demoiselles d'Avignon* would now end seven years later on the platform of the railroad station in Avignon.

Two months after the war began, Picasso's friends and peers were already unhappy with him. On October 10, Juan Gris would give Kahnweiler news he had been given by Matisse of Derain and Vlaminck and their situation in the army, and add that Picasso, Matisse had heard, was wealthy enough to withdraw 100,000 francs from a Paris bank on the outset of hostilities; and Juan Gris then added, with the intention perhaps to wound Picasso, his fellow Spaniard and once his *maître*, "I have no news from Braque, the one person who interests me most."[13]

The winter of 1914–15 was long for Picasso and Eva. She was entering her terminal illness, and they had the cemetery for a view:

> The endless sea of stone crosses that confronted them whenever they looked out their windows intensified the oppression that hung heavily over them both. It

Braque in the front lines, December 1914.

Braque, 1915.

was no less oppressive when they went outdoors. At cafés and in the streets men and women stared at him full of contempt . . . questioning his manliness, and he took refuge in sarcasm. "Will it not be awful," he said to Gertrude Stein, "when Braque and Derain and all the rest of them put their wooden legs up on a chair and tell about their fighting?" His black humor seemed even blacker when news reached Paris that Braque and Apollinaire had received dreadful head wounds and both had to be trepanned. Braque was moved from hospital to hospital before the operation, but not once did he hear from Picasso.[14]

There was much ill feeling concerning this. Many of Picasso's friends thought he ought to enlist; he knew otherwise. Dishonor was vastly superior to death; the latter was a clearinghouse where all your moral debts were settled, and rarely in your favor; death was in every vision he had of horror and catastrophe. He would work harder than any other artist alive for the next fifty-eight years, as if to draw his own moral balance against the accounts being kept in eternity, as if work itself could hold death off. He would certainly cultivate his body. Here is a photograph of Picasso dated no more closely than sometime around 1914.

And Fernande. What of Fernande, who had so appreciated that stocky body? She ends her book *Picasso and His Friends* with a description of a "grand dance in 1914" at van Dongen's during the spring before the First World War.

Picasso at his studio, c. 1914.

Lights shone; the walls, the gallery, everything was transformed by shimmering drapery. The effect was of brilliant colours, movement, chattering, a rather contrived gaiety and a certain mystery, provided by the darkened and shadowy corners, in which one seemed to make out human forms buried deep in piles of cushions . . .

That fancy-dress ball at his house brought together a number of artists and

society celebrities of Paris high-life. It is so easy to be in the swim in Paris! There were many women there, resplendently attractive and original—or so they thought . . .

They all have cars, and their present wives have fur coats. All of them have acquired needs and obligations which keep their noses to the grindstone.

They all have to work and work, whether out of habit, to pay for a new car or to maintain fame, which must often rest heavily on them.

Since they know the meaning of true spiritual solitude they no longer experience the same pleasure in working.

I know some of the women who lived with those artists, companions of the good and the bad hours of their youth; and they are growing old alone too, with only their memories as constant companions.[15]

She is trying hard to achieve her sense of superiority. The passage, written in the early Thirties, conceals her situation. The editor of *Souvenirs Intimes*, Gilbert Krill, summarizes an article by Roland Dorgeles in *Le Figaro Litteraire*, December 29, 1962:

After their breakup, she struggled courageously to earn a living, first at the house of Poiret, a facetious godfather of Max Jacob, and then she worked for an antique dealer, but Poiret went bankrupt, and the antique dealer closed his store.

Then she appeared at the Lapin Agile, where, in a beautiful deep voice, she recited Baudelaire and Duvigny. That lasted two or three years. Then she had to fall back on whatever came her way. She was a tutor for children, the secretary for a political group, a cashier in a meat market, a manageress in a cabaret, then, lower still, she did horoscopes, thanks to what she learned from Max Jacob. These expediences permitted her, at least, to eat, but she had the pride of never asking for anything from anyone, above all, from those who have never forgiven her.

It was only in 1918, when Picasso had just married Olga, that Fernande began to live with Roger Karl, an actor who had worked with Sarah Bernhardt, and was well known in the cinema, a friend of Max Jacob, of Roland Dorgeles, of Charles Dullin, a very handsome man with a large talent. I remember having heard from Fernande that Louis Jouvet had said, "If he wanted to work, he would have been the greatest actor of his generation." From 1918 to 1938, in the course of twenty years of living together, he never knew how to make her happy. In 1938, she decided to live alone for the rest of her life.

I found in my godmother's papers two pages that she entitled, "*À moi-même.*"[16]

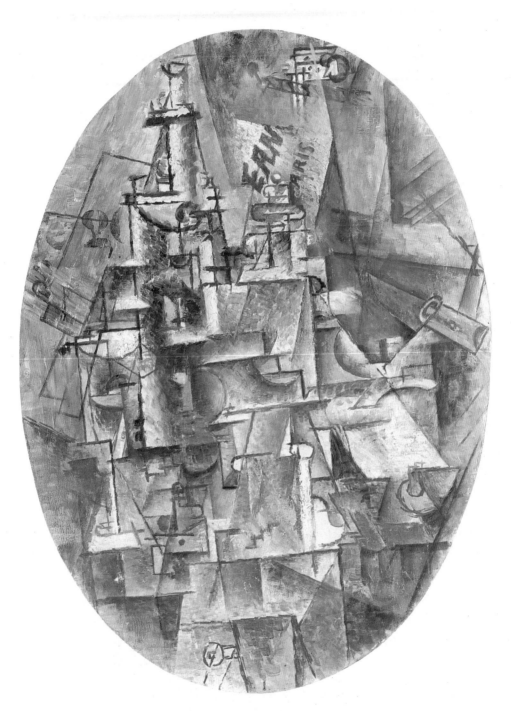

Colorplate 33. Bottle, Glass, and Fork, 1911–12. Oil on canvas, 28 x 21 in.
For accompanying text, see page 340.

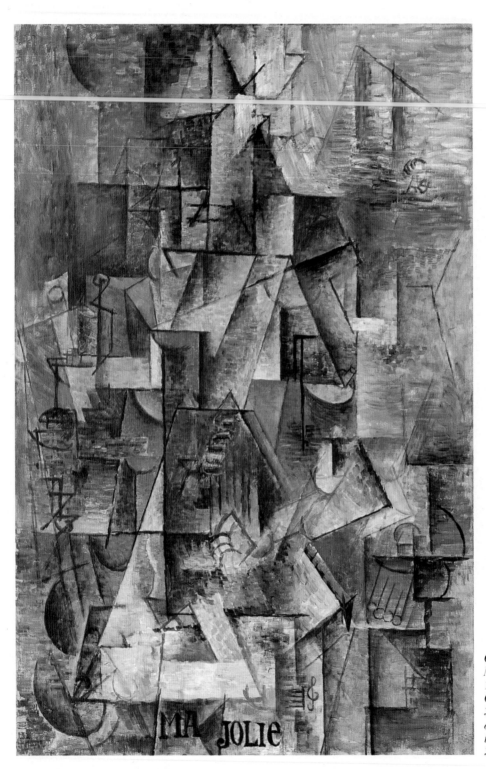

Colorplate 34.
Ma Jolie, winter
1911–12.
Oil on canvas,
39 x 26 in. For
accompanying
text, see page
340.

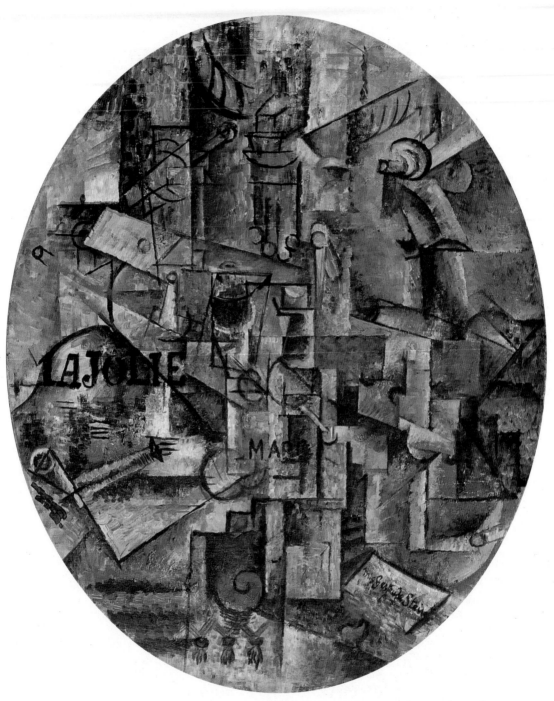

*Colorplate 35. The Architect's Table, early 1912. Oil on canvas mounted on oval panel,
29 x 23 in. For accompanying text, see page 340.*

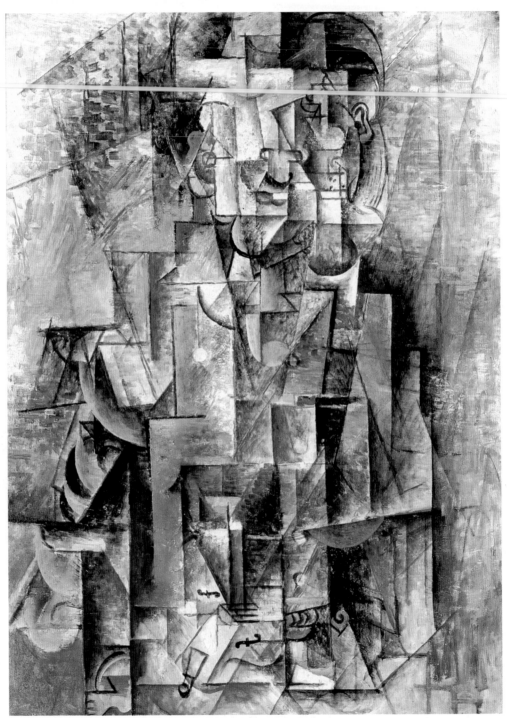

Colorplate 36. Man with a Violin, 1911–12. Oil on canvas, 39 x 30 in. For accompanying text, see page 340.

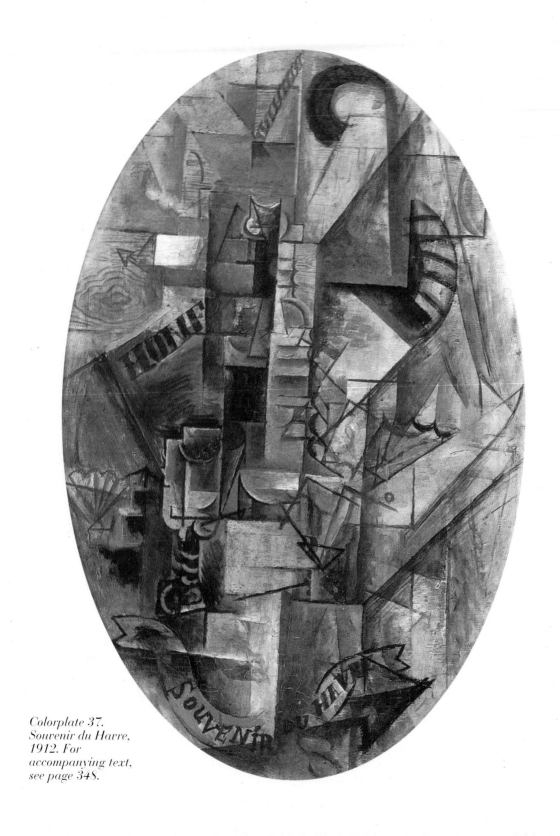

Colorplate 37.
Souvenir du Havre,
1912. For
accompanying text,
see page 348.

Colorplate 38. Spanish Still Life, spring 1912. Oil on canvas (oval), 18 x 13 in.
For accompanying text, see page 348.

Colorplate 39. The Poet, Sorgues, summer 1912. Oil on canvas, 25 x 19 in. For accompanying text, see page 349.

*Colorplate 40. The
Aficionado, Sorgues,
summer 1912. Oil on
canvas, 53 x 32 in.
For accompanying text,
see page 349.*

Colorplate 41. Guitar and Sheet Music, 1912. For accompanying text, see page 350.

Colorplate 42. Musical Score and Guitar, autumn 1912. Pasted and pinned paper on cardboard, 17 x 19 in. For accompanying text, see page 350.

Colorplate 43. Glass and Bottle of Suze, 1912–13. Collage with charcoal, 26 x 20 in. For accompanying text, see page 350.

Colorplate 44. Bottle, Guitar, and Pipe, 1912. Oil on canvas, 23 x 29 in. For accompanying text, see page 350.

Colorplate 45. Man with a Guitar, Céret, spring 1913. Oil on canvas, 51 x 35 in. For accompanying text, see page 350.

Colorplate 46. Card Player, winter 1913–14. Oil on canvas, 42 x 35 in. For accompanying text, see page 350.

Colorplate 47. Woman in an Armchair, 1913–14. Oil on canvas, 58 x 39 in. For accompanying text, see page 350.

Colorplate 48. Untitled (Man with a Mustache, Buttoned Vest, and Pipe, Seated in an Armchair), 1915. Oil on canvas, 51 x 35 in. For accompanying text, see page 357.

Souvenirs Intimes ends with this passage:

After my life as a woman began. I no longer desired anything but to be loved, not *desired*, understand me well, *loved*, with all that belongs to a certain kind of love which does not come from the senses but enhances them, encompasses them, and I gave myself, always, to the most loving, being able to feel stirred only by a love that enveloped me. Some men believed that I was, therefore, an easy woman, a superficial woman, and were hurt by my subsequent asperity, because I always knew how to remove myself from the kind of love they were offering me.

I was hard, brutal, cruel, indifferent, far-off, uncaring . . . I made many enemies among men—and among women—because I understood the absence of value in *their* friendship. Neither vicious nor simply sensual, I wanted to be loved, and was only able to love those who loved me. I called, I searched, I desired that love in order to be able to give myself entirely, and I did a few stupid things. Only one being have I ever loved out of the most profound part of myself. That didn't prevent me, later (for I was often cruel toward him), from quitting him brutally, even as I was tearing myself apart, for on that day I came to understand that he loved me less.[17]

Pablo Picasso, 1916.

By 1916, by the time Eva is dead and Fernande is a set of good and bad memories, Picasso has become friends with Jean Cocteau and will soon be designing a ballet set for Diaghilev. In the photograph to the left, he looks even younger than when he came back to Paris in 1904. He not only has an armory of cruel and intimate weapons with which to protect himself and injure lovers and friends, but he is obviously in possession of the secret of youth. Here is the youth holding a cigar.

That secret of youth, however, belongs to him. Will any one of us ever have a clue how he did it? Apollinaire, with all his wounds, was generous. A year before the war, he was ready again to celebrate Picasso: "He queried even the universe . . . a savage laugh in the purity of light."[18]

Let us end this book by answering an old question rather than posing a new one:

Who stole the *Mona Lisa?*

Well, in December of 1913, it was found in Florence:

> The thief proved to be a mad Italian housepainter named Vincenzo Peruggia, formerly employed in the Louvre, who had conceived it as his mission to return the picture to his native land. He had walked into the Louvre on that Monday morning of August 21, 1911, chatted with workmen on duty whom he knew, found the *Mona Lisa* unguarded; he took it down, removed the frame on a staircase, and walked out of the museum with the picture under his blouse.[19]

Notes

The accents of certain names in this book are given in Spanish rather than Catalan—e.g., Sabartés, not Sabartès, and Pallarés, not Pallarès.

Quotations, originally in French, from the works of Guillaume Apollinaire, André Salmon, and from Fernande Olivier's *Souvenirs Intimes*, have been translated by the author. There are minor elisions in the translation of *Souvenirs Intimes* that were not noted, for they occurred most often in clusters which if subjected to wholly conscientious treatment would have left the author's text bearing an unfortunate resemblance to Swiss cheese.

Part I: I, the King

Part I, Chapter 1

1. Josep Palau i Fabre, *Picasso: Life and Work of the Early Years 1881–1907*, p. 17.
2. Ibid., p. 22.
3. Ibid.
4. Ibid, p. 25.
5. Gertrude Stein, *The Autobiography of Alice B. Toklas*, p. 221.
6. Françoise Gilot with Carlton Lake, *Life with Picasso*, p. 60.
7. William Lieberman, *Matisse: Fifty Years of His Graphic Art*, p. 18.
8. Hélène Parmelin, *Picasso dit*, p. 32. Translated from the French by the author.
9. Roland Penrose, *Picasso: His Life and Work*, p. 18, cited in Palau, op. cit., p. 28.
10. Brassaï, *Picasso and Company*, p. 86.
11. Palau, op. cit., p. 31.

12. Jaime Sabartés, *Picasso: An Intimate Portrait*, p. 39.

13. Palau, op. cit. p. 32.

14. Penrose, op. cit., pp. 17–18, cited in Palau, op. cit., p. 32.

15. Antonio Olano, *La Coruña*, p. 4, in Antonio L. Marino, "Los cuatro años de Picasso en La Coruña."

16. John Richardson, *A Life of Picasso, Vol. I, 1881–1906*, p. 49

17. Arianna Stassinopoulos Huffington, *Picasso: Creator and Destroyer*, p. 30.

18. Ibid., p. 24.

19. Roberto Otero, *Forever Picasso*, p. 44.

20. Pierre Cabanne, *Pablo Picasso: His Life and Times*, p. 33.

21. Richardson, op. cit., p. 51.

Part I, Chapter 2

1. Palau, op. cit., p. 81.

2. Richardson, op. cit., p. 68.

3. Cabanne, op. cit., p. 33.

4. Palau, op. cit., p. 96.

5. Brassaï, op. cit., p. 56.

6. Roy MacGregor-Hastie, *Picasso's Women*, dedication to Tristan Tzara, front matter.

7. Ibid., p. 24.

8. Cabanne, op. cit., p. 38.

9. Stassinopoulos Huffington, op. cit., p. 37.

10. Palau, op. cit., p. 117.

11. Cabanne, op. cit., pp. 40–41.

12. Palau, op. cit., p. 151.

13. Patrick O'Brian, *Pablo Ruiz Picasso*, pp. 57–58.

14. Geneviève Laporte, *Sunshine at Midnight*, p. 26.

15. Stassinopoulos Huffington, op. cit., pp. 41–42.

16. Richardson, op. cit., p. 492.

17. Ibid., p. 106.

Part I, Chapter 3

1. Cabanne, op. cit., p. 46.

2. Sabartés, *Picasso: An Intimate Portrait*, p. 17.

3. Stassinopoulos Huffington, op. cit., p. 46.

4. Ibid.

5. Palau, op. cit., p. 83.

6. Richardson, op. cit., p. 113.

7. Ibid.

8. Sabartés, *Picasso: An Intimate Portrait*, p. 86.

9. Sabartés, *Picasso: Portraits et souvenirs*, p. 26; translated from the French by the author.

10. Cabanne, op. cit., p. 50.
11. Palau, op. cit., p. 182.
12. Penrose, op. cit., p. 138.
13. Sabartés, *Picasso: An Intimate Portrait*, p. 46.
14. Palau, op. cit., p. 199.

Part II: Paris

Part II, Chapter 1

1. Cabanne, op. cit., p. 54.
2. Letter of 25 October 1900, from C. Casagemas to R. Reventós with drawings by Picasso; translated from the Catalan by Francesc Parcerisas and Marilyn McCully, in Marilyn McCully, ed., *A Picasso Anthology*, p. 28.
3. Stassinopoulos Huffington, op. cit., p. 52.
4. Ibid., p. 53.
5. Palau, op. cit., pp. 203–04.
6. Letter of 11 November 1900, from Picasso and C. Casagemas to R. Reventós; translated from the Spanish (Picasso) and the Catalan (Casagemas) by Francesc Parcerisas and Marilyn McCully. Property of Jacint Reventós i Conti. In McCully, op. cit., p. 31.
7. Palau, op. cit., p. 210.
8. Ibid.
9. Ibid., p. 212.
10. Ibid., p. 213.
11. Palau, p. 214.
12. Sabartés, *Picasso: An Intimate Portrait*, pp. 45–46.

Part II, Chapter 2

1. Fernande Olivier, *Picasso and His Friends*, p. 30.
2. Richardson, op. cit., p. 209.
3. Ibid., p. 210.
4. Stassinopoulos Huffington, op. cit., p. 57.
5. Gustav Coquiot, "La vie artistique: Pablo Ruiz Picasso," *Le Journal*, Paris, 17 June 1901; translated from the French by P. S. Falla, in McCully, ed., op. cit., pp. 32–34.
6. Félicien Fagus, *La Revue Blanche*, 15 July 1901, in Palau, op. cit., pp. 514–15.
7. Palau, op. cit., pp. 211–12.
8. Richardson, op. cit., p. 211.
9. Sabartés, *Picasso: An Intimate Portrait*, p. 63.
10. Ibid., pp. 80–82.

Part II, Chapter 3

1. Richardson, op. cit., p. 244.
2. Sabartés, *Picasso: An Intimate Portrait*, p. 85.
3. Fagus, *La Revue Blanche*, Paris, September 1902.
4. Palau, op. cit., p. 310.

Part II, Chapter 4

1. Sabartés, *Picasso: An Intimate Portrait*, p. 91.
2. Palau, op. cit., p. 315.
3. Stassinopoulos Huffington, op. cit., p. 58.
4. Jacob, "Souvenirs sur Picasso contés par Max Jacob," *Cahiers d'Art* no. 6, Paris, 1927, p. 199; translated from the French by Marilyn McCully and Michael Raeburn, in McCully, op. cit., p. 38.
5. Cabanne, op. cit., p. 76.
6. Stassinopoulos Huffington, op. cit., p. 58.
7. Paul Verlaine, *The Sky Above the Roof*, p. 101; quoted in Stassinopoulos Huffington, op. cit., p. 68.
8. Jacob, op. cit., p. 202.
9. Stassinopoulos Huffington, op. cit., p. 69.
10. Richardson, op. cit., p. 266.
11. Laporte, op. cit., p. 19.
12. Lydia Gasman, "Mystery, Magic and Love in Picasso, 1925–1938: Picasso and the Surrealist Poets," p. 521.
13. Sabartés, *Picasso: An Intimate Portrait*, pp. 93–94.
14. Richardson, op. cit., p. 269.

Part III: Fernande

Part III, Chapter 1

1. Olivier, *Souvenirs Intimes*, p. 191.
2. Ibid.
3. Olivier, *Picasso and His Friends*, p. 17.

Part III, Chapter 2

1. Olivier, *Picasso and His Friends*, p. 16.
2. Olivier, *Souvenirs Intimes*, pp. 165–67.
3. Olivier, *Picasso and His Friends*, pp. 26–27.
4. Ibid., pp. 27–28.
5. Olivier, *Souvenirs Intimes*, p. 165.
6. Ibid.

7. Ibid., p. 166.

8. Ibid., pp. 166–67.

9. Ibid., pp. 114–15.

10. Richardson, op. cit., p. 304.

11. Guillaume Apollinaire, "Les Jeunes: Picasso, Peintre," *La Plume*, No. 372, 15 May 1905, pp. 478–80.

12. Ibid., p. 480.

13. Olivier, *Souvenirs Intimes*, p. 170.

14. Ibid., p. 172.

15. Ibid., p. 173.

16. Ibid., p. 168.

17. Ibid., p. 246.

Part III, Chapter 3

1. Olivier, *Souvenirs Intimes*, p. 12.

2. Ibid., p. 14.

3. Ibid., p. 16.

4. Ibid., p. 17.

5. Ibid., p. 23.

6. Ibid., p. 46.

7. Ibid., p. 63.

8. Ibid., p. 64.

9. Ibid.

10. Ibid., p. 65.

11. Ibid., pp. 65–70.

12. Ibid., pp. 70–77.

13. Ibid., pp. 79–80.

14. Ibid., p. 80.

15. Ibid., pp. 81–82.

16. Ibid., pp. 83–84.

17. Ibid., p. 84.

18. Ibid., pp. 83–93.

19. Ibid., pp. 93–95.

Part IV: Pablo and Fernande

Part IV, Chapter 2

1. Olivier, *Souvenirs Intimes*, p. 97.

2. Ibid., pp. 98–102.

3. Ibid., pp. 104–05.

Part IV, Chapter 3

1. Olivier, *Souvenirs Intimes*, pp. 106–07.
2. Ibid., p. 117.
3. Ibid., p. 121.
4. Ibid.
5. Ibid., p. 122.
6. Ibid., pp. 128–33.
7. Ibid., pp. 142–43.
8. Ibid., pp. 178–80.

Part IV, Chapter 4

1. Olivier, *Picasso and His Friends*, p. 48.
2. MacGregor-Hastie, op. cit., p. 45.
3. Olivier, *Souvenirs Intimes*, p. 48.
4. Ibid., pp. 184–88.

Part IV, Chapter 5

1. Olivier, *Souvenirs Intimes*, p. 191.
2. Stein, *The Autobiography of Alice B. Toklas*, p. 55.
3. Norman Mailer, *Genius and Lust*, pp. 185, 188–90.

Part V: Apollinaire

Part V, Chapter 1

1. Olivier, *Souvenirs Intimes*, pp. 192–93.
2. Francis Steegmuller, *Apollinaire: Poet Among the Painters*, p. 131.
3. Ibid.
4. Ibid., p. 125.
5. Parmelin, *Picasso Plain*, p. 124.

Part V, Chapter 2

1. Richardson, op. cit., p. 327.
2. Ibid.
3. Steegmuller, op. cit., pp. 27–28.
4. Richardson, op. cit., p. 331.
5. Steegmuller, op. cit., p. 58.
6. Ibid., p. 66.
7. Ibid., pp. 348–49.
8. See final endnote.
9. Olivier, *Picasso and His Friends*, pp. 63–64.

10. Steegmuller, op. cit., p. 76.
11. Ibid., pp. 74–75.
12. Roger Shattuck, *The Banquet Years*, p. 47.
13. Apollinaire, *Alcools et calligrammes*, pp. 60, 61; translated from the French by the author.

Part V, Chapter 3

1. Apollinaire, *Alcools et calligrammes*, pp. 60, 61.
2. Shattuck, op. cit., p. 6.
3. Salmon, *Souvenirs sans fin*, Vol. 1, p. 165.
4. Richardson, op. cit., p. 333.
5. Penrose, op. cit., p. 107.
6. O'Brian, op. cit., p. 135.
7. André Salmon, *La jeune peinture française*, Paris, 1913; reprinted in translation from the French in Edward Fry, *Cubism*, pp. 81–83.
8. O'Brian, op. cit., p. 134.
9. Apollinaire, *Alcools et calligrammes*, p. 107.
10. Ibid., p. 76.
11. Ibid., p. 117.

Part V, Chapter 4

1. Olivier, *Picasso and His Friends*, pp. 59–60.
2. Salmon, *Souvenirs sans fin*, Vol. 2, p. 92.
3. Salmon, *Souvenirs sans fin*, Vol. 1, p. 188.
4. Ibid., p. 351.
5. Salmon, *Souvenirs sans fin*, Vol. 2, p. 118.
6. Gilot and Lake, op. cit., p. 80.
7. Translated from the French by the author.
8. Gilot and Lake, op. cit., p. 80.
9. Apollinaire, *Ouevres en prose*, p. 472.
10. Ibid.
11. Ibid., p. 478.
12. Ibid.
13. Steegmuller, op. cit., p. 98.
14. Ibid., p. 96.
15. Parmelin, op. cit., p. 242, quoted in Richardson, op. cit., p. 362.
16. Richardson, op. cit., pp. 362–63.
17. Ibid., pp. 363–64
18. Ibid., p. 366.
19. Apollinaire, "Les Jeunes: Picasso, Paintre," *La Plume*, No. 372, May 1905, pp. 478–80.

Part VI: Gertrude Stein

Part VI, Chapter 1
1. Olivier, *Souvenirs Intimes*, p. 194.
2. Olivier, *Picasso and His Friends*, p. 42.
3. Cabanne, op. cit., p. 95.
4. Olivier, *Picasso and His Friends*, p. 47.
5. Olivier, *Souvenirs Intimes*, p. 202.
6. Ibid., p. 232.
7. Ibid., p. 197.
8. Ibid., p. 208.
9. Ibid., pp. 204–05.

Part VI, Chapter 2
1. Stein, *The Autobiography of Alice B. Toklas*, pp. 105–06.
2. Ibid., p. 17.
3. Ibid., pp. 5–6.
4. O'Brian, op. cit., p. 39.
5. Olivier, *Souvenirs Intimes*, p. 210.
6. Stein, *The Autobiography of Alice B. Toklas*, p. 13.
7. Leo Stein, *Appreciation: Painting, Poetry and Prose*, pp. 103–04.
8. Ibid., p. 102.
9. Stein, *The Autobiography of Alice B. Toklas*, p. 97.
10. Stein, *Picasso*, p. 41.

Part VI, Chapter 3
1. Stein, *The Autobiography of Alice B. Toklas*, p. 24.
2. Richardson, op. cit., p. 404.
3. Stein, *The Autobiography of Alice B. Toklas*, p. 60.
4. Cabanne, op. cit., p. 105.
5. Stein, *The Autobiography of Alice B. Toklas*, p. 14.
6. Ibid., p. 46.
7. Ibid., pp. 10–12.
8. LeRoy Breunig, *Apollinaire on Art*, p. 29.
9. Olivier, *Picasso and His Friends*, p. 23.
10. O'Brian, op. cit., p. 140.
11. Stein, *The Autobiography of Alice B. Toklas*, pp. 64–65.
12. O'Brian, op. cit., p. 399.
13. Peignot, "Les Premiers Picassos de Gertrude Stein," *Connaissance des Arts*, no. 213, November 1969, p. 125.

Part VI, Chapter 4

1. Olivier, *Picasso and His Friends*, p. 80.
2. Ibid.
3. Ibid., pp. 125–27.
4. Ibid., pp. 102–03.
5. Ibid., pp. 103–04.
6. Olivier, *Souvenirs Intimes*, p. 201.
7. Annette Rosenshine, *Life's Not a Paragraph*, pp. 112–13.
8. Richardson, op. cit., p. 464.

Part VI, Chapter 5

1. Stassinopoulos Huffington, op. cit., p. 86.
2. Olivier, *Souvenirs Intimes*, pp. 211–12.
3. Olivier, *Picasso and His Friends*, p. 93.
4. Olivier, *Souvenirs Intimes*, p. 213.
5. Ibid., p. 214.
6. Palau, op. cit., p. 440.
7. Richardson, op. cit., p. 451.
8. Olivier, *Souvenirs Intimes*, p. 216.
9. Ibid.; and Palau, op. cit., p. 465.
10. Olivier, *Souvenirs Intimes*, p. 216.

Part VII: The Brothel

Part VII, Chapter 1

1. Olivier, *Souvenirs Intimes*, pp. 222–23.
2. Stein, *The Autobiography of Alice B. Toklas*, p. 79.
3. Olivier, *Picasso and His Friends*, p. 88.
4. Leo Stein, op. cit., pp. 170–71.
5. Richardson, op. cit., p. 411.
6. Dore Ashton, *Picasso on Art: A Selection of Views*, p. 89.
7. Pierre Schneider, *Matisse*, p. 588.
8. Stein, *The Autobiography of Alice B. Toklas*, p. 79.
9. Pierre Daix, *Picasso créateur: La vie intime et l'oeuvre*, p. 74.
10. John Elderfield, *Matisse*, p. 42.
11. Ibid.
12. Jack Flam, *Matisse: The Man and His Art, 1869–1918*, p. 163.
13. Ibid.
14. Alfred H. Barr, *Matisse: His Art and His Public*, p. 83.
15. Olivier, *Picasso and His Friends*, p. 88.

16. Salmon, *Souvenirs sans fin*, Vol. 1, p. 188.
17. Edward Burns, ed., *Gertrude Stein on Picasso*, p. 97.

Part VII, Chapter 2

1. Cabanne, op. cit., p. 113.
2. Penrose, op. cit., pp. 124–30.
3. Cabanne, op. cit., p. 119.
4. Penrose, op. cit., p. 126.
5. Cabanne, op. cit., p. 119.
6. Ibid., p. 120.
7. Ibid.
8. Daniel-Henry Kahnweiler with Francis Crémieux, *My Galleries and My Painters*, pp. 38–39.
9. Cabanne, op. cit., p. 122.
10. Richardson, op. cit., p. 475.
11. Norman Mailer, *Of a Fire on the Moon*, pp. 300–01.
12. André Malraux, *Picasso's Mask*, pp. 10–11.
13. O'Brian, op. cit., p. 175.
14. Christian Zervos, "Conversation avec Picasso," *Cahiers d'Art*, no. 10, 1935.

Part VIII: The Suicide and the Banquet

Part VIII, Chapter 1

1. Olivier, *Souvenirs Intimes*, p. 218.
2. Ibid., pp. 219–20.
3. Stein, *The Autobiography of Alice B. Toklas*, pp. 30–34.
4. Olivier, *Souvenirs Intimes*, p. 11.
5. Ibid., pp. 225–27.
6. Stein, *Picasso*, pp. 32–33.
7. Richardson, op. cit., p. 406.

Part VIII, Chapter 2

1. Olivier, *Picasso and His Friends*, p. 120.
2. Jean-Paul Crespelle, *Picasso and His Women*, p. 60.
3. Olivier, *Souvenirs Intimes*, p. 228.
4. Penrose, op. cit., p. 140.
5. Olivier, *Picasso and His Friends*, p. 122.
6. Olivier, *Souvenirs Intimes*, p. 228.
7. Ibid.
8. Penrose, op. cit., p. 141.

9. Ibid., pp. 141–142.
10. Olivier, *Souvenirs Intimes*, p. 224.
11. Cabanne, op. cit., p. 171.
12. Gasman, op. cit., pp. 520–25.

Part VIII, Chapter 3

1. Salmon, *Souvenirs sans fin*, Vol. 1, pp. 188–89.
2. Steegmuller, op. cit., p. 158.
3. Ibid.
4. Ibid.
5. Stein, *The Autobiography of Alice B. Toklas*, p. 32.
6. Olivier, *Souvenirs Intimes*, pp. 229–30.
7. Olivier, *Picasso and His Friends*, p. 68.
8. Stein, *The Autobiography of Alice B. Toklas*, pp. 126–30.
9. Olivier, *Picasso and His Friends*, pp. 69, 68.
10. Stein, *The Autobiography of Alice B. Toklas*, p. 130.
11. Olivier, *Picasso and His Friends*, p. 69.
12. Stein, *The Autobiography of Alice B. Toklas*, p. 130.
13. Salmon, *Souvenirs sans fin*, Vol. 2, p. 54.
14. Stein, *The Autobiography of Alice B. Toklas*, pp. 130–31.
15. Olivier, *Picasso and His Friends*, pp. 67–70.
16. Stein, *The Autobiography of Alice B. Toklas*, p. 131–32.
17. André Salmon, "Testimony Against Gertrude Stein," pp. 14–15.
18. O'Brian, op. cit., p. 158.
19. Olivier, *Picasso and His Friends*, pp. 69–71.

Part IX: Cubism

Part IX, Chapter 1

1. Wilkin, *Georges Braque*, p. 16.
2. Isabelle Monod-Fontaine, *Kahnweiler-Leiris*, p. 166.
3. William Rubin, *Picasso and Braque*, pp. 16–17.
4. Wilkin, op. cit., p. 50.
5. Olivier, *Picasso and His Friends*, pp. 97–98.
6. Daniel-Henry Kahnweiler, *The Rise of Cubism*, p. 8.
7. Rubin, op. cit., p. 74.
8. Kahnweiler, *Der Kubismus*, p. 215.
9. Matisse, "On Modernism and Tradition," p. 6; also in Flam, *Matisse: The Man and His Art 1896–1918*.
10. Louis Vauxcelles, "Exposition Braque chez Kahnweiler," *Gil Blas*, Nov. 14, 1908.

11. Penrose, op. cit., p. 161.
12. E. Tériade, "Matisse Speaks," p. 21; reprinted in Jack Flam, *Matisse on Art*.
13. Dora Vallier, "Braque, la peinture et nous," p. 14.
14. André Verdet, *Entretiens, notes et écrits sur la peinture: Braque, Léger, Matisse, Picasso*, p. 21.
15. Gilot and Lake, op. cit., p. 76.
16. Vallier, op. cit., p. 14.
17. Rubin, op. cit., p. 41.
18. Richardson, *Georges Braque*, p. 26.

Part IX, Chapter 2

1. Olivier, *Souvenirs Intimes*, pp. 233–36.
2. Ibid., p. 236.
3. O'Brian, op. cit., p. 172.
4. Olivier, *Souvenirs Intimes*, p. 237.
5. Letter from Fernande Olivier to Gertrude Stein, Stein Collection, Beinecke Rare Book and Manuscript Library, Yale University.
6. Olivier, *Souvenirs Intimes*, pp. 236–38.
7. Ibid., p. 240.
8. Ibid., p. 244.
9. Olivier, *Picasso and His Friends*, p. 129.
10. Penrose, op. cit., p. 150.
11. O'Brian, op. cit., p. 177.

Part IX, Chapter 3

1. MacGregor-Hastie, op. cit., p. 61.
2. Cabanne, op. cit., p. 138.
3. Olivier, *Souvenirs Intimes*, p. 245.

Part IX, Chapter 4

1. Cabanne, op. cit., pp. 138–39.
2. Raymond Cogniat, *Georges Braque*, p. 65.
3. Daniel-Henry Kahnweiler, *The Rise of Cubism*, pp. 10–13.
4. Daniel-Henry Kahnweiler with Francis Crémieux, *My Galleries and My Painters*, p. 57.
5. Olivier, *Picasso and His Friends*, pp. 133–34.
6. Apollinaire, "Pablo Picasso," *Montjoie!*, March 14, 1913; also in Breunig, *Apollinaire on Art*, pp. 179–81.
7. Parmelin, *Picasso Says*, p. 38.
8. José Plá, *Vida de Manolo*, p. 161.

9. Linda Dalrymple Henderson, *The Fourth Dimension and Non-Euclidean Geometry in Modern Art*, p. 168.
10. Apollinaire, *Les Peintres Cubistes*, pp. 15–17.

Part X: The *Mona Lisa*

Part X, Chapter 1

1. Olivier, *Picasso and His Friends*, p. 207.
2. Francis Steegmuller, *Apollinaire: Poet Among the Painters*, pp. 182–83.
3. Ibid., p. 187.
4. Ibid., pp. 188–91.
5. Olivier, *Picasso and His Friends*, p. 146.
6. Steegmuller, op. cit., p. 193.
7. Ibid., pp. 192–95.
8. Ibid., p. 196.
9. Ibid., p. 197.
10. Ibid., p. 198.
11. Ibid., p. 191.
12. Ibid., pp. 191–92, 197.

Part X, Chapter 2

1. Olivier, *Picasso and His Friends*, pp. 147–48.
2. Steegmuller, op. cit., p. 200.
3. Salmon, *Souvenirs sans fin*, Vol. 2, p. 140.
4. Steegmuller, op. cit., pp. 202–04.
5. Ibid., p. 205.
6. Olivier, *Picasso and His Friends*, pp. 146–48.
7. Ibid., p. 148.
8. Olivier, *Souvenirs Intimes*, pp. 249–50.
9. Steegmuller, op. cit., pp. 206–07.
10. Ibid., pp. 211–13.
11. Ibid., pp. 216–18.
12. *Paris-Presse*, June 20, 1959; translated from the French in Steegmuller, op. cit., pp. 218–19.
13. Ibid., pp. 222–23.
14. Salmon, *Souvenirs sans fin*, Vol. 2, p. 118; translated from the French in Steegmuller, op. cit., pp. 229–30.

Part XI: The Decorator

Part XI, Chapter 1

1. Salmon, *Souvenirs sans fin*, Vol. 2, p. 140.
2. Olivier, *Souvenirs Intimes*, p. 250.
3. Stein, *The Autobiography of Alice B. Toklas*, pp. 117–18.
4. Ibid., p. 136.
5. Cabanne, op. cit., p. 149.
6. Isabelle Monod-Fontaine, *Kahnweiler-Leiris*, p. 165.
7. Ibid.
8. Ibid., pp. 165–66.
9. Isabelle Monod-Fontaine, *Daniel-Henry Kahnweiler: Marchand, editeur, écrivain*, p. 110b.
10. William Rubin, *Picasso and Braque*, p. 19.
11. Monod-Fontaine, *Kahnweiler-Leiris*, p. 168.
12. Rubin, op. cit., p. 396.
13. Monod-Fontaine, *Kahnweiler-Leiris*, pp. 168–69.
14. Rubin, op. cit., p. 397.
15. Ibid., p. 398.
16. Monod-Fontaine, *Kahnweiler-Leiris*, p. 169.
17. O'Brian, op. cit., p. 226.
18. Monod-Fontaine, *Kahnweiler-Leiris*, p. 167, cited in Rubin, op. cit., p. 395.
19. Stein, *The Autobiography of Alice B. Toklas*, pp. 136–37.
20. MacGregor-Hastie, *Picasso's Women*, p. 70.
21. Ibid., p. 77.

Part XI, Chapter 2

1. Rubin, op. cit., p. 390.
2. Stassinopoulos Huffington, op. cit., p. 97.
3. Rubin, op. cit., p. 19.
4. Penrose, op. cit., pp. 179–80.
5. Stassinopoulos Huffington, op. cit., p. 137.
6. Ibid.
7. Stein, *The Autobiography of Alice B. Toklas*, p. 208.

Part XI, Chapter 3

1. Mackworth, *Guillaume Apollinaire and Cubist Life*, p. 124.
2. Stassinopoulos Huffington, op. cit., p. 103.
3. Olivier, *Souvenirs Intimes*, pp. 240–44.
4. Monod-Fontaine, *Kahnweiler: Marchand*, p. 118.
5. Ibid.

6. Stassinopoulos Huffington, op. cit., pp. 136–37.

7. Steegmuller, op. cit., pp. 228–29.

8. Apollinaire, *L'Intransigeant*, November 29, 1912, in Breunig, *Apollinaire on Art*, p. 261.

9. Salmon, *Souvenirs sans fin*, Vol. 1, p. 271.

10. Monod-Fontaine, *Kahnweiler: Marchand*, p. 170.

11. Roger Shattuck, *The Banquet Years*, p. 247.

12. Apollinaire, *Oeuvres en prose*, p. 298.

13. Rubin, op. cit., p. 432.

14. Stassinopoulos Huffington, op. cit., pp. 135–36.

15. Olivier, *Picasso and His Friends*, pp. 161, 186.

16. Olivier, *Souvenirs Intimes*, pp. 251–52.

17. Ibid., pp. 251–53.

18. Apollinaire, "Pablo Picasso," *Montjoie!*, March 14, 1913.

19. Steegmuller, op. cit., p. 210.

AUTHOR'S NOTE: The citation is missing for Part V, Chapter 2, note 8. While the writer has a clear recollection of copying down that quotation and will vow that he did not make it up himself, he could not find it again. For this he apologizes to anyone who is pursuing the references.

Bibliography

Books

Guillaume Apollinaire. *Alcools et calligrammes*. Paris: Imprimerie Nationale Editions, 1991. Originally published as *Alcools*. Paris: Gallimard, 1920, and as *Calligrammes*. Paris: Gallimard, 1925.

———. *Les peintres cubistes*. Paris: Hermann, 1965.

———. *Ouevres en prose*. Paris: André Balland et Jacques Lecat, 1966.

Dore Ashton. *Picasso on Art: A Selection of Views*. New York: Viking, 1972.

Alfred A. Barr, Jr. *Matisse: His Art and His Public*. New York: Museum of Modern Art, 1951.

Brassaï. *Picasso and Company*. Translated by Francis Price. Garden City, N.Y.: Doubleday, 1966. Originally published as *Conversations avec Picasso*. Paris: Gallimard, 1964.

LeRoy Breunig, ed. *Apollinaire on Art, Essays and Reviews 1902–1918*. Translated by Susan Suleiman. New York: Viking, 1972. Originally published as *Guillaume Apollinaire: Chroniques d'Art*. Paris: Gallimard, 1960.

Edward Burns, ed. *Gertrude Stein on Picasso*. New York: Liveright, 1970.

Pierre Cabanne. *Pablo Picasso: His Life and Times*. Translated by Harold J. Salemson. New York: Morrow, 1977.

Raymond Cogniat. *Braque*. New York: Crown, 1970.

Jean-Paul Crespelle. *Picasso and His Women*. Translated by Robert Baldick. London: Hodder and Stoughton, 1969. Originally published as *Picasso, les femmes, les amis, l'oeuvre*. Paris: Presses de la Cité, 1967.

Pierre Daix. *Picasso créateur: La vie intime et l'oeuvre*. Paris: Seuil, 1977.

John Elderfield. *Matisse*. New York: Museum of Modern Art, 1978.

Jack Flam. *Matisse: The Man and His Art 1869–1918*. Ithaca: Cornell University Press, 1986.

Edward Fry. *Cubism*. New York: Oxford University Press, 1966.

Françoise Gilot with Carlton Lake. *Life with Picasso*. New York: McGraw-Hill, 1964.

Linda Dalrymple Henderson. *The Fourth Dimension and Non-Euclidean Geometry in Modern Art*. Princeton: Princeton University Press, 1983.

Daniel-Henry Kahnweiler. *The Rise of Cubism*. Translated by Henry Aronson. New York: Wittenborn, Schultz, 1949. Originally published as *Der Weg zum Kubismus*. Munich: Delphin-Verlag, 1920 (under the pseudonym Daniel Henry).

Daniel-Henry Kahnweiler, with Francis Crémieux. *My Galleries and My Painters*. Translated by Helen Weaver. New York: Viking, 1971. Originally published as *Mes galeries et mes peintres*. Paris: Gallimard, 1961.

Geneviève Laporte. *Sunshine at Midnight: Memories of Picasso and Cocteau*. London: Weidenfeld and Nicholson, 1975.

William S. Lieberman. *Matisse: Fifty Years of His Graphic Art*. New York: G. Braziller, 1956.

Roy MacGregor-Hastie. *Picasso's Women*. Harpenden: Lennard Associates, 1988.

Cecily Mackworth. *Guillaume Apollinaire and the Cubist Life*. London: John Murray, 1961.

Norman Mailer. *Genius and Lust*. New York: Grove Press, 1976.

———. *Of a Fire on the Moon*. Boston: Little, Brown, 1969.

André Malraux. *Picasso's Mask*. Translated by June and Jacques Guicharnaud. New York: Holt, Rinehart and Winston, 1976. Originally published as *La tête d'obsidienne*. Paris: Gallimard, 1974.

Antonio L. Marino. "Los cuatro años de Picasso en La Coruña." In *Picasso e a Coruña*, 1–15. La Coruña: Gráficas Coruñesas, 1982.

Marilyn McCully, ed. *A Picasso Anthology*. London: Arts Council of Great Britain, 1981.

Isabelle Monod-Fontaine. *Daniel-Henry Kahnweiler: Marchand, éditeur, écrivain*. Paris: Musée National d'Art Moderne, Centre Georges Pompidou, 1984.

———. *Donation Louise et Michel Leiris: Collection Kahnweiler-Leiris*. Paris: Musée National d'Art Moderne, Centre Georges Pompidou, 1984.

Patrick O'Brian. *Pablo Ruiz Picasso*. New York: Putnam, 1976.

Fernande Olivier. *Picasso and His Friends*. Translated by Jane Miller. New York: Appleton-Century, 1965. Originally published as *Picasso et ses amis*. Paris: Stock, 1933.

———. *Souvenirs Intimes*. Ed. Gilbert Krill. Paris: Calmann-Levy, 1988.

Roberto Otero. *Forever Picasso*. Translated by Elaine Kerrigan. New York: Abrams, 1974.

Josep Palau i Fabre. *Picasso: Life and Work of the Early Years 1881–1907*. Translated by Kenneth Lyons. Oxford: Phaidon, 1981. Originally published as *Picasso vivent 1881–1907*. Barcelona: Poligrafa, 1980.

Hélène Parmelin. *Picasso Says*. Translated by Christine Trollope. London: Allen and Unwin, 1969. Originally published as *Picasso dit . . .* Paris: Gonthier, 1966.

———. *Picasso Plain: An Intimate Portrait*. Translated by Humphrey Hare. London: Secker and Warburg, 1963. Originally published as *Picasso sur la place*. Paris: Juillard, 1959.

Roland Penrose. *Picasso: His Life and Work*. London: Granada, 1981. Originally published London: Gollancz, 1958.

José Plá. *Vida de Manolo*. Madrid: Mundo Latino, 1930.

John Richardson. *A Life of Picasso, Volume I, 1881–1906*. New York: Random House, 1991.

————. *Georges Braque*. London and Harmondsworth: Penguin, 1959.

William Rubin. *Picasso and Braque*. New York: Museum of Modern Art, 1989.

Jaime Sabartés. *Picasso: An Intimate Portrait*. London: W. H. Allen, 1949. Originally published as *Picasso: Portraits et souvenirs*. Paris: Louis Carré et Maximilien Vox, 1946.

André Salmon. *Souvenirs sans fin*. Vol. 1. Paris: Gallimard, 1955.

————. *Souvenirs sans fin*. Vol. 2. Paris: Gallimard, 1956.

Pierre Schneider. *Matisse*. Translated by Michael Taylor and Bridget Stevens Romer. London: Thames and Hudson, 1984. Originally published Paris: Flammarion, 1984.

Roger Shattuck. *The Banquet Years*. New York: Vintage, 1968.

Arianna Stassinopoulos Huffington. *Picasso: Creator and Destroyer*. New York: Simon and Schuster, 1988.

Francis Steegmuller. *Apollinaire: Poet Among the Painters*. New York: Farrar, Straus and Giroux, 1963.

Gertrude Stein. *The Autobiography of Alice B. Toklas*. New York: Vintage Books, 1961. Originally published New York: Harcourt, Brace, 1933.

————. *Picasso*. Boston: Beacon Press, 1959. Originally published Paris: Floury, 1938.

Leo Stein. *Appreciation: Painting, Poetry and Prose*. New York: Crown, 1947.

E. Tériade. "Matisse Speaks," reprinted in English in Jack D. Flam, ed., *Matisse on Art*. New York: Phaidon, 1973.

André Verdet. *Entretiens, notes et écrits sur la peinture: Braque, Léger, Matisse, Picasso*. Paris: Éditions Galilée, 1978.

Paul Verlaine. *The Sky Above the Roof*. London: Rupert Hart-Davis, 1857.

Karen Wilkin, *Georges Braque*. New York: Abbeville Press, 1991.

Periodicals, Dissertations, Unpublished Manuscripts

Guillaume Apollinaire. "Les Jeunes: Picasso, Peintre." *La Plume*, No. 372, Paris, May 15, 1905.

————. "Pablo Picasso." *Montjoie!*, March 14, 1913.

Félicien Fagus. *La Revue Blanche*. Paris, September 1902.

Lydia Gasman. "Mystery, Magic and Love in Picasso, 1925–1938: Picasso and the Surrealist Poets." Ann Arbor: University Microfilms, 1981.

Daniel-Henry Kahnweiler. "Der Kubismus." *Die weissen Blätter* (Zurich and Leipzig) 3, No. 9, September, 1916.

Peignot. "Les Premiers Picassos de Gertrude Stein." *Connaissance des Arts*, no. 213, Paris, November 1969.

Annette Rosenshine. *Life's Not a Paragraph.* Unpublished manuscript. The Bancroft Library (Banc. Mss. C-H 161) at the University of California. Berkeley.

André Salmon. "Testimony Against Gertrude Stein." *Transition* no. 23. Pamphlet no. 1 (Supplement). The Hague: February. 1935.

Stein Collection. Yale Collection of American Literature. Beinecke Rare Book and Manuscript Library, Yale University.

Dora Vallier. "Braque. la peinture et nous." *Cahiers d'art 29*, no. 1.. Paris. October. 1954.

Louis Vauxcelles. "Exposition Braque chez Kahnweiler." *Gil Blas*, Paris. November 14. 1908.

Christian Zervos. "Conversation avec Picasso." *Cahiers d'Art*, no. 10. Paris. 1935.

Photo Credits

All works by Pablo Picasso © 1995 Succession Pablo Picasso / Artists Rights Society (ARS), New York.

All works by Henri Matisse © 1995 Succession H. Matisse / Artists Right Society (ARS), New York.

All works by Georges Braque, Kees van Dongen, Marie Laurencin, and Maurice de Vlaminck © 1995 Artists Rights Society (ARS), New York / ADAGP, Paris.

Photographs from Christian Zervos, *Pablo Picasso* (33 vols. Paris: Cahiers d'Art, 1932–78) are by Bob Rubic / Precision Chromes.

Front Matter

p. iii Archives Picasso, Musée Picasso, Paris / © PHOTO R.M.N.
p. iv The Museum of Modern Art, New York. The William S. Paley Collection. Photograph © 1995 The Museum of Modern Art.
p. vii The Bettmann Archive
p. x Art Resource, N.Y.
p. xv Philadelphia Museum of Art, A. E. Gallatin Collection

Part I: I, the King

p. 1 Private Collection.
p. 4 Archives Picasso, Musée Picasso, Paris / © PHOTO R.M.N.
p. 5 Archives Picasso, Musée Picasso, Paris / © PHOTO R.M.N.
p. 6 Collection of Stephen Hahn, New York.
p. 7 (left) Ayuntamiento de Málaga, courtesy of Pablo Ruiz Picasso Foundation, Málaga. (right) Private Collection.

Part II: Paris

Part IV: Pablo and Fernande

Part V: Apollinaire

p. 169 Pushkin Museum of Fine Arts, Moscow, courtesy of Giraudon / Art Resource, N.Y.
p. 170 Kunstmuseum Goeteborg, Sweden, courtesy of Scala / Art Resource, N.Y.
p. 171 Collection of Mrs. John Jay Whitney.
p. 172 The Baltimore Museum of Art: The Cone Collection, formed by Dr. Claribel Cone and Miss Etta Cone of Baltimore, Maryland.
p. 173 National Gallery of Art, Washington, D.C., Chester Dale Collection.
p. 174 Pushkin Museum of Fine Arts, Moscow, courtesy of Giraudon / Art Resource, N.Y.

Part VI: Gertrude Stein

p. 183 The Metropolitan Museum of Art, New York; bequest of Gertrude Stein, 1946.
p. 185 Private Collection.
p. 186 (top, both) From *Picasso et ses amis*, Fernande Olivier, 1933.
(bottom) Private Collection.
p. 188 (left) Samir Traboulsi Collection.
(right) Petit Palais Musée, Geneva.
p. 189 Private Collection.
p. 193 Archives Picasso, Musée Picasso, Paris / © PHOTO R.M.N.
p. 194 The Baltimore Museum of Art, Cone Archives.
p. 195 Private Collection.
p. 196 The Baltimore Museum of Art: The Cone Collection, formed by Dr. Claribel Cone and Miss Etta Cone of Baltimore, Maryland.
p. 198 Zervos, vol. 6, nos. 673, 674, 675, 680.
p. 203 The Baltimore Museum of Art, Cone Archives.
p. 208 (left) Zervos, vol. 26, no. 78.
(right) Zervos, vol. 26, no. 26.
p. 209 Private Collection.
p. 210 Philadelphia Museum of Art: The Louise and Walter Arensberg Collection.
p. 211 Collection, The Museum of Modern Art, New York; gift of G. David Thompson in honor of Alfred H. Barr, Jr. Photograph © 1995 The Museum of Modern Art, New York.
p. 212 (left) Zervos, vol. 6, no. 745.
(right) Zervos, vol. 6, no. 747.
p. 213 (left) Zervos, vol. 1, no. 357.
(right) The Museum of Modern Art, New York. The William S. Paley Collection. Photograph © 1995 The Museum of Modern Art, New York.
p. 214 Philadelphia Museum of Art: The A. E. Gallatin Collection.
p. 215 The Metropolitan Museum of Art, New York; bequest of Gertrude Stein, 1946.
p. 222 Archives Picasso, Musée Picasso, Paris / © PHOTO R.M.N.
p. 224 Vidal Ventosa.
p. 226 (left) Private Collection.
(right) Marina Picasso Collection.
p. 227 (top left) Musée Picasso, Paris / Art Resource, N.Y.
(top right) Kunstmuseum Basel.
(bottom) The Barnes Foundation, Merion Station, Pa.

p. 229 Private Collection.

p. 230 The Menil Collection, Houston.

p. 231 (top left) Zervos, vol. 2, part 2, no. 628.

(top right) Zervos, vol. 6, no. 987.

(bottom) Zervos, vol. 6, no. 991.

p. 232 Victor W. Ganz Collection, New York, courtesy of Giraudon / Art Resource, N.Y.

p. 233 Zervos, vol. 9, no. 244.

p. 234 Zervos, vol. 13, no. 139.

Part VII: The Brothel

p. 235 The Museum of Modern Art, New York. Acquired through the Lillie P. Bliss Bequest. Photograph © 1995 The Museum of Modern Art, New York.

p. 241 The Royal Museum of Fine Arts, Copenhagen.

p. 242 The Barnes Foundation, Merion Station, Pa.

p. 244 (left) Zervos, vol. 26, no. 267.

(right) Musée Picasso, Paris / © PHOTO R.M.N.

p. 251 The Metropolitan Museum of Art, New York, Rogers Fund, 1956.

p. 252 (top) Musée Picasso, Paris / © PHOTO R.M.N.

(bottom) Musée du Petit Palais, Paris.

p. 253 (top) Zervos, vol. 26, no. 69.

(bottom) Musée Picasso, Paris / © PHOTO R.M.N.

p. 254 (left) Private Collection.

(right) Zervos, vol. 2, part 1, no. 41.

p. 255 (top) Kunstmuseum Basel.

(bottom) Zervos, vol. 26, no. 317.

p. 256 Musée Picasso, Paris / © PHOTO R.M.N.

p. 257 (left) The Museum of Modern Art, New York; gift of David Rockefeller. Photograph © 1995 The Museum of Modern Art, New York.

(right) The Hermitage Museum, St. Petersburg, courtesy of Scala / Art Resource, N.Y.

p. 260 The Museum of Modern Art, New York. Acquired through the Lillie P. Bliss Bequest. Photograph © 1995 The Museum of Modern Art, New York.

Part VIII: The Suicide and the Banquet

p. 261 The Museum of Modern Art, New York. Gift of Nelson A. Rockefeller. Photograph © 1995 The Museum of Modern Art, New York.

p. 269 The Hermitage Museum, St. Petersburg, courtesy of Giraudon / Art Resource, N.Y.

p. 272 (left) Museum of Fine Arts, Boston, courtesy of Giraudon / Art Resource, N.Y.

(bottom right) Zervos, vol. 26, no. 313.

(top right) Kunstmuseum Bern, Hermann und Margrit Rupf-Stiftung.

p. 276 (top) Archives SNARK / Musée de Grenoble, courtesy of Art Resource, N.Y.

(bottom) The Baltimore Museum of Art: The Cone Collection, formed by Dr. Claribel Cone and Miss Etta Cone of Baltimore, Maryland.

p. 277 Collection Viollet, Paris.

p. 284 The Museum of Modern Art, New York. Gift of Nelson A. Rockefeller. Photograph © 1995 The Museum of Modern Art, New York.

Part IX: Cubism

p. 285 The Museum of Modern Art, New York. Nelson A. Rockefeller Bequest. Photograph © 1995 The Museum of Modern Art, New York.

p. 287 Laurens Archive.

p. 288 Laurens Archive.

p. 290 Staatsgalerie Moderner Kunst, Munich, courtesy of Giraudon / Art Resource, N.Y.

p. 292 (left) Clipping from the Kahnweiler press albums / Photograph courtesy of The Museum of Modern Art, New York.
(right) Roger-Viollet, Paris.

p. 297 Picasso Archives, Musée Picasso, Paris / © PHOTO R.M.N.

p. 298 Picasso Archives, Musée Picasso, Paris / © PHOTO R.M.N.

p. 302 (left) Oskar Reinhart Collection, Winterthur, Switzerland, courtesy of Bildarchive Foto Marburg / Art Resource, N.Y.
(right) Annapolis Collection, Carleton Mitchell / Art Resource, N.Y.

p. 303 The Museum of Modern Art, New York. Nelson A. Rockefeller Bequest. Photograph © 1995 The Museum of Modern Art, New York.

p. 304 (left) Private Collection.
(right) Musée des Beaux-Arts de Lyon. Gift of Raoul La Roche.

Part X: The *Mona Lisa*

p. 315 St. Germaine-en-Laye, Musée des Antiquités Nationales / © PHOTO R.M.N.-Arnaudet.

p. 320 (left) The Museum of Modern Art, New York. Acquired through the Lillie P. Bliss Bequest. Photograph © 1995 The Museum of Modern Art, New York.
(right) St. Germaine-en-Laye, Musée des Antiquités Nationales / © PHOTO R.M.N.-Arnaudet.

p. 323 Bibliothèque Nationale, Paris.

p. 333 Harlingue-Viollet, Paris.

Part XI: The Decorator

p. 335 Washington University Gallery of Art, St. Louis, University purchase, Kende Sale Fund, 1946.

p. 336 (both) Archives Picasso, Musée Picasso, Paris / © PHOTO R.M.N.

p. 343 (both) The Beinecke Rare Book and Manuscript Library, Stein Archive, Yale University Library, New Haven.

p. 353 (top left) Zervos, vol. 3, no. 78.

 (top right) Musée Picasso, Paris / Art Resource, N.Y.

 (bottom left) Zervos, vol. 9, no. 94.

 (bottom right) Zervos, vol. 9, no. 46.

p. 354 (left) Zervos, vol. 16, no. 325.

 (right) Zervos, vol. 25, no. 108.

p. 355 The Museum of Modern Art, New York. Gift of Mrs. Simon Guggenheim. Photograph © 1995 The Museum of Modern Art, New York.

p. 356 (clockwise from top left) Zervos, vol. 33, nos. 150, 151, 138, 152.

p. 358 (clockwise from top left) Zervos, vol. 33, nos. 435, 437, 436.

p. 361 Sir Roland Penrose / © Lee Miller Archives, East Sussex, England.

p. 362 Private Collection, courtesy of Giraduon / Art Resource, N.Y.

p. 363 Archives Picasso, Musée Picasso, Paris / © PHOTO R.M.N.

p. 365 Zervos, vol. 29, no. 200.

p. 366 (both) Laurens Archive.

p. 367 Cahiers d'Art, Paris.

p. 369 Archives Picasso, Musée Picasso, Paris / © PHOTO R.M.N.

Color Insert

Colorplate 1: The Museum of Modern Art, New York. Acquired through the Lillie P. Bliss Bequest. Photograph © 1995 The Museum of Modern Art, New York.

Colorplate 2: Philadelphia Museum of Art: The Samuel S. White III and Vera White Collection.

Colorplate 3: The Hermitage Museum, St. Petersburg, courtesy of Giraudon / Art Resource, N.Y.

Colorplate 4: Musée Picasso, Paris / © PHOTO R.M.N.

Colorplate 5: The Hermitage Museum, St. Petersburg, courtesy of Scala / Art Resource, N.Y.

Colorplate 6: The Hermitage Museum, St. Petersburg.

Colorplate 7: Private Collection.

Colorplate 8: Musée Picasso, Paris, courtesy of Giraudon / Art Resource, N.Y.

Colorplate 9: Collection Alex Maguy, Paris / Art Resource, N.Y.

Colorplate 10: The Museum of Modern Art, New York. Given anonymously (by exchange). Photograph © 1995 The Museum of Modern Art, New York.

Colorplate 11: Pushkin Museum of Fine Arts, Moscow, courtesy of Scala / Art Resource, N.Y.

Colorplate 12: Private Collection.

Colorplate 13: Kunstmuseum Bern, Hermann und Margrit Rupf-Stiftung.

Colorplate 14: Kunstmuseum Basel. Gift of Raoul La Roche, 1952.

Colorplate 15: Moderna Museet, Stockholm.

Colorplate 16: Kunstmuseum Basel. Gift of Raoul La Roche, 1952.

Colorplate 17: The Museum of Modern Art, New York. Acquired through the Lillie P. Bliss Bequest. Photograph © 1995 The Museum of Modern Art, New York.

Colorplate 18: Albright-Knox Art Gallery, Buffalo, courtesy of Scala / Art Resource.

Colorplate 19: The Hiroshima Museum of Art / ARTOTHEK, Peissenberg.

Acknowledgments

Every effort has been made to acknowledge all source material appropriately and to secure permission from copyright holders as required. Any copyright holders we have been unable to reach are invited to contact the publishers so that a full acknowledgment can be given in future editions.

Grateful acknowledgment is made to the following for permission to reprint previously published material:

Beinecke Rare Book and Manuscript Library: Quotations from Fernande Olivier's letters to Gertrude Stein. Stein collection, Yale Collection of American Literature, Beinecke Rare Book and Manuscript Library, Yale University. Reprinted by permission.

Georges Borchardt, Inc.: Excerpts from *Pablo Picasso: His Life and Times* by Pierre Cabanne. Copyright © 1975 by Editions Denoel. Reprinted by permission of Georges Borchardt, Inc. And for excerpts from *Pablo Ruiz Picasso* by Patrick O'Brian. Copyright © 1976 by Patrick O'Brian. Reprinted by permission of Georges Borchardt, Inc., for the author.

Editions Calmann-Levy and Gilbert Krill: Excerpts from *Souvenirs Intimes* by Fernande Olivier, edited by Gilbert Krill. Copyright © Calmann-Levy, 1988, reprinted with the permission of Gilbert Krill and Calmann-Levy.

Editions du Centre Pompidou: Excerpts from *Daniel-Henry Kahnweiler: Marchand, éditeur, écrivain* by Isabelle Monod-Fontaine. Editions du Centre Pompidou, Paris, 1984. No. d'éditeur: 421. No. ISBN: 2-85850-264-1. Reprinted by permission of Editions du Centre Pompidou. Excerpts from *Donation Louise et Michel Leiris: Collection Kahnweiler-Leiris* by Isabelle Monod-Fontaine. Editions du Centre Pompidou, Paris, 1984. No. d'editeur: 425. No. ISBN: 2-85850-267-6. Reprinted by permission of Editions du Centre Pompidou.

Crown Publishers: Excerpts from *Appreciation: Painting, Poetry and Prose* by Leo Stein. Copyright © 1947 by Leo Stein. Reprinted by permission of Crown Publishers, Inc.

Editions Gallimard: Excerpts from *Mes galeries et mes peintres* by Daniel-Henry Kahnweiler. Copyright © Gallimard, 1961. Reprinted by permission of Editions Gallimard.

Gilbert Krill: Excerpts from *Picasso et ses amis.* Copyright © 1995 by the estate of Fernande Olivier, reprinted with the permission of the executor, Gilbert Krill, and Calmann-Levy.

McIntosh and Otis, Inc. Excerpts from *Apollinaire: Poet Among the Painters* by Francis Steegmuller. Copyright © 1963 by Francis Steegmuller. Copyright © renewed 1991 by Francis Steegmuller. Reprinted by permission of McIntosh and Otis, Inc.

Paul Padgette. Excerpts from *Life's Not a Paragraph* by Annette Rosenshine. Reprinted by permission of Paul Padgette and the Bancroft Library, University of California, Berkeley.

Josep Palau i Fabre. Excerpts from *Picasso: Life and Work of the Early Years 1881–1907* by Josep Palau i Fabre. Copyright © 1980 by Josep Palau i Fabre. Reprinted by permission of the author.

Random House, Inc. Excerpts from *The Autobiography of Alice B. Toklas* by Gertrude Stein. Copyright © 1933 and renewed 1961 by Alice B. Toklas. Reprinted by permission of Random House, Inc. Excerpts from *A Life of Picasso, Volume I, 1881–1906* by John Richardson. Copyright © 1991 by John Richardson Fine Arts Ltd. Reprinted by permission of Random House, Inc.

Dr. Jacint Reventós i Conti. Excerpt from letters from Casagemas and Picasso to Ramón Reventós. Copyright © 1995 by Jacint Reventós i Conti. Reprinted by permission of Dr. Jacint Reventós i Conti.

Simon & Schuster, Inc. Excerpts from *Picasso, Creator and Destroyer* by Arianna Stassinopoulos Huffington. Copyright © 1988 by Arianna Stassinopoulos Huffington. Reprinted by permission of Simon & Schuster, Inc.

University of California Press. Excerpts from *Picasso: His Life and Work* by Roland Penrose. Copyright © 1981 by Roland Penrose. Reprinted by permission of University of California Press.